# HADRIAN

## EMPIRE AND CONFLICT

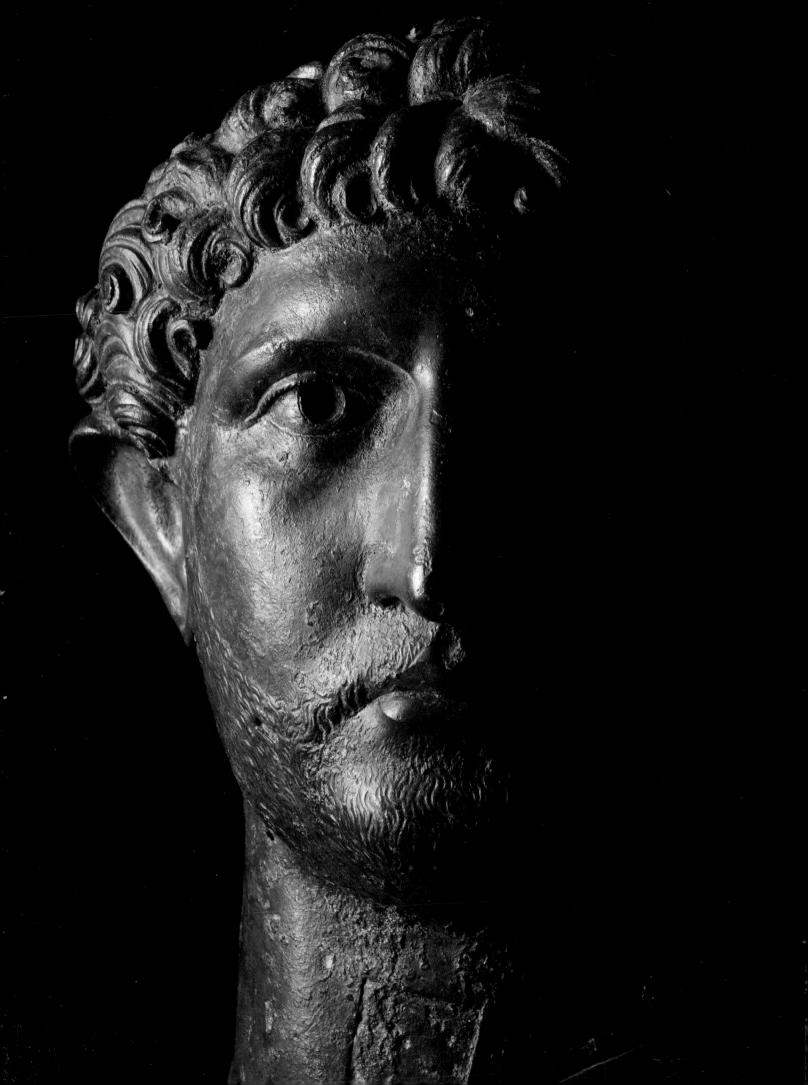

# HADRIAN

## EMPIRE AND CONFLICT

THORSTEN OPPER

HARVARD UNIVERSITY PRESS

CAMBRIDGE, MASSACHUSETTS

2008

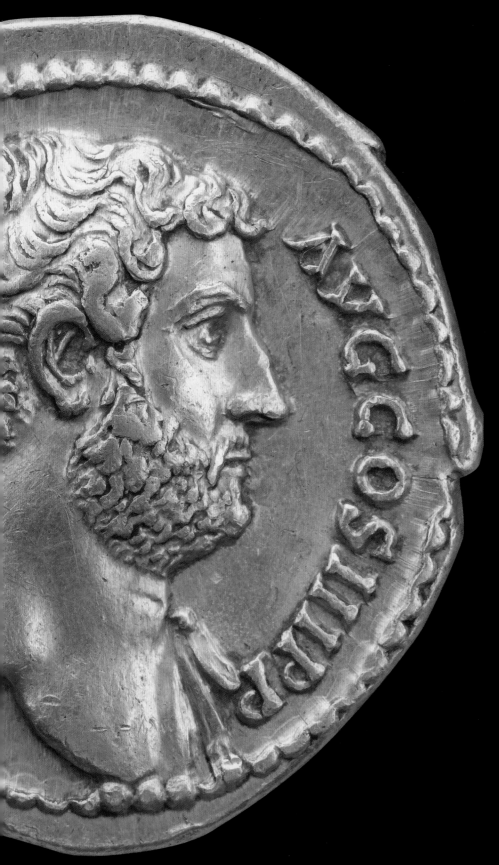

© 2008 The Trustees of the British Museum

Thorsten Opper has asserted the right to be identified as
the author of this work

First published in 2008 by The British Museum Press
A division of The British Museum Company Ltd

Library of Congress Cataloging-in-Publication Data

Opper, Thorsten.
 Hadrian : empire and conflict / Thorsten Opper.
    p. cm.
 Accompanies exhibition by the same name held at the
British Museum, July 24-Oct. 26, 2008.
 Includes bibliographical references and index.
 ISBN-13: 978-0-674-03095-4 (alk. paper)
1. Hadrian, Emperor of Rome, 76-138—Exhibitions.
2. Emperors—Rome—Biography—Exhibitions. 3. Rome—
Antiquities—Exhibitions. 4. Rome—History—Hadrian,
117-138—Exhibitions.
I. Title.
 DG295.O67 2008
 937'.07092—dc22
 [B]
                          2008008825

Designed by Price Watkins
Copyedited by Colin Grant
Index compiled by Indexing Specialists (UK) Ltd
Printed in Italy at Graphicom Srl.

Half-title: Pilaster capital from the Pantheon.
Frontispiece: Bronze portrait head of Hadrian
from Roman Britain.
Left: Gold aureus of Hadrian.
Opposite: Silver medallion of Hadrian.
Overleaf: The interior of the Pantheon.

# LIST OF LENDERS

Apart from the British Museum, the objects exhibited have been kindly lent by the following institutions:

DENMARK
Ny Carlsberg Glyptotek, Copenhagen

FRANCE
Musée de Picardie, Amiens
Department of Greek, Roman and Etruscan Antiquities, Musée du Louvre, Paris
Department of Egyptian Antiquities, Musée du Louvre, Paris

GEORGIA
Georgian National Museum, Tbilisi

GERMANY
Staatsbibliothek Bamberg
Antikensammlung, Staatliche Museen Berlin
Egyptian Museum, Staatliche Museen Berlin

ISRAEL
Israel Museum, Jerusalem
Israel Antiquities Authority

ITALY
Museo Tàttile Statale Omèro, Ancona
Museo di Ostia, Ostia
Sovraintendenza ai Beni Culturali del Comune di Roma, Mercati di Traiano – Museo dei Fori Imperiali
Sovraintendenza ai Beni Culturali del Comune di Roma, Museo della Civiltà Romana
Musei Capitolini, Rome
Museo Nazionale di Castel Sant'Angelo, Rome
Soprintendenza per i Beni Archeologici del Lazio – Villa Adriana
Vatican Museums, Vatican City

SPAIN
Museo Del Prado, Madrid
Museo Arqueológico de Sevilla

SWITZERLAND
Musée d'art et d'histoire, Geneva

TURKEY
Turkish Republic, Ministry of Culture and Tourism

UNITED KINGDOM
Manchester Museum, Manchester
The Duke of Northumberland
Society of Antiquaries of Newcastle upon Tyne
The Bodleian Library, University of Oxford
Stratfield Saye Preservation Trust
Mr Ivan Jones

UNITED STATES OF AMERICA
Houghton Library, Harvard
The Arthur M. Sackler Museum, Harvard University
Oriental Institute, University of Chicago

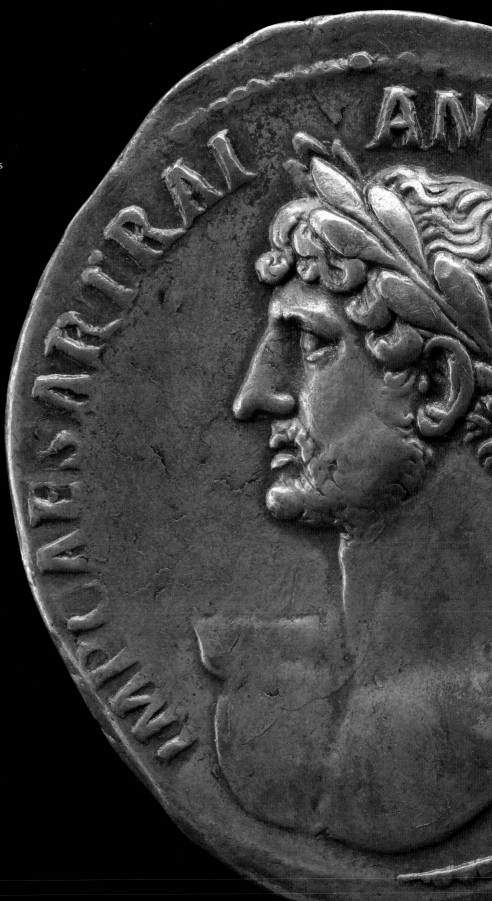

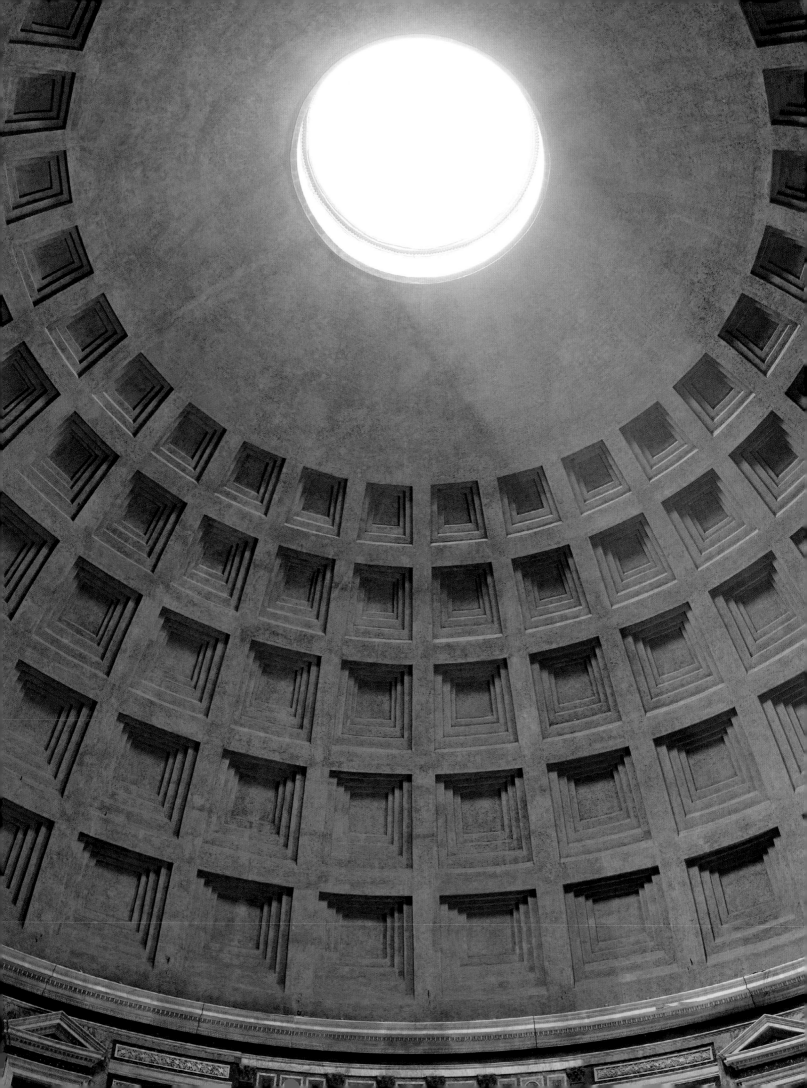

# CONTENTS

# SPONSOR'S FOREWORD

The Emperor Hadrian was one of the most remarkable leaders in Roman history, presiding over an empire that covered a landmass considerably larger than the size of the present European Union.

BP is pleased to support this exhibition, which offers a new appraisal of Hadrian's turbulent life and reign through artworks seen together here for the first time.

Hadrian's personality, public and private, is presented from a fresh perspective, exploring the influence of his reign on our lives today through his pioneering architecture, his attempts to unify disparate people through ambitious cultural projects, and his approach to government. The immense and lasting legacy of this great leader seems highly relevant in the modern world.

Dr Tony Hayward
CEO, BP plc.

# DIRECTOR'S FOREWORD

This is the second in a series of exhibitions exploring great rulers who shaped the world in which we now live. Coming after the investigation of the making of the Chinese Empire, this exhibition looks at the formative empire in the West under one of its most gifted rulers.

Hadrian's character and legacy have fascinated people for centuries. Judgements of him have naturally differed widely, depending on preconceptions and circumstances. *Hadrian: Empire and Conflict*, the largest ever exhibition devoted to Hadrian in this country, allows visitors to come face to face with the objects that tell his story and explore Hadrian for themselves. We are particularly grateful to the many colleagues from around the world who have supported the exhibition through very generous loans, allowing us to present on their behalf spectacular and sometimes deeply moving objects, many of them not seen before outside their source countries. Brought together for the first time, these objects will enter into new dialogues that will undoubtedly spark debate among general visitors as well as scholars.

The British Museum seems a particularly good place to explore Hadrian's legacy. Every child in Britain learns about Hadrian's Wall, and in the Vindolanda tablets we have a rare and precious insight into daily life in Roman Britain. The Museum holds the only surviving large-scale portrait of Hadrian from Britain – the famous bronze head recovered from the Thames in 1834 – as well as sculptures excavated in the eighteenth century at his famous villa in Tivoli, and important archive material of the period. The permanent galleries allow a wider glimpse of Hadrian's world, and, importantly, the other world empires that existed at the same time.

The astonishing topicality of many of the themes discussed in the exhibition and book demonstrates how significant Hadrian's legacy remains to this day. Not only can the past help us better to understand the present, but the present can also inspire a fresh look at the past.

Neil MacGregor
Director
The British Museum

# PREFACE AND ACKNOWLEDGEMENTS

Today, it is possible to reach even the furthest parts of what used to be Hadrian's empire in a few hours on a plane from London. The *Pax Romana* has long gone, different cultures have taken over, and conflicts simmer in some of the countries then united, prosperous and at peace. In visiting sites and museums abroad, it has been an exciting and at times touching experience to realise again how many of us have a share in this history. In the course of preparing this exhibition and book many colleagues abroad, some of them great characters and often wonderful ambassadors for their countries, have become true friends. New discoveries, the exchange of ideas and the ensuing debate are what keeps work in this field so singularly exciting. The seeds for a number of joint projects were sown during shared site visits and in countless museum galleries and storerooms, and I very much hope that these will come to fruition in future years.

In many ways, all the magnificent objects brought together here deserve detailed studies of their own, and I am only too aware of the shortcomings of my own knowledge and abilities in presenting them. However, I take some comfort in the fact that this exhibition gives us a unique opportunity to share these great treasures with a large international audience of interested members of the public and experts from many countries. Events in the field of classical archaeology can at times move very fast indeed, and it was less than a year ago that news of a fantastic new discovery in Sagalassos (south-west Turkey) reached the outside world. We cannot stress enough the extreme generosity and admirable efficiency of the Turkish Ministry of Culture, staff at the Turkish Embassy in London and the colleagues in Burdur and Leuven who have allowed us to include these fresh and unpublished finds in the exhibition and unveil the Sagalassos Hadrian to the wider public.

Exhibitions are always are an amazing team effort, and it is a great pleasure to thank the following friends and colleagues for their outstanding help and support in discussing the material or providing photographs and information (at the same time, I ask the forgiveness of those who cannot be named individually here): Benedetta Adembri (Villa Adriana), Antonio Aguilera (Barcelona), Lindsay Allason-Jones (Newcastle), Fiora Bellini (Rome), Piero Berni (Barcelona), Angela Carbonaro (Rome), Amanda Claridge (London), Mariana Cook (New York), Susanne Ebbinghaus (Harvard), Haci Ali Ekinci (Burdur), Geoff Emberling (Chicago), Çinar Ergin (London), Atilay Ersan (London), Roberto Farroni (Ancona), Paola Germoni (Ostia), Michèle Goslar (Brussels), Yannick Guillou

(Bény-sur-Mer), Marc-André Haldimann (Geneva), Joan Howard (Petite Plaisance), Kate Jenkins (Stratfield Saye), Nikolaos Kaltsas (Athens), Anna Karapanagiotou (Tripolis), Anna Maria Liberati (Rome), Zaccaria Mari (Rome), Jean-Luc Martinez (Paris), Marina Mattei (Rome), David Mevorah (Jerusalem), Marina Milella (Rome), Mette Moltesen (Copenhagen), Isabella di Montezemolo (Vatican), Charles Noble (Chatsworth), Irfan Önal (London), Jan Stubbe Østergaard (Copenhagen), Claudio Parisi-Presicce (Rome), Clare Pickersgill (Newcastle), Rosanna di Pinto (Rome), Pablo Quesada (Seville), Manfred Schmidt (Berlin), Andreas Schmidt-Colinet (Vienna), Stefan Schroeder (Madrid), Agnes Schwarzmaier (Berlin), Giorgios Spyropoulos (Athens), Werner Taegert (Bamberg), Annalisa Trasatti (Ancona), Lucrezia Ungaro (Rome), Marc Waelkens (Leuven), Susan Walker (Oxford).

In the British Museum, Rosario (Charo) Rovira Guardiola has provided absolutely indispensable support. Neither the exhibition nor this book could have been prepared without her tireless assistance. I am also grateful to all my colleagues in the Department of Greece and Rome, who had to shoulder parts of my normal workload while my life was taken up with Hadrian. In addition, great thanks are due to the following: Richard Abdy, Matthew Biggs, Karen Birkhölzer, Richard Blurton, Hannah Boulton, Rosemary Bradley, Andrew Burnett, Frances Carey, Joe Cribb, Rachel Dagnall, Darrel Day, Amy Drago, Ken Evans, Celeste Farge, Lesley Fitton, Rhiannon Goddard, Paul Goodhead, Michelle Hercules, Coralie Hepburn, Richard Hobbs, Mira Hudson, Caroline Ingham, Ralph Jackson, Nicholas Lee, Joanna Mackle, Jill Maggs, Carolyn Marsden-Smith, Owain Morris, Neil MacGregor, Carol Michaelson, Kate Morton, Michael Neilson, Jon Ould, Kim Overend, Sotiria Papastavrou, Hannah Payne, Saul Peckham, Virginie Perdrisot, Alex Reed, Paul Roberts, David Saunders, Margaux Simms, Steve Slack, Melina Smirniou, Jan Stuart, Judith Swaddling, Tracey Sweek, Alex Truscott, Kenneth Uprichard, Matthew Weaver, Dyfri Williams, John Williams, Jonathan Williams, Michael Willis, Barbara Wills, Katrina Whenham.

Finally, I would like to thank my wife, Ida Toth, and my son, Mattia Opper, for tolerating the inevitable absences and signs of strain that come with organizing such a project.

My own picture of Hadrian has changed a great deal during the past few months: while he was certainly a much darker character than commonly thought and only too human, one cannot but admire the incredible stamina and foresight with which he reorganized the Roman empire and helped to shape the world we live in today.

Thorsten Opper

# CHRONOLOGY

| | |
|---|---|
| 76 | 24 January: Publius Aelius Hadrianus born in Rome |
| 85 | Publius Aelius Hadrianus Afer, Hadrian's father, dies |
| | Marcus Ulpius Traianus (Trajan) and Publius Acilius Attianus become Hadrian's guardians |
| 94 | Hadrian begins political career |
| 96 | Emperor Domitian assassinated; senate elects Cocceius Nerva as new emperor |
| 96/7 | Hadrian military tribune with Legion II Adiutrix (Pannonia), then Legion V Macedonica (Moesia Inferior) |
| 97 | Nerva adopts Trajan |
| | Hadrian military tribune with Legion XXII Primigenia (Germania Superior) |
| 98 | Nerva dies; Trajan proclaimed emperor |
| c.100 | Hadrian marries Trajan's great niece, Vibia Sabina |
| 101–2 | First Dacian War |
| | Hadrian with Trajan as *quaestor principis*; becomes tribune of the people |
| 104 | Hadrian becomes praetor |
| 104–6 | Second Dacian War |
| 105 | Hadrian commander of Legion I Minervia |
| 106–8 | Hadrian governor of Lower Pannonia |
| 108 | Hadrian consul for the first time (*cos suff*) |
| 111–12 | Hadrian visits Athens, serves as archon |
| 114–17 | Parthian War |
| | Hadrian with Trajan as *comes* |
| | Armenia, Assyria and Mesopotamia occupied and officially declared new provinces; Jewish diaspora rebellion |
| 117 | Hadrian governor of Syria |
| | 7/8 August: Trajan dies at Selinus |
| | 11 August: Hadrian proclaimed emperor |
| 118 | 9 July: Hadrian's official entry into Rome as new emperor |
| | Hadrian consul for the second time (*cos II*) |

| | |
|---|---|
| 119 | Hadrian consul for the third time (*cos III*) |
| | Matidia, Hadrian's mother-in-law, dies and is deified on 23 December |
| 121 | 21 April: foundation ceremony for Temple of Venus and Roma |
| 121–5 | Hadrian embarks on first journey |
| | (Gallia, Germania Superior, Reatia, Noricum, Germania Inferior, Britannia, Hispania, Syria, Cappadocia Bithynia, Asia, Greece, Sicilia) |
| 122? | Plotina, Trajan's widow, dies and is deified |
| 123 | War with Parthians averted through show of strength and diplomatic conference |
| 127 | March to August: tour of Italy |
| 128 | Hadrian assumes title *Pater Patriae* |
| | From 128/9 Hadrian revered as *Olympios* in the east |
| 128–32 | Hadrian embarks on second journey |
| | (Africa, Greece, Asia, Syria, Palmyra, Arabia, Judaea, Egypt, Syria, Thrace, Moesia, Greece) |
| 130 | 24 October: Antinous drowns in the Nile |
| 130 | 30 October: Antinoopolis founded |
| 131/2 | Hadrian present at inauguration of Temple of Zeus Olympios in Athens; from 132 he takes the title *Panhellenios* in the east |
| 132–5/6 | Jewish revolt |
| 134 | Hadrian in Rome |
| 136 | Hadrian accepts second imperial acclamation (*imperator II*) to mark victory over Jews |
| | Hadrian adopts Lucius Ceionius Commodus |
| 137? | Sabina, Hadrian's wife, dies and is deified |
| 138 | Lucius Ceionius Commodus dies night before 1 January |
| | 25 January: Hadrian adopts Titus Aurelius Fulvius Boionius Arrius Antoninus (the future Antoninus Pius); Antoninus in turn has to adopt Marcus Annius Verus (the future Marcus Aurelius) and the younger Lucius Ceionius Commodus (the future Lucius Verus) |
| 138 | 10 July: Hadrian dies at Baiae |

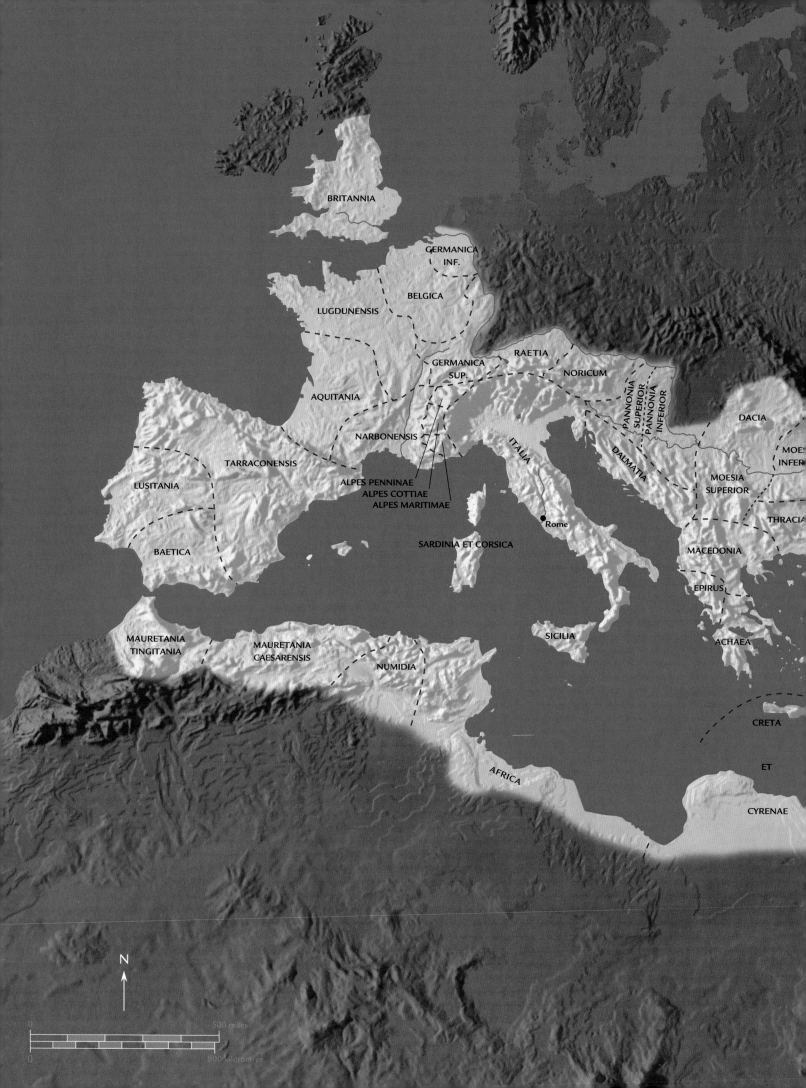

BRITANNIA

GERMANICA INF.

BELGICA

LUGDUNENSIS

GERMANICA SUP.

RAETIA

NORICUM

PANNONIA SUPERIOR

PANNONIA INFERIOR

DACIA

AQUITANIA

DALMATIA

MOES INFER

NARBONENSIS

ITALIA

MOESIA SUPERIOR

TARRACONENSIS

ALPES PENNINAE
ALPES COTTIAE
ALPES MARITIMAE

THRACIA

LUSITANIA

Rome

MACEDONIA

SARDINIA ET CORSICA

EPIRUS

BAETICA

ACHAEA

SICILIA

MAURETANIA
TINGITANIA

MAURETANIA
CAESARENSIS

CRETA

NUMIDIA

ET

AFRICA

CYRENAE

N

500 miles

0

0

800 kilometres

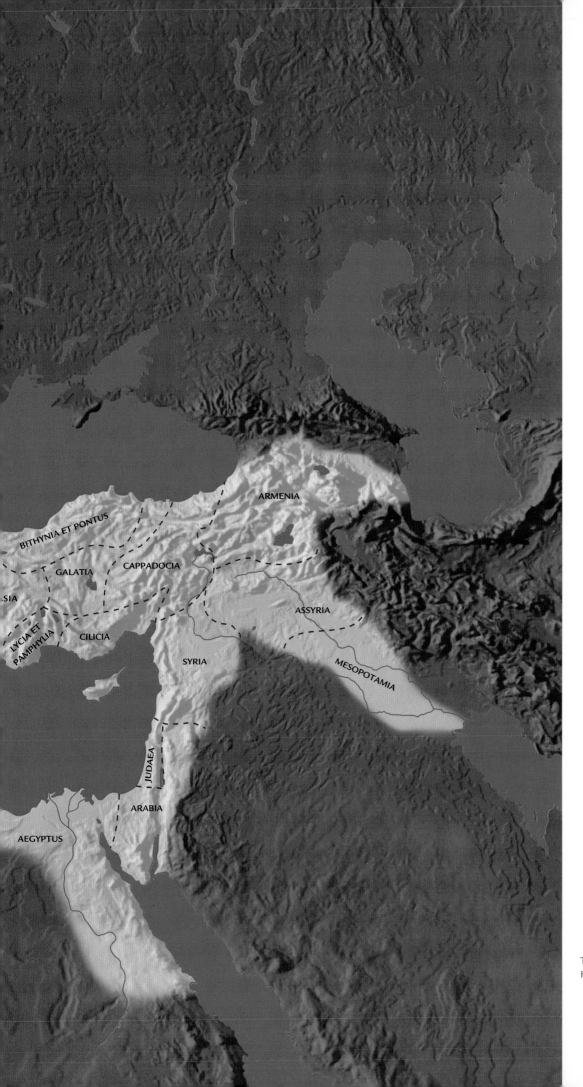

The Roman empire at the time of
Hadrian's accession in AD 117.

# Introduction

'Diverse,
manifold,
multiform'

EPITOME DE CAESARIBUS 14.6
ON HADRIAN'S CHARACTER

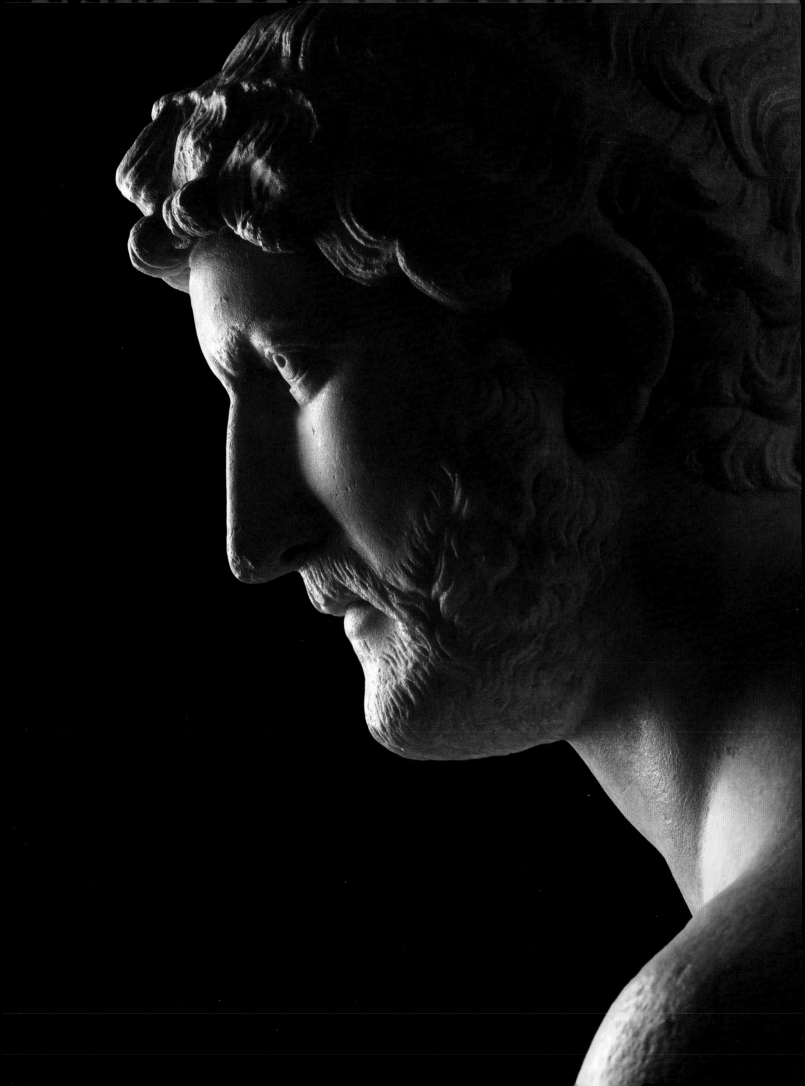

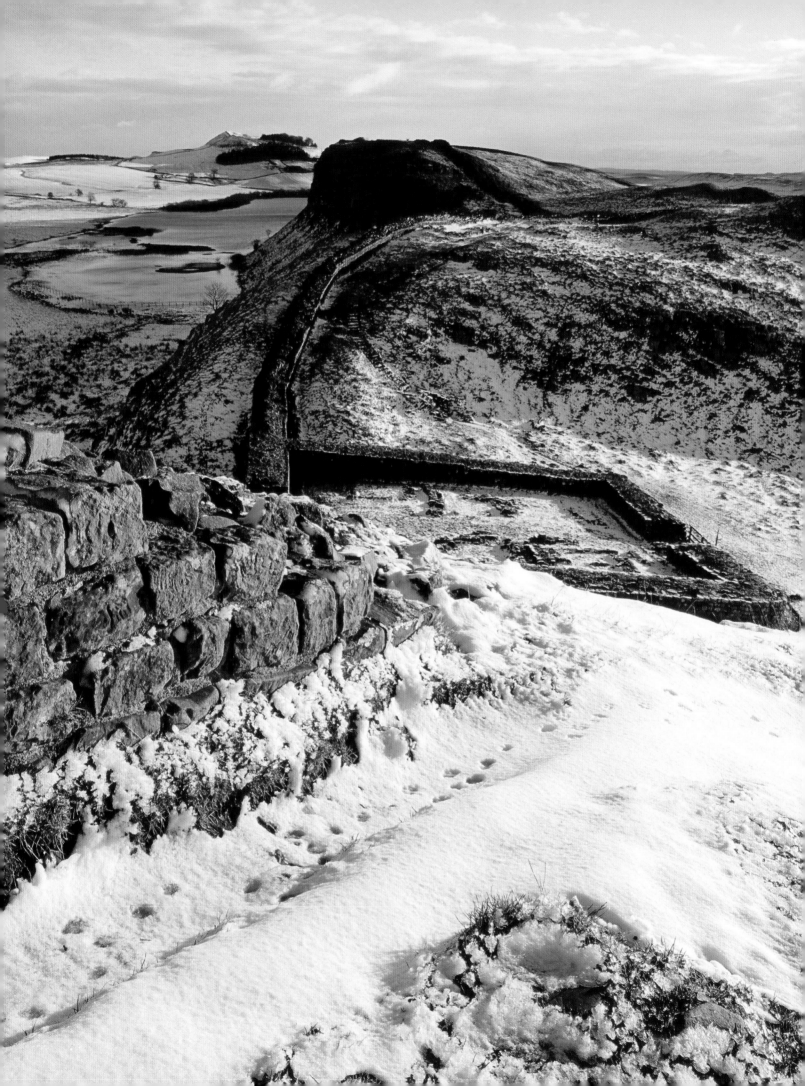

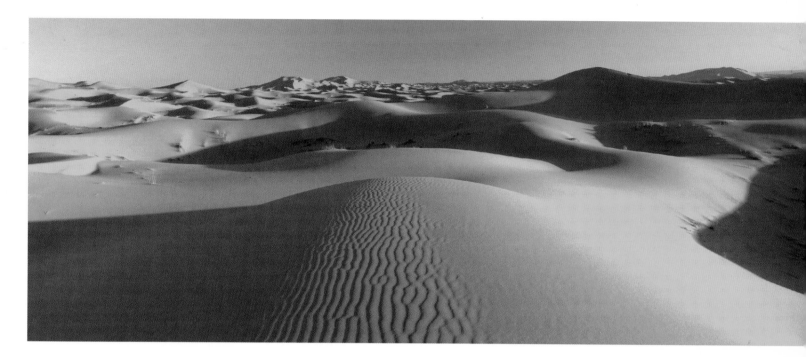

FOR almost twenty-one years, from AD 117 to 138, Publius Aelius Hadrianus ruled one of the mightiest empires the world has ever seen. The boundaries of this empire enclosed parts of three continents, stretching from the edges of the Scottish lowlands in the north to the Sahara Desert in the south, from the Atlantic Ocean in the west to the River Euphrates in the east.

At the heart of the empire was Rome, the largest city of the ancient Mediterranean, if not the globe, a pulsating capital of some one million inhabitants, seat of the emperors and the senate. The city was constantly remade. A continuous influx of people from all over the empire, as well as rural poor from Italy, ensured a steady turnover of population. Rome was a true metropolis, a world city that was home to substantial foreign communities, many of them slaves. Considerably more Greeks, for example, lived in Rome than in any of the old cities of the Greek heartland, and the same would have been true for many other nationalities of the empire.

At the same time, it is important to remember that the Roman empire did not exist in isolation. When Hadrian reigned in Rome, the Eastern Han ruled China, and India was dominated by the Satavahana. While there were no direct political contacts, Rome was linked to these other empires through a long-distance trade in luxury goods carried out by numerous middlemen. Roman oil amphorae, for example, have been found as far away as the Indian subcontinent and Sri Lanka, while Chinese silk was imported from the further reaches of Asia

(PREVIOUS SPREAD)
**Fig. 1** Bust of Hadrian from Rome.

LEFT AND ABOVE
**Figs 2 & 3** A world empire from Scotland to the Sahara: a milecastle on Hadrian's Wall in winter (left) and sand dunes in the Sahara Desert.

along the Silk Road and the caravan routes of the Middle East.[1] At Rome's eastern border was the Parthian empire, covering much of present-day Iran and Iraq, a constant focus of Rome's military and diplomatic activities.

Hadrian came to power at a moment of acute military crisis, demanding instant decisions with far-reaching consequences. He had to stabilize an empire that was dangerously overstretched, realign borders and instigate thorough reforms of the military, legal and economic system.[2] He dedicated himself to this task with tremendous personal energy, travelling through almost all the provinces of the empire in two long journeys that kept him away from Rome for more than half of his reign.[3] In the process he must have met more of his subjects than any emperor before him. He inspected army units and border installations, and met prominent members of the local elites, constantly spreading and refining his vision of what the empire should be. Government business had to be carried out on the move with a constant reception of embassies and delegations and extensive correspondence.[4]

In power, Hadrian faced two great challenges, one personal, the other

**Fig. 4** Hadrian spent more than half of his reign travelling the empire. His presence is so far firmly attested in all but five provinces (Aquitania, Lusitania, Sardinia et Corsica, Creta et Cyrenae, Cyprus).

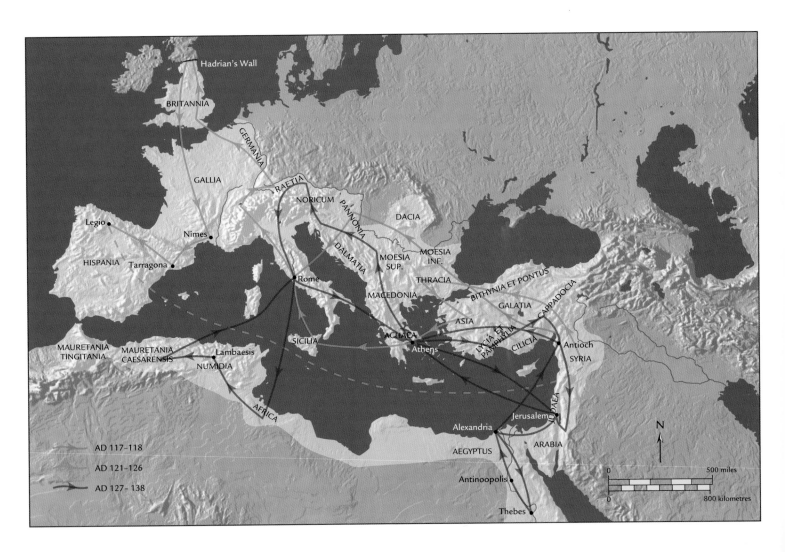

strategic. He belonged to a new elite with strong roots in the provinces, and despite kinship ties, if distant ones, he was only confirmed as heir to the throne through a last-minute adoption by his predecessor, so he continuously had to assert his legitimacy as ruler. Meanwhile, the empire needed to gain inner strength and cohesion, in order to be able to face the many threats to its prosperity and peaceful existence.

Hadrian's achievements in these areas were outstanding, his legacy immense. No observer looking back at his reign now can fail to be impressed by the sheer willpower and physical stamina with which he devoted himself to these tasks. In the end he died exhausted, aged only sixty-two, not a great age for a man of his social class, but in a position to pass on a strengthened and revitalized empire to his chosen successor.

Fig. 5 Bronze sestertius of Hadrian issued in the second half of his reign. He traversed the empire by land and sea.

It is much more difficult to form a picture of Hadrian the man, as opposed to Hadrian the ruler. Numerous anecdotes in the ancient literary sources describe Hadrian as a very complex character. He emerges as a highly gifted, intellectually curious, but also overpowering and controlling individual. A passionate hunter and trained military man who shared the burdens of his soldiers, he was also interested in the arts and is said to have tried his hand at many pursuits in this area. His personal life in particular has caused comment and intrigue.

Modern historical studies rightly concentrate on a sober presentation of facts. Yet current political events also lend Hadrian's actions a surprising topicality that cannot but have an effect on how we perceive aspects of his reign. In this sense each generation has to discover its own Hadrian and continue to explore the relevance of his legacy. One of Hadrian's very first official acts as a new ruler was to withdraw the Roman army from Mesopotamia, modern-day Iraq. At a time when western forces occupy the same territory this inevitably lends Hadrian's policies a different kind of attention. Indeed, the major conflict zones of Hadrian's time, the Balkans, Caucasus, Mesopotamia and Judaea/Palestine, are conflict zones now.

Much of the scholarly research on Hadrian up until the end of the Second World War, including the assessment of his achievements and world historical role, was intrinsically linked to the individual political standpoint and cultural background of the authors involved. This applies in particular to Hadrian's decision to give up most of the recent conquests by his predecessor and not lead any major wars of aggression. To scholars operating within the framework of authoritarian societies such as Wilhelminian Germany this appeared as stagnation and weakness, leading to the empire's ultimate decline. Others, particularly after the great wars of the twentieth century, on the contrary saw Hadrian as an exemplary, far-sighted leader and promoter of peace. The latter aspect in particular has a

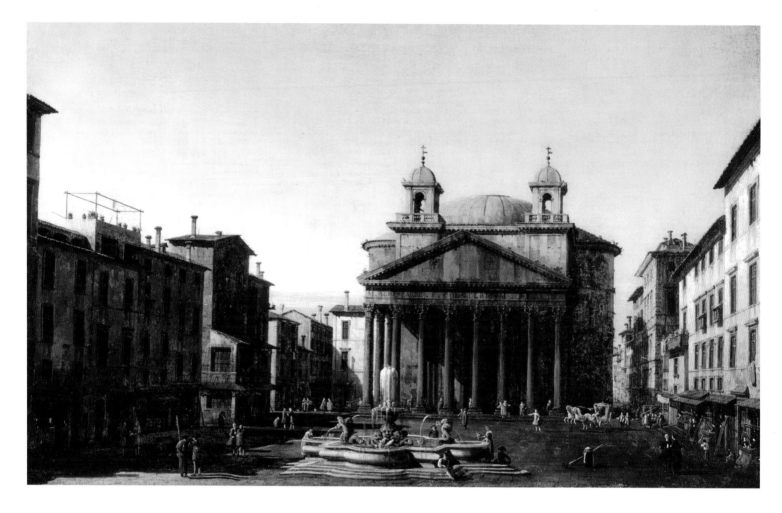

**Fig. 6** View of the Pantheon in Rome, painted by Bernardo Bellotto, *c.*1742.

strong hold on the wider public perception of Hadrian today.[5] The monument that most people would spontaneously associate with Hadrian's name, the wall he built in the north of England, belongs in this context. Yet even here, things might not be what they appear to be; after all, walls keep people in as well as out and serve as psychological as well as military means of rule, the most visually potent element of a much wider network of control. Here, too, the many walls and border installations that go up in the world today may have a bearing on how we will perceive their Roman equivalents.[6]

Closely tied to this assessment of Hadrian's foreign and military policy is the interpretation of his strong philhellenism; in the past Hadrian, the great traveller and peaceful ruler with a passionate interest in Greek culture, has been contrasted with his militaristic, aggressive predecessor, Trajan. Much of this over-simplified and anachronistic concept does not stand up to scrutiny. To some extent, if not within scholarly circles then at least among a wider public, the Roman Hadrian needs to be rediscovered behind the persuasive image of the *graeculus*, or 'little Greekling', that has so dominated the debate. Very sound political and strategic reasons, as well as cultural affinities, may have informed Hadrian's general attitude towards his Greek subjects, and in many ways Hadrian

only continued and expanded measures taken by his predecessors.[7] Hadrian's relationship with the Greek world, although strong and deep, has been unduly romanticized, no doubt in part influenced by his bond with his Greek companion Antinous.

Hadrian transformed the urban fabric of Rome through a massive building programme. Some of his monuments, like the Pantheon and his Mausoleum, now the Castel Sant'Angelo, form distinctive architectural landmarks to this day, while many others still lie buried underground. Yet Hadrian's munificence extended to cities throughout the empire; his reign coincided with major breakthroughs and innovations in construction technology and building design. Architecture thus forms one of the lasting legacies of Hadrian's reign, with a direct line of emulation, rediscovery and transformation leading, for example, from the Pantheon to the magnificent church of Hagia Sophia in Constantinople, itself the model for the great mosques of the Ottoman era, and to key Renaissance monuments in the west such as Brunelleschi's dome of Florence cathedral and Michelangelo's dome of St Peter's. Even Smirke's Round Reading Room in the British Museum stands in this tradition. Much more subtle and unexpected are the distant echoes of Hadrianic structures in the work of the great architects of the twentieth century, such as Louis Kahn, whose cutting-edge modernity very much encapsulates the impact that some of Hadrian's monuments must have had when first built.

Research on Hadrian and the Roman empire in general constantly evolves. There have been an astounding number of archaeological discoveries in the last decade or two that shed new light on Hadrian and his reign. They range from

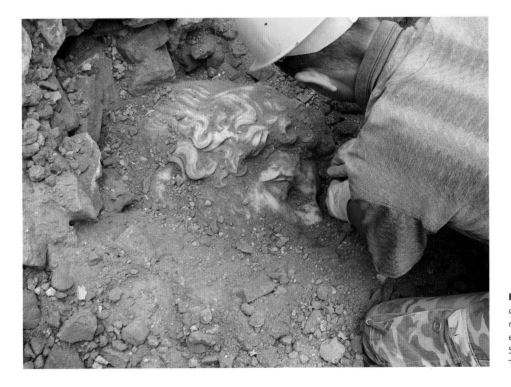

**Fig. 7** The moment of discovery: a colossal marble head of Hadrian emerges from the ground. Sagalassos, south-west Turkey, summer 2007.

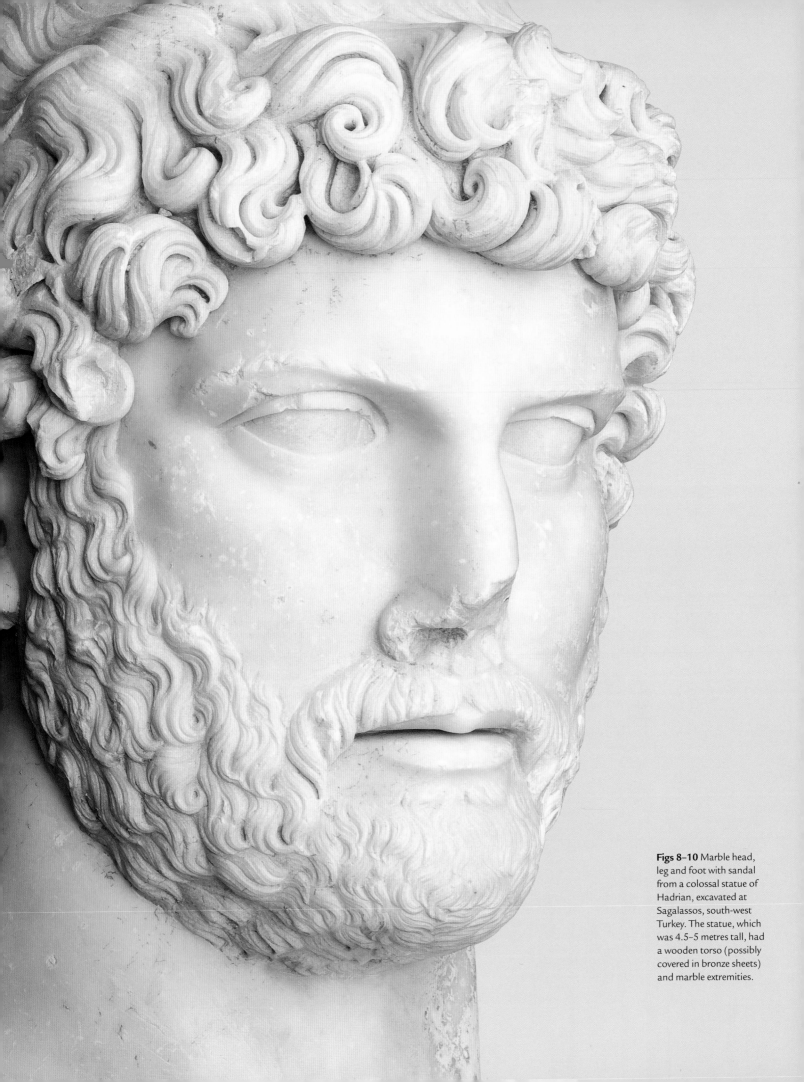

**Figs 8–10** Marble head, leg and foot with sandal from a colossal statue of Hadrian, excavated at Sagalassos, south-west Turkey. The statue, which was 4.5–5 metres tall, had a wooden torso (possibly covered in bronze sheets) and marble extremities.

## *Recent finds*

Hadrian was a great benefactor of the city of Sagalassos, which he made the capital of the prosperous province of Pisidia (south-west Turkey). In August 2007 fragments of a colossal statue of Hadrian were found in the remains of a bath building begun by Hadrian and finished by his successor, Antoninus Pius. Further colossal statues of the imperial family may have stood nearby. Fragments of colossal statues of Hadrian and his predecessor Trajan were also found in the Temple of the Deified Trajan at Pergamon.

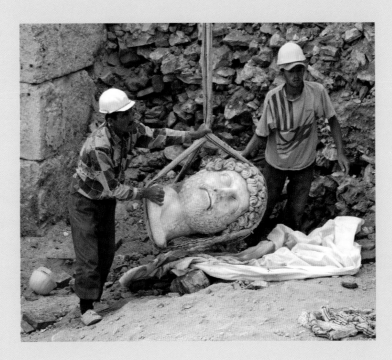

**Fig.11** The colossal head is carefully lifted.

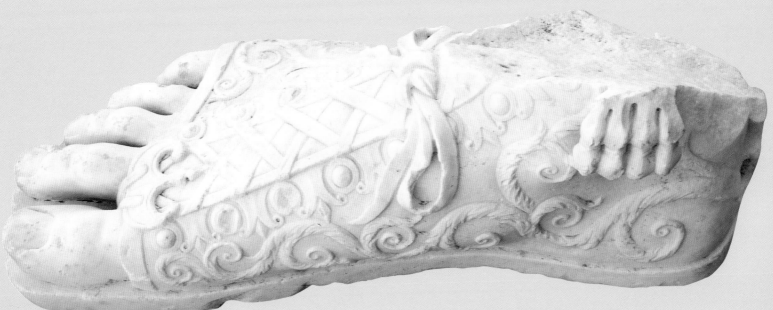

important recent finds at familiar sites such as Hadrian's villa at Tivoli or the centre of Rome, which add to or change our understanding of familiar monuments, to spectacular individual discoveries such as the magnificent fragments of a colossal marble statue of the emperor unearthed in the ancient city of Sagalassos in south-west Turkey in August 2007.[8] One of the aims of the following chapters is to present some of these new finds and set them into their wider context.

Irretrievably lost but for short mentions in the literary sources and some epigraphic evidence are the many spectacles that formed such an important part of the way Hadrian interacted with the Roman public. These included circus races, gladiatorial fights and animal hunts in the arena, athletic contests and other festivals throughout the empire, as well as religious and other rituals that tied the great new monuments into the collective consciousness of the Roman people.

Hadrian's success in unifying the empire was astounding. It can be said with little exaggeration that he laid the foundations for the great flourishing of Greek culture within the Roman world that would ultimately lead to the transformation of the Roman into the Byzantine empire. He revived the economy of the Greek-speaking territories and injected new confidence into their people by treating them as true partners in leadership. It was therefore partly also through Hadrian's legacy that the Byzantines came proudly to refer to themselves as *Rhomaioi*, or Romans, rather than *Hellenes*, or Greeks.[9] This eastern Roman empire lasted until the Muslim conquest in 1453. Eight years later, a still traumatized Pope Pius II, the Sienese classical scholar Aeneas Sylvius Piccolomini, led the first expedition to investigate the ruins of Hadrian's great country residence at Tivoli outside Rome.

## Written sources

Towards the end of his life, Hadrian wrote an autobiography, probably in the form of a series of letters to his adopted son and successor, Antoninus Pius. It is now completely lost but for a short, yet poignant, excerpt identified in a papyrus fragment from Egypt that was copied as a school exercise about a generation after Hadrian's death (fig. 209).[10]

Two senators wrote biographies of Hadrian or histories of his reign in the early third century AD. They drew on Hadrian's autobiography, which they do not quote verbatim but occasionally paraphrase or allude to, on numerous official documents in the archives of the Roman state and of course on a vivid oral tradition within their own families, who were part of the senatorial class. The first of these senators, Marius Maximus, composed a work entitled *vitae Caesarum*, 'Lives of the Caesars'. The *vitae*, too, are lost, but they formed one of the main sources for the so-called *Historia Augusta*, another series of imperial biographies written at the end of the fourth century AD. A complex work with an obscure compositional

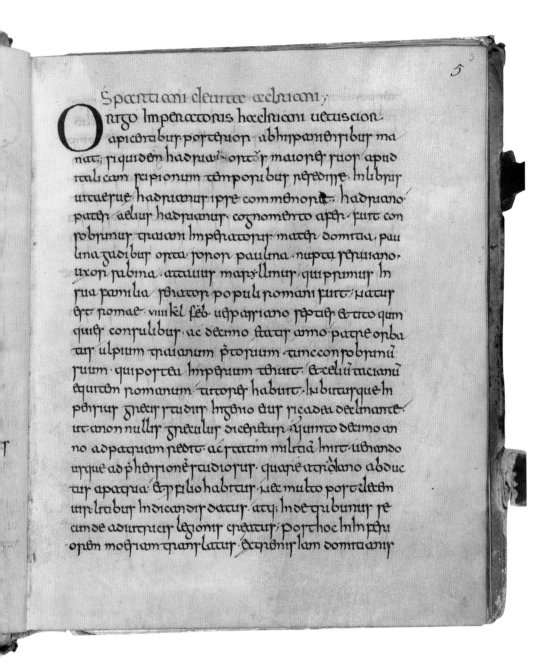

**Fig. 12** Ninth-century manuscript of the *Historia Augusta*, copied by an Anglo-Saxon scribe.

history and structure that have been painstakingly unravelled by modern historians, the *Historia Augusta* is a much condensed compilation interspersed with outright inventions.[11] Yet it remains a key source for Hadrian's life and, but for a very few early medieval manuscripts, it, too, would have perished. The second third-century writer covering Hadrian's reign was Cassius Dio. He published a history of Rome from its beginnings down to his own time. Frustratingly, book 69 of Dio's history, which dealt with Hadrian, is preserved only in a much abbreviated Byzantine synopsis and in some isolated, longer excerpts elsewhere.[12]

More information on Hadrian and his times is of course provided by the preserved texts of many second-century writers. Pliny the Younger in his eulogy for Trajan and extensive correspondence touches on many aspects relevant for

Hadrian's life before he came to power. Plutarch, Dio of Prusa, Arrian, and, later, Aelius Aristides, Fronto, Pausanias and Philostratus are among the authors who comment on aspects of Hadrian's reign.

Other sources are papyri, mostly from the sands of the Egyptian desert but also from places like Judaea. They range from documents drawn up by officials in the local administration to intensely personal letters and help flesh out what we know about daily life as well as local events in Hadrian's day. In a similar category fall the fascinating wooden writing tablets discovered most famously at Vindolanda near Hadrian's Wall. In addition, there are masses of inscriptions, giving us an often detailed, official version of specific events that can be utilized to confirm, complement and balance the literary tradition. Papyri and inscriptions provide the historian with the added frisson of making new discoveries, filling gaps, providing dates and contexts and all too often posing many new questions.[13]

## *Marguerite Yourcenar's* Mémoires d'Hadrien

It has by now become almost impossible to discuss Hadrian without mentioning at the same time the writer Marguerite Yourcenar and her acclaimed novel, *Mémoires d'Hadrien*. The novel, first published in 1951, takes the form of a long letter written by Hadrian to his adopted grandson Marcus Aurelius, in which the emperor recounts his life, in effect turning the *Mémoires* into Yourcenar's fictional version of Hadrian's lost autobiography. This book, like no other, has influenced the popular perception of Hadrian and also increasingly insinuated itself into the academic debate, becoming, in a sense, an integral part of Hadrian's modern reception history. The novel was an immediate success; it has been translated into the major world languages and in the half century since its first publication has never been out of print. A forthcoming film version will undoubtedly grant it a new lease of life and transmit Yourcenar's vision of Hadrian and his empire to yet another public.

To this day the book ranks as one of the finest historical novels ever written. Its lasting impact is partly derived from Yourcenar's conscious decision to

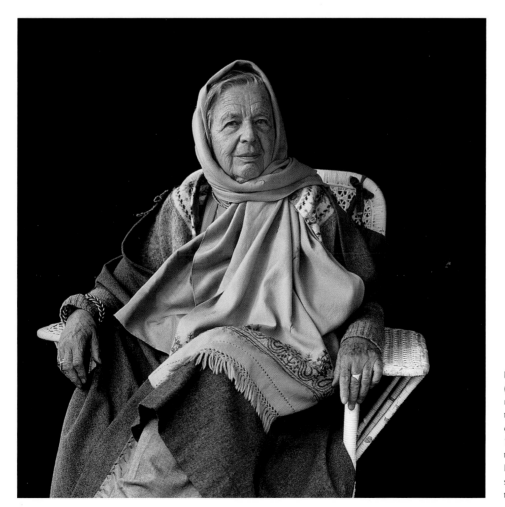

**Fig. 14** Marguerite Yourcenar (1903–88). An accomplished novelist, Yourcenar became the first ever female member of the Académie française in 1981. Yourcenar first formed the idea for her book on Hadrian in the 1920s, when she travelled extensively in the Mediterranean.

**Fig. 15** Yourcenar in the ruins of Hadrian's villa at Tivoli in 1924.

concentrate on the inner man, to do away with the detailed enumeration of historical paraphernalia that characterizes so many historical novels and instead stress the timeless greatness of Hadrian's personality. Over the long and troubled gestation period of the book, which lasted some twenty-seven years, she came to identify closely with Hadrian, no doubt influenced by her own experiences and extensive travels in his footsteps.[14]

Yourcenar appended a lengthy bibliographical note to her novel, discussing in some detail the primary ancient sources and works of modern scholarship that had informed her research. It was perhaps due to this addition that the *Mémoires* came to be perceived by some readers as far more than a standard work of fiction, and that specialist scholars felt invited to engage with it on their own terms. This process of 'academization' continued when Yourcenar's French publisher commissioned an illustrated edition of the *Mémoires*, for which Yourcenar herself selected the images, leading her to contact major museums and in some cases correspond in greater detail with curators and archaeologists.[15] Incidentally, it was in the British Museum during the First World War that Yourcenar had first set eyes on Hadrian,[16] and the museum's fine bronze head of the emperor recovered from the River Thames (see frontispiece and fig. 64) would remain one of the guiding images that informed her novel.[17]

The *Mémoires* remain popular, especially perhaps in Italy. For several years now there have been readings at the annual summer festival at Hadrian's villa and other places. Anniversaries linked to Yourcenar have been used as occasions to hold archaeological exhibitions, and a guide to Hadrian's villa based on Yourcenar's descriptions is available at the villa bookshop – ironic perhaps, given that the author resented the transformation by modern tourist infrastructure of this romantic ruin landscape where architecture was gradually reverting back to nature.[18] A Yourcenar documentation centre opened in Rome, appropriately located in the remains of the Temple of the Deified Hadrian.

The most profound and illuminating criticism of the *Mémoires*, or perhaps rather their reception by some of the audience, was formulated by the historian Ronald Syme.[19] Concentrating on the contents of the novel and Yourcenar's use of sources, Syme classed the work not as historical fiction but fictional history, drawing a close parallel with the ancient *Historia Augusta*. While Yourcenar had an admirable command of the ancient literary sources, which lends her novel a convincing aura of authenticity, she used these sources often in an uncritical way, and of necessity the details of some characters, mere names from history, are entirely invented. For a novel, this is of course appropriate; the comparison with some of our ancient written sources is the more instructive and helps to inject a necessary note of caution when dealing with these. In the end, the *Mémoires* should be read as they were intended; as a novel, not a work of history. Had Yourcenar written now, the book may have taken on quite a different character.

## *This book and exhibition*

The following chapters do not aim to provide a comprehensive account of Hadrian's life and reign. Rather, they discuss a number of selective themes that form important elements of his legacy or seem in particular need of a fresh look, perhaps even a more profound reassessment. Like every human being, Hadrian was a product of the society around him as much as an individual character. It therefore seems appropriate to look, at least in passing, at the economic and cultural background of the elite to which he belonged and at the wider context and significance of his reign beyond the merely personal. Many aspects touched upon in the text have developed into their own, often highly specialized fields of study. Every effort has been made in this overview to guide the reader to further literature without, however, over-burdening the text with footnotes.

Hadrian's psyche has fascinated and puzzled commentators from his own time onwards. 'He was, in the same person, austere and genial, dignified and playful, dilatory and quick to act, niggardly and generous, deceitful and straightforward, cruel and merciful, and always in all things changeable', says the *Historia Augusta*. Anything and everything can be read and has been read into such a statement, and that is why an exploration of his individuality, while certainly intriguing, beyond a certain point is best left to the novelist.

The often truly magnificent objects assembled for the exhibition and discussed in this book can be viewed and studied in many different ways. They range from breathtaking works of art that inspired artists from the Renaissance onward, to much more humble objects and simple written documents, the true building blocks of history often relegated to the footnotes of scholarly works. Many have been brought together and illustrated in colour here for the first time. Together, they reflect the important period in world history and world art over which Hadrian presided. It is particularly fortunate that quite a number of sometimes very recent finds could be included. There will, of course, never be a final history of Hadrian and his reign. Each generation, based on its own experiences, asks different questions of the past and finds new answers, and this is what keeps the study of Roman art and history dynamic and exciting.

# I

## A New Elite

'Hadrian was born in Rome on the ninth day before the kalends of February in the seventh consulship of Vespasian and the fifth of Titus'

HA HADRIAN 1.3

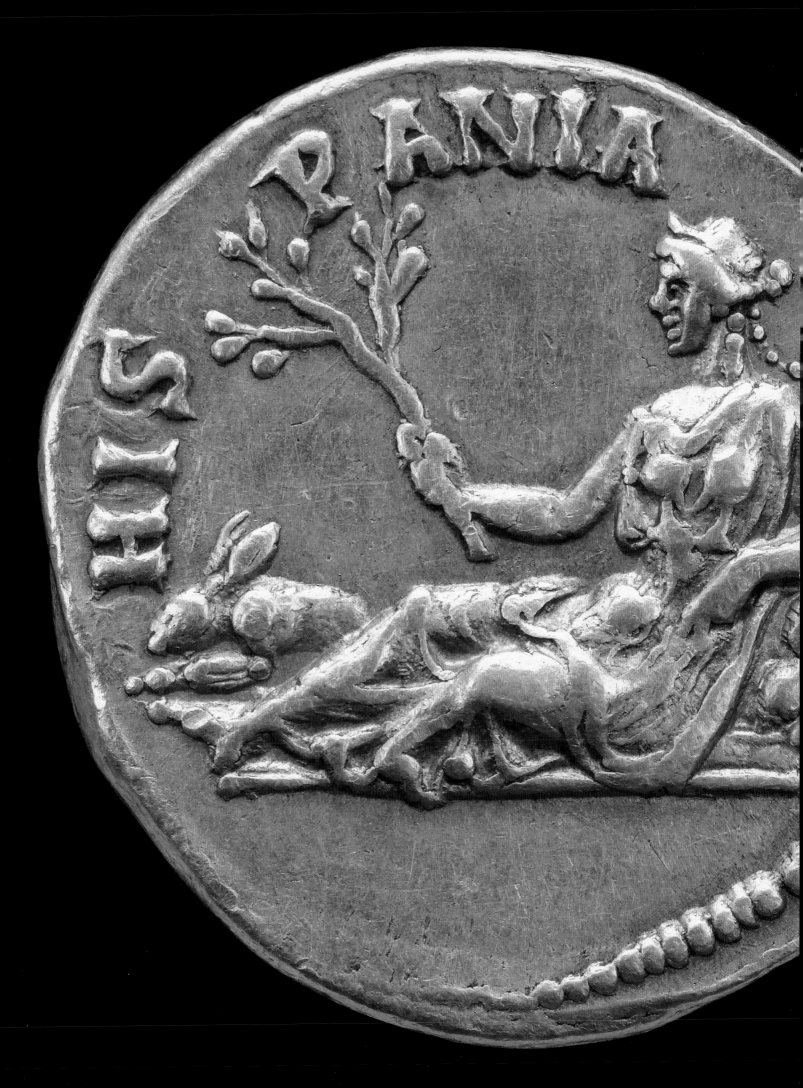

P UBLIUS Aelius Hadrianus was born in Rome on 24 January AD 76. His birth in the capital of the empire was probably a matter of chance caused by the residency requirements of his father as a Roman senator; Hadrian's family really came from Spain. The elder Hadrian, Aelius Hadrianus Afer, was a native of Italica, an old Roman settlement on the River Baetis, the modern Guadalquivir, in south-western Spain. His wife, Hadrian's mother Domitia Paulina, came from the wealthy city of Gades (Cadiz), not too far away on the Atlantic coast. Hadrian also had a sister, called Domitia Paulina like her mother, who was perhaps born a few years before him.

Little is known about his father's career, though as a senator, he must have been wealthy – the minimum property requirement for potential holders of that office was a fortune of one million sesterces – and we can assume that the young Hadrian was brought up in some comfort. He had a wet nurse called Germana, who, to judge by her name, was a slave-woman from Germany, to whom he stayed devoted throughout his life, later setting her free. Germana died in her eighties, having outlived Hadrian, and was buried near his great country villa at Tibur outside Rome (fig. 19).

After entering the senate, Hadrian's father is likely to have held further offices, perhaps helped by the influence of some of his Spanish relatives, either in Rome or the provinces. An inscription might one day be found to provide further evidence. Whatever happened, when Hadrian was nine years old, his father died, aged only thirty-nine.[1]

PREVIOUS PAGE
**Fig. 16** Gold aureus illustrating Hispania (detail of fig. 21).

OPPOSITE
**Fig. 17** Trajan (r. AD 98 –117). His energetic, clean-shaven looks and simple hairstyle project the image of a no-nonsense, dynamic leader.

BELOW
**Fig. 18** Stemma of Hadrian's family.

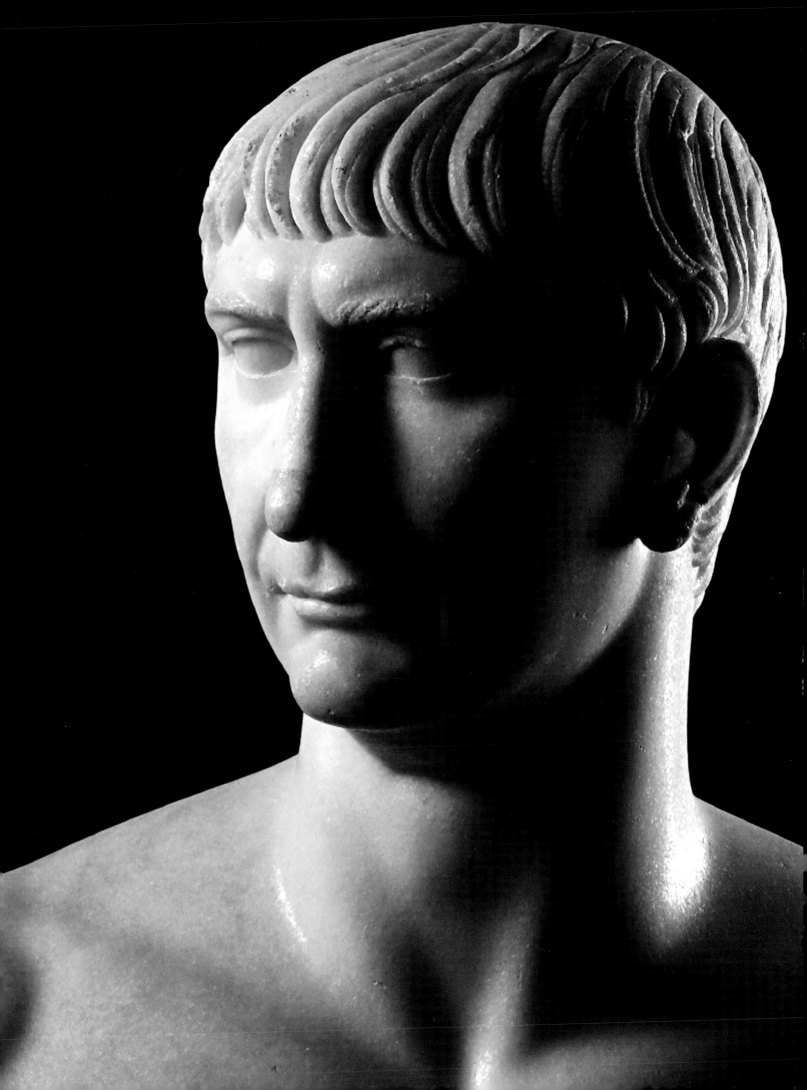

**Fig. 19** Tombstone of Hadrian's wet nurse, Germana. Later part of a Renaissance collection in Rome, it was acquired by the Prussian crown-prince in the early 19th century and is now set into a wall in Schloss Glienicke near Potsdam.

Guardians were appointed from among the boy's relatives. One of them was the elder Hadrian's cousin, another native of Italica who was beginning to make a name for himself as one of Rome's foremost generals: Marcus Ulpius Traianus (Trajan). The other was a knight from Italica, P. Acilius Attianus.

Italica had been founded as a settlement for wounded Roman soldiers left behind by the Roman general P. Cornelius Scipio after a campaign against the Carthaginians in 206 BC. Hadrian's ancestors had originally come from the town of Hadria in the Abruzzi region of eastern central Italy, Trajan's from Tuder in Umbria. Of Italic origin, these first settlers probably took local wives, and formed the nucleus of the future land-owning elite of the Spanish provinces.

Hadrian's great-grandfather's grandfather, a man called Marullinus, had eventually entered the Roman senate. He was one of many Spaniards to come to prominence over the next decades, for they controlled the natural resources of one of the most fertile and productive parts of the Roman empire. To an enterprising and ambitious landowner the province of Baetica in south-west Spain, in particular, was a land where milk and honey flowed.

## Oil country

At the foot of the Aventine Hill in Rome, not far from the River Tiber, there is a large, man-made mound, the Monte Testaccio ('Sherd Mountain'; fig. 23). Even today more than 40 metres high and with a perimeter of more than 1 km, the Monte Testaccio is made up entirely of densely packed, broken oil amphorae, double-handled transport containers made of fired clay. They were deposited

here in antiquity over a period of some 250 years, starting from the reign of Augustus and continuing into the mid-third century AD.

Following recent research, it is now estimated that the Monte was formed by some 24.75 million amphorae that once contained approximately 1.7 billion kilos of olive oil, an annual average of 700,000 kilos.[2] Further analysis has shown that more than 80 per cent of these amphorae came from the region of Baetica in south-western Spain, their import reaching a peak in the second century when they constituted between 90 to 95 per cent of the total.[3] Every single amphora sherd in this mountain is thus but the broken remainder of a complex process of commercial production and distribution, which made the landowning elites of Roman Baetica very wealthy indeed.

For the Romans, olive oil was not merely just another agricultural product, it formed a key commodity without which the empire could not function. The oil had a wide variety of uses, from nutrition to hygiene, medicine, lighting and many others. Roman cooking made ample use of olive oil, which still forms a key ingredient of the Mediterranean diet today, its health benefits having long been recognized. Applied to the body before exercise and then scraped off with a special implement, it was used instead of soap. It formed the basis of perfumes, and was used to fill oil lamps throughout the empire. Enormous fortunes could be made in the production and trade of this oil, and for the state it took on the character of a strategic commodity, necessary to feed the people of Rome and to supply the army.

Large *horrea*, or warehouses, had been constructed beside the River Tiber to receive goods from all over the empire, which were transported upstream on

**Fig. 21** Hispania reclines with an olive branch in her right hand and a hare by her feet. Gold aureus issued late in Hadrian's reign, one of a series commemorating the empire's provinces.

**Fig. 20** Landscape in Baetica. The mineral and agricultural wealth of the province was legendary; its olive oil was exported throughout the empire.

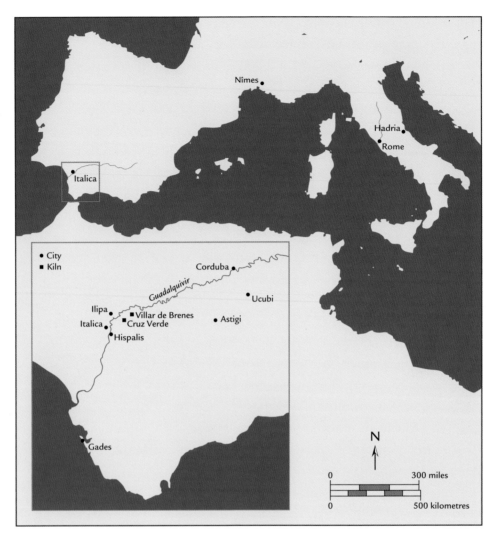

**Fig. 22** Italica, home town of the Aelii and Ulpii families, lay at the centre of the Spanish 'oil country'. The river (Guadalquivir) was lined with olive plantations, amphora kilns and transport facilities, all geared for export via the sea.

river barges from Rome's bustling coastal port of Ostia. Oil amphorae formed an important part of the cargoes thus delivered to the capital. The oil was often poured into smaller containers at the warehouses and then distributed further. Because of rancid oil residues in the porous clay, the containers in which the oil had arrived from overseas could not be reused when empty in the same way as those that were used to transport other goods. Instead, the oil amphorae were taken to an area set aside behind the warehouses, broken up to save space and covered in lime to suppress the smell. In this way, the Monte Testaccio was formed.

Importantly, the amphorae deposited in the Monte carry an astonishing amount of epigraphical information, which is not generally preserved at other sites. In total these inscriptions provide a set of data not unlike that used in modern product labelling. They were put on the amphorae in a number of different ways and at

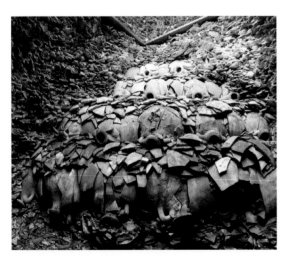

**Fig. 23** Some of the recent excavations at Monte Testaccio, the 'Sherd Mountain' in Rome. The densely packed amphorae are clearly visible. The overwhelming majority came from Spain.

different times during the production and distribution process, and have shed light on the manufacturing practices and trade patterns involved. They comprise stamps, *graffiti* (in this context defined as incised inscriptions) and *tituli picti* (painted inscriptions). The information thus supplied is highly complex and its precise interpretation is disputed, yet a number of main patterns can be established, turning the 'Sherd Mountain' into a gigantic archive of Roman economic history.

Stamps and certain types of graffiti were applied to the amphorae before they were fired in the kiln. The stamps, usually placed on the handles or shoulder, provide information on the producer of the oil or its owner, and also the owner of the kiln.[4] Graffiti incised at this stage, usually characters or numbers, are thought to have been added to group amphorae together in units for firing.

The painted inscriptions were added in black ink after the firing process, probably at the time when the amphorae were filled with oil or slightly later at a distribution or trans-shipment facility. The inscriptions can be split into six elements, each put on a specific place on the amphora. They provide information on the tare, that is, the weight of the container without its contents; the weight of the oil; and the name of the trader. Next to them is a section added by a state official supervising the trade, often giving the names of the consuls in office at the time and thereby providing a firm date. Under Hadrian the information related in the *tituli* became more complex, reflecting tighter state control of the distribution process as part of wider economic reforms.[5]

The Baetican oil amphorae (fig. 27), named *Dressel 20* after the nineteenth-century German scholar Heinrich Dressel who first classified them, were of a characteristic globular shape, strong and large and ideally suited for sea transport. The stylistic link made by Dressel between the amphorae from Monte Testaccio and the kilns in Baetica has since been confirmed through petrological and chemical analyses. A single amphora, between 70 and 80 centimetres high and with a diameter of 60 centimetres, weighed about 30 kilos and was filled with some 70 kilos of oil.

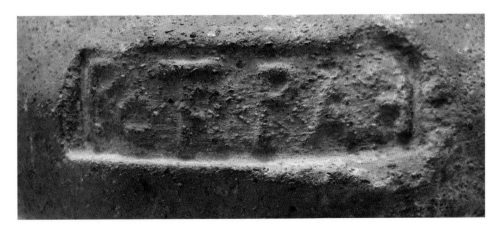

**Fig. 24** Amphora handle stamped with the letters 'PortPAH', produced in the kilns of Villar de Brenes and Cruz Verde (see fig. 22). The stamp has been linked to estates of Hadrian's father, Publius Aelius Hadrianus Afer, but this remains a conjecture.

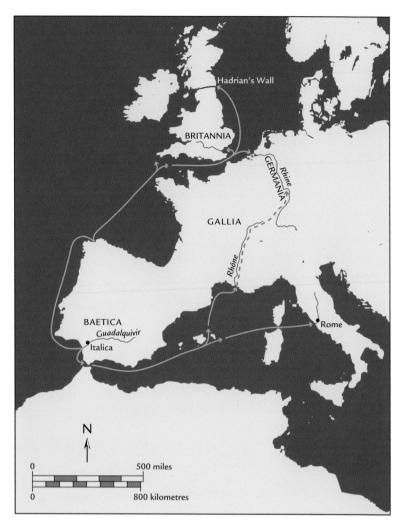

**Fig. 25** The main export routes for Baetican olive oil. Transport was mainly by sea. Some 80–85% of Rome's oil supply came from Spain. Baetica was also the principal source for oil used by the army in Britain and on the Rhine.

The amphorae were made in three separate sections: first the globular body, then the upper body and rim, and finally the handles. This may have allowed for a certain degree of rationalization in the production process, the individual parts being made by different workers.

The oil was produced in a roughly rectangular stretch of land between the cities of Corduba (modern Cordoba) in the east and Hispalis (modern Seville) in the west, crossed by the River Baetis (Guadalquivir). Large, ocean-going vessels could come up the river Baetis to Hispalis, smaller ones to Ilipa, and river boats to Corduba.[6] The amphora production centres were located along the river, where suitable clay deposits could be found and transport could conveniently be arranged. More than one hundred potteries have by now been identified. Their organization was complex and varied and not necessarily linked to specific producers or estates. Some potteries could reach a very substantial size, operating rows of kilns at the same time. Work was extremely labour-intensive and probably involved large numbers of slaves. Much of it was probably seasonal.

Some scholars have even suggested that some of these production centres might be linked to the estates of Hadrian's own family, which they accordingly located a few kilometres upstream from Italica, on the way to the town of Ilipa Magna. Amphorae produced in the nearby kilns of Villar de Brenes and Cruz Verde, were stamped with 'portPAH' (fig. 24), which may stand for *portus*, or warehouse, of Publius Aelius Hadrianus, Hadrian's father. However, this must remain purely hypothetical, as many other solutions are possible.[7]

Baetica not only supplied the city of Rome, but also the army of the western provinces. The army, in fact, was a major consumer of oil; it has been estimated that each legion required 1370 amphorae per year, the produce perhaps of up to 14,400 olive trees on about 112.5 hectares of prime agricultural land.[8] Baetican oil also reached the eastern Mediterranean and even territories outside the empire, such as India.

Oil was not the only great resource of the blessed Baetican landscape; the mineral wealth of the province was proverbial, and both grain and wine were produced in quantity. Another important export was *garum*, a fish sauce that was absolutely essential for Roman cooking and produced in different grades of quality. All this greatly benefited the Baetican elite, which became enormously prosperous and successfully used this wealth to gain influence in Rome. An upper estimate puts the proportion of Roman senators of Spanish origin under the Flavians at the end of the first century AD at nearly a quarter, hinting at the increasing economic and political clout of the colonial elite. The leading families of the province further consolidated this wealth through advantageous marriage alliances. Trajan's and Hadrian's families were at the very centre of this powerful network of upwardly mobile, highly ambitious clans, including the Dasumii and the Annii from the town of Ucubi. Their members maintained close links with the homeland, but also stuck closely together in Rome. Under the Flavians, who though Italian had come from outside the traditional Roman elite, they prospered more than ever. The great break for the Ulpii and Aelii had come when Trajan's father, the elder Marcus Ulpius Traianus, had found himself as one of three legionary commanders fighting under Vespasian in Judaea. Supporting Vespasian's bid for the imperial throne, he and his family were amply rewarded.

**Figs 26 & 27** Ancient product labelling: the diagram illustrates where information was put on amphorae. The photograph shows a Spanish oil amphora from Hadrian's Wall.

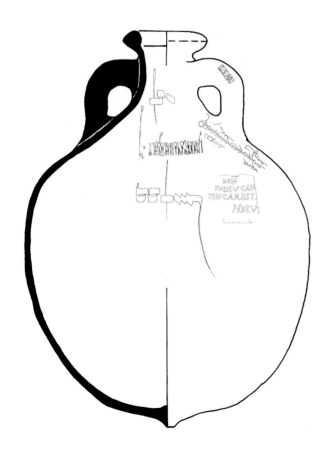

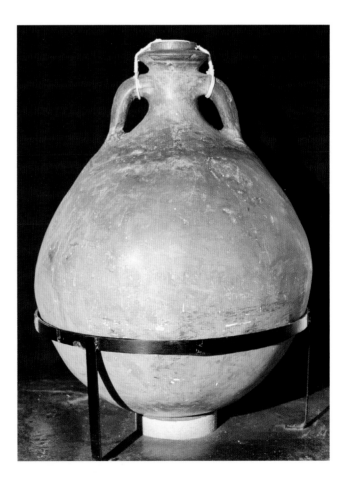

## *Military service*

In his teenage years Hadrian was sent back to Italica, a clear indication that his family still valued close links with their home region. Immediately on arrival, Hadrian enrolled in the official paramilitary youth organization, the *iuvenes*. He may have called on various relatives and inspected the family's estates that he was soon expected to take over; but to a young man used to the ways of the capital, entertainment appears to have been limited. Hadrian took to hunting, for which the local countryside was ideally suited, pursuing this pastime to such an excess that he incurred the censure of his guardians.

Trajan, who at the time was in command of Spain's sole legion, VII Gemina, was about to return to Rome to take up office as *consul ordinarius* at the beginning of AD 91, one of the few men so honoured by the Emperor Domitian, no doubt as a reward for loyally rushing his troops to Upper Germany against a would-be usurper in AD 89. He called Hadrian away with him and when they were back in Rome, Trajan treated Hadrian 'like a son'. Trajan continued to be staunchly loyal to Domitian, taking a leading part in a number of military expeditions, most probably on the Rhine or Danube frontiers.

Hadrian, in the meantime, continued his education and then entered public service in preparation for a senatorial career. In AD 94, aged eighteen, he served as a junior magistrate, a *decemvir stlitibus iudicandis*, or member of a board of ten selected to adjudicate lawsuits. This not very demanding position was soon followed by a rather prestigious, though entirely ceremonial, position as *praefectus feriarum latinarum*, owed no doubt to the patronage of family and friends in high office.[9] The *praefectus* nominally stood in for the consuls while they and all other magistrates attended the traditional festival of the Latin League outside Rome. Soon afterwards Hadrian served as *sevir turmae equitum*, one of six squadron leaders in the annual parade of the Roman knights. Again, this was a prestigious office that gave him excellent public exposure. Trajan clearly looked after his young ward well and set him up for a successful career, aided by his unwavering loyalty to Domitian at a time when many others were put to death for insubordination against the increasingly tyrannical emperor.

Hadrian's next step on the career ladder took him into the army. He became military tribune of Legion II Adiutrix, stationed at Aquincum (modern Budapest) in the Danubian province of Pannonia. It has been plausibly conjectured that Trajan served as governor of the province at the time, and as someone thoroughly familiar with the military, he clearly intended Hadrian to gain a similar level of experience. Traditionally, the military tribunate had been considered a precondition for entering the senate, but by the time that Hadrian held it, this rule seems to have been relaxed. His legion had seen military action in Britain before being transferred by Domitian to the Danube frontier in AD 86 to take part in fighting

**Fig. 28** Bust of Hadrian from Italica, home of the Ulpii and Aelii families. Although Hadrian was born in Rome, he did spend some time as a teenager in Italica. While he does not seem to have returned as emperor, he lavished funds and privileges on the city.

there. Hadrian was thus nominally second-in-command of a crack unit in a key frontier province.

When Hadrian's service with II Adiutrix came to an end in the summer of AD 96, he did not return to civilian life in Rome but took up a second commission with Legion V Macedonica in the province of Lower Moesia, also on the Danube. This second commission was highly unusual and was probably due to a natural aptitude for military life, as well as the continuing influence of his guardian Trajan, who had also served as tribune in at least two different legions.

Soon after, on 18 September AD 96, a group of conspirators succeeded in assassinating the Emperor Domitian in a palace coup in Rome. The senate instated one of its own, the elderly Marcus Cocceius Nerva, as his successor. Nerva, aged sixty-five and childless, surrounded himself with a group of octogenarian trusted friends. The army, which had been loyal to Domitian and been taken by surprise by events in Rome, needed to be kept on side. A number of senior commanders and government officials, who might be suspected of harbouring ambitions of their own, were hastily replaced; Trajan, ever the loyal servant of authority, now found himself appointed governor of Upper Germany.

Yet in October AD 97, stirred by its old allegiance to Domitian, the Praetorian Guard mutinied, striking terror into his successor and forcing Nerva to hand over Domitian's assassins, who were duly lynched. To add insult to injury, the emperor was compelled to thank the guard units by their commander. Without the support of the army or a strong family network around him, Nerva's position seemed increasingly untenable. His solution was inspired: at a public ceremony he declared the adoption of Trajan, the Spaniard who had both.

Delegations from all over the empire were sent to the Rhine to congratulate the new Caesar; his relative Hadrian was chosen to deliver the best wishes of the legions in Lower Moesia. Hadrian's life had been transformed at a stroke; he was now the closest male relation of the future emperor. Trajan moved on to Lower Germany but took care to install trusted relatives in positions of power nearby. In Upper Germany Hadrian's brother-in-law Julius Servianus took over; Hadrian himself was appointed military tribune of Legion XXII Primigenia stationed in the provincial capital. This was his third military tribunate, an exceedingly rare event – only one other example is known – that demonstrates Trajan's trust in him and indicates an intention to build up Hadrian's career in the forces, no doubt to help retain an influence in the army.[10]

Nerva finally died in Rome on 27 January AD 97. Hadrian had just turned twenty-one; Trajan was declared emperor the next day. The official messenger passed through Mogontiacum, and then both Hadrian and his brother-in-law Servianus vied to deliver the news to Trajan. Hadrian left to inform Trajan in person, but his efforts were apparently sabotaged by Servianus, who had sent his own messenger. The rivalry between both men was to continue, only ending with the death of one of them many decades later (see pp. 216–19).

Trajan stayed by the Rhine, keeping Hadrian with him; then he moved on to the Danube, installing Servianus as governor of Pannonia on the way, and wintered in Lower Moesia, no doubt to keep an eye on hostile tribes beyond the river who had caused problems under Domitian. He finally entered Rome as emperor late in AD 99, more than a year and a half after he had acceded to the throne.

Little is known about Hadrian in the following years, although there are some records of tensions with Trajan, which were soon reconciled through the efforts of friends and relatives. Most importantly, a marriage was now arranged between him and Trajan's great-niece Sabina (fig. 36), the daughter of Trajan's niece Matidia (fig. 34), whom the emperor, childless himself, treated like his own daughter. The marriage, which must presumably have taken place in AD 100, brought Hadrian even more closely into Trajan's own family, and there can be little doubt that it was designed to line him up as the heir presumptive. Love was not an object in this alliance; Hadrian was twenty-four, and his bride would have been fourteen if she got married at the customary age for Roman wives.

**Fig. 29** Marble bust of Lucius Julius Servianus, Hadrian's brother-in-law and rival.

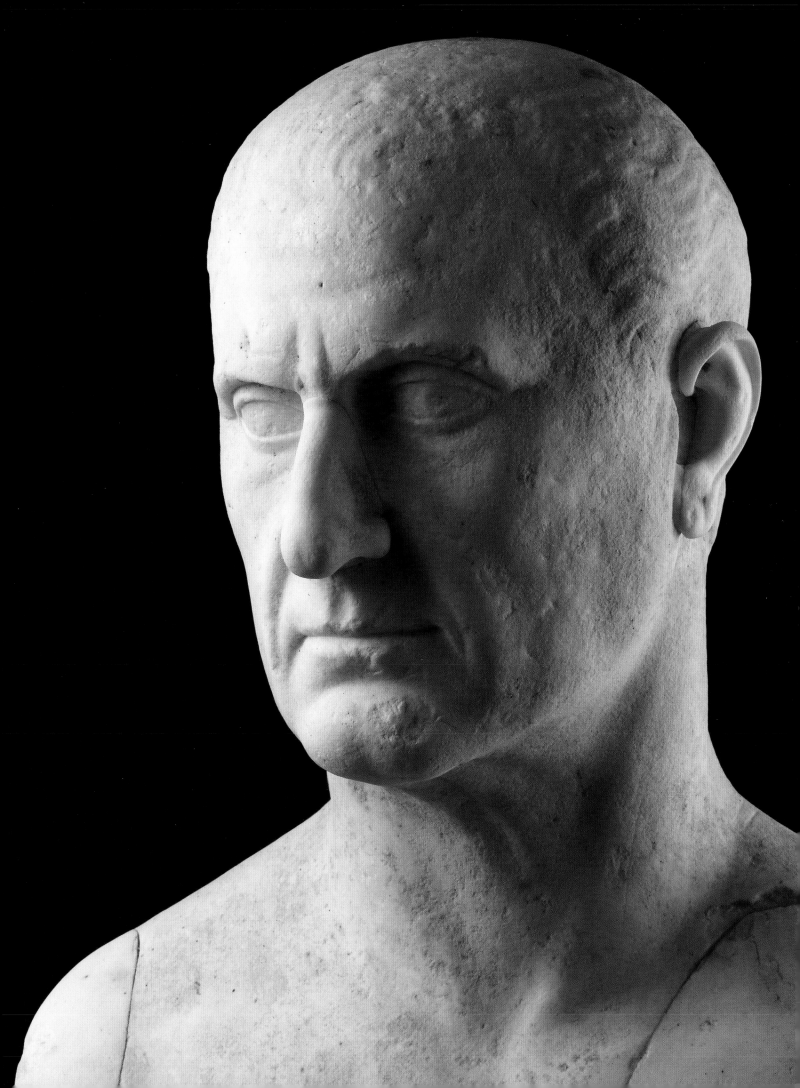

Soon after, Hadrian entered the senate, holding the office of *quaestor caesaris*. He may also have been enrolled at this time into two colleges of priests reserved for senators, the *septemviri epulonum*, the most junior of the four great priestly colleges, and the *sodales augustales*, priests devoted to the cult of the deified Augustus. This was another mark of Trajan's favour, as the emperor controlled access to these priesthoods.

A few months later, in March AD 101, Trajan set out on a military expedition against the Dacian King Decebalus across the Danube. Hadrian accompanied him as *comes Augusti*, a member of the emperor's staff, but may not have stayed for the two years it took the Roman forces to achieve victory. It is likely that he returned to Rome to hold the office of tribune of the plebs for the year AD 102; his brother-in-law Servianus meanwhile served as one of the two *consules ordinarii* of the year. It seems that he held this office in absentia, staying with Trajan on the Dacian front.

In AD 105 Hadrian reached the next rung of the career ladder and served as praetor. Trajan, the sources tell us, gave him a large sum of money to hold the games and spectacles expected of the holders of this office in style, clearly a mark of continuing favour. Then, by mid-year, Trajan moved to the Danube to open a second campaign against the obstinate Dacians. He took Hadrian with him, this time as commander of a legion, I Minervia.

By AD 106 the Roman army had achieved a decisive victory, capturing the Dacian capital of Sarmizegethusa and forcing King Decebalus to commit suicide in order to evade capture. Dacia was annexed and turned into a new Roman province. Hadrian, at the head of his legion, seems to have taken an active part in the first series of operations; 'his many outstanding deeds became renowned', as the *Historia Augusta* puts it. As in the first campaign, he was awarded military decorations, *dona militaria*, by Trajan, who also gave him a diamond ring that he himself had received from Nerva. Hadrian, it appears, took this as a sign that he now was the chosen successor, whether it was justified or not.

Before the Dacian campaign had come to an end, he was ordered to a different section of the Danube frontier, as the newly appointed governor of the province of Pannonia Inferior, created when the old province had been split in two. He took command of Legion II Adiutrix, the legion with which he had first served as military tribune. His task may have been to keep an eye on hostile barbarian tribes and thus secure the Roman flank; the *Historia Augusta* says that he 'restrained' the Iazyges.

In AD 108 Hadrian became consul, though only as

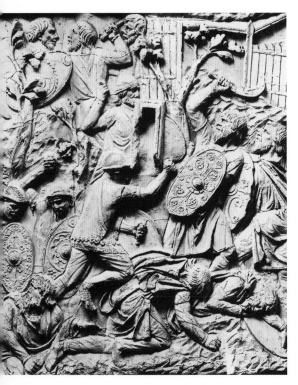

**Fig. 30** Detail of Trajan's column, erected in Rome near Trajan's forum to celebrate the emperor's victories over the Dacians. Roman auxiliaries are shown in close combat with Dacian tribesmen. Hadrian was decorated by Trajan for his bravery in both Dacian Wars. He commanded a legion in the second.

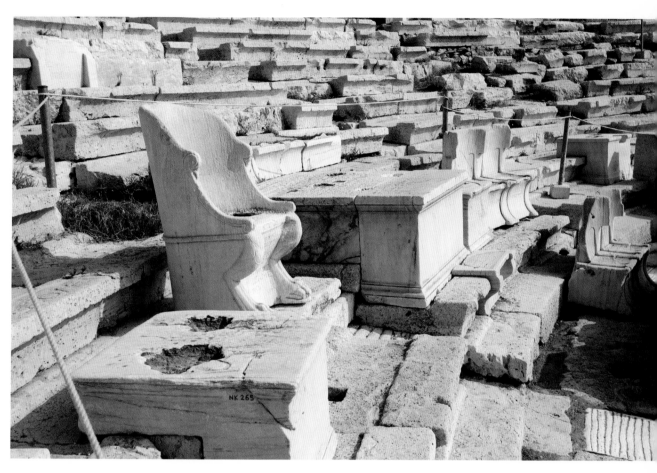

**Fig. 31** Seats of honour and statue bases in the Theatre of Dionysus, Athens. The large base in the centre supported a bronze statue of Hadrian. The inscription on its base is the key source of information on his career before he became emperor. Later, the Athenians dedicated further bronze statues of Hadrian in the Theatre, and a dozen of them were set up among the audience.

*suffectus* and not *ordinarius*. The *Historia Augusta* reports that he was told then that Trajan would adopt him, but the authenticity of this claim has been doubted. Three years later, Hadrian went to Athens. The Athenians, no doubt eager to curry favour with a close relative of the emperor, gave him Athenian citizenship and elected him *archon eponymus*, their chief official, for the year AD 112. A bronze statue of Hadrian was set up in the Theatre of Dionysus, and a lengthy inscription on its base provides our most important record of his career up to then.

Meanwhile, Trajan had turned his attention further east, to Rome's old arch-enemy Parthia. The Parthian empire was at the time much weakened and split between three rival kings, the old Pacorus and two younger contenders named Vologaeses and Chosroes. Chosroes had interfered with the dynastic arrangements in the neighbouring kingdom of Armenia, deposing King Axidares and installing instead his sibling Parthamasiris. This was in breach of an existing treaty that stipulated that the Armenian king should be nominated by Rome. Trajan assembled his armies and, when passing through Athens en route to the east, he was met by Parthian emissaries despatched by Chosroes suing for peace. Instead of accommodating them, he proceeded to Syria, taking Hadrian with him to serve on his staff, probably in the role of *comes Augusti* and *legatus Augusti pro praetore*.

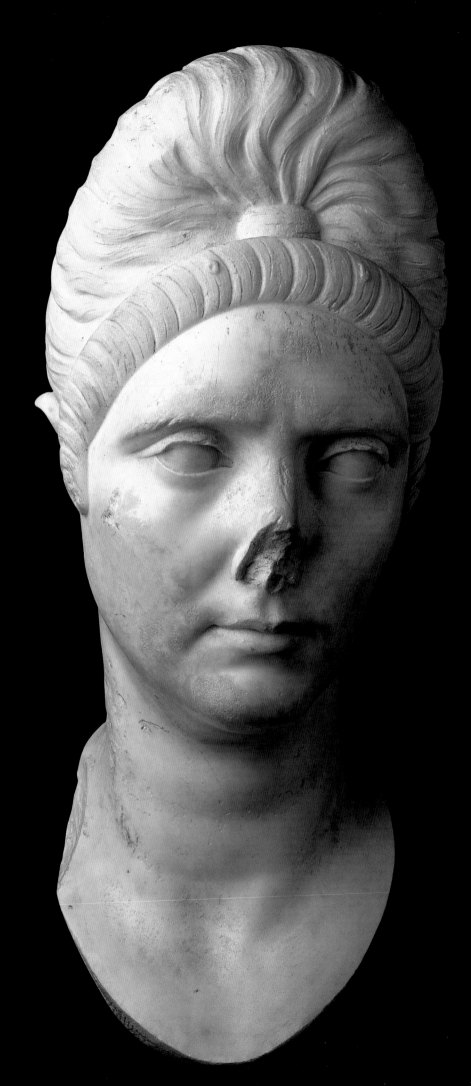

**Figs 32 & 33** Trajan's wife Pompeia Plotina (left) and his sister Ulpia Marciana (right). The portrait heads were originally set into full-length statues. Often the members of the imperial family were shown together. The women's elaborate coiffures required the services of special slaves.

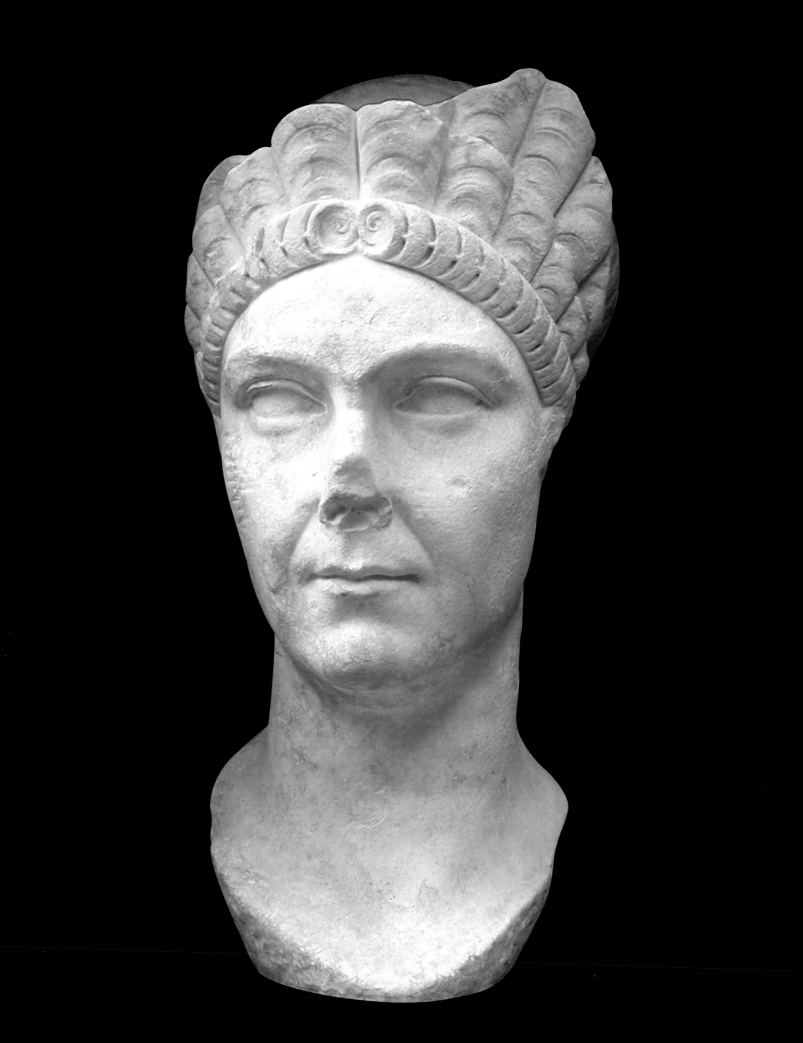

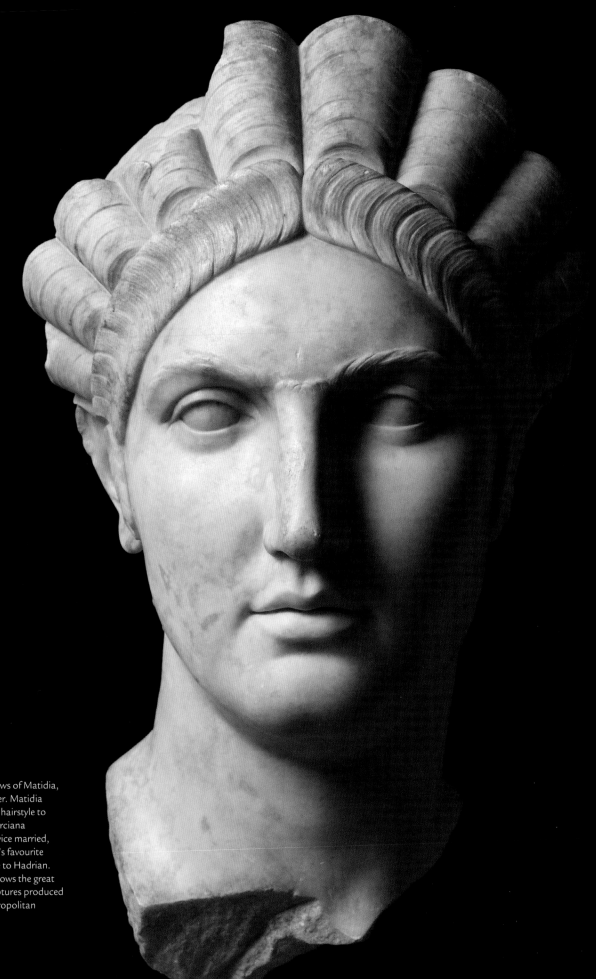

**Fig. 34** Two views of Matidia, Sabina's mother. Matidia wears a similar hairstyle to her mother Marciana (cf. fig. 33). Twice married, she was Trajan's favourite niece and close to Hadrian. The portrait shows the great quality of sculptures produced in Roman metropolitan workshops.

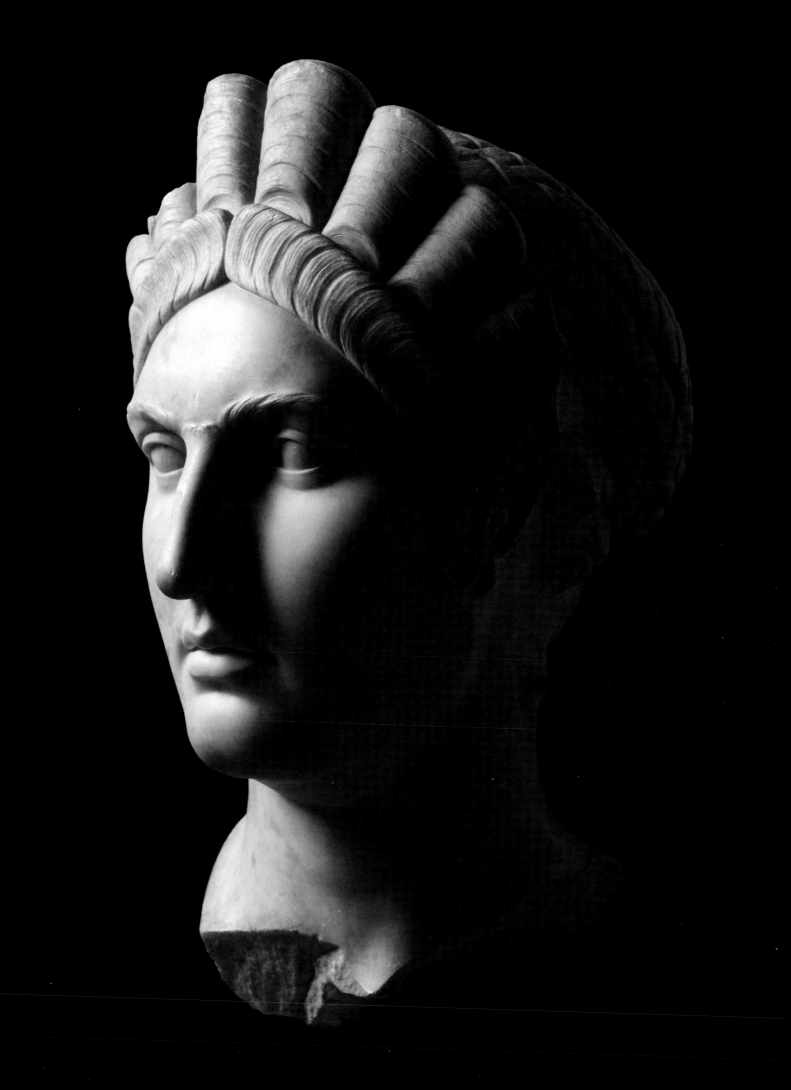

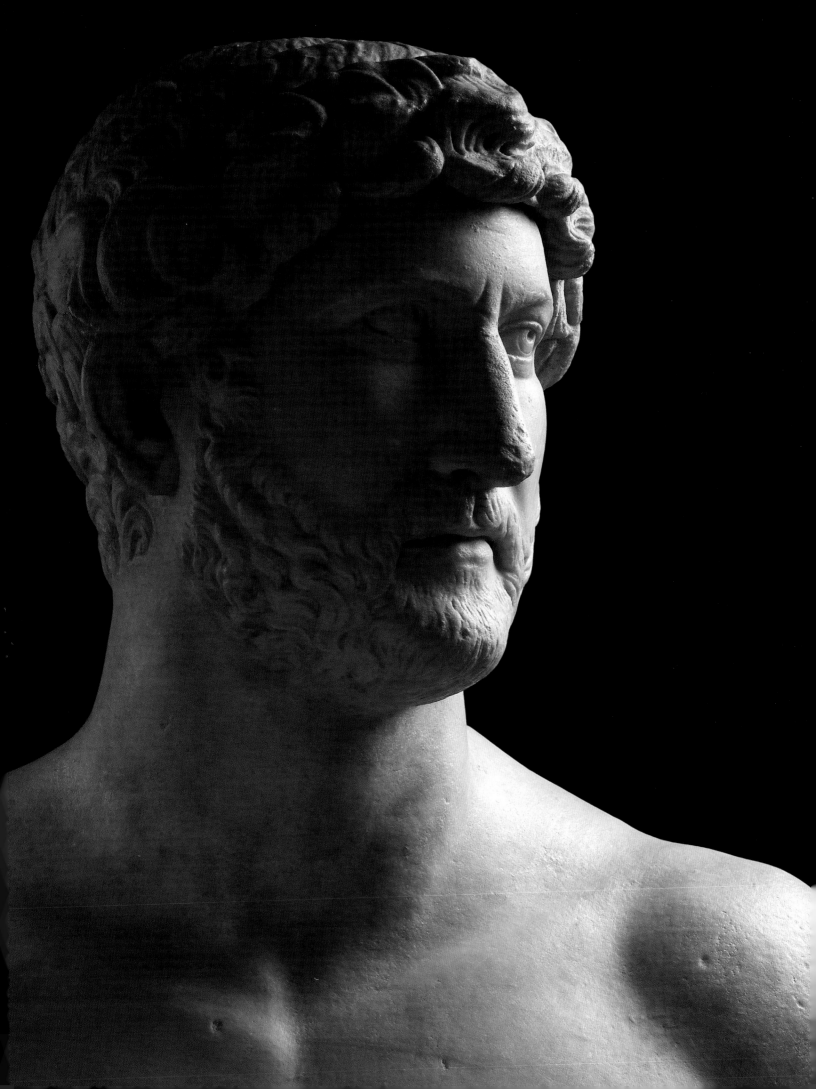

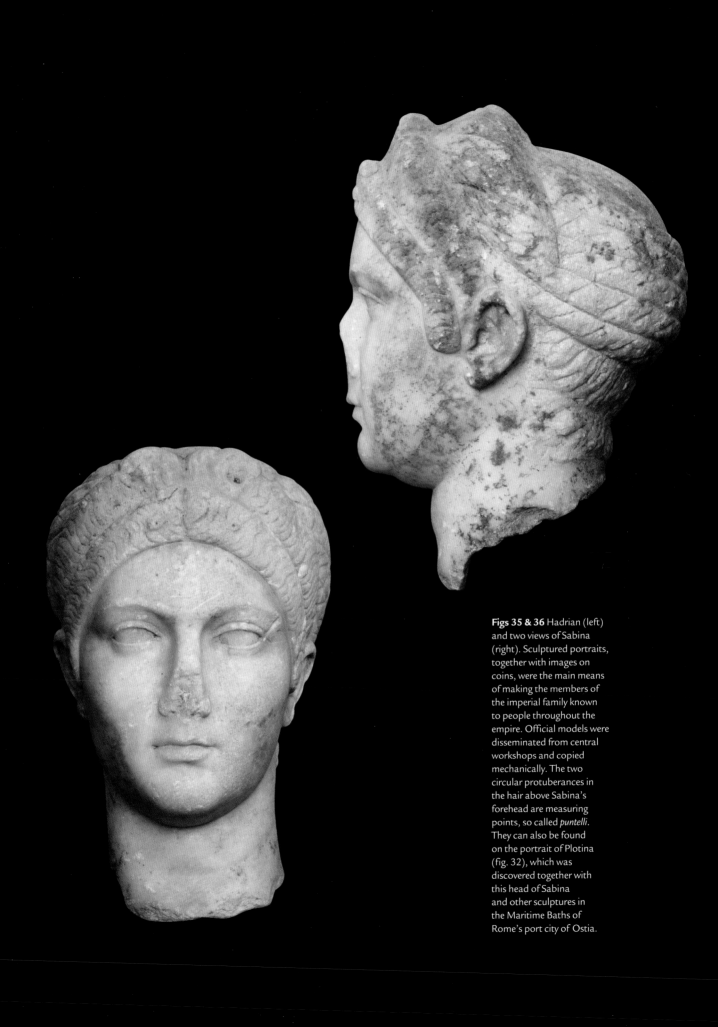

**Figs 35 & 36** Hadrian (left) and two views of Sabina (right). Sculptured portraits, together with images on coins, were the main means of making the members of the imperial family known to people throughout the empire. Official models were disseminated from central workshops and copied mechanically. The two circular protuberances in the hair above Sabina's forehead are measuring points, so called *puntelli*. They can also be found on the portrait of Plotina (fig. 32), which was discovered together with this head of Sabina and other sculptures in the Maritime Baths of Rome's port city of Ostia.

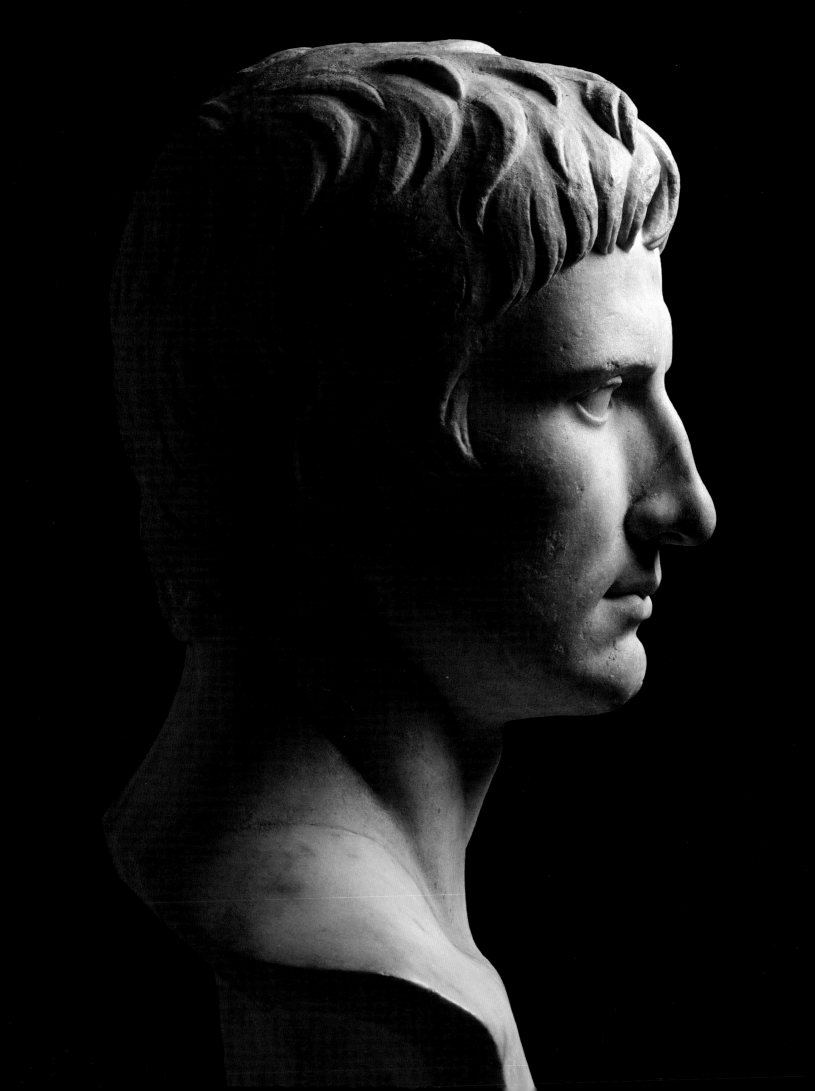

After a preparatory stay in Antioch, the capital of Syria, Trajan moved north to the Roman part of Armenia. There, at the city of Satala, he gathered his armies and received embassies from a host of eastern rulers, confirming some on their thrones and appointing new ones. The King of Armenia, Parthamasiris, then also sought to be reappointed by Trajan but was deposed and put to death. His kingdom was declared a Roman province. Trajan wintered at Antioch and resumed the campaign the following year, AD 115, leading his army into Mesopotamia. Victorious in several battles, at the beginning of AD 116 he finally captured Ctesiphon, the ancient Parthian winter capital, encountering little resistance. He now took the title of Parthicus; three days of circus games were held at Rome. Southern Mesopotamia was declared the Roman province Assyria.

Hadrian was appointed governor of Syria to succeed Julius Quadratus Bassus, who was sent to Dacia to deal with a rebellion that had broken out there. Further, he was designated as *consul ordinarius* for the year AD 118, through the influence of Plotina, the empress, according to the sources.

Trajan, who by then was already ill, had a stroke and became partly paralysed in addition to suffering from dropsy. In the summer of AD 117 he decided to return to Rome, accompanied by Plotina and his sister Marciana (figs 32 & 33), as well as the guard prefect Attianus, Hadrian's second guardian. At the port city of Selinus in southern Turkey the imperial party had to stop; the end was imminent. On his deathbed Trajan officially adopted Hadrian.

## A troubled succession

While Hadrian's marriage to Sabina, Trajan's closest eligible female relative, clearly accorded him a special status, Trajan had not made any formal, public arrangements for his succession until the very last moment. Inevitably, this led to uncertainties and rumours. On several occasions Trajan had asked high-ranking friends and senators to name men they thought fit to take over responsibility for the empire should anything happen to him. While he may not have been very serious about this, such behaviour could easily give the overly ambitious wrong ideas. Many senior figures were acutely aware of the brutal demise of Domitian twenty-one years earlier, and of the fact that his successor Nerva had been chosen by the senate from among their own. Trajan had no children, so why should his trusted old generals and other distinguished nobles automatically accept Hadrian as the obvious heir? It seems that this potential feeling of discontent was further exacerbated by Hadrian's urgent redrawing of the empire's eastern borders, surrendering most of the recent advances under Trajan (see next chapter).

While Hadrian was occupied mastering the military situation on the eastern front, some of the malcontents in the capital seem to have made, or at least threatened, a move. Attianus, the guard prefect, clearly felt compelled to deal with

**Fig. 37** Augustus (r. 27 BC–AD 14), whom Hadrian took as his main role model. He used a portrait of Rome's first emperor as his seal and kept a small bust of him among the images of household gods in his bedroom. After a series of severe military reverses Augustus had forgone any further attempt to expand the empire and pursued peace by diplomatic means. Highlighting Augustus' policies lent authority to Hadrian's similar measures after he had come to power.

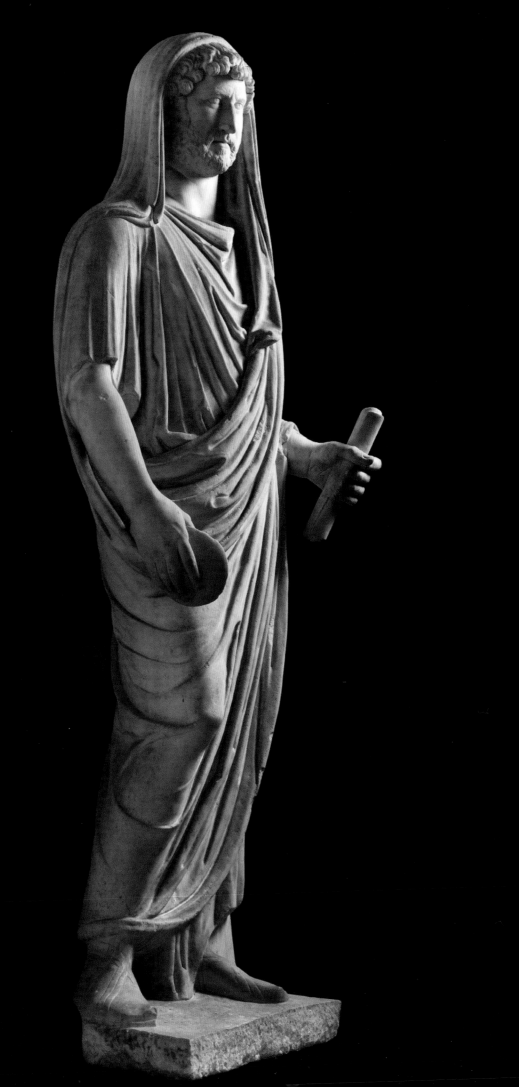

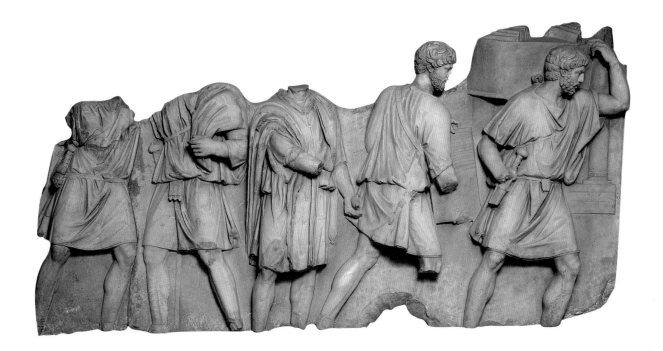

this situation immediately. Four senators suspected of plotting against Hadrian were put to death. The senate was outraged; this brought back grim memories of Domitian's worst days of tyranny. Hadrian immediately distanced himself from the action Attianus had taken, claiming no prior knowledge, and gave a solemn promise never in the future to sentence any senator to capital punishment without the senate's approval, but relations with this august body were irretrievably strained and the event would always cast a dark spell over his reign.

Hadrian's response was designed to gain favour with the masses as quickly as possible. One of his first measures was to remit people's debts to the *fiscus*, or state treasury, which he spectacularly set in train by burning the tablets with the relevant records in a dramatic public ceremony in the Forum of Trajan. A relief in Chatsworth House, Derbyshire (above) may show just this scene, with soldiers carrying baskets full of debt records to the ceremonial pyre. This act of generosity was duly celebrated in the imperial coinage and may even have had an immediate positive effect on the Roman economy, as some scholars have argued. Further coin issues duly celebrated the new-found stability (*securitas Augusti*) and praised Hadrian as restorer (*restitutor*) and enricher (*locuplatator*) of the empire.

## Hadrian's portraits

Practically all the sculpted portraits of Hadrian show a very peculiar and highly distinctive physiognomic detail. This is a deep, diagonal crease in both lower earlobes. Easily overlooked by the casual observer but unmissable to the trained eye, they

**Fig. 39** Relief from a Roman state monument. Soldiers of the Praetorian Guard or a similar unit carry containers with wax tablets. The adjacent slab must have shown the bonfire on the Forum of Trajan where the records of tax arrears were ritually burned. Hadrian remitted 900,000 sesterces worth of taxes owed to the *fiscus*.

**Fig. 38** The only preserved portrait of Hadrian in a toga, the Roman civilian state costume. Part of the toga is draped over Hadrian's head in the style of an officiating priest (both arms are later restorations).

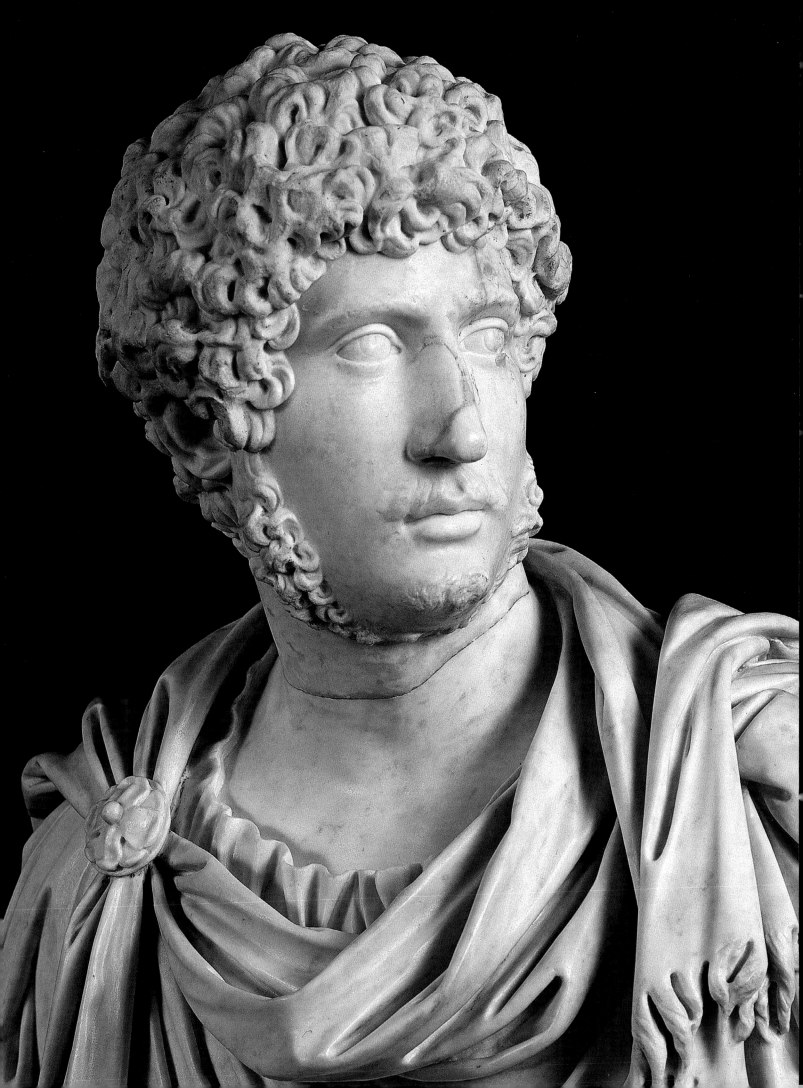

**Figs 40 & 41** The 'young' Hadrian. Now kept in the Prado in Madrid, the bust was part of the collection of Philip II of Spain in the sixteenth century. It can be securely identified as Hadrian through comparison with coins such as the aureus below. Minted some time after AD 128, the coin shows Hadrian on the obverse and his deified adoptive parents Trajan and Plotina on the reverse. It is unclear if Hadrian is shown here artificially rejuvenated or if a genuine portrait of him as a young man has been used.

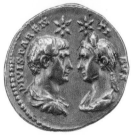

**Fig. 42** Detail of fig. 124, showing a marked diagonal crease across Hadrian's earlobe. This may have been a symptom of coronary artery disease.

provide a powerful diagnostic tool to the expert, helping to tell authentic ancient portraits from later copies and to prove or disprove doubtful identifications. Such diagonal earlobe creases do, in fact, occur in life and have been studied in the field of medicine. There appears to be a recognizable link between the occurrence of diagonal earlobe creases and coronary artery disease. While in retrospect we cannot tell for certain if Hadrian did indeed suffer from this particular disease (although attempts have been made to relate its known symptoms to ancient accounts of Hadrian's ill health at the end of his life and the circumstances of his death), they inject an unexpected dose of dramatic realism into his portrait, bringing us much closer to the living, real Hadrian.[11]

It is quite clear that Hadrian was honoured in public with statues even before he became emperor. This was by no means unusual for a man of his position, for certain offices, magistracies and priesthoods routinely led to portrait honours. Hadrian's proximity to the emperor may have provided an added, albeit quite limited factor. His marriage to Sabina in AD 100 could have been one occasion that warranted the creation of a portrait, his first consulship in AD 108 even more so. Two statue bases are preserved that can be firmly dated to the period before his accession.[12]

Hadrian's preserved portrait types, dated through a comparison with inscribed and therefore often chronologically better-fixed coin portraits, are generally thought to belong to the years of his reign or a short period immediately before. However, there is a most enigmatic portrait type linked to Hadrian that might possibly show him as a young man. In nineteenth-century books on Roman iconography this type was anonymously labelled as 'young Roman'. It was much copied from the Renaissance on and continued to be popular in the seventeenth and eighteenth centuries, leading some scholars to the conclusion that the type was modern altogether. It was only in 1954 that an indisputably ancient copy was found in excavations at Hadrian's country residence in Tivoli, proving that the type was indeed ancient. It can in fact be linked to a very limited coin issue from much later in his reign that clearly identifies this portrait type as Hadrian. What is more, the two best replicas of the type show the characteristic earlobe crease associated with his confirmed portraits.

In this portrait type Hadrian looks rather different from his other portraits; here, there are no long strands of hair but a dense mass of tight curls. Instead of

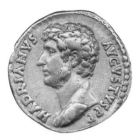

ABOVE

**Fig. 43** Aureus with, on
the obverse, a portrait of
the 'young' Hadrian and,
on the reverse, Hadrian as a
new Romulus, the mythical
founder of Rome. On this
coin Hadrian is shown
without a moustache, as
on the marble head from
Tivoli (right).

RIGHT

**Fig. 44** Marble head
of 'young' Hadrian
discovered during
excavations in Hadrian's
villa at Tivoli outside
Rome in 1954.

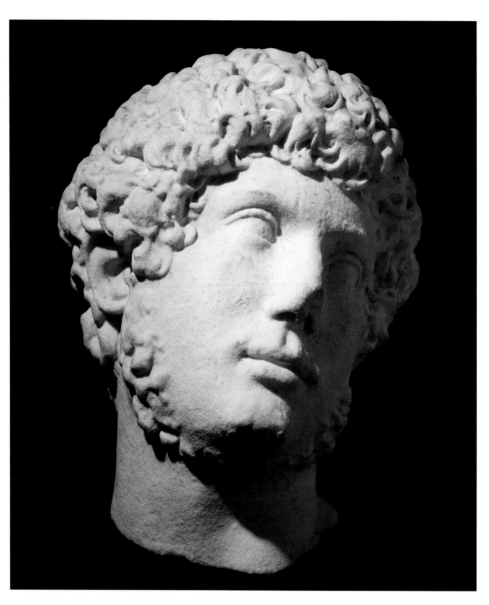

a full beard, much of the cheeks remains free of hair. Sometimes, a thin mous-
tache and a little hair on the chin are added.

The interpretation and dating of this type is much disputed. Some schol-
ars have linked it to other coins that refer to Hadrian as *renatus*, or reborn, either
in religious mysteries or in connection with the death of Antinous, suggesting
that it shows an artificially rejuvenated version of the portrait. However, in one
instance the type is combined on coins with images of the deified Trajan and
Plotina, Hadrian's adoptive parents (fig. 41). Perhaps the type might therefore be
related to the period of or before the adoption, and therefore copy genuine por-
traits of the young Hadrian not otherwise preserved. Like the coins, sculpted
versions of the type were circulated (again) late in his reign and afterwards influ-
enced the iconography of the imperial princes, Marcus Aurelius and Lucius Verus.
Much mystery still surrounds this unusual portrait type.

**Fig. 45** Sardonyx cameo
with double portrait of
Trajan and Plotina. Luxury
objects of this type were
circulated among the elite.
Many of the best gem
cutters came from the
Greek part of the empire.

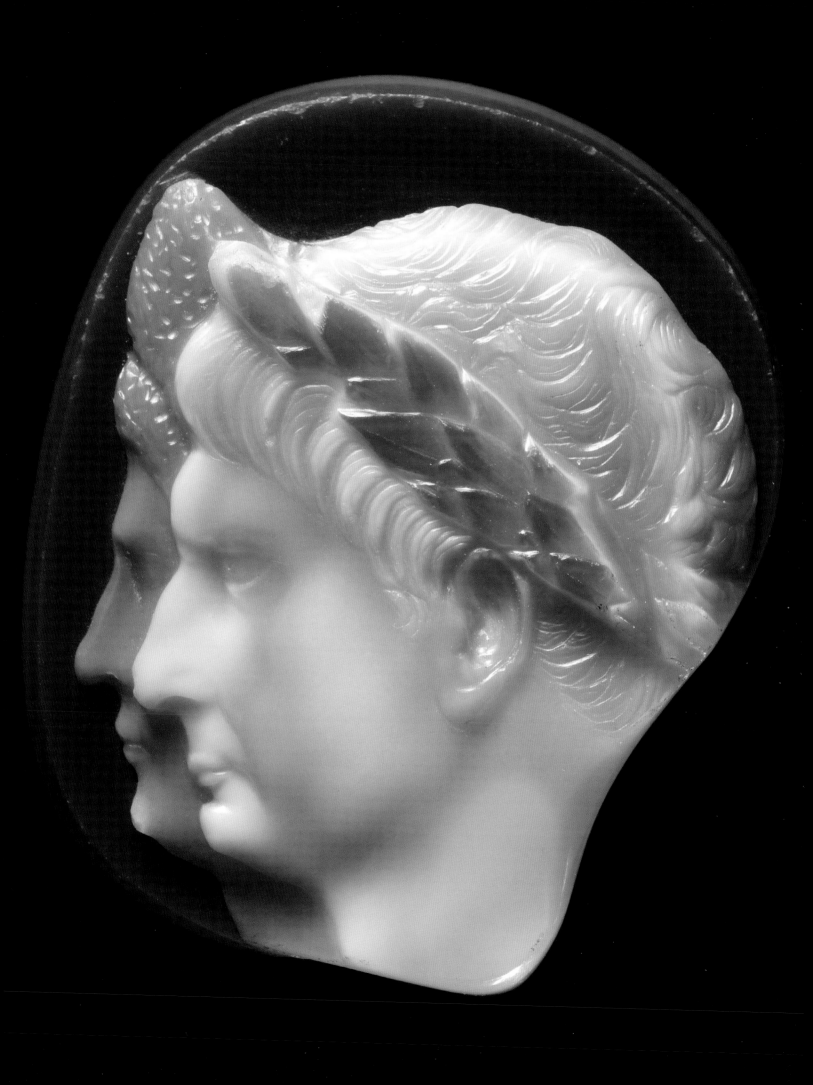

# II War and Peace

*'The nations conquered
by Trajan were in revolt;
the Moors were on a
rampage; the Britons
could not be kept under
Roman sovereignty;
Egypt was ravaged by
uprisings; finally, Libya
and Palestine displayed
their spirit of rebellion.'*

*HA HADRIAN 5.2*

POPULAR accounts of Hadrian's reign stress his complete break with the policies of his predecessors, forgoing any further expansion of the empire and instead creating fixed borders of which Hadrian's Wall in the north of Britain is the most iconic.[1] This does indeed seem to constitute a fundamental shift away from traditional Roman ideology and consciousness; the Roman poet Virgil, glorifying the reign of Augustus, had popularized the concept of an empire without limits, and Trajan must have appeared to his contemporaries as a living embodiment of these virtues:

> *Inde lupae fulvo nutricis tegmine laetus Romulus excipiet gentem, et Mavortia condet moenia, Romanosque suo de nomine dicet. His ego nec metas rerum nec tempora pono; imperium sine fine dedi.*

> 'Then Romulus, proud in the tawny hide of the she-wolf, his nurse, shall take up the line, and found the walls of Mars and call the people Romans after his own name. For these I set neither bounds nor periods of empire; dominion without end have I bestowed.'[2]

In reality, the issue is far more complex. It needs to be determined how far Hadrian implemented a fundamentally different vision of Roman rule or simply had to react to circumstances on the ground, possibly against his own deeper convictions. Equally, it is interesting to consider whether his contemporaries experienced his policies as a radical departure from established patterns in the way many modern historians have viewed them, or if they expressed a variety of opinions.[3] Intimately linked to this question is the wider assessment of Hadrian's character and merit as a ruler, an issue that was intensely debated by historians in the nineteenth and early twentieth centuries.[4]

## The new emperor

When Hadrian learnt of Trajan's death on 11 August AD 117, the military situation in a substantial part of the empire was disastrous.[5] The Emperor had died just before the wider Roman public could fully appraise the actual state of affairs and departed the world with his image as all-conquering hero intact. In truth, his last campaign had been a catastrophic failure. While Trajan, perhaps in May AD 116, stood at the shores of the Persian Gulf and bemoaned the fact that his age prevented him from following in Alexander the Great's footsteps by conquering India, rebellions broke out behind his back in the territories only just occupied.[6] Yet the Emperor still sent out triumphant despatches to the senate in Rome, confident of his place in history.[7]

PREVIOUS PAGE
**Fig. 46** Bronze bust of Hadrian from Judaea (see pp. 88–97).

**Fig. 47** Bronze coin showing Trajan handing the world to Hadrian. This was issued after the adoption to make the transfer of power appear planned and orderly.

In Armenia a Parthian leader named Vologaeses had by then confronted the Roman troops; stymied, Trajan had to offer him part of the province in return for peace. A major insurgency had begun in Mesopotamia and quickly escalated. The trusted general Lusius Quietus, a Moor in command of crack Moorish cavalry units, managed temporarily to regain the initiative, recapturing the cities of Nisibis and Edessa, and burning the latter to the ground as he did so. Seleucia on Tigris was also recaptured and sacked. Meanwhile the general Maximus was defeated and killed. In a hastily arranged ceremony at the Parthian capital of Ctesiphon, Trajan now crowned the Parthian prince Parthamaspates as the new king.

Shortly before this, in late spring or early summer AD 116, members of the Jewish diaspora community had risen against Rome, creating havoc in the provinces of Cyrenaica, Egypt and Cyprus. In Cyrenaica the Jews under their leader Andreas slaughtered both Greeks and Romans, killing 220,000 people according to Dio. Many public buildings and several temples were destroyed in Cyrene itself, and even the roads were made unusable. From there the Jewish rebels entered Egypt, where the local Jewry rose in support and defeated a Roman legion. On

**Fig. 48** Conflict zones in the eastern empire (marked in red). Hadrian had to relinquish Trajan's newly proclaimed provinces of Armenia, Assyria and Mesopotamia and withdraw from parts of Dacia and Moesia Inferior. Elsewhere, internal rebellions were put down.

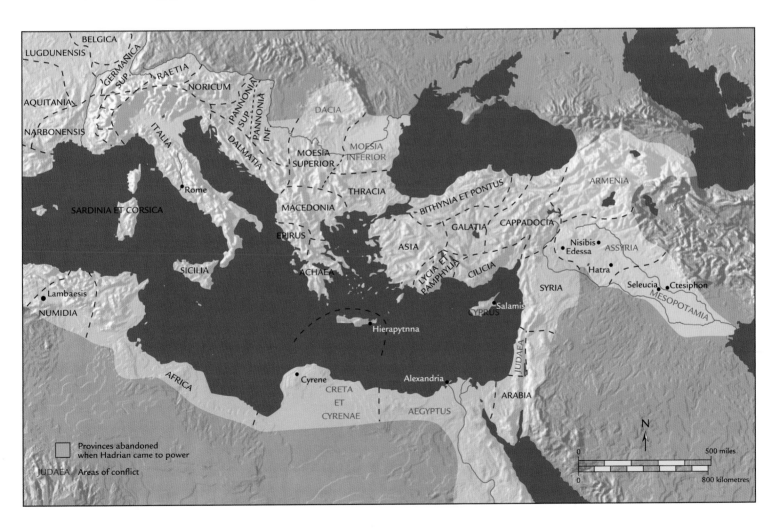

Cyprus Dio reported that the Jews under their leader Artemio slew 240,000 and that the provincial capital, Salamis, was ransacked.[8]

Trajan had to send additional troops into Egypt and Cyrenaica under the command of Marcius Turbo, who went on to kill Jews in their tens of thousands, supported in Egypt by the native population. At the same time, he ordered Quietus to deal brutally with the large Jewish diaspora population in Mesopotamia, lest they should rise in support of the wider rebellion. From there Quietus was sent on to Judaea and installed as the new governor of the province that comprised the traditional Jewish heartland and could be expected to cause further difficulties. Meanwhile, Trajan himself narrowly escaped injury while directing the siege of the Mesopotamian desert city of Hatra; his health began to fail soon after this and in late July or early August AD 117 he decided to return to Rome, with the east still in turmoil.

This was the worrying situation Hadrian urgently had to confront when he succeeded as emperor. Stationed in the province of Syria, he was close to all major conflict zones. An experienced and hardened military man, and surrounded by senior officers with a good grasp of events, he acted at once. Having received his imperial acclamation by the troops under his command, Hadrian ordered the immediate and complete evacuation of the provinces of Mesopotamia, Assyria and Greater Armenia. Next, he dismissed Quietus and his Moors, probably doubting the general's loyalties. The Mauretanians now rose against Rome, outraged by the treatment of their troops, and Marcius Turbo, still mopping up resistance in Cyrenaica and Egypt, was rushed to stand against them.[9]

At about the same time in Dacia, Trajan's most significant conquest, the Roman commander Quadratus Bassus died on campaign, either against the Dacians or their Sarmatian neighbours, the Roxolani

**Fig. 49** Hadrian as supreme commander in military regalia, quashing a barbarian foe. This statuary type was very popular in the Greek part of the empire, where it may have offered assurance to a population traumatized by recent rebellions.

and Iazyges. With many detachments of the Dacian and Danubian legions and their auxiliaries still away in the east, the situation must have seemed precarious; accordingly, armies were sent ahead to stabilize the position, soon followed by Hadrian himself. His next actions hint at the scale of the problem: large parts of Trajan's conquests north of the lower Danube that had been part of the enlarged province of Lower Moesia were abandoned; as an even more potent symbol of the dramatic reversal of Roman fortunes, the superstructure of Trajan's great bridge over the Danube, a celebrated feat of Roman military engineering carried out under the directions of the architect Apollodorus of Damascus, was dismantled, presumably because enemy forces threatened to break through.[10]

To senators and the Roman public at large, far from the front lines and their purses still filled with newly minted coins that graphically proclaimed Trajan's endless victories, all this must have come as a profound shock, breeding instant resentment in some.[11] Hadrian was in a most difficult position. Any public doubt of his adoptive father's policies or even worse, open criticism of them, however justified, could only have worked against him. Hadrian's own legitimacy as the new ruler on the contrary depended on the glorification of his predecessor and thus the validation of Trajan's choice of him as successor. In practical terms however, Hadrian's measures, especially with regard to the eastern borders, marked a return to the less adventurous policies of previous rulers and were soon flanked by careful diplomacy.

The Euphrates again delineated the empire's eastern border, as Augustus had envisaged it long before. Hadrian removed Parthamaspates, the Parthian puppet ruler installed by Trajan, giving him instead the buffer state of Osrhoene just beyond the upper Euphrates, and left the Parthian territories further east to Chosroes and his rival Vologaeses. Armenia, a constant bone of contention between Rome and Parthia, was turned into a Roman client kingdom under a Parthian prince, as it had been under Nero. In this way Hadrian retained a strong influence well beyond the borders, without having to commit troops to a doubtful occupation.[12] Similarly, a new treaty was concluded with the ruler of the Roxolani in the Balkans, who now became a Roman citizen and ally.[13] The benefits of these arrangements would eventually be recognized.[14] In the meantime, it was essential that Hadrian continued to project a strong military image.

**Figs 50 & 51** Empty rhetoric? Coins advertising Trajan's recent conquests and diplomatic triumphs. The political situation changed shortly after they were minted and Hadrian had to deal with the fallout. The coin at the top shows a triumphant Trajan with the subdued personification of Armenia flanked by two river gods (the Euphrates and Tigris). Above, Trajan, on a dais surrounded by staff officers, assigns territories to client kings.

**Fig. 52** Torso from the city of Cyrene in northern Africa of the same type as that opposite.

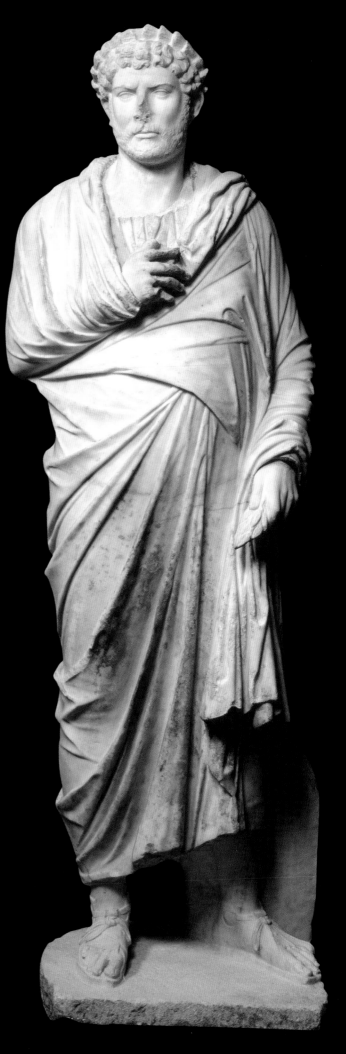

**Fig. 53** The iconic statue of
Hadrian in a Greek mantle –
a Victorian construct.
A recent examination of the
sculpture has demonstrated
that head and body did not
originally belong together.

## Politics and public image

The uncertainty among modern scholars about the way Hadrian's actions with regard to military matters and foreign policy should be interpreted extends to the analysis of his public image and the manner in which he was represented in official portraits, the main medium of reaching out to his subjects. There is a strange but illuminating dichotomy between the few preserved ancient references and the intense, and often controversial, debate on this issue.

The differences in appearance between Hadrian's and Trajan's official images could not have been more pronounced.[15] Trajan, clean-shaven, mature, and energetic had a very simple coiffure that required little styling (see fig. 17). Hadrian, by contrast, was the first Roman emperor to sport a full, carefully groomed beard. His coiffure, too, was more luxurious, with antecedents in the Flavian era; his locks, for example, were artfully modelled with curling irons, requiring the services of specially trained slaves.

Unsurprisingly, many scholars have seen in Hadrian's attire an echo of his general character and outlook, replacing the martial attitude of Trajan with an interest in culture and the arts, expressed particularly in his well-known philhellenism. In this reading, Hadrian's beard becomes a Greek beard, the distinctive outward sign of the *graeculus* Hadrian. For a full beard had long been associated with the Greeks, especially the Greeks of the classical past to which their modern descendants increasingly turned, while a clean-shaven look was considered a mark of Romanness.[16]

Perhaps there is no single sculpture that seems to express Hadrian's philhellenism more strongly than a statue in the British Museum that was discovered in 1861 in the ruins of the Temple of Apollo in the ancient city of Cyrene in northern Africa.[17] Not only does Hadrian here sport his customary beard, but he also wears the *himation*, that is, the distinctive Greek mantle, as opposed to the Roman toga. Consequently, the statue – the only one of its kind – has become an iconic symbol of Hadrian, his politics and personality, and is illustrated to this day in every major book on his reign, if not on Roman art in general.[18] Yet its very uniqueness should raise suspicion; the dedication of statues in the public sphere was highly circumscribed, requiring official decrees that sanctioned the chosen location as well as material and iconography. This was even more important when it concerned imperial images, for which workshops with access to centrally disseminated official portrait types had to be commissioned. But, as hundreds of surviving imperial statues demonstrate, there were only three ways in which the emperor could officially be represented: in the battle dress of a general; in a toga, the Roman state civilian costume; or nude, likened to a god. These iconographic formats powerfully and effectively evoked the emperor's role as commander-in-chief, magistrate or priest, and finally as the ultimate embodiment of divine providence.

What then, are we to make of the Cyrene statue? The sculpture was in fact found in many pieces, the body broken horizontally in two, the hands and head separate. There were fragments of other marbles, too: a helmeted head of Athena/Minerva lay between the statue's legs. The excavators, not yet identifying the subject but eager to assemble entire figures, reported that the separately carved head fitted the hollow socket in the statue's neck. In London the portrait was recognized as Hadrian and the head permanently fixed onto the body, to enter art and history books the world over. Some raised cautious doubts about the statue's unusual iconography, but these were soon dismissed by the alternative explanation that the head might have been inserted in antiquity into an alien body as an expedient measure of swift dedication or repair.[19] And yet the Temple of Apollo was one of many buildings that Hadrian restored after their destruction during the Jewish revolt, so any image of the imperial benefactor in this prestigious temple, possibly only finished under his successor, could be expected to be executed with great care and to the highest standard. With this in mind, the statue was recently carefully re-examined and the head removed – the carving clearly proves that it was never intended to join this particular Greek body (see fig. 53).[20] The awkward transition of the smooth, long neck to the square socket had been purposefully hidden under thick layers of Victorian plaster. Clearly, a sculpture had here been created to fit a preconceived notion of Hadrian – and as this statue can be physically exploded, so too can much of the popular myth of Hadrian as a peaceful philhellene.

Most statues of Hadrian certainly show the emperor in a very different light. A good example of this is a colossal marble statue from Hierapytna in Crete, now in Istanbul (fig. 49).[21] Towering over the spectator, here is a fierce-looking Hadrian in military cuirass, trampling underfoot a defeated barbarian. The scene on the cuirass itself is programmatic, too: the she-wolf, symbol of Rome, with winged Victories and the *palladium*, emblem of Rome's eternal might. Many fragments of such statues have survived in the eastern parts of the empire, and it is believed that the type was developed in a Greek, perhaps Athenian studio, almost overemphasizing its distinctive Romanness.[22] Clearly, this is a powerful, mighty Hadrian, not one to tamely surrender Roman territory. One might wonder if the popularity of this type in the Greek east does not reflect a different reality: the emperor as a protector of the Greeks from their barbarian and perhaps Jewish foes. By the time Hadrian had come to power, the relationship between the Greeks and Rome had certainly become more balanced; the Greek-speaking provinces, as a quick look at a map with the military flashpoints at the end of Trajan's reign amply demonstrates (see fig. 48), formed the still mostly calm hinterland of major conflict zones. To keep the Greeks on side was an overwhelming strategic necessity for the Roman authorities, as Hadrian was most keenly aware. Similarly, the Greek population of several provinces had just

**Fig. 54** Hadrian as Mars. He was the first Roman emperor to be represented in this manner. The statue copies a well-known classical type of the god of war.

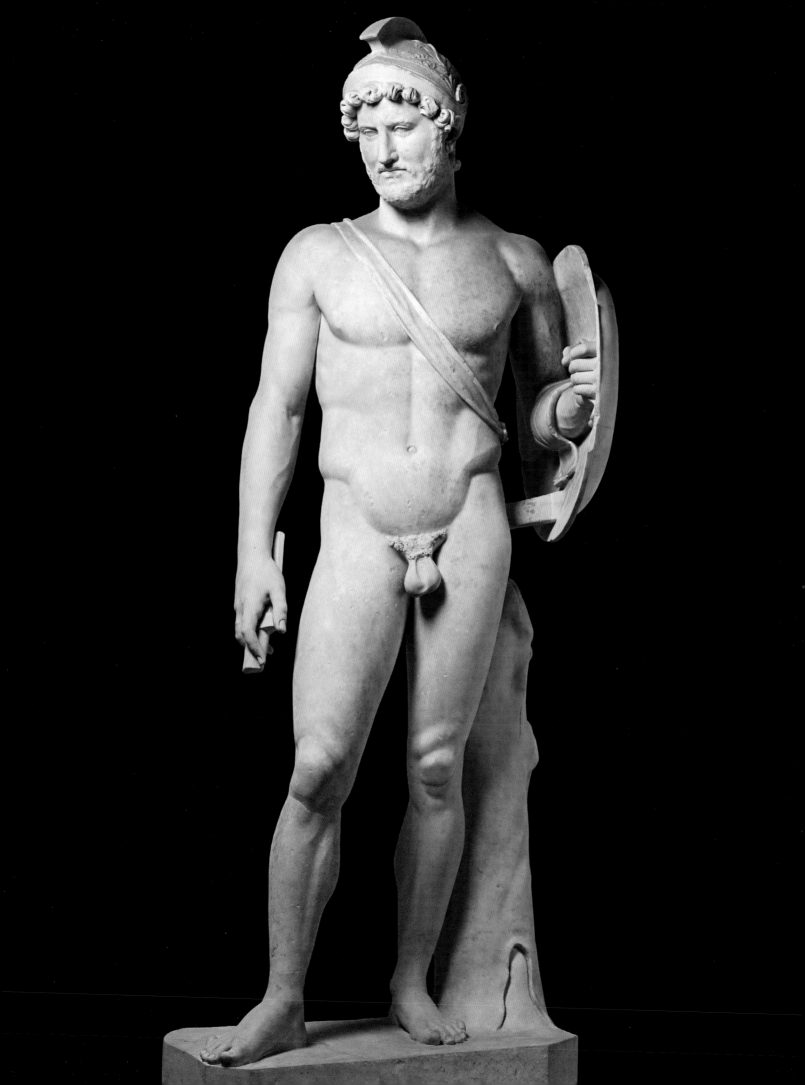

suffered terribly from the Jewish uprising, with Rome's armed might offering the only protection. There was therefore a very clear political and strategic side to Hadrian's philhellenism, in addition to the cultural one, and the Greeks may have sensed that this worked to their benefit. Hadrian's thorough familiarity with the Greek world, in turn, could partly be seen as a function of this gradual shift in the importance of the Greek provinces for Rome that had begun some decades before.[23]

In addition to the powerful and graphic image of Hadrian as the determined military leader quashing the empire's enemies, a more subtle, but equally strong alternative type was created that carried the same message in a different way. A statue in the Capitoline Museum in Rome depicts Hadrian nude, in the guise of Mars, the god of war, utilizing a well-known classical body type of the divinity.[24] Curiously, Hadrian seems to have been the first emperor who chose to be depicted in this manner, but seen in this wider context it is not surprising he did so. Perhaps this was a more sophisticated mode of conveying the same message to a Roman audience. Mars, after all, was the father of Romulus, and thus the mythical ancestor of the Roman warrior race.

Both the Istanbul and the Capitoline statues employ early versions of Hadrian's portrait type, indicating that these statuary formats were developed at the beginning of the reign. This is of course when images projecting such a reassuring message were most needed, which seems to support the interpretation proposed here.

All this brings us back to Hadrian's beard. While it may have been unusual for an emperor to grow a beard, it was distinctly less so for other men of Hadrian's generation and background. Flavian princes had already frequently been represented on coins with bearded cheeks and it is quite possible that the seemingly clean-shaven marble portraits in fact originally showed painted beards. There are certainly indications that beards became quite fashionable, especially among young men during the later first and early second centuries AD. Similarly, there is clear evidence that beards were sported by the military, especially on campaign, as even a quick glance at the Arch of Trajan at Beneventum or Trajan's column in Rome can confirm. In both cases we find hairstyles and beards similar to Hadrian's worn by common troopers as well as staff officers. In consequence, some have felt tempted to see Hadrian in every bearded figure depicted close to Trajan on these monuments, perfectly possible perhaps in some cases, but not in all, and of course impossible to prove. What emerges, therefore, is a very different reading of the beard. It becomes the mark of a military man of the younger generation.[25]

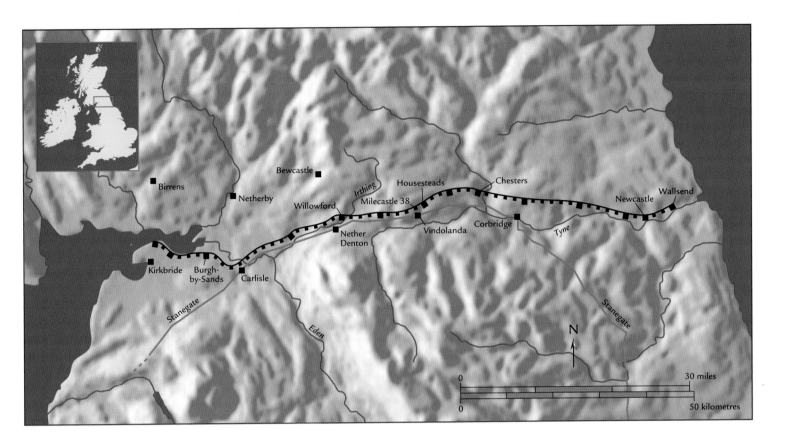

## Hadrian's Wall

*Ergo conversis regio more militibus Britanniam petiit, in qua multa
correxit murumque per octaginta milia passuum primus duxit, qui barbaros
Romanosque divideret.*

'And so, having reformed the army quite in the manner of a monarch,
he set out for Britain, and there he corrected many abuses and was the
first to construct a wall, eighty miles in length, which was to separate
the barbarians from the Romans.'[26]

One of the most famous monuments associated with Hadrian stands in Britain:
the wall now named after him. Yet despite its renown, the wall's function and sig-
nificance are often misunderstood as a highly symbolic border demarcation by
a peace-loving emperor.[27] Recent research and an analysis of the wider military
and political context suggest quite different conclusions to the popular ones.[28]

After military incursions under Caesar (55/54 BC) and Caligula, Britain had
finally become a Roman province only thirty-three years before Hadrian's birth,
with the conquest by Claudius in AD 43. Roman rule was initially confined to the
south and east, while allied local chieftains were left in power further afield. When
the loyal queen of the northern tribe of the Brigantes was overthrown

**Fig. 55** Map of Hadrian's
Wall, with some of the forts
mentioned in the text.

OVERLEAF
**Fig. 56** Housesteads Crags,
Hadrian's Wall.

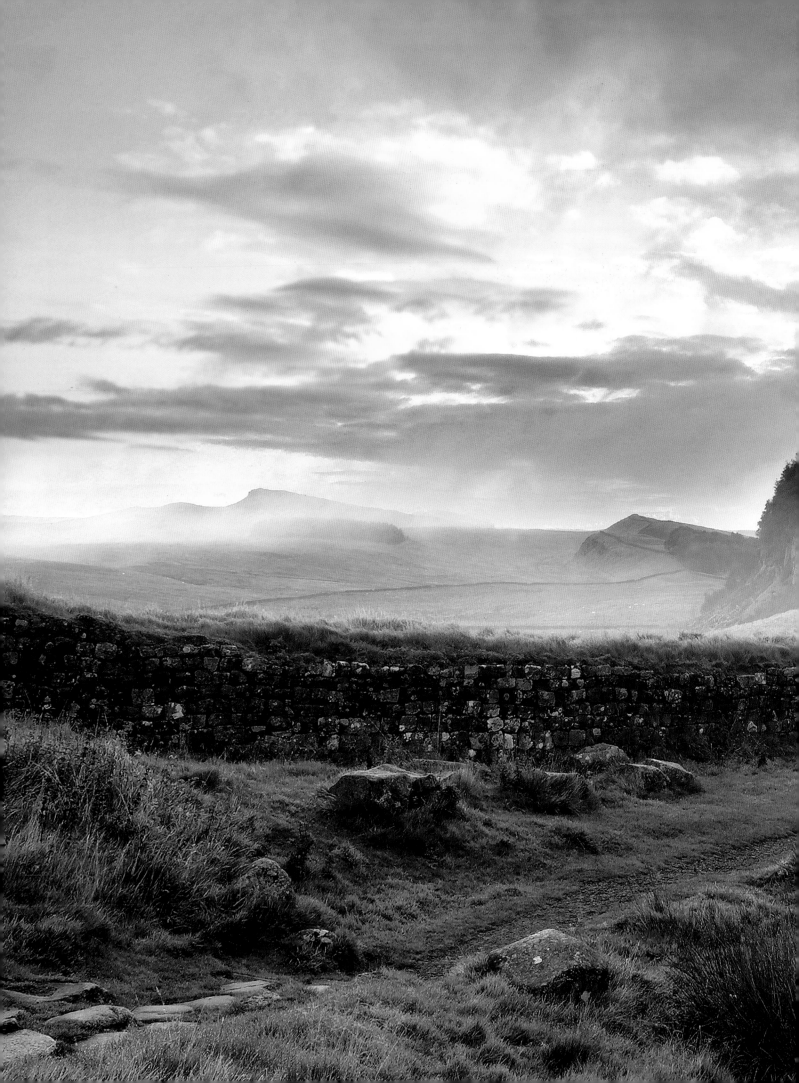

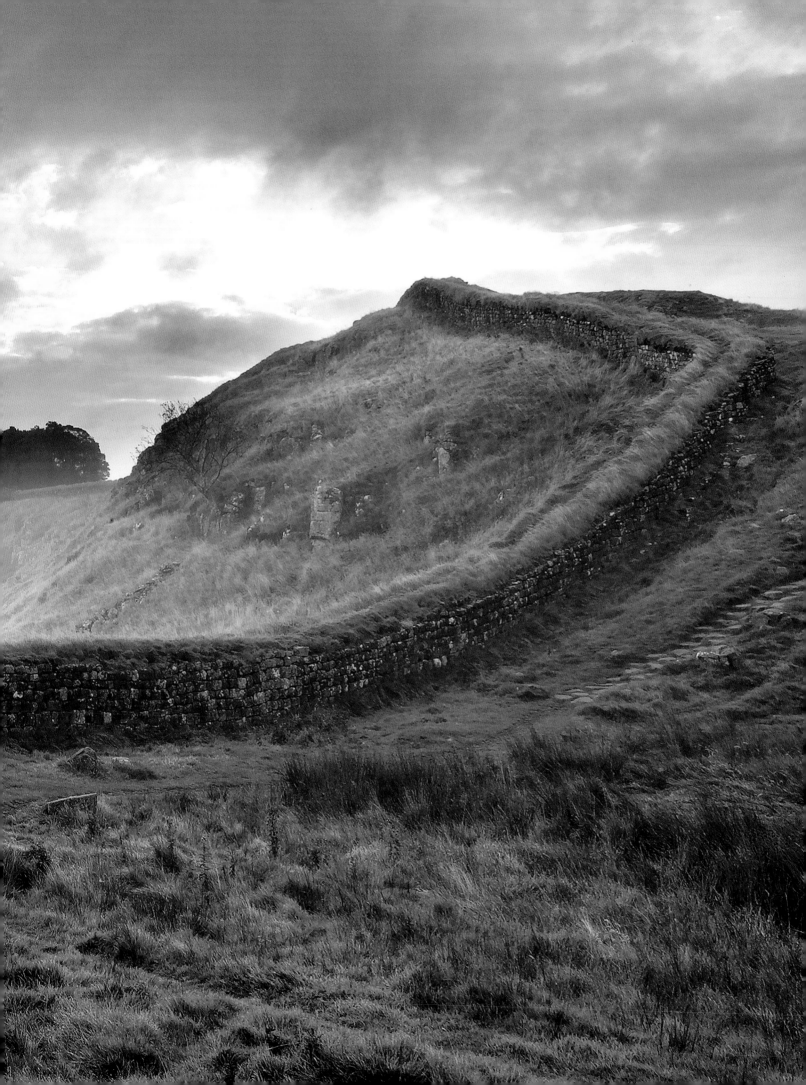

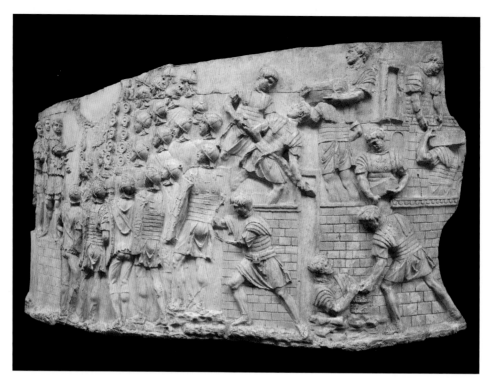

LEFT AND OPPOSITE
**Figs 57 & 58** Two scenes from Trajan's column: Roman legionaries build fortifications during the Dacian Wars. Two to three decades later, Hadrian's Wall was constructed by units from the three British legions in a similar manner.

during internal strife in AD 69, the Roman army intervened and occupied the tribal area, reaching the Solway in the process. The reigning emperor Vespasian, who as legionary commander had taken an active role in the original military conquest, now ordered the occupation of Wales and a further expansion north. Under Julius Agricola, who was governor from AD 77 to 84, the Roman army reached the borders of the Scottish highlands, defeating the Caledonians in a major battle at Mons Graupius, and established military camps to secure the area and create a new frontier zone in the glens.[29]

Yet in AD 86 Vespasian's son and successor Domitian had to withdraw one of the four British legions together with numerous auxiliary units to the Balkans front, in order to counter the increasing threat from the Dacians in the eastern theatre. This would be a recurring theme from then on. In consequence, the northernmost Roman forts were abandoned;[30] troops were subsequently concentrated further south along the Tyne–Solway isthmus, a comparatively narrow and therefore easily controllable stretch of land in a friendly tribal area with good access to major east–west and north–south communication and supply lines. Forts already existed at Carlisle at the head of the Solway estuary and at Corbridge, where the Deere Street, a major road coming up from the south, crossed the River Tyne. These two forts were linked by a road, now known by its medieval name of Stanegate. As part of the strategic force realignment, the Corbridge base was rebuilt in a slightly different position and completely new forts constructed at Vindolanda and Nether Denton. Thus a line of four camps was established at intervals of 22 km, or roughly a day's march. A few forts were still retained north

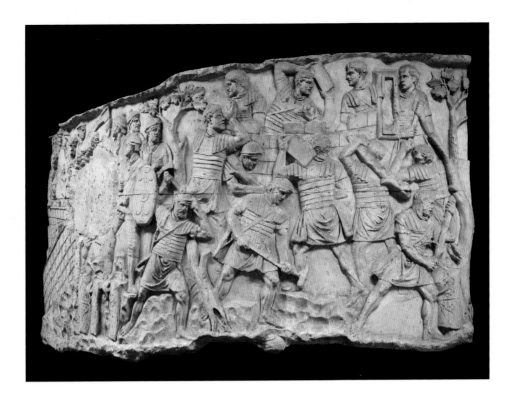

of this section. The remaining legions returned to bases further south; the existing forts at Chester and York were rebuilt in stone, and a new one was constructed at Caerlon in Wales. The other two former legionary camps, at Lincoln and Gloucester, were turned into veterans' settlements.

This was the situation when Hadrian's predecessor Trajan came to power in AD 98. Little is known about the following years in Britain in those years, but it seems that by about AD 103 virtually all forts north of the Tyne–Solway line had been given up. Like Domitian, Trajan withdrew further military units from the province in preparation for his own Balkan wars, designed to deal once and for all with the Dacian problem, after earlier attempts by Domitian had not only failed but had led to major reversals on that front.

Defences along the Tyne–Solway isthmus were further strengthened. There is evidence for rebuilding at some of the bases in these years, while a number of additional forts were established in between the existing ones, shortening distances to a half day's march. Further outposts were installed to the west of Carlisle at Burgh-by-Sands and Kirkbride, controlling an important ford across the Solway estuary and offering additional protection against the hostile Segovii tribe. It is possible that already at that stage a turf wall was constructed to strengthen defences in this area. Four turrets were built to provide lookout posts along the isthmus line, either still under Trajan or early in Hadrian's reign; all predate the wall, but two were later incorporated in it. All military installations along the isthmus were manned by auxiliary units, while the legions remained much further south.

Taken together, these activities appear to indicate that Trajan had concluded that requirements in the east made a return to pre-Domitianic policies in northern Britain permanently impossible. In simple strategic terms it seems clear that the Roman army could have secured the territories further north, but this would have required a substantial number of additional troops and any potential gain was clearly outweighed by the cost – in other words, the return for military expenditure was much higher in the richer and more urbanized east, as Trajan's spectacular conquests were soon to prove.

Wooden writing tablets found at the Roman fort at Vindolanda provide a fantastic insight into life among the military units along the Tyne–Solway line under Domitian and Trajan. They also indicate that troops were widely dispersed with various detachments fulfilling specific roles elsewhere; on occasion elements from different units were brigaded together as circumstances might demand. All this demonstrates very clearly that the forts on the isthmus did not form a rigid defence line but merely provided fortified bases at nodal control points, allowing a much wider area to be policed by highly mobile units. Efficient communication between the various, widely spread detachments was essential for this sort of active control of a deep frontier zone.

The following period is cloaked in darkness as far as the situation in Britain is concerned. British society was much less literate than that of Rome's eastern foes, leaving no written account of events, and the focus of Roman historians was firmly on Trajan's eastern campaigns and then on Hadrian's accession. There are occasional glimpses of troubles in Britain in this period, with Roman military reversals and perhaps even major warfare, but there is frustratingly little hard evidence and no clear dates emerge. Commenting on Hadrian's first years in power, the *Historia Augusta* states that 'the Britons could not be kept under Roman control'.[31] On his way to Rome from the east, Hadrian met the governor of Lower Moesia, his friend Pompeius Falco, and dispatched him to Britain to deal with the situation there.

The fragmentary and not precisely dated tombstone of a centurion at Vindolanda records

**Fig. 59** Tools used by Roman soldiers (hammers, axe heads, plum leads, chisel, turf cutter). From various places along Hadrian's Wall.

**Fig. 60** The fort at Housesteads from the air. The new series of forts sat astride the wall, reflecting a change in military strategy.

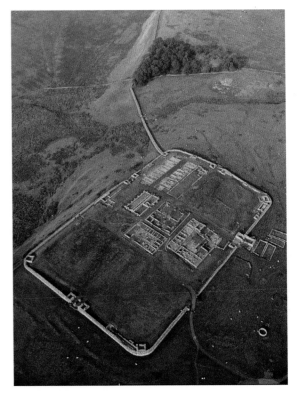

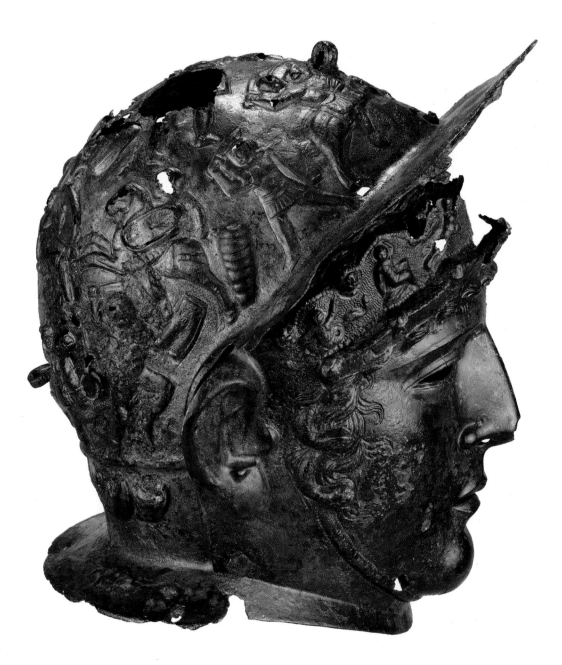

Fig. 61 The Ribchester
Helmet, the ornate parade
gear of an auxiliary
cavalryman. The writer
Arrian, an officer and friend
of Hadrian, describes the
parade drill in his *Ars Tactica*.
Depersonalized in their
gleaming masks, the highly
trained Roman horsemen
must have made a
considerable impression
on the local population
witnessing the spectacle.

his death in a war, while two further inscriptions refer to an 'expeditio Britan-
nica', a military campaign perhaps rather than anything merely linked to the
emperor's visit. The first mentions T. Pontius Sabinus, who led to Britain a force
of 3,000 men drawn from three legions stationed in the provinces of Upper Ger-
many and Spain; the second refers to M. Maenius Agrippa, who was chosen by
Hadrian to head another military expedition and is later attested in command
of the first cohort of Spaniards at Maryport. Finally, Cornelius Fronto wrote of
the deaths of many Roman soldiers in Britain during Hadrian's reign. There may
in fact have been two wars in Britain under Hadrian, one in AD 117–19, the other
perhaps in the mid-120s. For a long time it had been thought that the entire

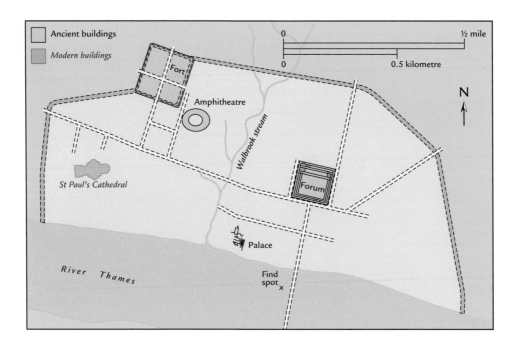

**Fig. 62** Map of Londinium, the Roman capital of Britain. The bronze head of Hadrian (opposite) was found in the River Thames at London in 1834.

Ninth Legion was destroyed during these events, although this now appears less certain. Clearly, the situation was unsatisfactory, and some sort of more permanent settlement was urgently required.

Hadrian arrived in Britain in the summer of AD 122 en route from Germany, taking with him, it is thought, the Sixth Legion under its commander Platerios Nepos with its associated auxiliary units from its garrison at Vetera in Lower Germany.[32] By now he had decided to mark the spine of the existing deep frontier zone in spectacular fashion with a continuous rampart, much of it in the form of a stone wall. The wall itself allowed the efficient control of any traffic in people and goods, while a system of forts and outposts allowed the control of substantial territory to the north and south, further facilitated by highly mobile cavalry units. Seen in context, the new works simply formalized, rather than radically altered, existing border arrangements. In parts, it may even simply have continued policies initiated by Trajan. By splitting up formerly contiguous tribal areas, control of potentially unruly elements among the subject peoples was further facilitated, here and elsewhere.

**Fig. 63** Hadrian addresses the army of Britain. This rare coin belongs to a series dedicated to the armies of the frontier provinces. Much of Hadrian's time during his journeys was taken up inspecting the troops and reforming the military.

The wall's original plan appears to have been designed on a drawing board with little allowance for any peculiarities of the terrain. It envisaged a 3-metre-wide stone wall running 72 km from the lower Tyne to the River Irthing, followed by a 6-metre-wide turf rampart covering the 45 km from there to Bowness-on-Solway. At every Roman mile (1.6 km), there was a fortified gateway with a tower, a so-called milecastle, and in between two further towers, thus forming a continuous line of watch towers at intervals of one third of a Roman mile, or 495 metres. Milecastles and towers continued beyond the end of the wall for about 32 km

**Fig. 64** Head from an over-lifesized bronze statue of Hadrian. It is the only portrait of Hadrian to survive from Britain. The style suggests that it was made locally, perhaps to commemorate Hadrian's visit to the province in AD 122.

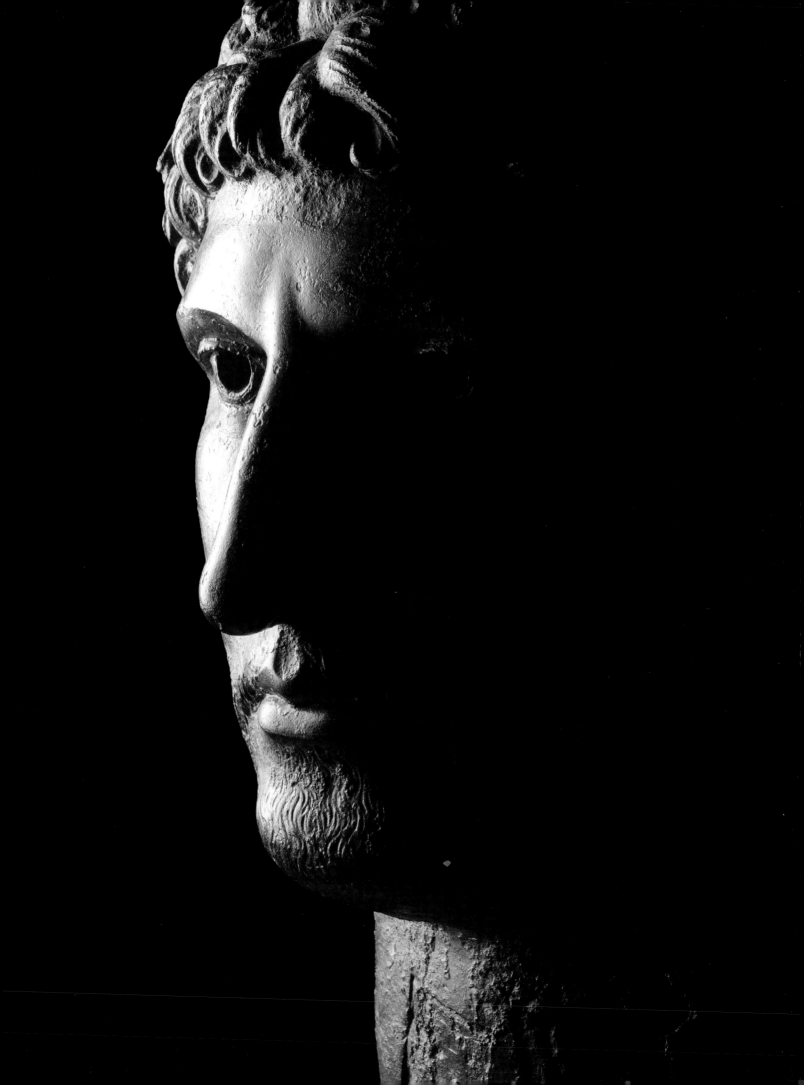

southward along the Cumbrian coast to offer protection against seaborne raiders. The existing forts initially remained at the Stanegate, a little to the south of the new wall. New outlying forts were built at Birrens, Netherby and Bewcastle to protect the territory of the Brigantes located to the north of the wall.

While building work was still in progress, two major changes were implemented for as yet unknown reasons. The forts were now brought forward to sit astride the wall, at an average distance of 11.6 km from each other. Perhaps as a consequence of the additional construction effort this entailed, the width of the as yet unfinished sections of the stone wall was reduced from 3 to 2.4 metres; occasionally the direction of the wall was slightly readjusted to take better account of the terrain. In the east the wall now seems to have been extended from Newcastle, where a bridge, the *Pons Aelius*, crossed the Tyne, to Wallsend. To the south of the wall, a 6-metre-wide and 3-metre-deep ditch flanked by additional earthworks on either side, the so-called *vallum*, was constructed. The *vallum* defined the southern limit of the immediate military zone, and channelled any traffic through a limited number of gates near the main forts. An alternative explanation could be that the *vallum* protected the line while the castles were built and before the wall in between them was finished.

The construction of the wall was carried out by the legions. It appears that at first the foundations were laid along the entire line of the wall, then milecastles and turrets were built. Only later were the sections of wall built up in between. It is possible that the wall face was plastered and then painted to create the impression of regular, square-cut masonry blocks. Subsequently, some sections of the wall were further strengthened by a ditch running along its northern side. At Chester, Willowford and Carlisle bridges spanned the Rivers North Tyne, Irthing and Eden, continuing the line of the wall.

Hadrian brought a substantial entourage with him to Britain. His presence is not explicitly attested in any specific location, but it is mostly assumed that he personally inspected the area of the new wall. Understandably, excavators throughout the province have linked certain structures to his presence, but little can be proven.[33] A new fort was constructed in this period at Vindolanda, and living quarters finished to a higher standard than one would usually expect have been interpreted as Hadrian's quarters during his visit. A number of writing tablets survive from this later period. One is a draft petition by a civilian contractor complaining about corporal punishment he received from a centurion. The writer addressed it to someone he calls 'your majesty', surely a high-ranking person, perhaps the provincial governor – more optimistically, Hadrian himself.

A bronze portrait head of the emperor in the British Museum (fig. 64) – the only sculptured likeness of Hadrian to have survived in Britain – may have been set up in the centre of Londinium to commemorate his

**Fig. 66** Inscriptions from Hadrian's Wall. The smaller ones are so-called centurial stones, with which each century (a unit of eighty men) marked the section of the wall it had constructed. In the centre is a dedication by Legion II Augusta to Hadrian from milecastle 38 near Housesteads, giving the name of the governor Aulus Platorius Nepos. This inscription was of great importance in demonstrating to eighteenth-century antiquarians that the visible remains of the wall indeed dated to Hadrian's reign, not to that of one of his successors.

**Fig. 65** A wooden *pilum murale*. Each legionary was issued with two; they were used to fortify the ramparts of marching camps.

IMP CAES TRAIAN
HADRIANI AVG
LEG II AVG
A PLATORIO NEPOTE LEG PR PR

## *Paterae*

A fine group of three metal *trullae*, perhaps superior versions of Roman mess tins, not only provides a glimpse of Roman craftsmanship in the province of Britain but also first-hand evidence for the wall and the diversity of people who served along it. They seem to have been made near the Wall by craftsmen working perhaps largely for a military clientele in the middle of the second century AD. All are inscribed with the names of forts along the western end of the Wall. They may have served as special souvenirs from the frontier, perhaps even as retirement gifts for military personnel. The so-called Staffordshire Moorlands Pan, discovered in 2003, in addition is inscribed with *rigore vali aeli draconis*. The interpretation of these words is ambiguous but intriguing. They could refer to a person named Aelius Draco – perhaps the maker or more likely owner of the *patera* – or to the wall itself; *vallum aelii*, 'the wall of Aelius', might then be the Roman name of Hadrian's Wall.

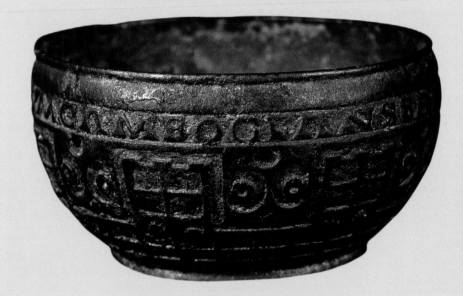

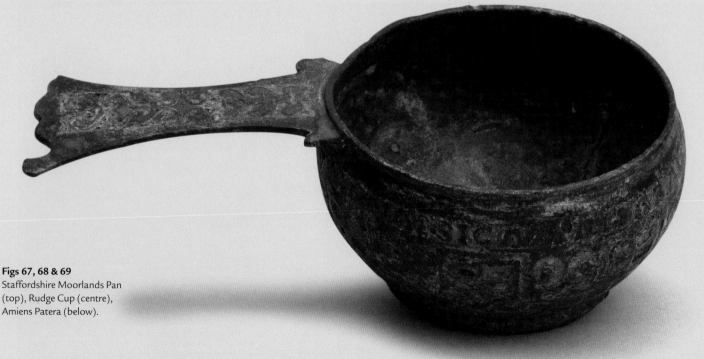

**Figs 67, 68 & 69**
Staffordshire Moorlands Pan
(top), Rudge Cup (centre),
Amiens Patera (below).

visit. After three months in the province, the imperial party left for Gaul; much of the construction work on the wall, and certainly the changes in plan with the relocation of the forts up from the Stanegate line, therefore fall into the period after Hadrian's visit. Perhaps they reflect troubles that occurred at the time; work certainly continued well into the 130s.

## Military reforms

Hadrian continued to devote much of his time to military matters and ensured that the army, well exercised and kept at a peak of readiness, could successfully deter any enemy.[34] This concept he defined with the term *disciplina*, and two series of coins were issued to stress the discipline and readiness of the provincial armies. Dio states: '*Both by his example and by his precepts he so trained and disciplined the whole military force throughout the entire empire that even today the methods then introduced by him are the soldiers' law of campaigning. This best explains why he lived for the most part at peace with foreign nations.*'[35] The literary sources refer to Hadrian's very personal involvement with the troops, his sharing of their hardships and constant encouragement in matters of training, discipline and battle tactics.[36] How he did so in practice can be gleaned from a remarkable monument discovered near Rome's African border. Here, on the parade ground of the legionary fortress of Lambaesis the text of several speeches Hadrian had delivered to the assembled troops after closely observing their manoeuvres was carved on the stone base of a large memorial column, built to serve as permanent reminder of his visit in the summer of AD 128 (fig. 72).[37]

Addressing the Spanish auxiliaries of *cohors* II Hispanorum, Hadrian gave praise and encouragement, and it does not take much to imagine him delivering a similar speech to the British legions six years earlier: '*What others would have spread over several days took you only one to finish: you have built a wall, a lengthy construction, normally made for permanent winter-quarters, in not much more time than is required for a turf rampart – and in that kind of work the turves are cut to standard size, and easy to carry and handle and can be laid without difficulty. You have built with stones, large, heavy and irregular at that, which no one can carry or lift or lay without these irregularities being noticeable. You have cut a ditch in a straight line through hard and rough gravel and have made it smooth by levelling. When the work was approved, you entered camp at speed, got your food and weapons and followed the cavalry that had gone ahead, hailing them with a great shout as they returned.*'

Hadrian, who must have witnessed countless exercises of this kind, appears throughout the speeches as an experienced, skilful leader, raising the morale of his troops by acknowledging and appropriately rewarding their skill and eagerness, but also offering advice and criticism. The cohort's associated cavalry unit was admonished thus: '*Open order tactics I do not approve of ... a trooper should ride out*

*from cover and be more cautious in pursuit – if he doesn't watch where he's going and can check his horse at will, he is exposed to hidden pitfalls.'*

In July Hadrian addressed the legionaries of III Augusta and their cavalry unit, who seem to have performed better than their colleagues of the auxiliary cavalry: *'Military exercises have, in a way, their own rules: if anything is added or removed from them, the exercise either becomes less useful or too difficult. You performed the most difficult of difficult exercises, throwing the javelin while wearing the cuirass … I also approve of your spirit.'* The emperor's remarks to the legion's senior centurions reflect a briefing he had received from their commander *'that one cohort is absent, because it has been sent on the annual rota to serve in the* officium *of the proconsul; that two years ago you gave up one cohort and four men from each century to reinforce your comrades of the Third; that many outposts, and widely scattered ones, split you up; that within my own memory you have not only changed base twice but have built a new fortress.'*

The new fortress was the camp at Lambaesis, built up under Hadrian from a small Flavian outpost into the main base of the III Augusta Legion, more than 100 km to the south-west of their previous headquarters at Ammaedara. This was the only legion to protect the entire North African territory from the Atlantic seaboard in the west to the western border of Egypt in the east. The move itself was probably connected to an aggressive assertion of Roman control in the province, continuing a steady expansion of Roman influence already begun by the Flavians and Trajan. At the same time linear border defences, remarkably similar in many details to Hadrian's Wall in Britain, were constructed much further south, beyond the Aurès Mountains, and strengthened by several smaller outpost forts. This fortified line, the so-called *Fossatum Africae*, consisted of a wall built of mud bricks over a length of 60 km, with a gateway every Roman mile and an additional watchtower halfway between two gates, fronted by a continuous ditch broken only in front of the passageways. Again, this wall was not intended

**Fig. 70** Hadrian marches at the head of his troops. The emperor's easy familiarity with the common soldier and his ability to lead by example are recorded in the literary sources.

**Fig. 71** Remains of a hall (post-Hadrianic) in front of the headquarters of the legionary fortress at Lambaesis, northern Africa. Hadrian visited Lambaesis and the surrounding area in AD 128, inspecting the local military units.

to provide static defence; the purpose rather seems to have been to control movement between the settled population in the fertile region to the north and nomadic herders in the south, whose different interests and demands on the environment provided a constant source of potential conflict. The border fence, which in fact considerably expanded the area of direct Roman influence, allowed management of the nomadic activities on terms beneficial to Roman interests. Relatively small army units supported by permanent fortified observation posts could easily control the major water sources in the region and thus the main transhumance routes.

Some of the work must have been carried out under the command of Sextus Julius Maior, legate of III Augusta and in practice governor of the province, who, despite his Latin-sounding name, was a Greek from Tralles in Asia Minor. Just before Hadrian's arrival he had handed over to Q. Fabius Catullinus, probably a Spaniard.[38] In fact, the African provinces had become ever more important economically, joining Baetica, for example, in exporting olive oil and having members of the local elites rise to prominence in Rome.[39]

Hadrian's visit was a typical combination of administrative and military restructuring. The importance of keeping the army at readiness would become clear in Judaea a few years later.

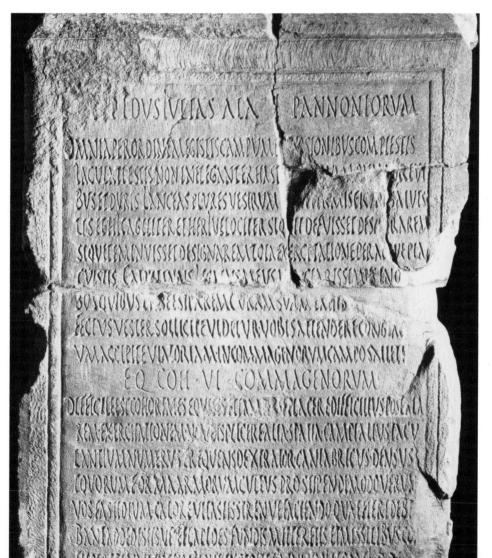

**Fig. 72** Text of Hadrian's speech to cavalry units from Pannonia and Commagene stationed near Lambaesis. The only extant authentic speech of an ancient leader to his army, it was inscribed on a large monument in the centre of the local parade ground to commemorate Hadrian's visit (see p. 85).

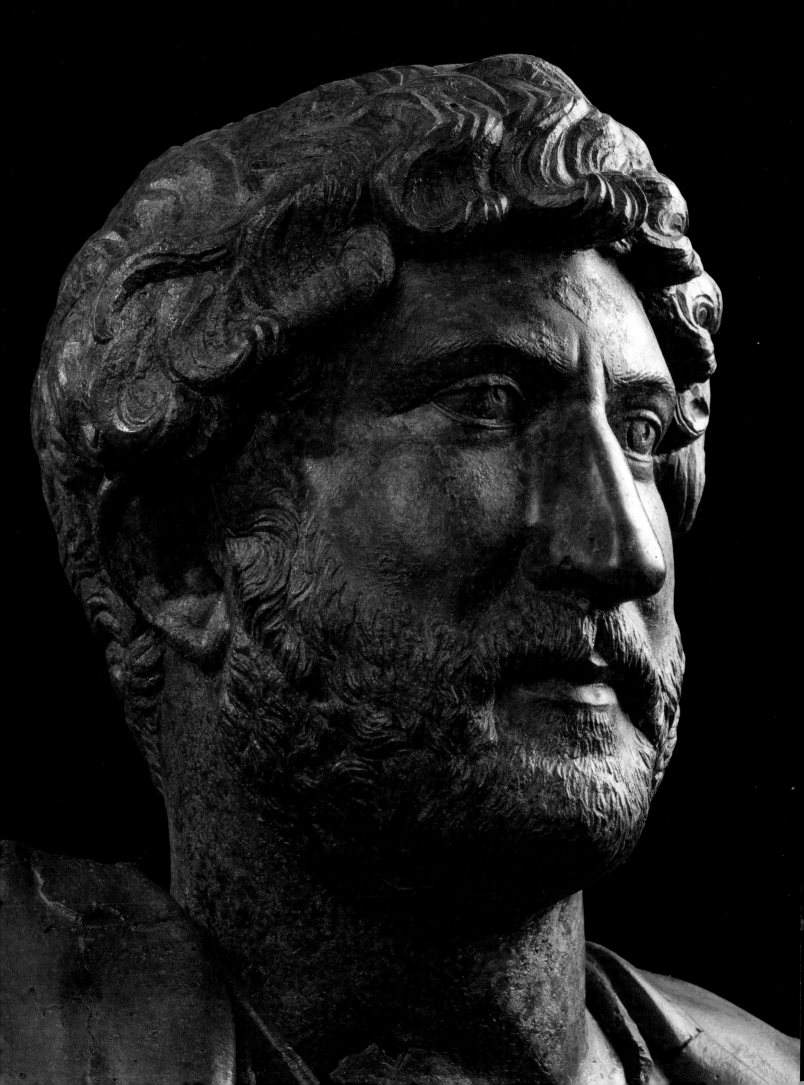

## The Bar Kokhba revolt

If rebellions had overshadowed Hadrian's early reign, worse was to come towards the end. In the province of Judaea in AD 132 the Jewish population rose against Roman rule, taking the occupying power completely by surprise and causing heavy casualties.[40] Spectacular archaeological discoveries have added much material that helps us gain a better understanding of this Jewish revolt. Here, too, we can see Hadrian's legacy; the leader of the Jewish rebels, Simon Bar Kokhba, is alive in Jewish tradition to this day.[41]

Recent research indicates that the revolt was indeed of far greater consequence for the empire than previously assumed, although much of the evidence is still disputed among scholars and, where present-day national identity is concerned, not free from politics.[42] Yet because so much material has survived and because here we can clearly hear the victims' voices, the Bar Kokhba rebellion is not only important within the context of Jewish history, but may stand in for the countless other revolts against Roman rule.[43] This shows a very different facet of Hadrian's character: Romans as perpetrators of extreme violence and destruction, not a civilizing power.

Historical accounts are sparse, but Dio's description, the main Roman source, gives an impression of well-planned guerrilla warfare suddenly unleashed by the rebels, who had set aside arms caches and prepared a network of secret hideouts.[44] Roman forces – two legions and about a dozen auxiliary regiments under the command of the legate Tineius Rufus – were quickly overwhelmed. Reinforcements containing the Third Legion and other units were rushed in from the north by the governor of Syria, Publicius Marcellus, while the Twenty-Second Legion arrived from Egypt, only, it appears, to be wiped out by the rebels. The rebellion soon seems to have spread to other Jewish communities elsewhere, and the rebels were reinforced by incoming supporters as well as non-Jewish allies within the province. It may well be that the neighbouring province of Arabia was affected; its Roman governor Haterius Nepos and his troops were certainly involved in the fighting, either there

**Fig. 74** Hadrian's profile on a Roman coin overstruck with a symbol of the Jewish rebels.

**Fig. 73** Bronze head of Hadrian from the legionary camp at Tel Shalem.

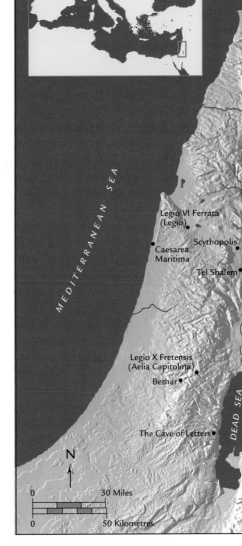

**Fig. 75** Key sites in Judaea and the neighbouring regions during the Bar Kokhba rebellion.

or in Judaea proper. Contemporary documents prove that non-Jewish Nabateans participated in the rebellion.[45]

United under the command of a single leader, Simon Bar Kokhba (a *nom de guerre* meaning 'Son of the Star', which indicates his messianic convictions),[46] the rebels established their own rule in the territory they held. Bar Kokhba took the title 'Prince of Israel' (*nsy' Ysr'l*) and had coins minted that display symbolic and emotive motifs referring to the destroyed Temple of Jerusalem and the ritual associated with it. The rebels declared a new era of the 'Redemption [or 'Freedom'] of Israel' and used it for dating, with documents of the Years One to Four covering the period from March/April AD 132 to autumn 135. Bar Kokhba was supported by the most important Jewish religious authority of the period, Rabbi Akiba, who according to Jewish sources was arrested and put to death by the Romans.

The reasons for the rebellion appear to have been chiefly religious, but religion was of course indivisibly entwined with Jewish cultural identity. It is not entirely clear what exactly triggered the outbreak of hostilities. After the Roman conquest of Jerusalem and the traumatic destruction of the Temple in AD 71, Jews had been forbidden to rebuild their sanctuary. Furthermore, Jews from all over the empire were then forced to send their customary half-shekel offerings for the upkeep of the temple and its associated rituals to the Temple of Jupiter Capitolinus in Rome instead.[47] Hadrian's plans for the extensive rebuilding of Jerusalem as a major Roman colony with the new name of Aelia Capitolina seem to have been an appalling indication that the expulsion of Jewish life from the city was indeed meant to be permanent; a projected massive temple of Jupiter near the site of the Jewish Temple added insult to injury.[48] To this was added a new regulation that outlawed circumcision and thus fundamentally interfered with Jewish customs. Christians, in as far as they refused to cooperate with the rebels against the Romans, were nonetheless treated as enemies, so that all later Christian sources are hostile to the rebel cause and Bar Kokhba in particular.

Hadrian seems to have come to the province personally, although the exact intention for his appearance is unknown. Several inscriptions refer to the war as *expeditio Judaica*, which in Roman terminology indicates the emperor's presence. The governor of Britain, Sextus Julius Severus, an experienced military man, was ordered to Judaea to take charge of operations. Severus took a number of officers with him, as well as further reinforcements. Troop numbers in Judaea were further bolstered by the transfer of sailors (or marines) from the Misenum fleet to the Tenth Legion, probably to make up for heavy losses.[49] Further personnel were urgently conscripted in Italy, an unusual, and probably unpopular emergency measure. It is unknown how many Roman legions were ultimately involved in quashing the rebellion;

**Figs 76 & 77** Defiant symbols of Jewish statehood during the Bar Kokhba uprising: a coin with the façade of the destroyed temple at Jerusalem (above), with the Ark of the Covenant shown in the centre, and an official weight used in the rebel territory (below right).

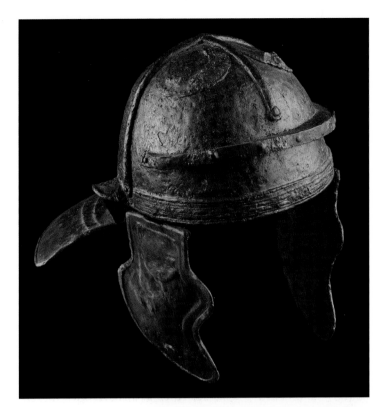

**Figs 78–81** The Roman army in Judaea (from left to right and top to bottom): helmet of a late Trajanic/early Hadrianic type; caltrop (a spiked device that was thrown into the path of enemy horsemen); emblem of Legion X Fretensis; stamped tile from the brickyards of the Legion X outside Jerusalem with the imprint of a soldier's hobnailed footwear.

the minimum number in addition to the province's normal garrison of two should comprise seven legions either in full strength or represented by strong *vexillationes*, or detachments. In reality, the number could easily have been higher, perhaps reaching a total of twelve or thirteen legions, with units from many provinces.[50]

With new forces at his disposal, Tineius Rufus exacted terrible revenge on the Jewish population before he was replaced by Julius Severus, perhaps early in AD 134. Severus turned the war into a slow extermination campaign. In the end resistance was in vain. Bar Kokhba, who had made a last stand at the fortress of Bethar, was killed, and his head cut off and delivered to Hadrian, according to one source. Final Roman victory may not have been achieved until early AD 136. Many of the surviving Jews were sold into slavery.

IMP·CAES · DIVI · TRAIANI · PAR
THICIF·DIVI·NERVAE·NEP·TRAIANO·HADRIANO·AVG
PONTIF·MAX·TRIB·POT·XX·IMP·ĪĪ·COS·III·P·P·S·P·Q·R

**Figs 82 & 83** The monumental inscription on the Tel Shalem arch with proposed restoration (after W. Eck) (above) and the preserved fragments (below and opposite below).

The emperor now accepted his second imperial acclamation from the army, a measure of the intense relief felt, and indeed the gravity of the war just won. Similarly, the most high-ranking officers, Julius Severus, Publicius Marcellus and Haterius Nepos, now received supreme military honours, the *ornamenta triumphalia* (a substitute for the Republican triumph, which during the empire was reserved for the *princeps* alone), while the rank and file were given *dona militaria*.[51] This seems to have been the first time that *ornamenta* were awarded since the Dacian Wars, when Trajan bestowed them on three of his successful generals, a clear measure of the significance of this occasion.[52]

Monuments were set up in Rome to commemorate the victory; the base of a colossal statue of Hadrian dedicated in the Temple of the deified Vespasian and Titus – the first destroyers of the Jews – has survived. It appears that fragments of inscribed slabs discovered near Tel Shalem in the Jordan Valley may have belonged to a large triumphal arch erected to celebrate the Roman victory.[53] In a nearby military camp, built by a detachment of the Sixth Legion to control communication routes in the area, remains of a magnificent bronze statue of Hadrian (figs 46 & 73) were found, and this, too, was perhaps part of the same context.[54] The name of the rebellious province was officially changed from Judaea to Syria-Palestina as further punishment of the defeated and the Jewish population expelled.[55]

**Fig. 84** Military diploma awarding citizenship to a discharged Roman soldier. This is the first known document to use the new name of the province, Syria-Palestina, introduced to punish the rebels and extinguish their memory. This is the only instance of such an action in Roman history.

LEFT
**Fig. 85** Mouth of a cave in a wadi west of the Dead Sea. Caves in this area were used by rebels and the civilian population fleeing the Roman army during the Bar Kokhba uprising.

RIGHT
**Fig. 86** House keys from the Cave of Letters, a potent and eternal symbol of refugees all over the world.

BELOW
**Fig. 87** Leather sandal.

## Cave of Letters

The Romans put down the Jewish revolt with particular ruthlessness: according to Dio, 'fifty of their most important outposts and 985 of their better known villages were razed to the ground. 585,000 were killed in the various engagements or battles. As for the numbers who perished from starvation, disease or fire, that was impossible to establish.' Spectacular finds from caves in the desert wadis west of the Dead Sea, where Jewish civilians had sought refuge from the Roman onslaught, bear graphic witness to the unfolding drama.[56] Of particular importance is the so-called Cave of Letters, where people linked to the leaders of the rebellion had found shelter. Here, letters by Bar Kokhba himself, but also fascinating documents illuminating life in the province before the outbreak of hostilities were discovered.[57]

**Figs 88 & 89** Among the refugees seeking shelter in the cave were many women. Mirror in a case (right) and wooden jewellery box and container (below right).

**Figs 90 & 91** Luxury items indicate the high social status of some of the cave's occupants. The glass plate (right) probably comes from a workshop in Alexandria in Egypt. It is astonishing that such fragile objects were taken to this remote hideout. Items like the bronze *patera* (offering bowl, above) are hard to interpret. The internal decoration is taken from classical mythology (here the nymph Thetis on a sea-monster) and decidedly non-Jewish. Perhaps not all the refugees in the cave were Jews, or attitudes to the use of such items were more relaxed. Or were they taken as booty from the Romans?

**Figs 92–4** Due to the arid desert climate, organic materials from the cave are extraordinarily well preserved. Straw basket, wooden plate, knife and keys with wooden handles, and bronze jugs (above); bronze bowl with string (right); and bronze incense shovel (far right).

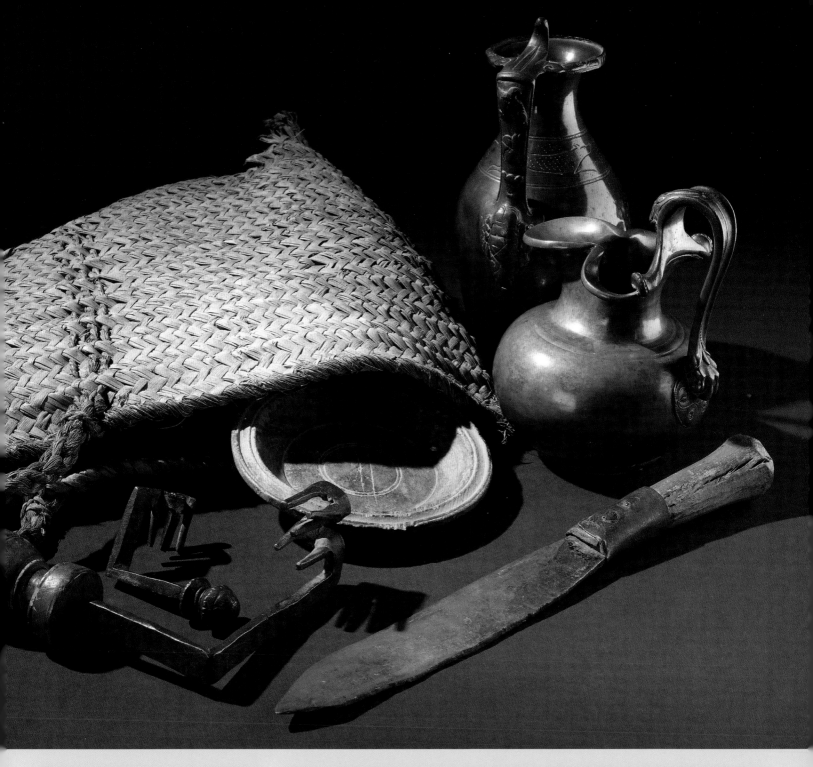

# III  Architecture and Identity

'He built
something
in almost
every city.'

*HA HADRIAN 19.9*

HADRIAN'S reign gave rise to a sustained building boom that encompassed not only the capital of Rome itself, but cities and regions all over the empire. A combination of political and dynastic considerations, as well as a deep personal interest in architecture, ensured that building was one of Hadrian's key priorities.[1]

He was driven by a desire to establish his family permanently as the third imperial dynasty of Rome, worthy successors of the earlier Julio-Claudians and Flavians.[2] More immediately, he also had to live up to the precedent set by Trajan, whose baths, markets, spectacular forum and other buildings had transformed the centre of Rome, so as not to be compared unfavourably with his own predecessor.[3] This may have seemed the more acute, as the military situation did not allow any repetition of Trajan's successes in that arena. Building provided an alternative, and, in consequence, architecture became one of the lasting legacies of Hadrian's reign: it was highly influential in antiquity and has shaped our environment from the Renaissance to the present.[4]

However, when discussing some of the buildings associated with Hadrian, it is always important to see them not merely as great, abstract works of architecture but as monumental backdrops to the life of the Roman people, closely tied to the rituals, assemblies and many other activities that went on in and around them.

In Rome Hadrian completed, restored and commissioned numerous structures. Parts of the city were transformed into a commemorative landscape that strongly affirmed Hadrian's role as Trajan's rightful heir, from magnificent temples to his deified predecessor and other members of the family to Hadrian's own monumental tomb (discussed in more detail in the final chapter). Other monuments, such as the new Temple of Venus and Roma, gave form to his vision of Rome's place in the world in religious terms.

In very practical terms this building activity quite naturally strengthened the cohesion of the empire, especially as far as the highly urbanized eastern provinces were concerned. The new buildings that

PREVIOUS PAGE
**Fig. 95** Pilaster capital from the Pantheon (see fig. 114).

BELOW
**Fig. 96** Map of Rome highlighting the buildings of Trajan and Hadrian.

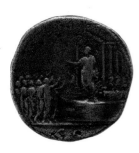

**Fig. 97** Hadrian addresses the people of Rome. The building in the background may be the Temple of the Deified Trajan, one of the first monuments commissioned by Hadrian and key to his assertion of legitimacy.

rose in the capital were partly made of materials imported from the far-flung corners of the empire, particularly high-quality marbles and other precious stones; specialist workmen had even to be brought in from the provinces to cope with demand. This led to a continuous exchange of ideas and designs. Monuments commissioned in the provinces either by Hadrian himself or wealthy members of the local elites in turn reflected what went on in the capital. Much of Hadrian's time spent travelling the empire would have been taken up inaugurating new buildings, and Hadrian could demonstrate favour and largesse to individuals or entire cities by, for example, making available exclusive building materials from quarries under imperial control.[5]

A look at a few selected examples from Rome and the provinces will illustrate how this process worked in detail, while Hadrian's famous villa, a brilliant architectural cosmos of its own, will be discussed separately in the next chapter.

## Hadrian, architecture and architects

There is plenty of external evidence to suggest that Hadrian did not simply follow in the footsteps of his imperial predecessors, but also took a keen personal interest in architecture. This comes not least from the many novel structures built at his Tiburtine villa under his direct patronage and for his own use.

Hadrian was born into a social class whose members routinely commissioned buildings for their own private purposes or were involved in the supervision of building projects while holding high political office. He also lived through a tremendously exciting period in which the urban landscape of Rome was dramatically reshaped and construction technology developed at breakneck pace. The culmination of a 'concrete revolution' in Roman engineering practice allowed the erection of structures never seen before in human history.[6] Capitalizing on this almost uninterrupted flurry of building activity, the elite, including Hadrian's own family, invested in the industry, particularly brick production, which became a great source of wealth in its own right.

When the young Hadrian was born in Rome in AD 76, work was well under way on the great Flavian amphitheatre, or Colosseum, which for many years created a huge building site in the centre of the city. Later he witnessed the construction of many other new monuments as well as extravagant palaces under Domitian, and then the transformation of Rome's city centre under his guardian Trajan. At the same time, other landmark buildings like Nero's vast palace, the Domus Aurea, disappeared – a useful lesson on the powerful impact, but also the sometimes transient nature, of great architecture.

Against this background, it is no surprise that Hadrian became knowledgeable and deeply involved in architectural matters. While not himself an architect or even an amateur architect in the modern sense – the Roman elite considered

**Fig. 98** A miniature marble stadium from Hadrian's villa at Tivoli, perhaps an architectural model.

detailed meddling in such professions as socially unde-sirable (architects had the status of specialist craftsmen) – as a patron he had a keen understanding of architec-tural spaces and probably could conceive basic design ideas, leaving the technical and engineering detail to trained professionals.[7]

Unfortunately, many discussions of Hadrian's rela-tionship with architecture and architects, particularly in the popular literature, have been overshadowed by a sin-gle anecdote related by the late compiler of Cassius Dio's history. It refers to Hadrian's personal connection with Trajan's famous master of works, Apollodorus of Dam-ascus: '*[Hadrian] first banished and later put to death Apollodorus, the architect who had built the various creations of Trajan in Rome – the forum, the Odeon and the baths. The reason assigned was that he had been guilty of some misdemeanour, but the true rea-son was that once when Trajan was consulting him on some point he had said to Hadrian, who had interrupted him with some remark: "Be off and draw your pumpkins. You don't understand any of these matters" – it chanced that Hadrian at the time was making such a drawing. When he became emperor, therefore, he remembered this slight and would not endure the man's freedom of speech. He sent him the design of the Temple of Venus and Roma by way of showing that a great work could be accomplished without his aid, and asked Apollodorus whether the proposed design was satisfactory. The architect in his reply stated first, in regard to the temple, that it ought to have been built on high ground and that the earth should have been excavated beneath it, so that it might have stood out more con-spicuously on the Sacred Way from its higher position, and might also have accommodated the machines in its basement, so that they could be put together unobserved and brought into the theatre [i.e. the nearby Colosseum] without anyone being aware of them beforehand. Secondly, in regard to the statues, he said that they had been made too tall for the height of the cella. "For now," he said, "if the goddesses wish to get up and get out, they will be unable to do so." When he wrote this so bluntly to Hadrian, the emperor ... restrained neither his anger nor his grief, but slew the man. Indeed, his nature was such that he was jealous not only of the living, but also of the dead.*'[8]

First and foremost, the story demonstrates the persistent hostility felt towards Hadrian in senatorial circles long after his reign, for if Dio included it in his history, he must have believed it. Many since have taken Dio's anecdote at face value and linked it to other negative references to Hadrian's character; but, as we shall see, there is much in this story that does not add up (see p. 126) and many scholars now dismiss its historicity altogether.[9] If anything is to be salvaged from Dio's account, it is the fact that it perhaps not unrealistically places the

young Hadrian at important meetings where architectural matters were discussed. The doodles so sharply criticized by Apollodoros are now widely believed to have been amateur sketches of complicated domed structures in the latest concrete technology.[10]

As a consummate politician with first-hand experience of such matters gained under Trajan, Hadrian clearly understood the powerful impact of architecture on the public psyche, and he went on to utilize it to give substance to his vision of an empire united through cultural progress and religious tradition. In addition, he must have been well aware that the extensive building activity in the capital provided employment for vast numbers of the free but unskilled urban poor, and in this sense helped to develop ties of loyalty and stimulate the economy.[11] We can picture him thus, surrounded by a train of architects, engineers and other highly skilled professionals – but in Roman society still associated with the lowly ranks of manual trades – initiating projects, examining plans and drawings, constantly involved, challenging, criticizing and demanding.

The architectural writer Vitruvius described three kinds of graphic depiction of a building familiar to Romans: the *ichnographia*, a ground plan executed on a smaller scale with the aid of rulers and a compass, from which the outlines of the components of the building could later be taken on the building site; the *ortographia*, an upright image of the façade and a depiction of the future building in the correct proportions at a smaller scale; and, lastly, the *scaenographia*, the illusionistic rendering of the façade and the lateral walls following a sort of perspective.[12] Sadly, no such drawings have survived, but a number of reliefs with the depiction of ground plans do exist. Models were also used, although very few are preserved, and it is perhaps no coincidence that one possible candidate should come from Hadrian's villa at Tivoli.[13]

## The Roman building industry under Hadrian

Rome under Hadrian continued to be a gigantic building site, an incessant hive of activity. Romans could witness spectacular new buildings rise before their eyes, as well as events like the removal of Nero's colossus to make way for the new Temple of Venus and Roma (see p. 126). The arrival and transport of building materials such as enormous column shafts from the far reaches of the empire must have drawn large crowds, comparable to those depicted in representations of the removal and re-erection of ancient obelisks from the Renaissance period on. Cranes and scaffoldings marked the skyline of large parts of the city and must have left a strong imprint on the public psyche as a potent symbol of a prosperous future.

A closer analysis of these Hadrianic projects reveals that earlier workshop practices were largely continued, coupled with a frantic increase in volume that

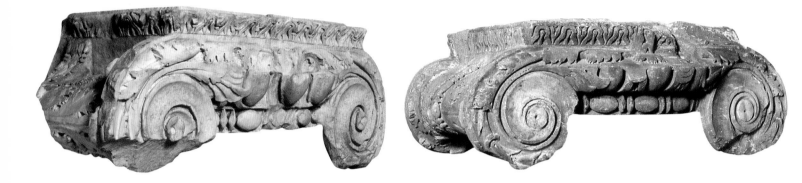

**Figs 99–102** Capitals from Hadrian's villa. Two Ionic capitals of the same design in different-coloured marbles (above) and two Corinthian capitals (opposite above).

soon necessitated a thorough restructuring of the way the building industry was organized, in order to cope with relentless demand. Hadrian may have reformed the system by introducing a strict, central organization along military lines. Such a reform seems to be implied by the writer Aurelius Victor, who says in his Epit-ome de Caesaribus, 'For indeed, on the example of the military legions, he had mustered into cohorts workmen, stone-masons, architects, and, of men for the building and beautifying of walls, every sort.'[14]

Further evidence of organizational structures, given the lack of other writ-ten sources, can be gleaned from the architecture itself. One detailed study, for example, has concluded that under Hadrian three major workshops produced capitals for public buildings in Rome.[15] They appear to have originated during the period of Domitian in the last quarter of the first century AD; a clearly dis-cernible continuation in style over several decades suggests that the workshops existed throughout, probably attached to the imperial administration, and were not assembled from scratch for every single project.

Their output differed in quality; the best workshop produced capitals for the major public buildings of Rome, the other two for lesser buildings and sites outside the capital.[16] The massive Hadrianic building boom not only in Rome but also in Ostia and Tivoli led to an increased demand for decorative architectural elements carved from marble that soon outstripped the capacity of established metropolitan workshops. Masons and carvers from Greece and Asia Minor had to be brought in to satisfy demand.

Work within the individual workshops was highly specialized, and it seems that individual masons worked exclusively on elements like capitals and frieze blocks. Furthermore, individual workshops seem to have concentrated on particular types of marble, sometimes, but not necessarily, reflecting the origin of the carvers. Attic stone workers worked predominantly in Pentelic marble, those from Asia Minor in Proconnesian. On some buildings this division of labour between workshops can be observed in detail, such as the Forum Baths at Ostia, where Attic workmen carved the capitals that were made of Pentelic marble and

**Fig. 103** Frieze with cupids and sea creatures from Hadrian's villa. This was a popular decorative theme and can also be found on Hadrianic buildings in Rome.

a metropolitan workshop crafted the entablatures out of Proconnesian.[17] The greatest metropolitan workshops, comprising large numbers of specialists from all over the empire, seem to have been competent in working all types of marble and were of a sufficient size to be split into smaller units that could work on different sites at the same time.[18]

Further rationalization helped to increase the workflow. The various types of capitals on Hadrianic buildings can all be related to a limited number of basic original designs. This provides an important insight into the planning and execution of the architectural decoration by architects and designers. Basic capital types were individualized and adapted to specific buildings with a limited number of additional decorative elements. The extent to which these elements were added and elaborated was closely linked to the importance and status of the building. The architect only had to fix the basic measurements of the capital in proportion to the height of the building; the workshop could then devise an appropriate variation of the basic model.

The chief designer could ask various workshops to supply different types of capital; master models were then made and copied within the workshop. The head of the workshop was an important middleman, ensuring a swift translation of the design into finished elements. This system also allowed for a certain degree of stockpiling and the production of standard-size blocks in the quarries.

In the AD 120s Proconnesian marble began to be imported to Rome in greater quantity. It seems to have been processed largely by carvers from Asia Minor, who brought their own workshop traditions and style with them. Together with the best metropolitan workshop, they were employed on the most prestigious building projects, underlining the trust placed in their skills. While obliged to work according to metropolitan models, they added small details typical of their own workshop tradition.[19]

## Brick and concrete

The fine marble ornaments carved by specialists in major workshops formed only the most elaborate part of many Hadrianic buildings. At their core were massive walls of brick or brick-faced concrete. Accordingly, brick formed one of the essential building materials of ancient Rome. The brick industry, too, seems to have been regulated during the boom years of the 120s; and it was through the brick industry that the senatorial aristocracy and the imperial family itself became involved in a much more direct, and very lucrative, way in the major building projects that transformed the capital.[20]

Fired or baked brick (*later coctus*), as opposed to sun-dried brick (*later crudus*) seems to have been introduced first under Augustus. The firing process removed the need for bricks to be cured over a two-year period, as they left the kilns dry

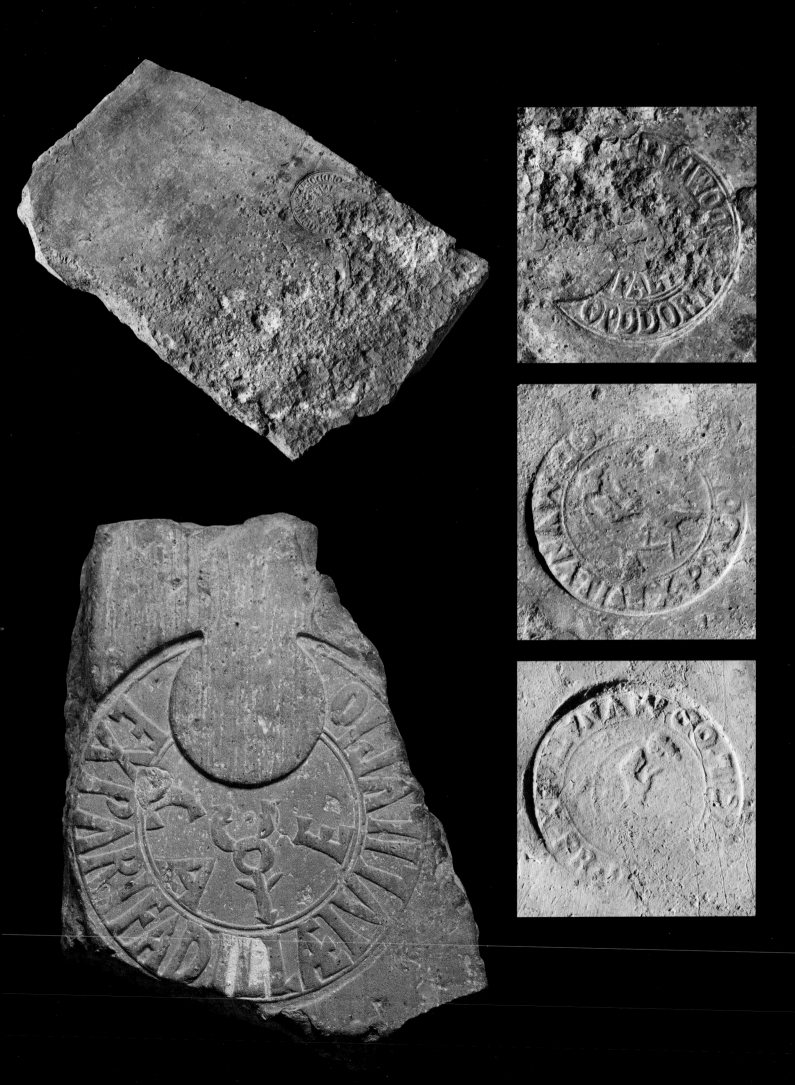

and did not shrink after production. It also meant that the production period itself was not dependent on the weather. Baked bricks were produced in standard sizes: *bipedales* (2 Roman feet, or *c.*59.2 cm long), *sesquipedales* (1 ½ feet, or *c.*44.4 cm) and *bessales* (²/₃ foot, or *c.*19.8 cm). They all could be easily cut down to create smaller standard units. In the heyday of the Roman brick industry, the period from the Flavians to Hadrian, brick masonry was executed with great style, elegance and rarely matched skill.

The massive reconstruction effort after the great fire of Rome in AD 64 seems to have led to a great increase in demand for baked brick, which was met by an ever-expanding, highly sophisticated industry. While this industry can be found throughout the empire, the centre of production coincided with the centre of demand, Rome and the Roman Campagna. On occasion, the remains of kilns and associated production installations have been observed – many, for example were located in the Tiber valley, where proximity to the river afforded easy transport – but above all the evidence for the organization and evolution of the brick industry is epigraphical.

Beginning in the time of Augustus, the bricks were occasionally stamped at the point of manufacture, before being fired. Over the following century the stamps became more and more elaborate and included ever more information. In AD 110 the name of the consuls of that year were included for the first time, thus providing a firm date for the production. What induced the producers to stamp their wares is quite disputed: a sort of much abridged legal contract or perhaps a means of quality control have been postulated.

The stamps carry a complex array of information, much varied and almost never quite complete, but through a painstaking comparison of the information on many hundreds or even thousands of bricks it has become possible to gather an astonishing amount of data, even if some of the ensuing interpretations are disputed. The information thus revealed through the stamps, usually much abbreviated, specifies the type of product, the name of the clay field that provided the raw material or the brickyard responsible for the production (*figlina*), the owner (*dominus* or *domina*) of the estate (*praedia*) from where the clay was sourced, the person in charge of brick production (*officinator*, occasionally also *conductor*), and, crucial for dating, the names of the officiating consuls (*cos(s)*) of the production year.[21]

The practical utility to the modern scholar of a *terminus post quem* provided by the consular date is self-evident and has consequently transformed the understanding of the chronology of many monuments, whether in terms of a construction date or the building phases of a given structure. Obviously, the stamps can only provide a relative date, for it is known that bricks were often stockpiled in great quantity; in periods of great demand new bricks could be supplied to construction sites almost immediately. In other instances much more time may have passed

between production and use. Much depended on circumstances, rendering the search for firm rules rather futile.

Equally important is the information revealed about the social background of the people involved. The wealthy estate owners, a surprising number of them women, often belonged to the highest aristocracy. The data gleaned from the stamps also allows a diachronic assessment of individual brickyards. From this it is apparent that the industry developed rapidly from the time of Nero and the Flavians to the reign of Trajan, and then reached an absolute climax under Hadrian. Under Hadrian, too, some sort of regulatory measure was attempted, for in the year 123 every brick was stamped with the names of the consuls. This may have been initiated by the prefect of the city, Marcus Annius Verus, an influential *dominus* himself as well as a close ally of Hadrian and, surely not coincidentally, a member of the Spanish elite.

The *domini* appear to have owned both the clay fields and brickyards, but left the running of these establishments to subcontractors, the *officinatores*. It is disputed how far their specific involvement reached, whether they simply leased out their clay deposits, thus deriving additional income from their estates to complement that from agricultural and similar produce, or took a more active entrepreneurial role. Illuminating comparisons have been made with the English aristocracy in the eighteenth century and their attitude to the exploitation of coal deposits on their estates. Perhaps not unexpectedly, these varied, and likewise will those of the *domini* of ancient Rome.

Ownership of the *figlinae* passed through generations, and in many cases an increasing concentration in the hands of a few extraordinary wealthy individuals can be observed. Marriage alliances played a role, and it is noticeable that the Spanish elite showed its customary economic astuteness in this field, too. One of the most important *dominae* was Domitia Lucilla, mother of Hadrian's adopted grandson, Marcus Aurelius. Partly because these families were so closely connected, many of the *figlinae* eventually became imperial property.

The other key building material was concrete, in Latin called *opus caementicium*. One of the greatest Roman inventions in the field of architecture, this allowed the rationalization of building processes and opened up entirely new structural possibilities, which were constantly refined and explored further by architects and engineers.[22]

First developed in the third century BC, concrete was mixed together from sand, water, mortar (that is, fired limestone) and small stones. The concrete could then be formed into any shape with the aid of wooden casings and hardened when drying out. Over time, Roman engineers experimented with different aggregates and substituted heavier components in the mix with lightweight volcanic matter, such as lapilli (hardened ash). In this way, much lighter concrete could be produced for even more daring vaulted or domed structures.

## The Pantheon

Few buildings symbolize the lasting triumph of Roman architecture like the Pantheon. With its enduring physical presence in the centre of Rome, it encapsulates both the genius and the surprising flaws of great monuments, as well as the continuing uncertainties among scholars about details of interpretation. For these reasons, the Pantheon merits a central position in any discussion of architecture in the time of Hadrian.

Covered by the largest un-reinforced concrete dome in the world, the Pantheon's breathtaking interior space has awed visitors for nearly two millennia, a fitting symbol for the tremendous innovation of Hadrianic building practice. It is a truly Hadrianic space also in a more practical sense, for we know that Hadrian held court here, an aspect that merits particular attention. The Pantheon therefore is not only one of the most famous buildings of the ancient world, an iconic touchstone for architects ever since, but it also provides the most authentic glimpse of a purpose-built environment in which Hadrian acted on a public stage.

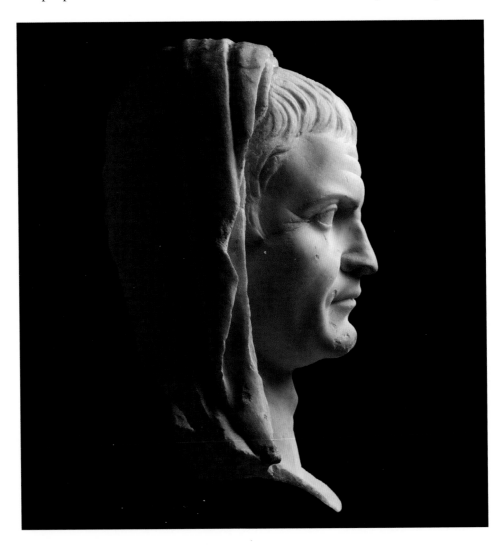

**Fig. 105** Portrait head of Agrippa, son-in-law of Augustus and builder of the first Pantheon.

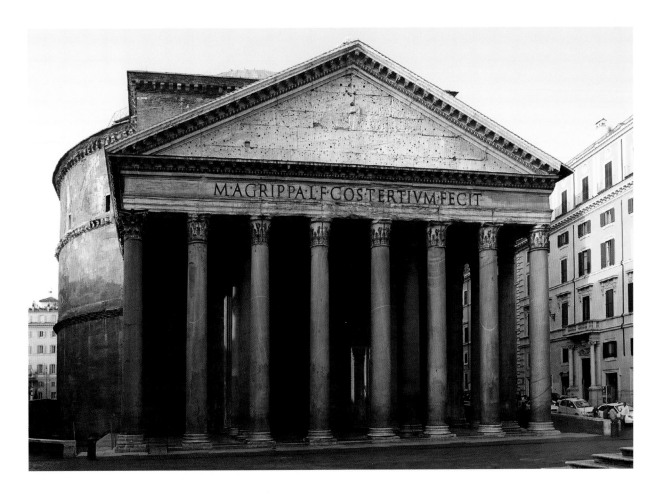

The Pantheon's history was both complex and an important factor in Hadrian's vision for the monument. The building we see today is in fact its third incarnation. Marcus Vipsanius Agrippa, son-in-law of Rome's first emperor Augustus, built the first Pantheon, probably in 27 or 25 BC, but this burned down a century later, in AD 80. Its successor, constructed on the orders of the reigning emperor Domitian, was struck by lightning in AD 110 and also burnt,[23] to be replaced under Hadrian by the version familiar to us now. With carefully calculated modesty Hadrian had the original dedicatory inscription (*Marcus Agrippa L. F. cos. III fecit* – 'Marcus Agrippa, son of Lucius, three times consul, made this') repeated on the new Pantheon's architrave.[24] This confirms the *Historia Augusta*'s statement that Hadrian preserved the names of the original dedicators in his restoration projects, perhaps in part to deflect the fierce criticism levelled at the tyrannical Domitian, who had not shied away from emblazoning his own name on buildings by others that he merely restored.[25] Hadrian's studied act of modesty led to centuries of confusion about the Pantheon's history. For a long time it was thought that the frontal porch of the building was actually part of Agrippa's Pantheon and just the rotunda Hadrianic. Only with the publication of dated brick stamps from various parts of the building in 1892, did it become clear that the current building in its entirety dates to a single construction phase.[26]

**Fig. 106** The exterior of the Pantheon with the dedicatory inscription by Agrippa, as restored by Hadrian.

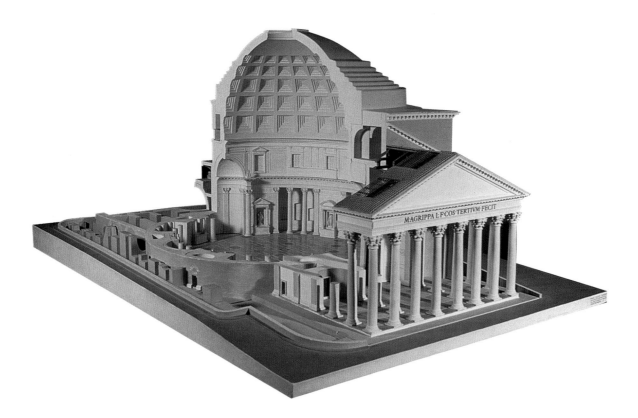

**Fig. 107** Cutaway model of the Pantheon. To the left are the foundations of neighbouring buildings.

Very little detail was known about the shape of Agrippa's Pantheon or indeed its Domitianic successor, making it hard to assess how innovative the Hadrianic building really was. Fortunately, new excavations carried out in 1996–7 have finally provided some clarification and rendered a number of earlier theories obsolete.[27] In short, they seem to demonstrate that the building was orientated north throughout its history and always combined a conventional temple façade with a circular space behind.[28] The front porch of the Agrippan and Domitianic building seems to have been some 10 metres wider than the present one. What mostly set the Hadrianic Pantheon apart, however, was in particular its spectacular concrete dome, an engineering feat that structurally would simply not have been possible before. The earlier buildings probably had in its place a conical wooden roof structure, which might also explain the extent of fire damage.[29] Hadrian's Pantheon thus followed the established ground plan while resulting in an entirely new and, in some details, radically innovative building.

The exact function of the Pantheon defies clear definition. The name itself, possibly a popular nickname rather than the monument's official title, suggests a temple to all the gods. The historian Cassius Dio, writing in the early third century, was already unsure about the exact reasons for the name. He states that among the statues it contained were those of many gods, including Mars and Venus, whom he mentions by name. Agrippa, he continues, had wished to place a statue of Augustus among them and name the building after him; when the emperor refused, he instead set up a statue of Caesar in the interior and statues

**Fig. 108** The interior of the Pantheon seen from the entrance to the rotunda.

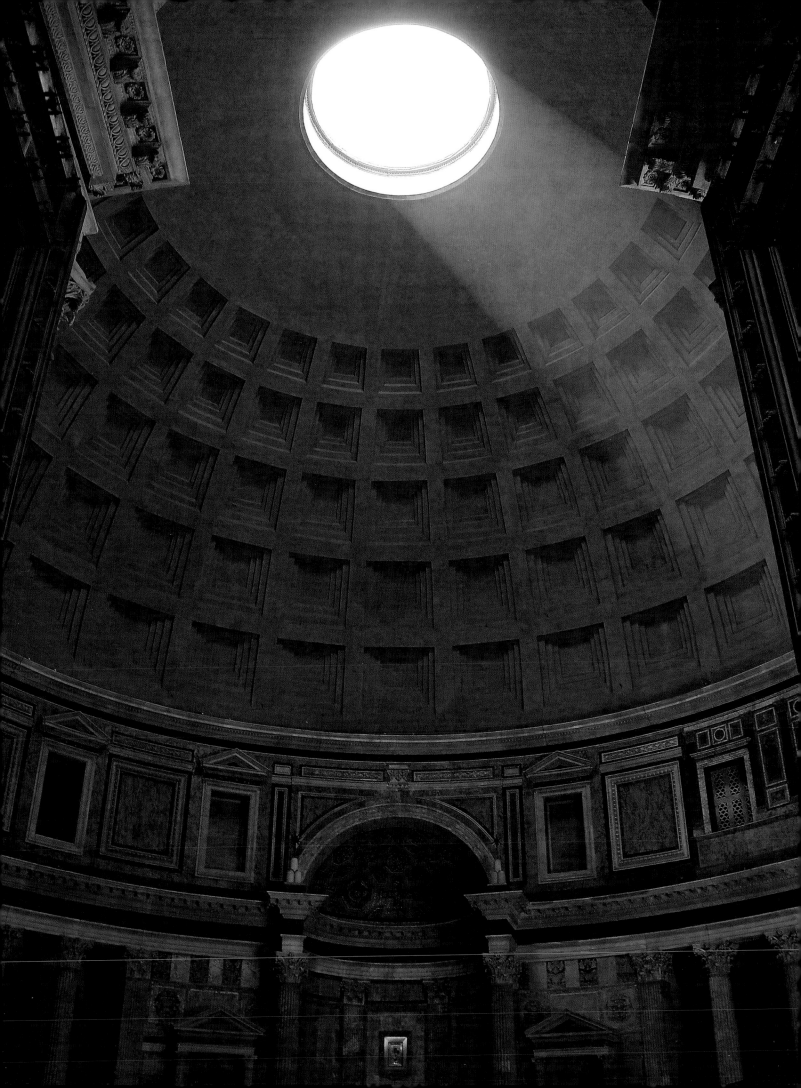

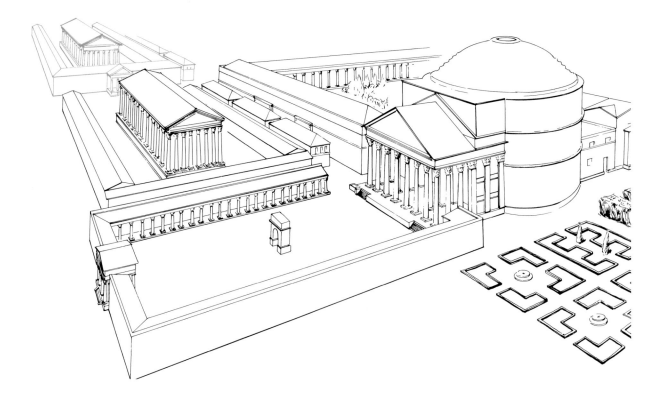

**Fig. 109** Sketch drawing of the Pantheon and surrounding area. The Pantheon was hemmed in by other buildings on all sides, so that it at first appeared like a conventional rectangular temple. To the left is the Temple of the Deified Matidia, and behind that is the Temple for the Deified Hadrian built by Hadrian's successor Antoninus Pius.

of Augustus and himself in the porch.[30] From these sparse remarks it seems that the Pantheon served as a shrine to the family of Augustus with its associated patron deities, not dissimilar to the statue galleries in the Forum of Augustus and in keeping with Pantheia in the Hellenistic Greek east, which showed the kings among the gods. Carved marble friezes on the outside of the transitional block with reliefs showing sphinxes and ritual implements conjure up a suitably religious air. Significantly, the building sits on the same axis as the mausoleum of Augustus whose entrance it faces at a distance of some 7–800 metres. A close connection between the two monuments therefore appears quite logical.

Dio himself thought that the name derived from the building's domed roof, which reminded him of the heavens. Many since have seen a cosmological dimension in the Pantheon's architecture, and indeed ideal and therefore symbolically potent numbers permeate its design.[31]

Re-consecrated in AD 609 as the Christian church of Santa Maria ad Martyres, the Pantheon enjoyed a level of protection that makes it the best-preserved monument of ancient Rome.[32] Yet the seemingly genuine character of the building itself belies the subsequent radical transformation of the surrounding area that once formed an integral part of the complex and determined the way the ancient viewer experienced the space and associated function of the Pantheon. If we reconstruct this wider ancient context, the Pantheon emerges as the crowning glory of a cluster of monuments that celebrated the new dynasty by firmly linking it to the established tradition and demonstrating its ability to marshal the resources of the empire, expressed in the unbelievable extravagance of the

materials used. The Pantheon and the area around it then in a sense appear as Hadrian's urbanistic answer to the Forum of Trajan.

In antiquity the Pantheon was hemmed in by other, contemporary structures on all sides, completely changing its relationship to the surrounding space. The exterior of the rotunda is divided by two horizontal marble cornices; the brick surface one can see now was originally rendered in plaster, perhaps incised to suggest the appearance of masonry blocks, but little of this would have been visible. The only approach and uninterrupted vista was from the north. Here, one entered a rectangular, forum-like square that was paved in travertine and flanked by porticoes.[33] Raised several steps above the level of the square, these porticoes were 4.6 to 6 metres deep. Their column screens consisted of shafts of grey Egyptian granite with capitals and bases of white marble. At the end of the square rose the front porch of the Pantheon. The building first appeared to the viewer as a monumental temple of conventional type, eight columns wide at the front, with a massive gable, its dimensions similar to the Temple of Mars on the Forum of Augustus, which was substantially restored in Hadrian's reign. While due to the rising ground level it is now on the same plane as the modern Piazza Rotonda, in antiquity the Pantheon stood on a wide podium, which was 1.8 metres higher than the level in the square and extended some 4.6 metres forward from the first line of columns. Two rectangular ornamental fountains were located on the square at either end of the podium, and next to them two stairways of seven steps each gave access to the Pantheon's platform.[34]

Crossing the platform, the ancient visitor, just like his modern counterpart, entered a forest of columns. Their colour and material alone told the ancient

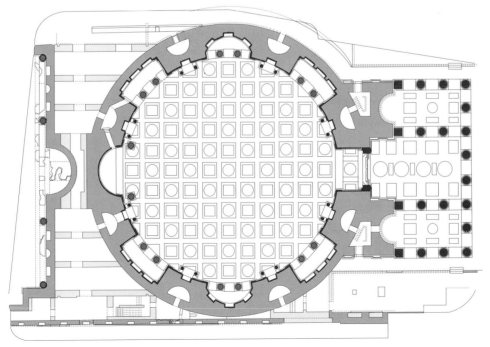

**Fig. 110** Floor plan of the Pantheon.

viewer, imbued in the visual culture of the age, that he was about to enter a building of great significance erected under the patronage of the emperor. The front row of eight columns, with bases of white Pentelic marble from Attica and finely carved Corinthian capitals of white Italian Luni marble, had unfluted monolithic shafts of grey granite quarried at Mons Claudianus in the eastern desert of Upper Egypt (see p. 122). The columns of the two rows behind had shafts of rose granite from Asswan, also in Egypt. Both these quarries were imperial property. The second and third row consisted of only four columns each, arranged so as to form three aisles. The widest, in the centre, leads to the entrance of the building, while the lateral aisles end in two tall semi-domed, apsidal niches that probably held colossal sculptures. Subtle optical refinements, such as *entasis*, a tapering of the columns towards the top, lend the façade its lively dynamism.

The ceiling of the front porch originally had wooden trusses sheathed in bronze that supported a barrel-vaulted bronze structure in the central aisle and flat bronze ceiling coffers along the lateral aisles.[35] As the visitor passes the last line of columns and enters a short corridor leading through the transitional block, nothing prepares one for the enormity and splendour of the space beyond. Through massive bronze doors one enters a vast rotunda lit solely by the central opening of its imposing dome, its floor and walls covered entirely in a wide array of different marbles and other precious stones such as porphyry, arranged in colourful geometric patterns.

The overwhelming, yet deeply satisfying and harmonious spatial volume of this rotunda is the result of perfect geometry. The hemispherical dome sits on a cylinder of equal height, so that doubled it would form a complete sphere within the confines of the rotunda. The architecture here seems like a monumental illustration of Archimedes' famous axiom that a hemisphere and cylinder of the same radius and height have the same surface area.[36]

The eye is immediately drawn upwards to the rotunda's majestic dome. Radiating outwards from the mighty oculus, a central aperture nearly 9 metres in diameter, are five horizontal rings of twenty-eight ceiling coffers each. In antiquity this would have been a glittering canopy to echo the polychrome splendour of the space below, for it is thought that that bronze rosettes were affixed to the centre of each coffer. The coffers themselves, apart from their practical function of lessening the weight of the dome, show the same subtle refinement that permeates the entire building and contributes to its lightness and vibrancy. Their profiles are asymmetrical, with the central field moved towards the upper border, thus ensuring that it is fully visible from the ground. Much speculation surrounds the choice of number; twenty-eight is the number of days in the lunar calendar and might support an even more detailed celestial symbolism expressed in the dome, but here we reach the limits of interpretation.[37]

Opposite the entrance portal is a central apse, flanked by two tall columns

**Fig. 111** The Pantheon's monumental doorway.

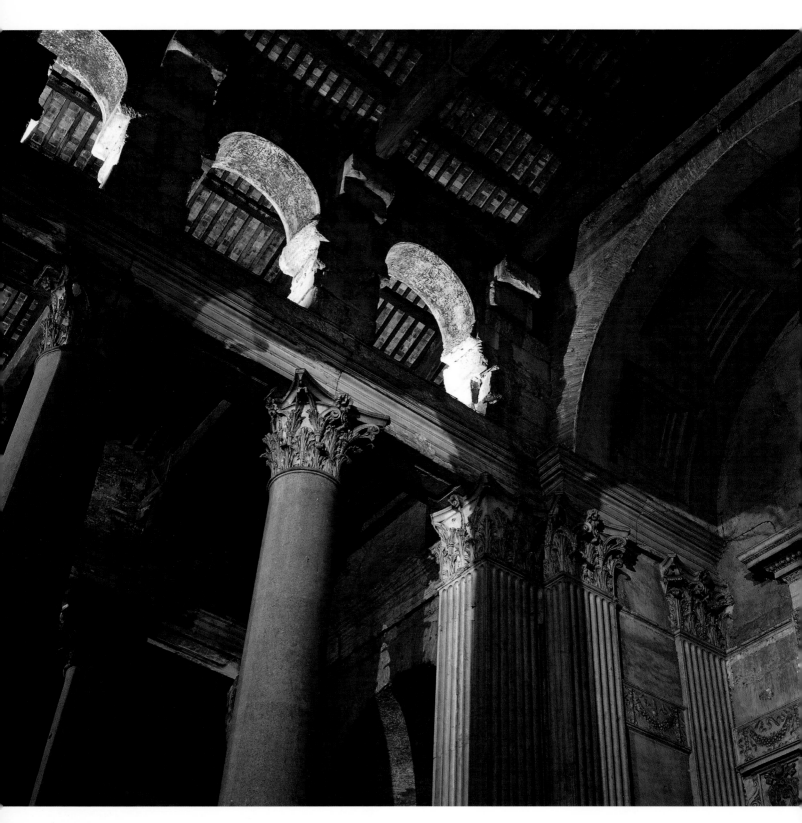

**Fig. 112** Ceiling of the
Pantheon's front porch,
stripped of the original
decorative bronze sheets.

of purple *pavonnazetto* marble. The lateral spaces on either side are pierced by three large exedrae, or niches, each, all screened off from the central space by a pair of columns. The two niches on the rotunda's cross-axis are semicircular, with *pavonnazetto* columns to match those of the central apse; the four niches defining the two diagonal axes are rectangular and have columns in yellow *giallo antico* marble. Between the niches eight *aediculae* – small, raised shrines that appear like miniature temple fronts with two columns supporting a pediment – project from the wall of the rotunda. Here, too, the materials used are exquisite and subtle variations together with carefully calculated symmetries structure the space along a hierarchy of axes. The four *aediculae* flanking the main axis have triangular pediments supported by fluted columns of *giallo antico*, while those on the cross axis have round-headed pediments with unfluted columns of deep red porphyry. A further band of porphyry runs along the rotunda's entablature.

The interior of the drum is thus divided into a lower zone with the main order and an attic zone divided by pilasters with shafts of porphyry between blind windows, related by the proportion of 3:2. Yet curiously, the attic pilasters do not align with either the main order below or the ceiling coffers above, a factor that profoundly disturbed later observers. Drawings by Renaissance architects, consciously or not, changed the arrangement of the pilasters; in the mid-eighteenth century the entire attic zone was finally radically remodelled and the offending pilasters removed. As a result of this intervention, the British Museum has in its collection six of the original Hadrianic pilaster capitals (fig. 114) that were acquired by the eighteenth-century collector Charles Townley. A small portion of the ancient attic was reconstructed in the 1930s. More recently, this break from the monotony of predictable vertical alignments has been seen as an element that adds vibrancy to the architecture and was the result of a conscious choice by the ancient architect.[38] Close analysis reveals that the alignment of crucial elements is restricted to certain main axes (the centre axis, cross axis and diagonal axes), thus anchoring the floor, wall and ceiling decorations at cardinal points but avoiding the empty monumentality of a rigid, overall symmetry.

In Hadrian's time the Pantheon was filled with statues of the gods and members of the imperial family. It is quite possible that their locations were chosen with a special effect in mind; the strong beam of light that enters through the central oculus changes according to the time of day and season, highlighting different parts of the rotunda. Through careful astronomical calculations, this may have been utilized to illuminate specific statues on certain special days, such as feast days dedicated to specific gods, thus strikingly reinforcing their supernatural presence.

Constructing the new Pantheon unsurprisingly proved a highly complex challenge. In terms of structural engineering, it built on existing experience and tested precedents for some of its components, but transformed them into some-

thing completely new, on a scale never seen before. The brick walls of the transitional block and rotunda conceal what is otherwise a structure made entirely of concrete. The entrance passage and apse, together with the six lateral exedrae, create substantial voids in the wall of the rotunda, leaving the eight thick sections between them as the building's principle support pillars. Additional, half-moon-shaped voids were inserted into these sections to further lessen the weight of the structure. A system of brick arches set into the curved wall, now clearly visible on the outside of the rotunda, helped to distribute the dome's weight evenly onto the main supports.

The dome remains as the unsurpassed engineering masterpiece of its kind. It forms the culmination of a period of rapid technological advance. With a diameter of 43.3 metres – twice as large as any earlier known dome – it provided an awesome structural challenge. Scholars are divided on how exactly the construction process was organized; as the dome was made of a complex aggregate of moulded concrete and had an estimated weight of 5000 tons, it required substantial and very robust wooden centring on a scale not attempted before.[39] The wooden centring frames needed to be some 26 metres long to span the distance from the spring of the dome to the edge of the oculus. This is close to what has been calculated for the apsidal ends of the Basilica Ulpia, completed under Trajan not long before, but now had to be applied to a complete dome rather than just a semi-dome. These frames would have been supported by a very tall, wooden central tower or, alternatively but perhaps less likely, by a central ring around the oculus that would have dispensed with any need for ground support.[40] A central tower would also have provided a convenient means of lifting material up and down to where it was needed. Both the tower and the centring would have required immense quantities of high-quality wood of great structural strength. From these observations alone it is evident what a great number of workers were required here, from engineers and specialist carpenters to scores of manual labourers to move materials.

It appears that the rotunda was built first, followed by the transitional block and portico.[41] A number of inconsistencies in the transitions between these elements have long troubled students of the building. There is a curious ghost of a second pediment on the face of the transitional block, higher up on the building

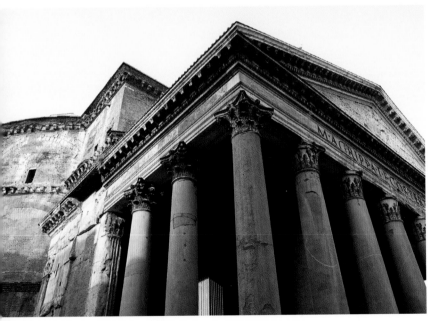

**Fig. 113** Exterior of the Pantheon. The frieze of the front porch and the central frieze of the rotunda do not align.

Fig. 114 One of the pilaster capitals from the interior of the Pantheon, removed in 1747.

than the portico pediment and partly obscured by it, but otherwise of the same dimensions. Unusually, the columns and cornice of the front porch and transitional block do not align with the cornices on the rotunda's outer wall. A recent study, which has since found wide acceptance, suggests that the plan of the portico had to be changed due to logistical problems with the supply of the columns while work on the Pantheon was in full progress.[42]

As stated earlier, the shafts of the columns supporting the Pantheon's portico are made of two types of rare Egyptian stone: those across the front and down the sides of grey granite from Mons Claudianus and the inner two rows of rose granite from the Asswan quarries. They are 40 Roman feet (c. 11.8 metres) tall and monolithic, that is, made of a single piece of stone rather than a number of superimposed drums. It appears from a number of detailed observations, however, that the initial design envisaged monolithic shafts even taller, at 50 feet (c. 14.8 metres). The Pantheon's pediment, for example, is unusually heavy for columns of the present height and diameter, and the columns are spaced further apart than one would expect. Taller and thicker columns would have been more suitable.

**Fig. 115** The harsh desert landscape of Mons Claudianus in Upper Egypt, where the Pantheon's columns were quarried.

The great effort expended on extracting and transporting monolithic shafts of this enormous size, suggested a mastery of resources that greatly enhance the prestige of a building and its patron. The weight of a 50-foot shaft has been estimated at 100 tons, stretching Roman transport technology to the limit. With the quarries at Mons Claudianus in the eastern desert of Upper Egypt, this posed a considerable challenge. The columns had to be transported through the desert some 100 km west to the Nile and loaded onto special barges that could only sail during the few months when the waters of the river afforded sufficient depth. On reaching the delta, they had to be trans-shipped onto massive, sea-going vessels, specially constructed *naves lapidariae* or stone transports, exposed to the constant risk of shipwreck.

While several such colossal shafts had been used previously in Trajan's Baths and, at about the same time as the Pantheon was built, for Hadrian's Temple of the Deified Trajan, a sudden logistical impasse seems to have led to an acute shortage of 50-foot shafts just when they were required for the Pantheon, forcing a re-design of the porch in mid-build.[43] Evidence from Egypt provides a vivid impression of the effects that this increased demand for building materials in the distant metropolis had locally. A papyrus letter describes the challenges of transporting a 50-foot column through the desert in the third year of Hadrian's reign, just when the Temple of Trajan and the Pantheon were built.[44]

The material for the Pantheon was delivered to the wharfs on the Tiber close to the Mausoleum of Augustus. Such was the amount of building activity that the area immediately adjacent to the mausoleum was given over to the building huts and marble workers. Here, scratched into the travertine paving stones of the open square in front of the tomb, archaeologists discovered what appears

to be the original plan of the Pantheon's gable and, in all likelihood, one of the capitals originally intended to crown a 50-foot shaft.[45]

With two major building projects simultaneously requiring monolithic shafts of 50 feet, major supply problems seem to have occurred. In the end it may have been decided for political reasons to complete the Temple of Trajan to this design but revert to more easily obtainable 40-foot shafts for the Pantheon.

In other respects, too, the Pantheon was calculated to impress through sheer size: the threshold of its portal might be the largest piece of Africano marble in existence, just as its entrance cornice, with a length of 8.6 metres, is the longest block of Pentelic marble known and perilously close to the maximum structurally possible for this type.[46]

The coloured marbles and other stones used for the Pantheon's decoration were the best available and sourced from all over the empire: porphyry and granite from Mons Porphyrius and Mons Claudianus in Egypt, Africano from Ionia, *giallo antico* from Numidia (Tunisia), *pavonazetto* from Phrygia, serpentine (green porphyry) from the Peloponnese, *verde antico* from Thessaly. White marbles came from the Pentelicon quarries in Attica, the Proconnesos and Luni.

Some scholars have suggested that the design of the present Pantheon and possibly the beginning of its construction fall into the last years of Trajan's reign and that its radical interior plan is the work of the architect Apollodorus.[47] The links between some aspects of the Pantheon's design and engineering practice and earlier Trajanic projects are indeed strong and obvious. At any rate, it is perhaps not unlikely that initial plans and concepts for the rebuilding of the damaged monument were drawn up soon after the catastrophic fire of AD 110; even the ordering and stockpiling of materials may have been initiated. The designing master may therefore have been Apollodorus or any member of his team familiar with the earlier projects; surely it was not Hadrian himself. In the end, however, it would have fallen to Hadrian, and no one else, to endorse or select any plans that had been worked up and make them fit his vision.[48] This seems particularly pertinent when the wider area is taken into account and the way the new buildings there may have been linked to the new Pantheon's intended function.

Already in Agrippa's time, the Pantheon was only one of several important structures built by him in this area. Immediately to the east, its west wall directly abutting the Pantheon rotunda's outer perimeter, was the Saepta Iulia. A vast square 120 metres wide and 310 metres long, this had been Republican Rome's main voting precinct. Surrounded by porticoes on all sides, its northern façade was in line with the front of the Pantheon. Following Agrippa's rebuilding of the complex (completing a project started by Julius Caesar), its political functions soon became obsolete and it turned into an upmarket shopping district and a grand public square full of famous works of art.

Immediately south of the Pantheon is a building commonly identified as the Basilica of Neptune; further south were baths, also constructed by Agrippa. Other large baths, dedicated by Nero, stood north-west of the Pantheon, immediately behind the western side of its colonnaded forecourt. With the exception of the Baths of Nero, Hadrian had all these buildings restored and, as with the Pantheon, this often seems to have implied rebuilding them from the ground up.

In addition to these 'restoration' projects, a very important new building complex was constructed north-east of the Pantheon. This was a massive temple dedicated to Hadrian's deified mother-in-law Matidia, who died in AD 119, flanked by satellite structures and deep, two-storey porticoes on either side that came to be known as the basilicas of Matidia and Marciana.[49] Hadrianic medallions show the façade of the temple and basilicas; a few isolated column drums of fine green cippolino marble that have survived in the area suggest that its columns were up to 17 metres tall, taller still than those of the Pantheon. Work on this monumental and magnificent temple precinct must have progressed at speed and in parallel with construction of the Pantheon. If the area previously had been closely associated with the family of Augustus, it now took on a distinctly Hadrianic flavour, celebrating the new Spanish dynasty.

With this in mind, it may not have been a coincidence that Hadrian chose to hold court in the new Pantheon. The prominent band of porphyry running round the interior is perhaps an indication of the special character of the space, and links it to the presence of the emperor and his family. In this way the Pantheon, too, served as a splendid performance space for the imperial court ritual. According to Cassius Dio, Hadrian held public audiences there, seated on a tribunal and surrounded by his most eminent advisers.[50] The huge celestial dome set the emperor into an almost cosmological framework. The splendour and rarity of the building materials, the coloured marbles and other stones in particular, reinforced the sense of Rome's physical dominance of the globe, while the statues of the gods of the Graeco-Roman pantheon underlined its theological destiny at the pinnacle of the ancient world, with Hadrian as the legitimate heir to its most able rulers, the great Augustus foremost among them.

LEFT AND RIGHT
**Figs 116 & 117** Remains of the so-called Basilica of Neptune immediately to the south of the Pantheon, with a detail of its splendid marble frieze (left). It was one of the many buildings in the area restored by Hadrian.

## The Temple of Venus and Roma

If the Pantheon's architecture was distinctly Roman in character, Hadrian's next great project, the double temple of the goddesses Venus and Roma, was even larger in scale and transplanted Greek architectural forms into the centre of Rome.[51]

By far the largest such building in the city of Rome, the Temple of Venus and Roma with its associated cult and festival was intended as the focus of a new state ceremonial reflecting Rome's origins and glorious achievements. Not only was the combination of the two goddesses unusual, but such an explicit worship of Roma in her own city and on such a scale had little precedent. Hadrian appeared here as a new Romulus, the founder of the city, while the architecture provided a spectacular backdrop for events involving the entire populace, jointly reaffirming a common identity.

The temple's location, on the Velian Hill at the eastern end of the forum, just north of the Sacred Way, was symbolically charged: here the vestibule of Nero's infamous Domus Aurea had stood. To make way for the new temple, Nero's colossus, a 30-foot bronze statue of the sun god Helios, had to be moved, a complex feat that required the services of twenty-four elephants and was supervised by the architect Decrianus.[52] His colleague Apollodorus, in turn, was asked to design a new complementary statue of the moon goddess Luna.[53]

The temple precinct stood on a massive artificial platform of 145 by 100 metres and visually dominated its surroundings. Incidentally, all the elements concerning the substructure supposedly put forward by Apollodorus are in fact in place, including vaulted chambers opposite the Colosseum.[54] From the few dated brick stamps recovered from the building, it seems that construction started in the mid-120s and was not completed until a decade later; the precinct itself was consecrated much earlier, in 121. The occasion appears to have been the traditional festival of the *Parilia*, celebrated on 21 April, which Hadrian henceforth turned into the *Romaia*, an opulent commemoration of the foundation of Rome. Coins struck to commemorate the event proclaim a new Golden Age, the *saeculum aureum*; lavish games in the circus accompanied the inauguration of the precinct and commencement of building works, which would last for a long time. It is possible the final completion of the monument fell under Hadrian's successor, Antoninus Pius.

A fire in AD 307 severely damaged the Hadrianic temple; much of what can now be seen is the result of rebuilding by Maxentius that considerably altered the monument. The original temple rose on a continuous *crepis* of seven steps in the Greek manner. It had ten columns along the short and twenty columns along the long sides. Recent research suggests that it was a *dipteros*, surrounded by two rows of columns along the sides and

**Fig. 118** Coin thought to represent the façade of the Temple of Venus and Roma.

three along the fronts, thus directly copying models from the Greek east, in particular the huge Temple of Olympian Zeus at Athens.[55] These columns were of Proconnesian marble.

In its centre was a massive double cella; almost square in plan, each cella measured some 25.7 metres. The eastern one probably housed the cult statue of Venus, the western equivalent that of Roma. Along the sides of each cella ran low podia that supported eight columns on either side, probably with a second order superimposed on the first. Lateral doors may have provided access from one cella to the next.

The mouldings of the temple's entablature, carved from Italian Luni and eastern Proconnesian marble, seem influenced by buildings in Asia Minor and specialist carvers from there may have been brought in to work on the building.[56]

Along the long sides of the platform ran two porticoes, or possibly open colonnades, of grey granite columns, broken in the centre by a propylon-like wider pavilion of *cipollino* columns. A wide staircase gave access to the temple platform from the west, while on the east two-flight corner staircases led up from the square in front of the colosseum.

## The provinces

Hadrian's activities were by no means restricted to the capital. Many places in Italy and the Greek east, but also the western provinces, equally saw an architectural Renaissance, often closely supported or even initiated by the emperor.[57] Especially in the east, the major cities actively vied for the emperor's attention. Hadrian's extended journeys (see map, p. 20) provided a constant means to inspect, instruct and build; and many monuments seem to have been constructed in anticipation of his visit. A contemporary, Cornelius Fronto, consequently wrote that one might 'see memorials of his [i.e. Hadrian's] journeys in most cities of Europe and Asia'.[58]

Hadrian's desire to strengthen traditional religion is evident in the numerous temples and religious buildings he commissioned or restored all over the empire. These comprised anything from ancient rural sanctuaries and local shrines to massive new temples, such as the colossal Temple of Zeus at Kyzikos in Asia Minor. Engineering and infrastructure projects, especially new roads and water supplies, extended the benefits of Roman civilization throughout the provinces.

All these projects helped to spread prosperity, tie the local urban elites to the emperor and ultimately to achieve a cultural unity throughout the empire that provided a strong sense of purpose and common destiny. Politics were never far away, as a brief look at three selected examples – Athens, Cyrene and Italica – may demonstrate.

**Fig. 119** Plans of the Temple of Venus and Roma in Rome (top) and the Temple of Zeus Olympios in Athens (above).

## Athens

Hadrian intended Athens to be the magnificent new spiritual centre of a revitalized Greek east that would serve as a bulwark against Rome's barbarian foes and less loyal subject populations. To this end, he destined the city to be the seat of a newly founded league of Greek city-states, the Panhellenion.[59] Architecture played a key part in the realization of this grand vision. Athens received imperial largesse on an unprecedented scale and was physically transformed, even more so than Rome. What had been a sleepy university town and picturesque heritage site full of classical monuments was turned into a gleaming stage where the Greeks could pay homage to their ruler.[60]

Ancient authors, like the second-century Greek travel writer Pausanias, give a first-hand account of Hadrian's benefactions in Athens, and many others are known through epigraphic sources. Hadrian was of course thoroughly familiar with the city, which he had visited on several occasions. Among his most ambitious projects in Athens was the completion of the Temple of Zeus Olympios, the supreme god of the Greek pantheon. This very large temple had been begun in the distant past (sixth century BC) by the Athenian tyrant Peisistratos but soon abandoned. In the second century BC the powerful King Antiochos IV Epiphanes of Syria had resumed the project under the direction of the Roman architect Cossutius, but again it remained incomplete. In the early first century BC the Roman general Sulla removed some of the interior columns to Rome, to be used in the reconstruction of the damaged Temple of Jupiter on the Capitoline.[61] Hadrian, finally and in record time, had the temple finished and lavishly decorated with a colossal cult statue of a seated Zeus made of gold and ivory, a feat that gained him immense prestige with his Greek constituents. A massive structure of ten by twenty Corinthian columns in double rows, the new sanctuary also seems, as we have seen, to have inspired the Temple of Venus and Roma in Rome (see fig. 119). The completed building was officially dedicated in Hadrian's presence in AD 131/2; Antonius Polemo, the leading Greek orator of the time, delivered a celebratory address to the assembled festive crowd.[62]

Other new buildings in Athens included the splendid, though not yet firmly identified headquarters of the new Panhellenion.[63] Hadrian also dedicated a Temple of Hera, a new library and a basilica-like building on the city's historic main square, the agora. Further structures included a new water supply and an entire new district of the city, of which a grand entrance gate remains. The Athenians in turn accorded Hadrian unprecedented honours, worshipping him as 'Olympios' and thus likening him to their supreme god, Zeus.

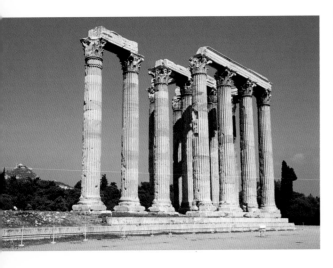

**Fig. 120** Temple of Zeus Olympios, Athens.

## Cyrene

In other provinces Hadrian had to address recent disasters. On his orders the Cyrenaica, the region around the Greek city of Cyrene in northern Africa that had been devastated by the Jewish revolt in AD 115, was substantially resettled and rebuilt, earning him the titles of 'founder' and 'saviour' in the city's public inscriptions.[64] The dedicatory inscriptions of the newly restored buildings clearly hint at the violent storm of the recent Jewish uprising, with unusually explicit references to the 'wrecking, burning, overthrowing, breaking up, plundering and destruction' caused by the rebels.[65]

Among Hadrian's first projects was the repair of a major road linking Cyrene with its port Apollonia, 19 kilometres to the northeast. This had been much damaged by the Jews, who had carved a menorah into the road surface as a proud symbol of their defiance. Next he restored a bath complex, perhaps one that had been dedicated by Trajan earlier, reasserting in the process the Roman imperial and cultural presence in the city, for great bath buildings of this type had been one of the most successful Roman architectural exports and a subtle agent of Romanization.

The restoration of other temples and shrines followed, with prominent local citizens playing their part in the reconstruction effort. Hadrian also included Cyrene in the new Panhellenion league, further proof of his wider strategy.[66] His subsequent decision to found a Roman veteran colony, Aelia Capitolina, to take the place of the Jewish capital of Jerusalem (see p. 90), seems in part to have been inspired by a desire to exert tight control over the Jews, so as to make a repeat of the catastrophe that had befallen Cyrene and other eastern cities impossible.

## Italica

While the main focus of Hadrian's building activity may have been on Italy and the Greek east, both highly urbanized and economically prosperous, he also lavished attention on the old ancestral home of his family, the city of Italica in Spain. An entire new quarter of the city, larger in size than the existing old town, was laid out in an orthogonal grid, with porticoed streets that linked wealthy residences and monumental public buildings and squares. In the process, building materials as well as the latest designs from the urban centres of the eastern empire were introduced. The new amenities included an amphitheatre with a seating capacity of 25,000 as well as vast baths and a new water supply. The crowning element, on a summit overlooking the city, was a large precinct for the imperial cult, the so-called Traianeum, for which precious marbles were imported from Italy and Greece. Although Hadrian did not visit Italica again when he was emperor, he thus proved himself as a generous benefactor and enhanced its local prestige by granting it the elevated legal status of a Roman *colonia* under the new name of Colonia Aelia Augusta Italica.[67]

# IV

## Hadrian's Villa

*'His villa at Tibur
was marvellously
constructed, and he
actually gave to parts
of it the names of
provinces and places
of greatest renown ...'*

*HA HADRIAN 26.5*

A LMOST immediately after his accession, Hadrian made plans for the creation of a substantial country residence in the foothills of the Tiburtine Mountains outside Rome. The result, after less than twenty years of major building activity, was the largest villa known from the Roman world (see fig. 127).[1]

An extensive palace and alternative seat of government, the villa appeared almost like a small city, to some perhaps even like the empire in miniature. Daring experiments in the design and construction techniques of its buildings turned the site into a vast architectural playground, with some structures that had no equal in the ancient world. Through the richness of this built heritage and the splendour of its decor, the villa not only shaped the way the inner circle of the Roman elite viewed Hadrian and his vision of empire, but in the centuries since it has become one of the seminal places for the evolution of art and architecture and the nascent disciplines of classical archaeology and art history.

The scale of the villa is staggering. Its known structures alone comprise some 900 rooms and corridors.[2] They provided a finely nuanced network of public, semi-public and private spaces for different purposes. The grounds of the villa accessible today alone cover some 40 hectares, but it is estimated that the estate originally comprised at least 120, even if its exact perimeters are still not known. The peripheral areas of the site are still largely unexplored, while many centrally located buildings have only been partially excavated. Even small interventions carried out now can therefore radically alter our understanding of individual structures and the villa as a whole.[3]

PREVIOUS PAGE
**Fig. 121** Black and white mosaic from Hadrian's villa (see also fig. 133).

BELOW
**Fig. 122** View of Hadrian's villa from the large east–west terrace ('Poecile').

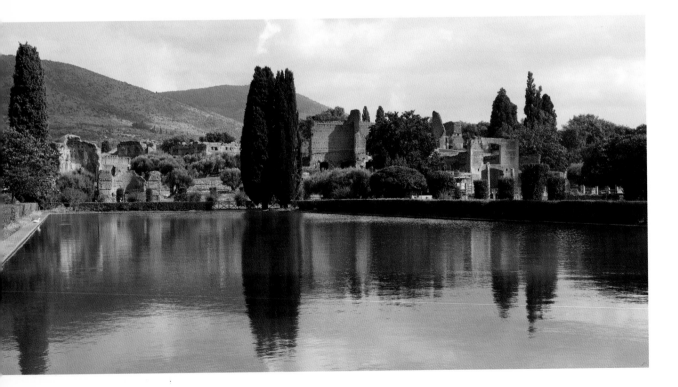

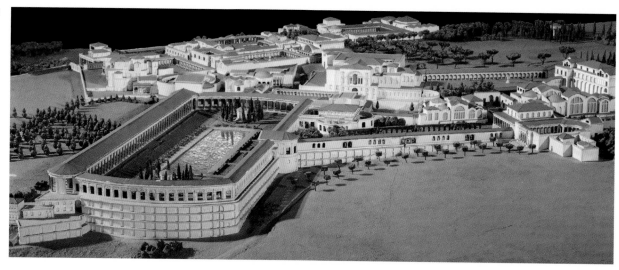

There are many ways of studying the site and its rich heritage. One is to regard the villa as a living microcosm of the empire, a prominent stage on which some of Hadrian's key policies and beliefs were played out.

## Site of the villa

Located some 28 kilometres to the east of Rome, in the middle of the countryside but within easy reach of the city, the villa occupied a position that could hardly be bettered. It combined a splendid landscape setting with an extremely fortuitous local topography and excellent infrastructure network.

The area extended over a long tufa plateau bordered by small valleys to the east and west that contained two streams and provided lush surroundings. North of the plateau these combined into a single stream that soon after flowed into the nearby River Aniene. The terrain sloped gently from south to north, ensuring good drainage and straightforward hydraulic logistics if water was brought in at the highest point in the south-east. The water supply itself was greatly facilitated through the vicinity of aqueducts that carried water from the Aniene river to the city of Rome and could be tapped through newly built branch lines for the villa.[4] The area also had good exposure to sunlight and the prevailing winds; a sanctuary not too distant provided healing, sulphurous waters.

A major road, the Via Tiburtina, passed along the site's northern perimeter. This provided a convenient link to the city of Rome and the nearby town of Tibur. Further access was provided by the River Aniene, at the time still navigable by barges, which allowed bulk supplies and building materials to be brought in. In addition, some of the key raw materials could be sourced on site, a great advantage given the enormity of the construction effort. Clay and pozzolana sand came from the southern fringes, travertine and tufa from nearby quarries, while local limestone provided lime.

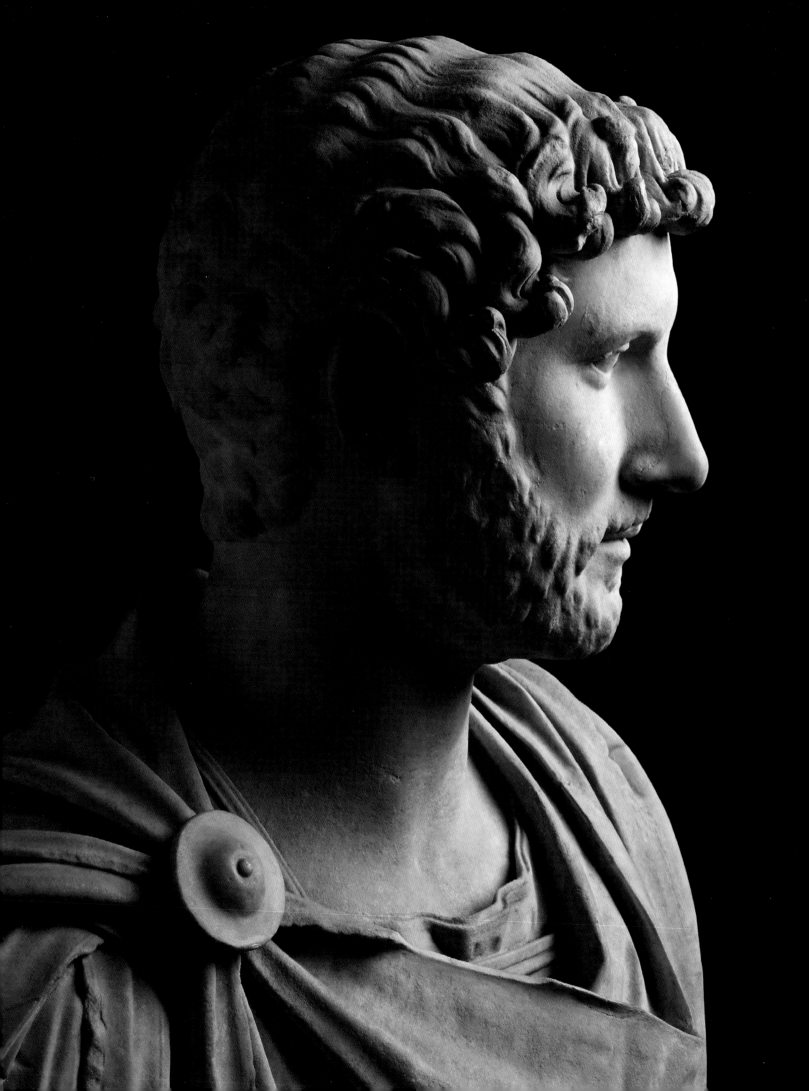

It seems that the vast grounds of the villa had largely been in the hands of one single proprietor. This was somewhat unusual, since the area had long been one of the favourite haunts of the Roman elite and was otherwise densely populated with villas.[5] Remains of a single, substantial Republican-period villa were located to the north of the plateau. Under Hadrian they were extensively rebuilt and formed the nucleus of the new complex. Unfortunately, it is not known who the owner of the villa estate before Hadrian was.[6] Both the *gens Vibia*, the family of Sabina, and the *gens Aelia*, the family of Hadrian, have been suggested. There is some evidence that the wider area was particularly popular with members of the Spanish elite, which may have been an additional attraction for Hadrian or at least have made him thoroughly familiar with the location early on.[7] Hadrian's father, a Roman senator himself, may have had a property in the area.[8] An estate in the nearby San Stefano Hills, near the villa's southern perimeter, has been tentatively associated with the Vibii Vari, relatives perhaps of Sabina. Existing family holdings in this popular area would certainly have facilitated the creation of the large, unified estate on which the villa was eventually built; otherwise, lands would have had to be expropriated on a substantial scale with all the problems this entailed.[9]

## Imperial precedents

With the erection of this vast villa, Hadrian followed an established tradition of the Roman emperors since Augustus that was motivated by social convention and programmatic considerations rather than practical need. A new reign thus almost inevitably saw the construction of new imperial villas that, whether intentional or not, closely reflected the incoming emperor's concept of rule.

Hadrian's predecessor Trajan had built several new country residences. One was located near Arcinazzo, in the upper valley of the River Aniene. This site, currently under excavation but not mentioned in the ancient literary record, was ideal for hunting.[10] Another was near Centum Cellae, on the coast north of Rome, and originally built so that the emperor could closely supervise work at the new nearby port, while continuing to carry out all the work associated with government in a relaxed setting.[11] The letters of Pliny the Younger, consul in AD 100, a frequent guest at Trajan's villa, vividly describe the life in these surroundings. Hadrian would presumably have known both places well, and as a young man he may have visited Domitian's immense estates at Albano and other places.

While Hadrian inherited his predecessors' villas as part of the imperial property, he nonetheless at once set about planning his own new country residence, and the speed and scale of construction there suggest a great sense of urgency, a desire finally to put into practice a long-held dream, now that the resources connected with imperial power had become available.

**Fig. 124** Bust of Hadrian in military dress. This was one of the many portraits of the emperor and his family found at the villa.

Crucially, the new site provided the space needed to develop these ideas, which would not have been possible in the densely built-up urban fabric of Rome, and at the same time it was free from any structures associated with the tainted memory of past rulers, such as Nero and Domitian, that might otherwise have been hard to overcome. Consequently, from the Renaissance on, this vast estate has come to be known simply as 'Hadrian's villa'. After all, its size and mention, albeit brief, in Hadrian's biography in the *Historia Augusta* suggest an absolute pre-eminence among the emperor's residences. In antiquity the site was referred to more simply as *villa Tiburtis* or *villa Tiburtina*, named after the neighbouring town of Tibur, the modern Tivoli.[12] The far more neutral ancient name hints at the important fact that despite its enormous scale the Tiburtine residence was by no means Hadrian's only villa. In fact, Hadrian's favourite retreat, according to the writer Philostratus, was at Antium.[13] Further imperial properties kept in use by Hadrian were located on the Bay of Naples at Puteoli, where he spent his final days, and at Baiae, and evidence for Hadrianic alterations and additions to Trajan's villa at Centum Cellae may suggest that Hadrian intended to use it for himself.[14]

Wealthy Romans traditionally kept many villas, and on longer journeys, from Rome to the Gulf of Naples for example, it was considered normal to spend the night on one's estates. It is therefore likely that there were many more, smaller villas that Hadrian continued to visit or had built specifically for himself.[15]

In the city itself Hadrian seems to have ordered some relatively minor alterations to the imperial residence on the Palatine Hill. Yet Domitian's palace on the Palatine had been designed to overawe any visitor, its architecture therefore eminently unsuitable for the new-style, consensual form of imperial rule. Hadrian

**Fig. 125** Olive grove at Hadrian's villa. The oldest olive tree on the site is more than a thousand years old.

ordered improvements to the heating system of the palace, indicating that he may have intended to use it as a winter residence, and a number of modifications to rooms and façades.[16] He also seems to have built a small palace-like structure in the Horti Sallustiani, large gardens along the north-eastern fringes of the city that had long been imperial property and were not associated with Domitian's years of misrule.[17]

Given Hadrian's prolonged absences from Rome on his empire-wide journeys and the existence of several further retreats, he cannot have spent all that much time at his Tiburtine villa. Yet considering the funds lavished on it and his close personal involvement in the building project, it must have been central to him. To understand the special significance of the villa for Hadrian, and the sheer scale and astonishing ambition of the building work involved, it is instructive to examine the construction process and the function of the various spaces in greater detail.

## Structure and layout

While today the warm glow of the villa's remaining walls, set against the silvery green of the surrounding olive groves, creates a dreamily romantic atmosphere and the looming presence of its massive ruins adds a powerful sense of melancholy, it is now nearly impossible for the modern visitor to get an impression of the site in Hadrian's time. Access to the villa is through a large opening cut in the eighteenth century through the interior wall of a large hall that has lost all its columns, catapulting the visitor into the midst of a site that would have been approached very differently in antiquity. None of the bare walls we see now would have been exposed in antiquity. In fact, an ancient inscription refers to the residence as *Aelia villa frontibus pictis*, 'the Aelian villa with the colourful walls', encapsulating succinctly a sense of its original splendour when every surface would have been covered in marble, stucco, fresco or mosaic.[18]

To understand the villa, it is necessary to regain an idea of what we have lost, to order its seemingly confusing maze of buildings into functional units and to dispel some of the myths surrounding Hadrian's intentions in commissioning them. Most importantly it needs to be seen as a space that was actively used for very specific purposes. The term 'villa', associated in Roman usage with the

**Fig. 126** The central wall of the large north hall of the east–west terrace, seen through an ancient doorway looking west (top). Like most walls in the villa, it is stripped bare (detail, above).

## *Hadrian's villa*

Maps showing the location and main structures of Hadrian's villa near Tivoli, outside Rome. The larger map includes buildings excavated only very recently, such as the Antinoeion (5). The area highlighted in beige covers some 40 km and is accessible to the public today. Further remains are located to the south.

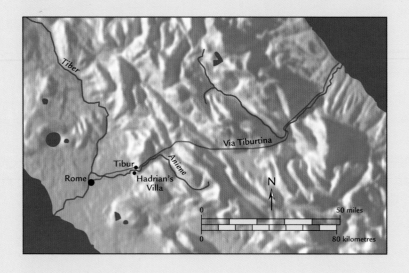

Roads

Subterranean roads

Service areas

1 'Greek Theatre'
2 Republican Nymphaeum
3 East-West Terrace ('Poecile')
4 Service Quarters ('Cento Camerelle')
5 Antinoeion
6 Access road to the Vestibule
7 Vestibule
8 Scenic Triclinium ('Serapeum')
9 Scenic Canal ('Canopus')
10 Great Baths
11 Central Service Building ('Praetorium')
12 Small Baths
13 'Building of the Three Exedrae'
14 Garden – stadium
15 Winter Palace
16 Peristyle Pool Building
17 Heliocaminus Baths
18 Absidial Hall ('Philosopher's Chamber')
19 Island Enclosure ('Maritime Theatre')
20 Nymphaeum

21 Fountain Court West ('Latin Library')
22 Fountain Court East ('Greek Library')
23 Portico Suite ('Imperial Triclinium')
24 East Belvedere ('Tempe Pavilion')
25 'Hospitalia'
26 Residence Quadrangle ('Courtyard of the Libraries')
27 Republican Cryptoportico
28 North Service Building ('Guard Barracks')
29 Residence
30 Ceremonial Precinct ('Chamber of the Doric Pillars')
31 Water Court ('Piazza d'Oro')
32 'Temple of Pluto'
33 Grotto ('Inferi')
34 West Belvedere ('Roccabruna')
35 West Terrace ('Garden of the Accademia')
36 Palaestra
37 Reverse-Curve Pavilion
38 Circular Hall ('Temple of Apollo')
39 Southern Range ('Accademia')
40 Pantanello

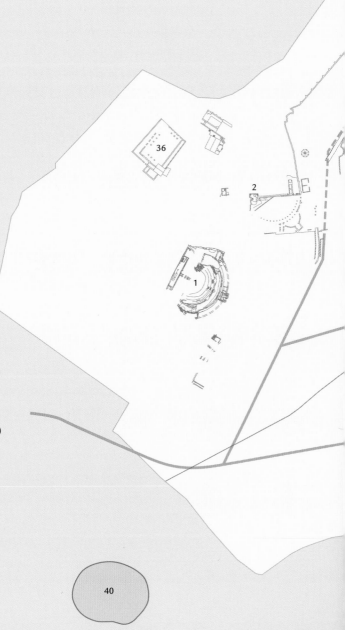

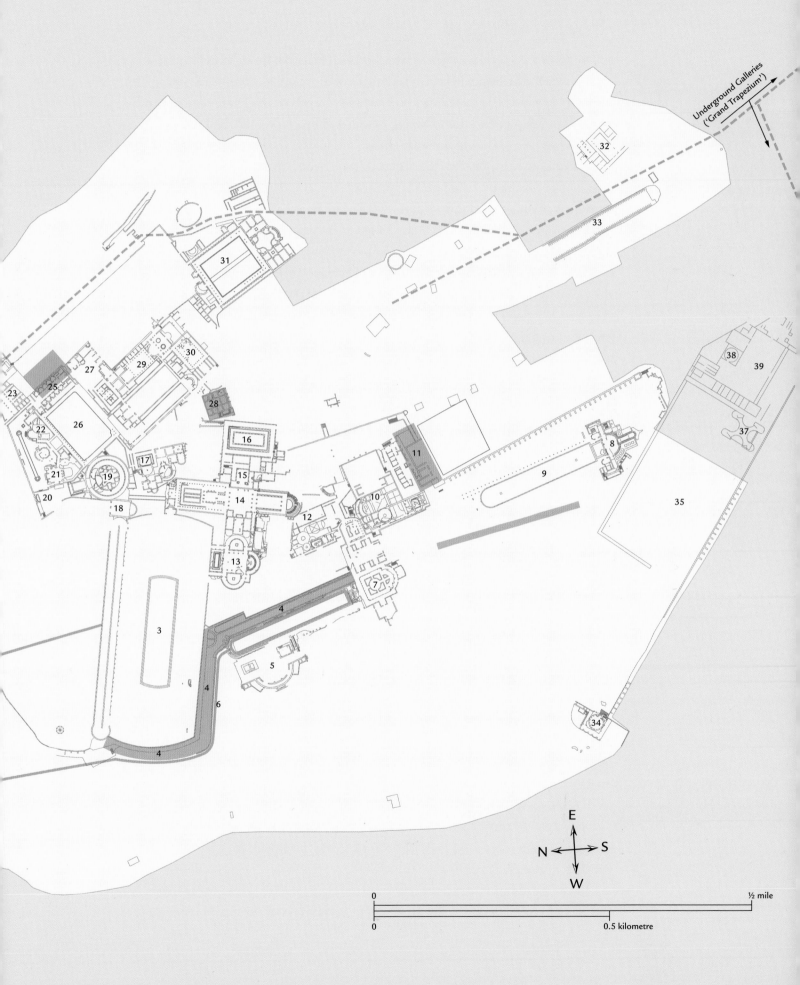

Underground Galleries
('Grand Trapezium')

sphere of *otium*, or leisure, is perhaps misleading. It is often thought that this was Hadrian's private world, where he could withdraw from public life and even escape from his strained relationship with the senate. But this clearly was also where imperial policy was formulated and disseminated in a more informal setting to invited members of the empire-wide elite.

Building work on the villa seems to have been carried out in two major phases. The first phase lasted until approximately AD 125 and provided Hadrian with a set of fully functional structures when he returned from his first major journey around the empire. This is supported by the great preponderance of bricks dated to the years AD 123 and 124.[19] The second phase followed thereafter, and by about AD 130 major construction at the villa was nearing completion. Despite the great volume and at times challenging design involved, the building process clearly was highly efficient, and brick and concrete construction allowed swift progress. All materials were of the best quality and the workmanship highly competent throughout.

A project on this scale would have required a team of architects and a master of works to ensure well-coordinated progress. The preparation of the site itself required the presence of highly skilled engineers and hundreds, if not thousands, of manual labourers to prepare the ground. Slaves, specialists from the civic administration and possibly army experts may all have been involved. To accommodate this large workforce, temporary quarters would have been built, along with many other installations, such as builders' yards for the storage of the enormous quantities of material that poured in constantly, endless workshops and stables for the hundreds of work animals needed. New roads would have been required to facilitate access. Artisans and craftsmen, many of them highly skilled, must have populated the site in their hundreds to provide the interior decoration of the architectural spaces once the builders had finished the shells.

Recent research suggests that the general layout of the villa was based on a complex master plan that was decided at the very beginning. This plan included the location of the villa's extensive, integrated and highly sophisticated water and sewage systems and a nexus of subterranean passageways that seem to have been constructed in the very first phase of the project.[20] More importantly, the site's natural landscape was radically transformed, requiring earth-moving on a colossal scale.[21] In total, five very large terraces were constructed. The precision of the engineering work involved is manifest in the precise correspondence of ground levels between areas located at considerable distances from each other. The new terrace walls and perimeter structures with their massive buttresses at the same time greatly enhanced security at the complex, which towered fortress-like over the surrounding landscape.

The master plan, furthermore, carefully segregated the servants' quarters and access roads from the residential and guest quarters of the villa, so that the

day-to-day business of running this vast estate could take place largely unseen by its noble residents. The underground staff passages alone have been tracked to a length of 4.8 km.[22] In order to build the so-called great trapezium, a system of wide underground passageways in the southern part of the villa, with the combined length of its four sides measuring 840 metres, some 20000 cubic metres of rock had to be removed.[23] Some of the service quarters were positioned unobtrusively in the buttresses of the large terraces, so that they were hardly noticeable from the areas above.

The built space was ordered through well-defined axes, often covering great distances and partly influenced by the terrain, which intersect at a variety of angles. Three distinct groups with different orientations thus emerge. The old Republican villa and its Hadrianic successor faced north-west. The buildings in its immediate vicinity, the first to be erected, follow this alignment strictly or with only slight modifications. The second main block however, the so-called winter palace, develops along an east–west axis, while the southernmost structures follow yet another orientation.

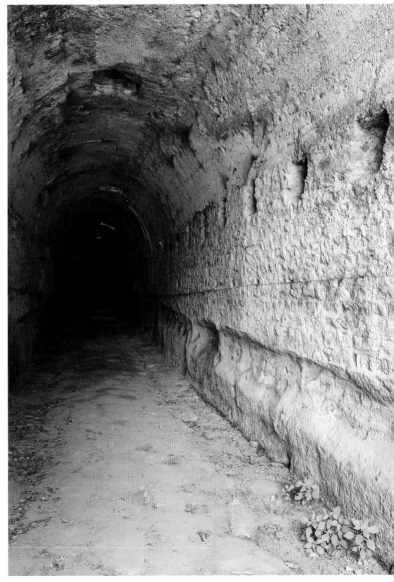

**Fig. 128** One of the underground staff passageways.

Construction above ground started with the renovation and expansion of the existing villa, whose general plan was retained but substantially adapted. This building dated back to the second or early first century BC and had already been modified in the mid-first century BC and then again in the Augustan period. It was approached from the north through a large peristyle garden that bordered the *basis villae*, a massive platform that raised the main residential block above the surrounding landscape in a manner typical for villas of this period. This platform contained a beautifully decorated cryptoportico, an underground walkway that provided pleasant coolness during summer and was linked to the upper level via a staircase. The living quarters above comprised a traditional atrium and a *tablinum*, the main reception room of the Roman house, behind which lay a rectangular peristyle courtyard with smaller rooms along the sides. Garden terraces framed the main

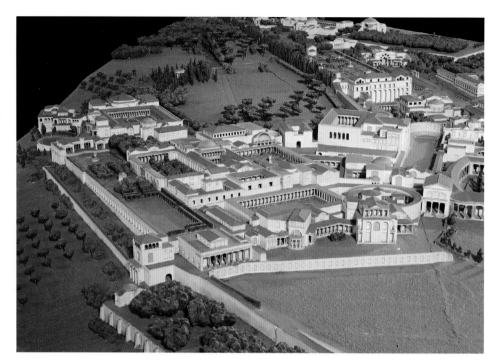

block to the east and west.[24] Further structures existed already also to the north of the lower garden court, among them a *turris*, an observation tower for domestic use, possibly built shortly before Hadrian came to power.[25]

While major work was carried out to transform the surrounding landscape, the old villa was extensively reconfigured to provide the main residential core of the new estate, soon flanked by important satellite structures. The old villa's atrium was turned into a peristyle court, while the *tablinum* was transformed into a library with a small adjacent basilica, followed by a suite of rooms that may have housed associated administrative staff. To the west followed more private apartments, suitable for the emperor himself. Nearby were service areas and lodgings for senior staff or high-ranking guests. Added to the south and reached via a separate court decorated with a number of fountains, was the ceremonial precinct, where audiences could be held and delegations received.

The area to the north of the garden was also altered considerably. A second tower apartment was built, followed by a fountain court on a terrace overlooking the countryside to the north. From here and from the main residence the villa's most intimate space could be reached, an exquisite apartment on an island enclosure, the so-called Maritime Theatre, complete with its own private bathing suite linked to the surrounding canal that doubled as a swimming pool.

Bricks dated to AD 117 indicate that the first buildings to be erected were the Maritime Theatre and adjacent Absidial Hall, followed before AD 123 by new structures erected around the existing Republican villa and the Heliocaminus Baths.[26] To the south of the residence lay a large enclosed garden with the most sumptuous waterworks, the so-called Piazza d'Oro. This space was linked to the

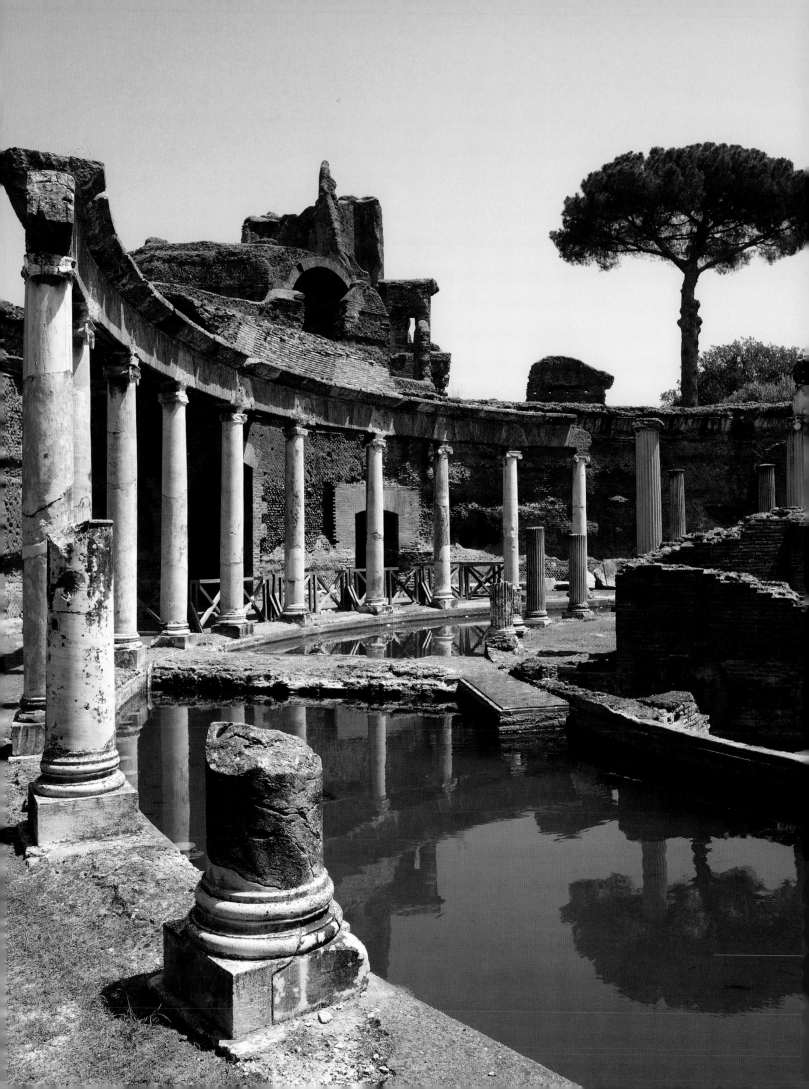

main residence by service areas and entered via a splendid octagonal vestibule. Covered ambulatory spaces surrounded the central garden court. At the end of its main axis was a large nymphaeum with six fountains and symmetrical suites located along the cross-axis. It is likely that this space served as a summer *triclinium*, a large dining hall. Further to the east was another nymphaeum, joined at a lower level, but still well above the valley floor, by an arena, below which followed a stadium.

The west valley ridge provided a smaller, separate area at a considerable distance from the main residence; this could have been an even more private space for the emperor to withdraw to. Others have seen here Sabina's part of the villa.

## Staff and status

The running of the villa required a very substantial staff of many hundred, possibly thousands. Most of them inevitably would have been slaves. In addition, military units, probably drawn from the Praetorian Guard, provided security.

Staff roles and their status naturally varied greatly and ranged all the way from lowly slaves who stoked the furnaces in the great baths and heating plants of the winter palace to specialists who ensured the smooth running of the place. Those with greater responsibility, which on occasion brought them into proximity with the emperor or his senior officials, could reasonably expect to eventually receive their freedom as reward for years of dedicated service. The tombs of several such people and other trusted old retainers seem to have been located along the villa's perimeter. They included Hadrian's old wet nurse Germana (see p. 34), two *tabularii*, bookkeepers or administrators, and a *commentariensis*, or archivist. This suggests that they and their families permanently resided in or near the villa. Other positions mentioned in the epigraphic record are a *diaetarius* (accountant), *topiarius* (landscape gardener) and *dispensator* (steward).[27] The north theatre, which may have served the entire villa population, and the urban-sized great baths, themselves requiring perhaps sixty to eighty people for their running, hint at the numbers of service personnel involved.[28]

The villa's kitchens have yet to be located.[29] The numerous dining suites dotted around the site suggest that entertaining took place on a lavish scale and would have required large numbers of associated service staff. Gardeners, gamekeepers and many others would have been needed in equally large numbers.

DIS MANIBVS
AELIAE T F PERPETVAE
QVAE VIXIT ANNIS III
MENS VII DIEB XXIII
T AELIVS AVG LIB
AMPLIATVS
TABVLARIVS
VILLAE TIBVRTIS ET
FLAVIA APHRODISIA
PARENTES FILIAE
DVLCISSIMAE

**Fig. 131** Tombstone set up by T. Aelius Ampliatus and his wife for their three-year-old daughter. Ampliatus had been given his freedom by the emperor and is referred to as '*tabularius villae Tiburtis*' – bookkeeper at the Tiburtine villa. The drawing is based on a Renaissance publication of the text. Only a small fragment of the inscription is still preserved and was recently rediscovered in a private collection.

In practice, the villa comprised two strictly separated, almost parallel worlds. Slaves and servants were concentrated in several large accommodation blocks well out of sight and could reach their work places through subterranean passageways and service corridors completely unnoticed by the villa's elite residents. A striking example of this physical separation is provided by the so-called Cento Camerelle, a series of rooms located over several floors reminiscent of the tenement blocks of urban Rome and Ostia and in places up to 12 metres high. A road runs along these rooms and enters the extensive underground network just by the *vestibulum*. Separated by a screen wall and located on a substantially higher level is one of the main access roads for official visitors to the villa, from where it was hardly possible to notice the staff quarters.[30]

An extensive subterranean road network, called 'great trapezium' by the modern excavators, allowed vehicle access to large areas of the villa. Its main artery runs some 1.6 km from north to south and is some 3 metres wide.[31] Additional uses as stables have been proposed, and also the storage of ice during the summer months – there is an underground corridor 60 metres long with twenty-one side chambers lined with waterproof cement. Extensive stabling must have been provided; perhaps the fifty-one large and eighty smaller stalls along the great trapezium's eastern flank provided space for mules and oxen. Other mews must surely have existed, perhaps located closer to the Tiburtina road. A further service building lies immediately to the north of the so-called winter palace.

Similarly, the villa provided separate bathing facilities for servants and elite residents and their visitors. Based on their modest level of decoration, it now seems clear that the so-called great baths, for example, exclusively served the lower status villa population.[32] These baths were isolated from the surrounding buildings and could be bypassed on two levels through a cryptoportico below ground or a higher terrace situated above.

Recent research has greatly enhanced our understanding, sometimes by rather unexpected means, of the way that the villa's buildings were utilized by different social groups, which in itself helps to identify their original function. This is because the specifications and interior decoration of the built environment closely reflected the status of their expected users. Thus, three basic hierarchical levels can be discerned. The top level was for the emperor and his family, the next

**Fig. 132** The Cento Camerelle ('Hundred Rooms'), a large accommodation block for staff. The service road in front is on a lower level, out of sight of the normal visitors.

OVERLEAF
**Fig. 133** Intricate black and white mosaics from the Hospitalia, accommodation for high-ranking villa staff or guests.

for high-ranking personnel and the last for the servants' quarters. Walls with marble revetments and inlaid marble floors (*opus sectile*) denote rooms for high-status residents. The use of porphyry tiles within these decorative patterns in particular suggests the presence of the imperial family. Such rooms also contain the finest mosaic composed of minute cubes, the so-called *vermiculatum*. Secondary areas had frescoed walls and simpler, black and white mosaic floors, often with beautiful vegetal motifs. Finally, spaces with simply plastered walls and monochrome mosaic floors denote the service quarters.[33]

The villa's sanitation facilities closely support this reading of the spatial separation. Large, multi-seater toilets with very basic decoration can be found in the service areas, while guest quarters and dining facilities normally had clusters of single seaters. Areas exclusively associated with members of the imperial family by contrast had lavishly decorated, sometimes even architecturally innovative single-seater toilets.[34]

One particular ancient literary reference to the villa has intrigued its modern interpreters from the Renaissance on. The *Historia Augusta* reports that Hadrian '*built up the Tiburtine villa wonderfully, in such a way that he could apply to it the names of the provinces and places most renowned and could call (parts of it), for example, the Lycaeum, the Academy, the Prytany, the Canopus, the Poecile, Tempe. And so that he might omit nothing, he fashioned even a Hades.*'[35] For the study of the villa and its remains this has had two main consequences. Firstly, attempts were made early on to identify the known structures of the villa with the various names mentioned in the text. Some of these attributions seem more likely than others, but many remain unresolved and not a single one is independently confirmed. Secondly, the mention of famous Greek and Egyptian sites seemed to reflect closely Hadrian's intimate knowledge of the empire and its provinces gained on his extensive journeys and also to express his perceived desire to bring them together. In this reading the villa becomes not only an empire in miniature, but also an ideal one, uniting all that is best in perfect harmony.

The reality, however, was rather different. From the late Republic on wealthy villa owners had taken to naming areas of their country estates after famous classical sites, conjuring up a contrived atmosphere of appropriate learning. Cicero, for example, in his letters to Atticus described parts of his villas with very similar names, and from the context it is clear that appropriate statuary was meant to induce specific associations with certain places. Statues of athletes, for example, evoked a Greek gymnasium, but in a very general sense.[36] By Hadrian's time this was therefore nothing but a well-established topos. In short then, the Tiburtine villa was not unusual or even individual in its general design. It was extraordinary only in its enormous scale and in the daring innovation and experimentation of its architecture. This, rather than anything else, reflects Hadrian's personal choice, if not his own direct influence.

## The power of architecture

The buildings of Hadrian's villa provide a vast panorama of classical architecture from the traditional to the breathtakingly unexpected. Models that were modified and explored further, leading to ingenious alternative solutions, were in part derived from the great palace complexes of the previous era, such as Nero's Domus Aurea and Domitian's Domus Augustana on the Palatine, the latter designed by the architect Rabirius. Much, however, had no known precedent. In their novelty some buildings, like the Building of the Three Exedrae, even foreshadow late antique and early Christian designs.[37]

Like much of Hadrianic planning, the villa made maximum use of the new structural capabilities of the most recent construction techniques, pushing materials such as concrete to their absolute limit.[38] Further innovation was achieved through the completely novel application of established elements, employing the classical orders, for example, in new contexts, but also in a non-structural way merely for scenic effect.[39]

While some of the basic components of the villa's buildings may have been conventional, their individual design was highly differentiated and often entirely original. The recent advances in concrete construction techniques, in particular, allowed architects and planners to experiment with newly devised elements of the design repertory, among them the addition of circular and semi-circular extensions to rectangular spaces, often crowned by domes. The sheer audacity of the villa's domes and semi-domes alone is staggering, the level of architectural experimentation a fitting complement to the thorough engineering of the underlying infrastructure. Novel ways of lighting rooms were then explored through the cutting of openings in these imposing concrete vaults and domes in a great variety of shapes and positions.

Plans of great complexity with daring spatial dispositions are a common feature, with a continuously evolving integration of square and circular features. Arches rise from curved plan lines, and some buildings are based on highly unusual

**Fig. 134** The villa's variegated rooflines. The smaller baths are in the centre left, the large baths in the centre right.

reverse-curve plans, a joining of concave and convex lines that lends the architecture a refreshing vitality. These revolutionary designs can be found on the island enclosure and the great viewing pavilion on the western terrace. While basic grid systems were used in the design process, they vary greatly between buildings.

Standard architectural devices, such as the spacing of columns, are often at notable variance from the precepts formulated by the architectural writer Vitruvius in the first century BC, reflecting the uncompromising novelty and experimentation of the design.[40] In other cases a conventional-seeming, linear façade belies the completely unexpected complexity of circular spaces behind it. Disjointed plans, together with this use of circular designs instead of or in surprising combination with traditional linear arrangements, frequently result in non-classical spatial experiences. There is a constant element of surprise, a maze of volumes that create a powerful sensual dynamic as they are transgressed and reveal themselves one by one, with numerous entrances providing ever-new sequences and combinations of individual spaces and multiple viewpoints. An overwhelming, vibrant energy emanates from this amalgamation of circles and squares, hexagons, octagons and innumerable configurations of segments that emerge when they are superimposed, their three-dimensional volume further shaped by variously vaulted or domed roof structures.

One gets a sense of almost divine perfection sought in this powerful combination of ideal shapes. A tremendously audacious creative spirit can still be felt in these spaces, a supremely confident, subtly controlled use of irregularity that defies convention. There is at times a playful informality, an almost effortless lightness that betrays great genius. In the villa the full potential of classical design elements is finally realized, for they are treated merely as minor building

**Fig. 135** A section of *opus sectile* floor from the Building of the Three Exedrae. Inlays of expensive multi-coloured marble tiles are arranged in a geometric pattern.

blocks in a restless, constantly evolving creative process rather than a restrictive canon. This evolutionary transformation of the classical vocabulary, as opposed to a simple monumentalization of fossilized standard forms, is perhaps one of the reasons why the villa proved so inspirational to the humanist spirit of Renaissance architects.

**Figs 136 & 137** Remnants of original wall and ceiling decoration: multi-coloured fresco (left) and ornate stucco fragments (right).

The bath buildings with their multiplicity of spaces for varied air and water temperatures, indoor and outdoor, the manipulation of light and shadow, with rooms of startling geometry, are emblematic of the experience offered by the villa as a built environment. The result is one of the greatest forms of luxury imaginable, celebrating almost subliminally the genius of its creator and the power of the empire that he ruled.

Buildings were often not left as designed on the drawing board. There is frequent evidence of changes in plan during construction, as well as subsequent alterations that may in part be due to changes in the function of rooms or suites, but also to attempts to improve the look and feel of given spaces. It is hard not to see here the influence of Hadrian himself, his close involvement with the architectural genesis of the site. Clearly there were intense debates between the imperial patron and his architects and master builders, with close inspections of newly completed sections after each return of the emperor from longer absences and duties elsewhere.

The striking geometric volumes of the architecture were further enlivened by the constant modification of wall surfaces, broken by series of niches of

**Fig. 138** The Dove Mosaic, a high-quality work made in the *opus vermiculatum* technique from minute tiles. It is probably based on a famous Hellenistic painting.

different shapes that were framed by a great variety of pilasters and columns, sometimes positioned on consoles. Wall and ceiling surfaces and floors were finished with staggering opulence, the rare exquisiteness of some of the materials used in itself a symbol of the empire's might and unparalleled resources. Occasionally small sections of stuccoed ceilings or beautifully decorated floors and walls have survived. They provide a rare glimpse into the richness of the original decor that must have been quite overwhelming in the finished building.

In a heating chamber adjacent to a side room of the so-called Building of the Three Exedrae – an elaborate, arcaded *triclinium*, or dining suite – fragments of the ancient wall incrustation were recently discovered. They can be restored to

make up a number of panels of the utmost richness and intricacy, combining small, specially cut pieces of marble and coloured glass into a scene that appears to show charioteers of the main circus factions.

The interior decoration of rooms was as varied as the rooms themselves. Together with sophisticated, individual lighting solutions, this heightened the sequential drama as one progressed through the buildings. One of the basic design principles of the site was to provide an enormous variety of individual spaces to be experienced, together with carefully selected and framed views of the surrounding countryside, the mountains and the plain. Serried rows of columns, a feature now almost completely missing but visually most prominent when the villa was built, amalgamated the structures and smoothed the transition from indoor to outdoor spaces and gardens. Some of these passageways were roofed, others took the form of colonnades or pergolas open to the sky.

In the combination of all these elements the design created an appropriate architectural context for the intellectual and aesthetic pursuits traditionally associated with villa life, a finely tuned, immensely varied stage set against which the emperor's role could be played out to greatest effect before an ever-changing audience of invited guests. The occasionally startling originality of the built environment only reinforced this powerful message.

As an intellectual manifesto, the villa set a new standard. Visitors, even from the largest cities of the empire, were used to traditional solutions, typical

**Fig. 139** Recently discovered fragments of wall revetment made of thin veneers of multi-coloured marble. This formed a figurative central panel framed by geometric borders. Represented are a horse and charioteer, probably alluding to the famous race teams (the Blues, Greens, Reds and Whites) in the Circus Maximus in Rome.

buildings that defined Romanness and could be found anywhere in the empire. The concept of power expressed through familiarity, the simple scaling up of established designs, so pervasive for example in standard military architecture, here faces an overwhelming alternative expression, where the novel mastery of space in the very centre of the empire must have suggested to the overawed visitor something of the cosmological might of Rome. It is this supreme confidence in the inspiring persuasiveness of the utterly unconventional that projects an almost modern sense of leadership in strong contrast to the monumental façades, strict symmetry and absurdly exaggerated scale employed by other regimes before and since.

It is important to remember that Hadrian's villa was to a large extent a public space, albeit in a strictly controlled manner, a gathering place for the empire's elite, where the power of architecture to impress and inspire a sense of belonging, pride and even superiority could be physically demonstrated and immediately put to practical use. In this gigantic built manifesto, the senatorial aristocracy could encounter a powerful vision of the empire and its future. Most importantly, they would also have felt a constituent part of the enormous civilizing power that stood behind this achievement, and many senators were subsequently to replicate elements of the villa's architectural landscape on their own estates.

The empire's inner elite here experienced a subtler version of Rome's might, one that the forest-dwelling barbarians beyond the empires northern borders, the nomads of the eastern steppes but also the sophisticated empire of the Parthians, could not equal. To these select few an alternative vision of the empire emerged, quite different from that projected by Trajan's gigantic monuments in the centre of Rome or Domitian's assertion of power through the oppressive force of his new palace.[41] Architecture works in very subtle ways, because the sensual quality of built volumes is instinctively felt by anyone who enters them, without any need for prior reflection. The villa thus expressed the invigorating vision of a brighter, freer world. While its buildings were certainly meant to impress, they do so through an almost playful monumentality that celebrates the limitless creativity of the human spirit rather than through sheer scale and the endless repetition of dominating blocks. Among many members of Hadrian's entourage this would have been noted, discussed and analysed, for these men were important patrons in their own right, commissioning splendid villas and important civic buildings in their local communities. The echo of this revolution reverberates to this day.

## Estate and landscape

The buildings were set in extensive, carefully landscaped grounds that formed a key part of the villa experience. While some structures were quite self-contained, with apartments organized around internal courtyards and gardens, most communicated with the surrounding landscape, and some buildings are in effect best understood as elaborate viewing platforms. A carefully controlled framing of nature clearly mattered a great deal, to the extent that even toilets, if the most luxurious ones, provided spectacular views of the surrounding countryside.[42]

The abundance of water provided by the site's natural streams and the network of newly built aqueducts were essential for turning the villa into a luxurious, pleasant environment. The water entered from the south-east, from where an intricate network of channels, cisterns and pipes gradually developed to feed the more than one-hundred hydraulic installations of the villa. At the opposite, northern end of the site, large channels drained the used water into the River Aniene. The considerable difference in height between the major terraces from south to north created great amounts of artesian energy to feed numerous jets and sophisticated waterworks, of which at least some evidence has survived. Practical and ornamental use went hand in hand. Pools and canals, with water cascading down in constant flow, countless grottos and nymphaea were used for scenic effect; the incessant splash and sparkle of fresh water not only created a lively, melodious

**Fig. 140** A lead *fistula* (water pipe) from the villa's extensive hydraulic system. It is stamped with the name of the imperial freedman Restitutus (shown in the detail below), who was in charge of the work.

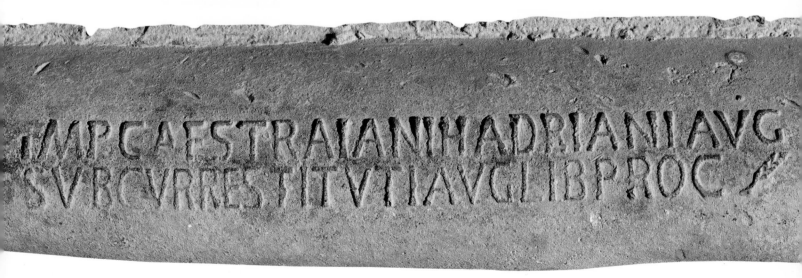

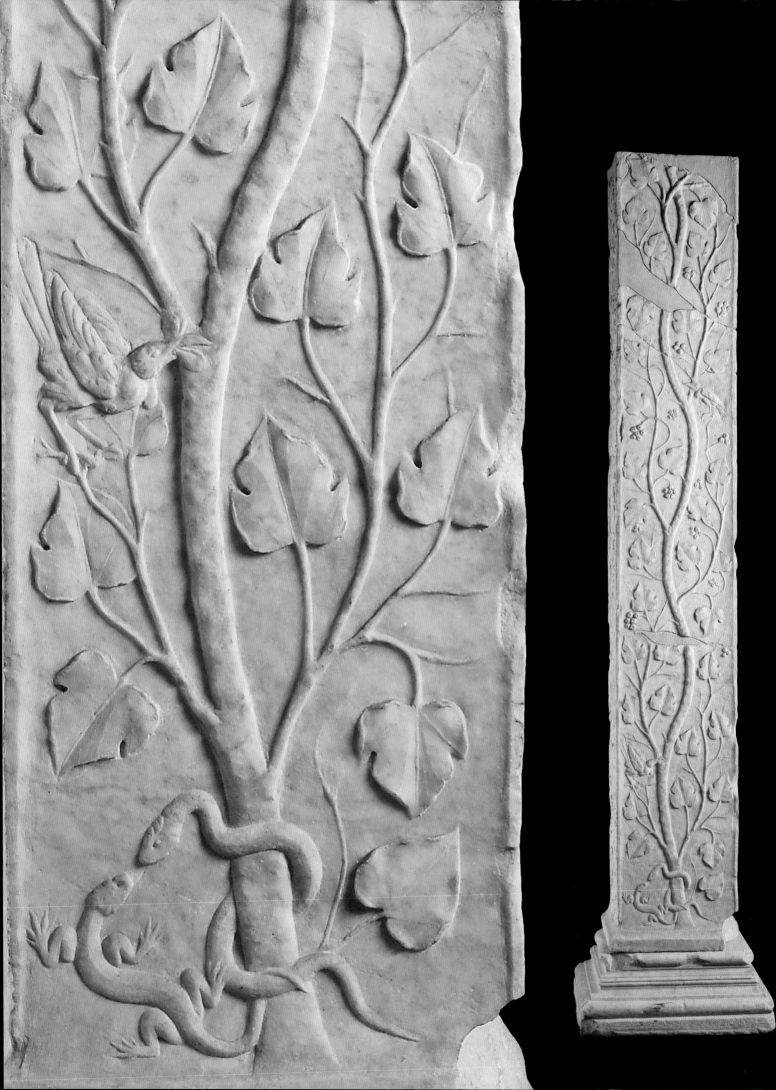

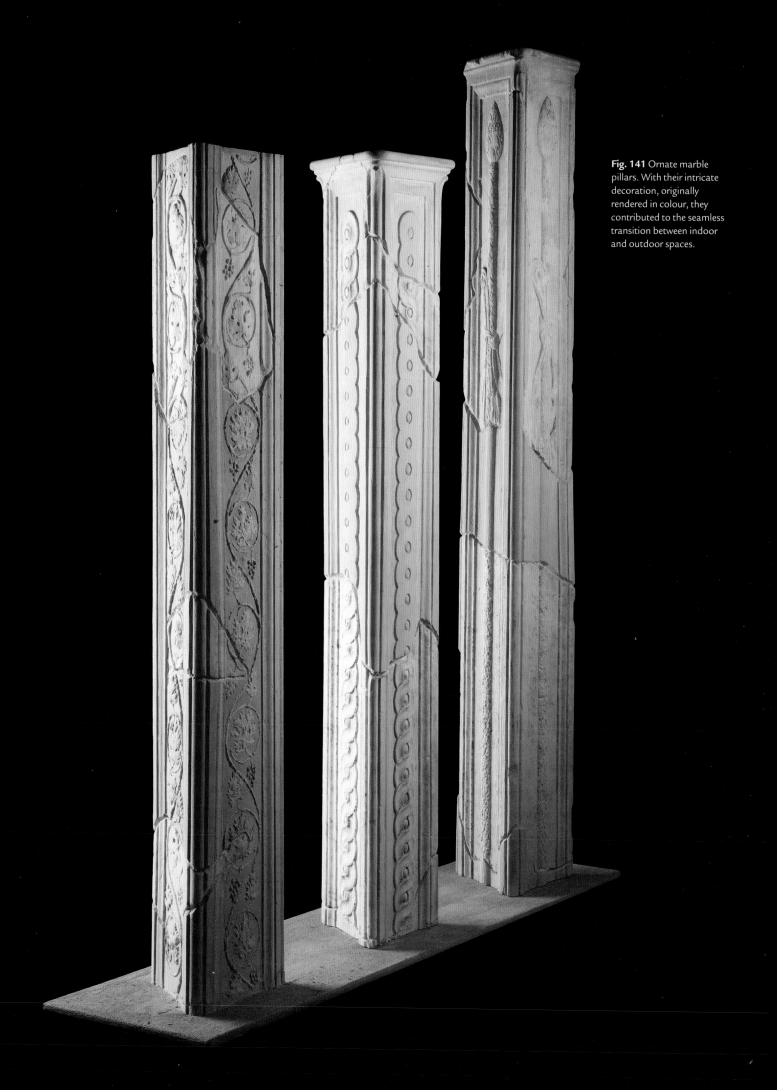

**Fig. 141** Ornate marble pillars. With their intricate decoration, originally rendered in colour, they contributed to the seamless transition between indoor and outdoor spaces.

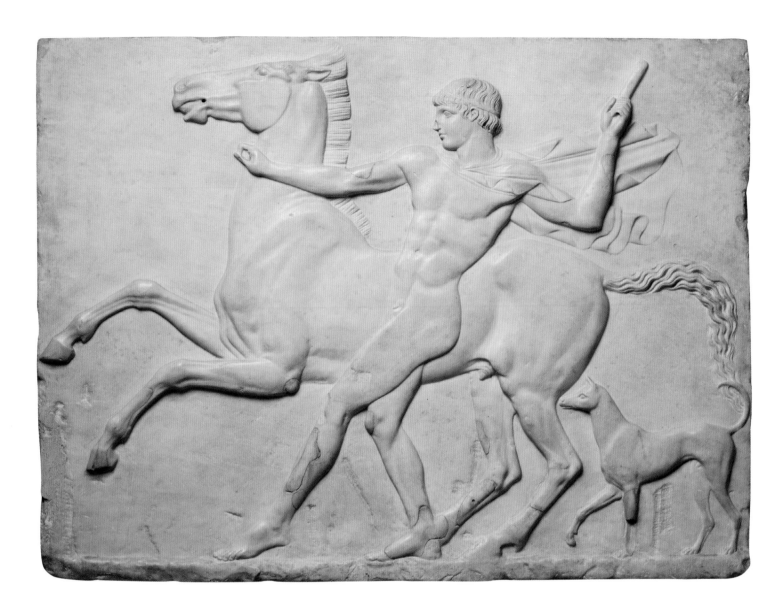

**Fig. 142** Youth taming a horse. The relief evokes Greek works of the classical period of the fifth century BC.

ambience but also of course provided a highly efficient means of air conditioning both outside and inside, generating coolness in the summer heat.

Intense irrigation allowed the establishment of lush gardens with topiary, groves and exotic flowers, punctuated by isolated pavilions, sculpture and the like. Open water may have covered as much as 1.5 acres of the site, and it is perhaps possible that the marshy area of the Pantanello, which contains a Hadrianic drain, was originally an artificial lake.[43]

It is unknown to what extent the villa's vast grounds may also have been used for agriculture and whether the traditional aristocratic Roman villa owner's pride in the self-sufficiency of his estate applied here also, at least in part. Presumably there were large kitchen gardens, and extensive pasture must have been provided for horses and work animals. Hunting may have played a major role at the fringes of the estate, given Hadrian's great love for it, even if no specific evidence has survived.

## Life at the villa

It would be quite wrong to regard the villa as a private place removed from official affairs. On the contrary, there is clear evidence that Hadrian carried out government business when he was in residence. In August or September AD 125, for example, he sent a letter from the villa to officials at the sanctuary of Apollo at Delphi in Greece; similarly, an inscription with the text of a letter of thanks to Hadrian by the cities of Hispania Baetica indicates that the official edict for which the Spaniards now expressed their gratitude had originally been issued at the villa.[44]

The villa was well within the 20-mile (32-km) residence limit that seems to have been stipulated for senators, in fact within commuting distance of Rome. According to the *Historia Augusta* Hadrian 'always attended regular Senate meetings if he was in Rome or in the neighbourhood', and this neighbourhood clearly comprised the Tiburtine villa.[45] A core team of the imperial secretariat would have been at hand wherever Hadrian went, including the villa. It is unfortunately very difficult to assign buildings or sets of rooms within the villa to specific functions; the small library with its adjacent basilica and set of small offices in the main residence may have housed the officials, clerks and others necessary for the running of the administration from the villa, and various buildings have been tentatively identified as audience halls.

Yet, the main aspect of government carried out at the villa seems to have been of a different, far more informal nature, more appropriate to its character. For the scale and likely function of many of the villa's buildings indicate that entertaining regularly took place on a large scale. In fact, many of the structures provided dining facilities for any time of the year and parties of all different sizes. Senators and leading provincials would clearly be received here in very significant numbers.

Upper-class Roman social life revolved around the *convivium*, or dinner party. The writer Pliny the Younger describes in considerable detail such events, which took place when he served as one of Trajan's advisers, and the atmosphere under Hadrian will have been very similar. Guests could discourse eloquently on conventional, strictly prescribed

**Fig. 143** Head of a goat. The parkland surrounding and linking the villa's main structures was dotted with sculptures.

conversation topics, alternating with more informal discussions that suggested a tantalizing degree of intimacy with the leader. The *Historia Augusta* specifically mentions Hadrian's love of dinner parties.[46]

*Triclinia*, or dining rooms, abound at the villa, although some are more easily identified than others and opinions among scholars may vary. A look at only some of the major dining facilities reveals the variety of scales and settings available: the Building of the Three Exedrae was an architectural gem originally decorated with the most lavish splendour; the Water Court had a beautiful outdoor garden setting accommodating large numbers; and the Scenic Triclinium, under its imposing semi-dome once encrusted with sparkling mosaic, looked out over a beautiful canal some 121 metres long. A smaller reflecting pool flanked by two pavilions mediates between the dining area and the canal, while several service corridors allowed unobtrusive staff access. The curved podium for the diners, the *stibadium*, had seven places. Hadrian dined 'in the company of all the foremost and best men, [with whom such a] meal together was the occasion for all kinds of discussions'. Like on a gigantic stage set, the emperor appeared at the centre of this built microcosm. Other parts of the villa probably also contained dining facilities. The top storey of the central service building, for example, facing south to a large garden park, may also have contained a dining suite.

**Fig. 145** Head of Dionysus, a copy after a classical Greek work.

**Fig. 144** View of the so-called Canopus. At the end is a beautiful outdoor dining room under an imposing semi-dome.

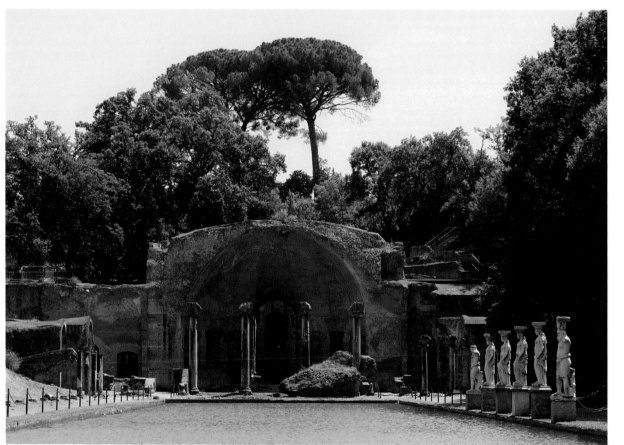

PAGES 162–3
**Figs 146 & 147** A colossal head of Hercules in the style of early classical Greek models (left) and the head of one of the companions of Ulysses (Odysseus; right). The latter belonged to a dramatic multi-figure group of Ulysses and his fellow Greeks blinding the drunk giant, Polyphemus, with a stake, copied after a famous work of the Hellenistic period.

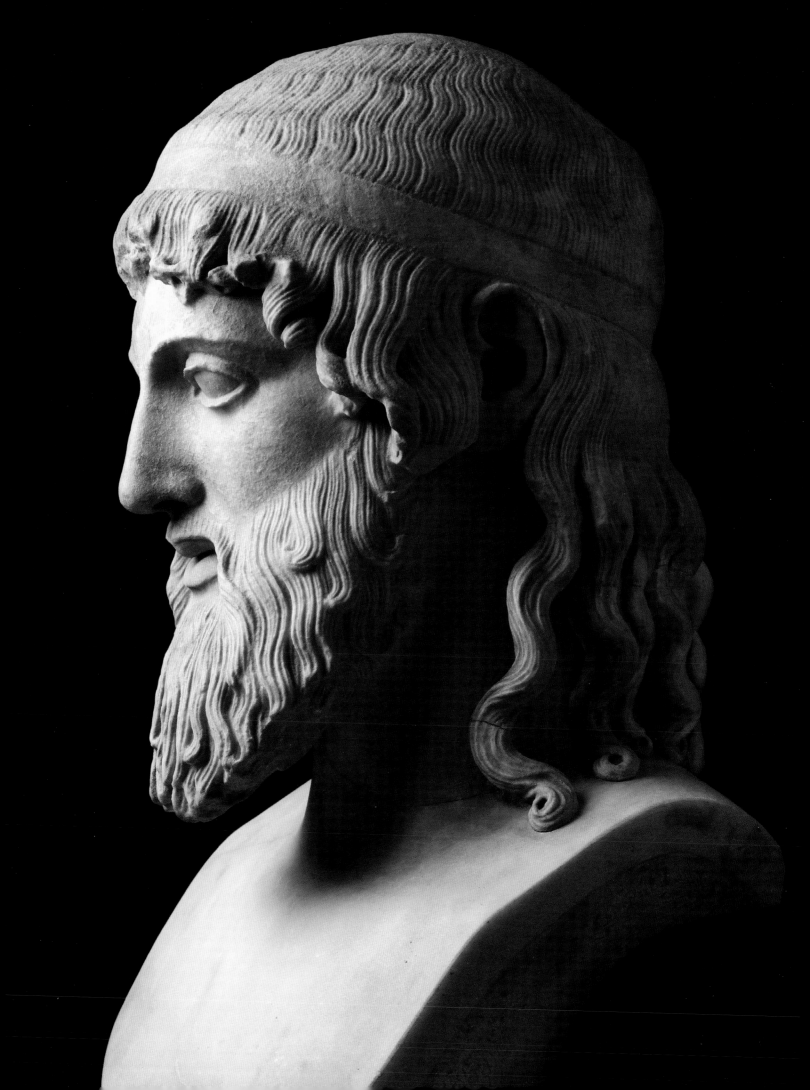

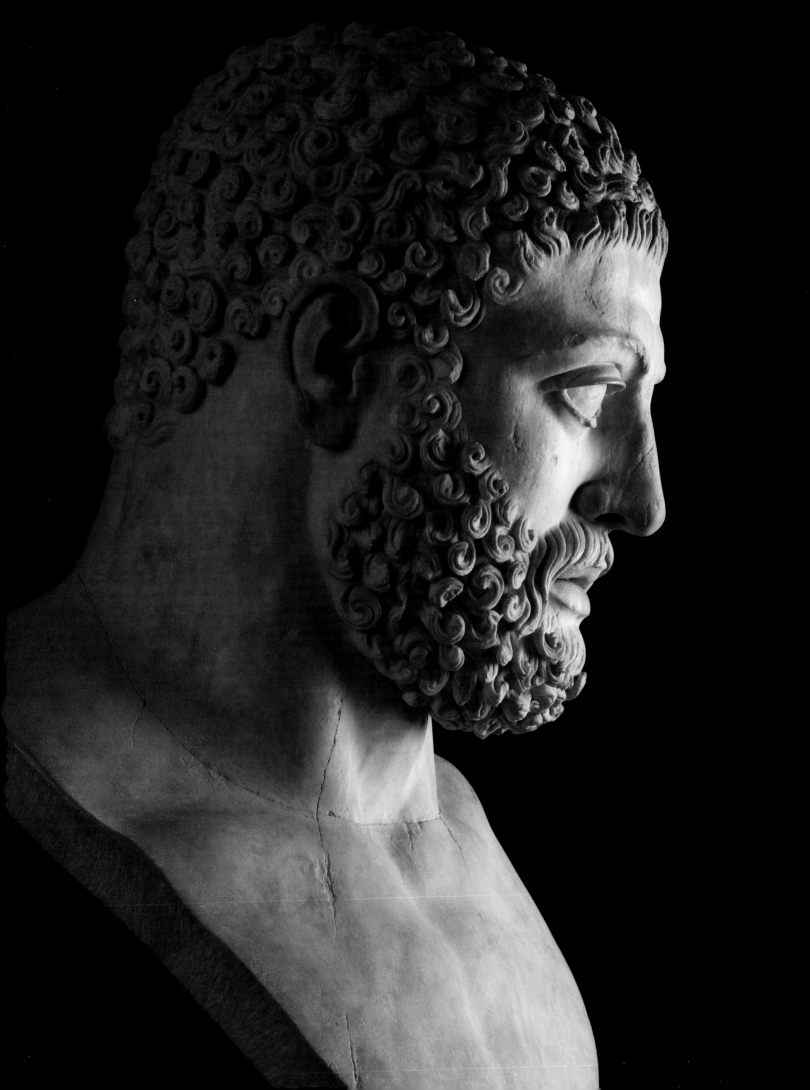

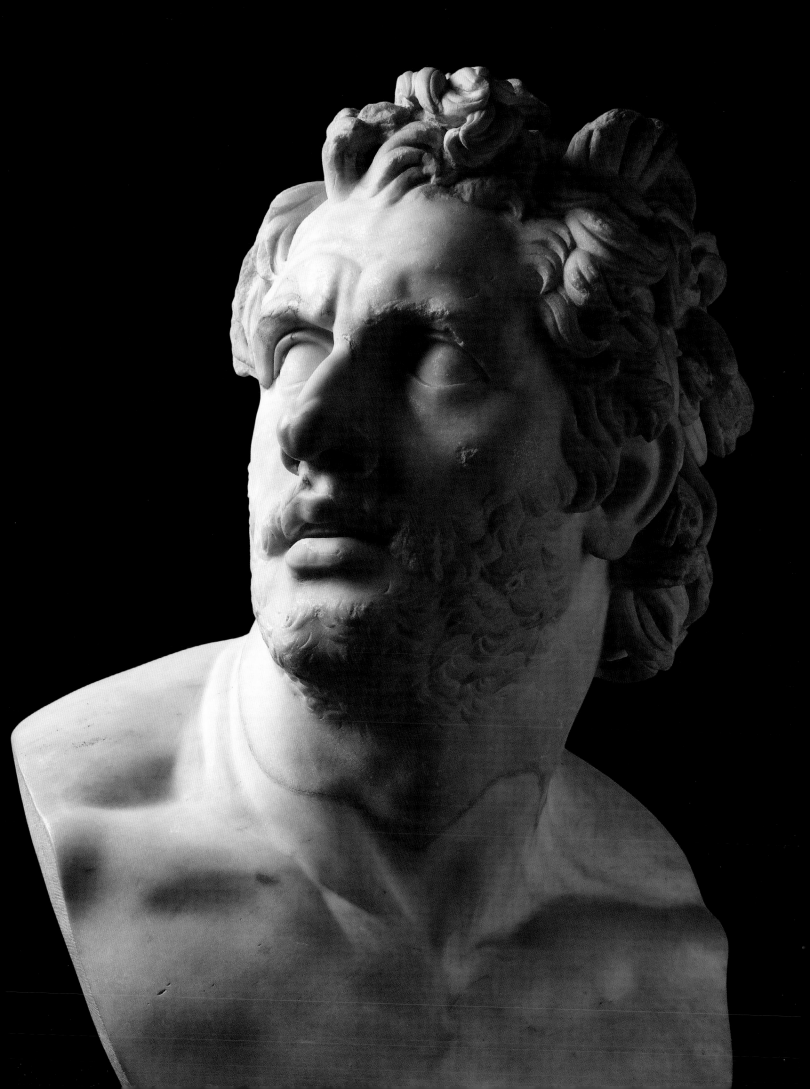

Apart from its architecture, the villa is particularly well known for its extensive decorative programme and its immense holdings of art. Sculptures and other figurative artworks were skilfully blended with the architecture and surrounding landscape, creating harmonious, highly evocative spaces. Little of this is obvious to the casual observer today, as much of the site is now only a shadow of its former splendour. Yet there is enough evidence to give at least a sense of the character of some of the spaces, even if all detail may be lost. Cuttings and clamp holes show that reliefs and paintings were attached to the walls of important buildings, and hundreds of sculptures framed in shrines and niches.

In all this it is important to keep in mind that the villa's vast sculptural programme, difficult to reconstruct for specific spaces because so much was moved or destroyed, is a mirror of high-imperial upper-class culture and taste rather than an expression of Hadrian's individuality.[47] Sculptures could be united in groups or displayed as symmetrical pairs. The sculptural decoration could give specific allusive meaning to otherwise abstract architectural spaces. Statues frequently appeared within strict architectural frames or were seen through openings in adjacent rooms, often with different light levels, sometimes separated from the viewer.[48] This isolated presentation invited the aesthetic appreciation of a piece. Other statues were integrated into the villa's extensive grounds, some freestanding, many others in small shrines and enclosures.

In line with other such sites, the sculpture was eclectic. There were copies of *opera nobilia*, recognized masterpieces of classical fifth- and fourth-century Greece. These were complemented by copies after large, multi-figure groups of the Hellenistic era, but also archaizing images and a large quantity of Egyptianizing figures, vivid testimony of that exotic country's enduring hold over the Roman imagination. Parts of the villa resembled a bucolic landscape peopled by Dionysian figures who symbolized a carefree life.

Portrait galleries abounded; there were the usual images of Greek philosophers, orators and statesmen. Much less known are the Hadrianic copies of late Republican and early Augustan portraits, which clearly must have had a more specific, political function.[49] Finally, there were portraits of the members of the imperial family; here some personal touches can perhaps be seen, and this is certainly the case where the numerous images of Antinous are concerned (see next chapter).

Some works appear to be new creations of the Hadrianic period, operating competently within the classical stylistic vocabulary, but nonetheless with a distinct sculptural language of their own. Hadrianic sculptures often,

**Fig. 148** Headless sphinx, found in the villa during recent excavations.

for example, played with the discrepancy between a severe, linear build of the body and the smooth softness of its surface, resulting in a discernible style.[50]

The workshops may have been based locally, in some instances perhaps even at the villa.[51] Certainly most of the marble used is of Italian origin, even if it is likely that many of the sculptors and marble carvers came from the Greek east or were trained in that tradition. They all remain anonymous except for two individuals, the Greeks Aristeas and Papias from Aphrodisias in Asia Minor, whose signatures have survived on some magnificent centaurs now in the Capitoline Museum and who may also have carved a famous satyr in red stone.[52] The workshops involved in furnishing the villa with all these statues, unsurprisingly, may have produced the portraits of Antinous as well.[53]

By and large, these sculptures were not necessarily meant to be seen as individual masterpieces, but were there to conjure up mythological and religious associations and create spaces rich in allegorical significance. Together they constitute a complete classical cultural and religious Pantheon, impressing on the contemporary observer the significance of Rome as the powerful guardian of Greece's ancient heritage but also its seemingly preordained dominance expressed in the assured use of these icons for its own purposes. In assembling these works, Hadrian did not have in mind the creation of a 'museum' of classical art, even if in retrospect the villa has in part taken on this function, with all that entails. In some cases, villa sculptures now have to stand in for lost originals or provide important information otherwise not available to us. The copies of the Erechtheion Caryatids from the Canopus at the villa, for example, preserve details no longer visible on the originals on the Athenian Acropolis.

Whether some of the artworks, in particular specific mosaic panels, are in fact pre-Hadrianic collector's pieces is debated. Certainly fragments of original Middle-Kingdom Egyptian statues were recently excavated at the Antinoeion; but on the whole these sculptures were custom-made and installed to celebrate Hadrian's political ideas and virtues as a ruler. Greek-looking art served here, as it often did in Roman contexts, as an abstract symbol of current political ideas. The villa thus constituted a vast mnemonic landscape full of classical connotations. The Dionysiac world stood as topos for an essential *joi de vivre*, while mythological references symbolized the heroic past, all ultimately politically representative signs of the underlying virtues that made possible Hadrian's new *saeculum aureum*, or golden age.

**Fig. 149** A satyr in red stone. Much admired by visitors on the Grand Tour, the statue was discovered close to the Dove Mosaic (fig. 138) in the south-west of the villa. It may be the work of sculptors from the city of Aphrodisias in Asia Minor, who signed two sculptures found nearby.

# V Antinous

'This shameless
and scandalous boy'

ST ATHANASIUS, *APOLOGIA
CONTRA ARIANOS*, PART III, 5.230

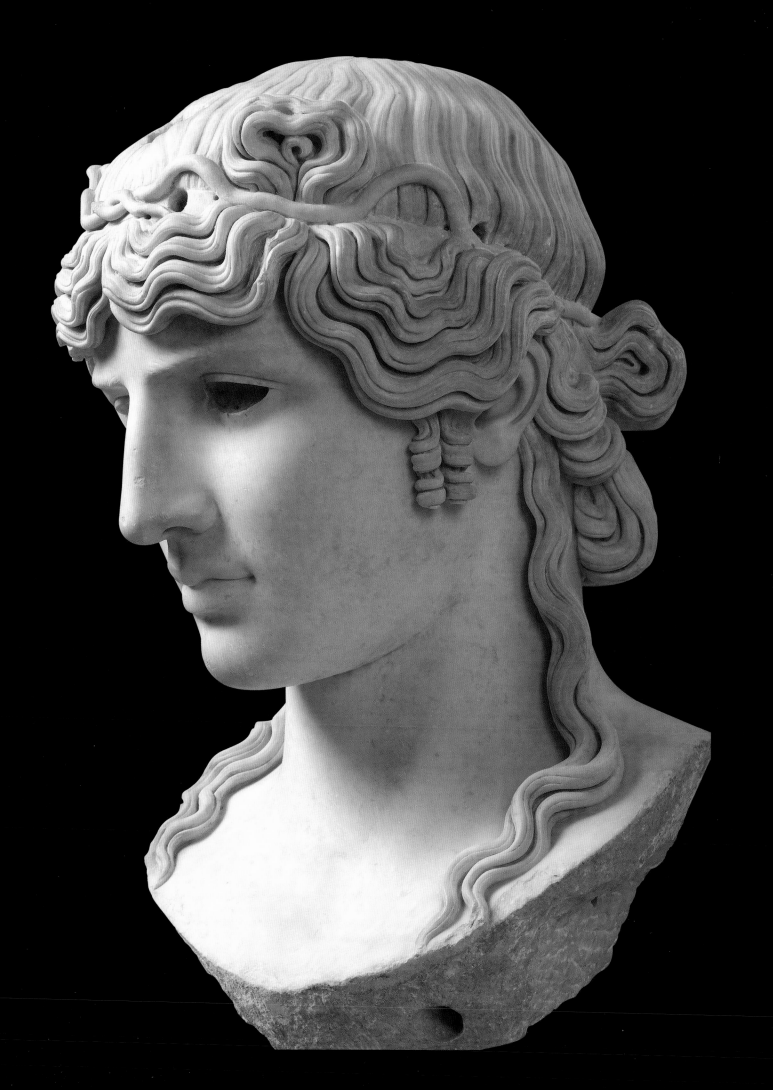

HADRIAN was gay. The exact nature of his sexuality has been the subject of much speculation, ranging from contemporary detractors to enraged Christians and shamefaced modern historians, and it continues to occupy his biographers to this day.[1] Yet to ordinary Romans it mattered little, for in the beginning, at least, Hadrian's predilections seemed nothing special.

If anything set Hadrian apart, it was that his name became forever associated with one particular individual: Antinous, a young Greek in his entourage. This was prompted not by their behaviour towards each other in public or private, but by the unprecedented honours Hadrian lavished on his deceased lover after Antinous' death in the Nile in AD 130. The spread and continuing popularity of Antinous' posthumous cult sparked extremely hostile reactions, especially by Christians eager to eliminate this spiritual rival to their own Christ. At the same time, the countless images set up in Antinous' memory form a very visible and highly influential part of Hadrian's legacy.[2]

Attempts by modern scholars to reconstruct Antinous' biography and, with it, his significance in Hadrian's life are hampered by the limitations of our sources and their often manifest partiality. Much of what has been said is therefore tenuous to the extreme. Yet by changing our perspective, we can see Hadrian's relationship with Antinous as a mirror of Roman society and the development of his cult as a revealing metaphor for the subtle workings of Roman rule.

## Sexual relations in ancient Rome

There must have been many gay men and women in the Roman empire. Yet the Romans had an attitude to homosexuality so radically different from that of modern western societies as to render this categorization meaningless.[3] It is important at the outset to understand this Roman context and not, as many have done, to dwell automatically on possible Greek precedents for Hadrian's behaviour only because Antinous was Greek and Hadrian a philhellene.

Language is one of the most revealing pointers in defining Roman concepts of sexuality: in Latin there is a finely nuanced slang vocabulary for various gay sex acts, but no word for homosexuality.[4] In his sexual relationships the Roman male was expected to prove his dominance and virility. This, however, depended not on his choice of partner but on his role in intercourse. What mattered was to be the active partner, not the passive, penetrated. Passive partners by definition included women, but also slaves and the young. A freeborn Roman adult male who allowed himself to be in a passive role with a partner of either sex invited ridicule and a lasting damage to his reputation. Such men were abused as *cinaedi* or *pathici*.

Yet a concept of illicit sexual intercourse, defined by the term *stuprum*, certainly existed. *Stuprum* involved illicit relationships with married women and

PREVIOUS PAGE
**Fig. 150** The Mondragone Head of Antinous
see p. 184).

male adult citizens. There was some form of legislation, the *lex Scantinia*, to deal with such transgressions, but it seems to have been evoked mostly for political slander and was rarely enforced.[5] In practice then, many Roman men, certainly those of the upper class, were what we now would call bisexual. Yet provided that they took the active part in their sexual encounters, this would not have led them to question their own manhood in any way.

Revealingly, the only reference to Hadrian's intercourse with women is precisely within this context of *stuprum*, indicating the hostility of our source. Hadrian, it says, had a 'passion for adult males and adulteries with married women'.[6] This passage has been much quoted by those interested in finding evidence at least of Hadrian's bisexual practices – more palatable to some than an outright admission of his homosexuality – yet it simply enumerates the twin sources of possible sexual transgression in Roman society.[7]

A quick glance at the *Lives of the Caesars* by Suetonius, a writer and official active at Hadrian's court until his sudden fall from grace, underlines how unexceptional Hadrian's own sexual preferences must have appeared to his contemporaries. Of the twelve rulers included in Suetonius' work, only two lack any homosexual proclivities. Nero, for example, is said to have been 'married' to his freedman Doryphorus, a ceremony in which he willingly took the role of the bride,[8] while Domitian was devoted to the eunuch Earinos, a relationship likened by the poets Martial and Statius to that between Jupiter, the king of the gods, and his youthful cup-bearer Ganymede.[9] While both these rulers found an ignoble end, such accounts are by no means restricted to 'bad' emperors. The best example of how the mere fact that a man slept with other men or boys had no negative effect on his reputation is Trajan, the warrior-ruler and 'best of princes'. As Hadrian's distant relative and guardian, Trajan furthermore provided an immediate role model for the young Hadrian. According to the historian Dio, Trajan was 'devoted to

**Fig. 151** The Warren Cup. The luxury silver drinking vessel (the handles are now missing) shows scenes of gay love-making in a Hellenized interior setting. Although the cup was probably made in the early empire, it can serve to illustrate the homoerotic culture of the Roman elite in Hadrian's time.

boys',[10] and various sources, all favourable to the emperor, confirm this.[11] The boys in question were mostly pages at the imperial court. He also had a penchant for young male dancers, two of whom, Pylades and Apolaustus, are specifically named in the sources and were summoned to be with Trajan at his campaign headquarters in Syria. If the emperor's sexual preferences were no secret, they were aimed at groups outside the strict moral codes applying to citizens and therefore caused no negative comment. On the contrary, while indulging himself with his favourites, Trajan could at the same time be considered a model family man. He was married to Pompeia Plotina, whom he treated with the greatest respect in public, and always remained close to his own sister Ulpia Marciana (see chapter I). The imperial family thus projected a traditional image that neither its members nor the Roman public would have considered duplicitous.

A first indication that Hadrian shared his guardian's sexual tastes may be implied by an obscure reference in the *Historia Augusta*. Hadrian got into trouble 'due to the activities of the guardians of certain boys whom Trajan loved ardently'.[12] Later we hear that he 'cultivated Trajan's boy favourites and had frequent sexual intercourse with them when an inner member of the court'.[13] Several sources mention that Hadrian composed poems to his favourite boys, none of which have survived.[14]

Trajan's example should already warn against looking for a Greek cultural context when explaining Roman pederasty, that is, a sexual preference for boys. This is confirmed by an analysis of Roman literary sources that do not mark out this practice as particularly Greek.[15]

In classical Greece it had been considered quite normal for adolescents to have a sexual relationship with an older man, to an extent that this could become a natural rite of passage.[16] The man in such cases was the active partner (*erastes*), the boy the passive one (*eromenos*). This relationship ceased when the boy reached manhood, for gay sex between adults was deemed unnatural and bad. While Roman men engaging in sex with boys could thus theoretically consider such relationships to be culturally sanctioned by the classical precedent, they certainly did not need to. Yet in the case of Hadrian scholars have consistently linked his association with Antinous precisely with his interest in all things Greek.

## Life of Antinous

Hardly anything is known about Antinous' life, and the fact that our sources get more detailed the later they are does not inspire confidence.[17] He was a Greek from the city of Bythinion-Claudiopolis in western Asia Minor, modern Turkey, or more precisely from a place called Mantinium not far away. The surviving literary sources make no mention of where and when Hadrian first encountered

Antinous, but it is possible that they met when Hadrian toured the province in AD 123, so that their relationship may have lasted for up to seven years. Yet all this must remain conjecture, for it is not until AD 130 that Antinous is explicitly mentioned in Hadrian's presence, and then the only reference to their shared activity is in relation to hunting (see p. 173). Already, therefore, the frustrating limits of our knowledge become painfully obvious. Was Antinous the beautiful boy who accompanied the emperor on his travels, was he with him during the prolonged stay in Greece, did he live at the sumptuous villa near Tivoli as many fantasize? Or was he simply a skilled young huntsman, one of many in the entourage of a ruler who was impassioned about the chase?

Like Trajan before him, Hadrian was a passionate, almost obsessive hunter. He spent much of his time as a teenager in Spain occupied with this pursuit, taking it to such an excess that imperial censure was swift to follow.[18] When he became emperor himself, Hadrian continued hunting with undiminished zeal wherever he went. Favourite hunting dogs and his beloved charger, Borysthenes, were buried where they fell. Hadrian composed epigrams extolling their virtues that were inscribed on their tombstones. Hunting trophies were dedicated in small rural shrines and commemorated in similar ways. A new city in Asia Minor was even named Hadrianoutherai – 'Hadrian's Hunts'.[19]

There existed of course a long tradition of glorifying the ruler as an accomplished hunter. In peacetime there could be no better way of demonstrating his courage and physical vigour. It could even be claimed that, like the heroes of ancient mythology, the hunting ruler in a very practical manner rid the countryside of dangerous beasts and thus protected his peasant subjects and their harvests. Accordingly, the

**Figs 152 & 153** Two reliefs celebrating the hunting exploits of the emperor: a boar hunt (above) and a lion hunt (below left). The figure in the background of the boar hunt tondo, riding behind Hadrian, bears a strong resemblance to Antinous, but cannot be identified with certainty.

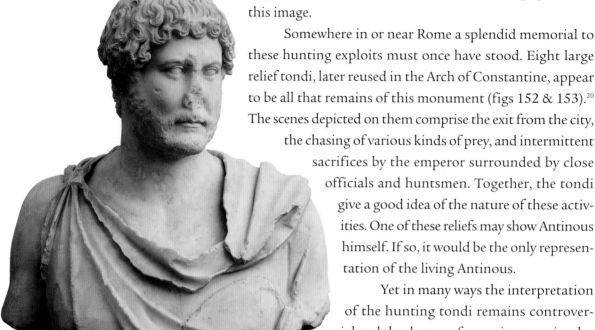

**Fig. 154** Bust of Hadrian in a *paludamentum* (cloak), similar to the one worn by the emperor in the hunting reliefs.

imperial mint struck coins that reinforced and popularized this image.

Somewhere in or near Rome a splendid memorial to these hunting exploits must once have stood. Eight large relief tondi, later reused in the Arch of Constantine, appear to be all that remains of this monument (figs 152 & 153).[20] The scenes depicted on them comprise the exit from the city, the chasing of various kinds of prey, and intermittent sacrifices by the emperor surrounded by close officials and huntsmen. Together, the tondi give a good idea of the nature of these activities. One of these reliefs may show Antinous himself. If so, it would be the only representation of the living Antinous.

Yet in many ways the interpretation of the hunting tondi remains controversial and the danger of resorting to a circular argument is constant. This begins with the date of the tondi. Now generally believed to be Hadrianic, they were considered in the past to have a Trajanic or, much less likely, an even earlier date. If a Hadrianic date is assumed, then it is tempting to recognize Antinous; if one imagines that one sees Antinous, then the tondi automatically become Hadrianic. Crucially, the face of the emperor in the centre of each tondo was radically recarved in later antiquity, as were the faces of some of his companions. Deprived of the identifying original imperial portrait, the date of the tondi thus depends on stylistic considerations – and on whether one believes Antinous is depicted or not.

Yet, while several of the tondi show a young huntsman, he does not look the same in each relief. Is this because the huntsmen are indeed different people, and if so, would this indicate Antinous' unexceptional status as one among many? Or is Antinous shown at different stages of his life, towards the end so different from the familiar images that we hardly recognize him?

It seems that the tondi do indeed show real events and real people. Some of the emperor's companions occur in several episodes and bear distinctive portrait features. The same bearded, mature man reappears, for instance, and is perhaps the master of the imperial hunt. It is important to keep in mind that the imperial hunt was a highly organized event involving dozens, if not hundreds, of specialized personnel, and the core staff would have accompanied the emperor on his travels.

Whether he is depicted on the tondi or not, we know that Antinous hunted with Hadrian; it is only his status we are uncertain about. Whatever the truth,

a deep physical and emotional bond must have developed between the two by the time the imperial party approached the Nile.

## Death of Antinous

Hadrian and his entourage arrived in Egypt from Judaea in the summer of AD 130. He was only the third emperor to visit the province in person; much had to be inspected, including perhaps the reconstruction work in the aftermath of the Jewish rebellion that had ended with the extermination of Alexandria's Jewish population a decade earlier. Antinous was with Hadrian. A poem by the Alexandrian Greek Pankrates describes in epic detail a dramatic lion hunt in the Libyan desert in which Antinous and Hadrian play the major part.[21] In effect, this is the only testimony to their joint activity:

### The Lion Hunt Poem

*And swifter than the horse of Adrastus*
*Which once saved the king as he fled ... in battle-throng.*
*Such was the steed whereon Antinous sat in wait for the deadly lion,*
*Holding in his left hand the bridle-rein*
*And in his right a spear shod with adamant.*
*First Hadrian his brass fitted spear wounded the beast*
*But slew him not, for of purpose he missed the mark,*
*Wishing to test to the full the sureness of aim*
*Of his beauteous Antinous, son of the Argus-slayer.*
*Stricken, the beast was yet more aroused,*
*And tore up in his wrath the rough ground with his paws,*
*And dust rising in a cloud dimmed the light of the sun.*
*He raged even as the wave of the surging sea*
*When Zephyrus is stirred forth after the wind of Strumon.*
*Straight he rushed upon them both,*
*Scourging with his tail, his haunches and sides*
*While his eyes, beneath his brows, flashed dreadful fire;*
*And from his ravening jaws the foam showered to the earth*
*As his teeth gnashed within.*
*On his mighty head and shaggy neck the hair stood bristling.*
*On his limbs it was bushy as trees,*
*And on his back ... it was like whetted spear points.*
*In such wise he came against the glorious god, upon Antinous*
*Like Typhoeus of old against Zeus, slayer of giants ...*

**Fig. 155** Papyrus fragment with the Greek poem by the Alexandrian writer Pankrates.

Eventually, after an extended stay in the provincial capital, the royal party embarked on a voyage up the Nile. In the second half of October they reached the city of Hermopolis. On 22 October the people of Egypt celebrated the traditional festival of the Nile, and on the 24th they commemorated the death of Osiris, the Egyptian god who, according to ancient myth, had drowned in the river.[22]

It was on that very day that disaster struck: Antinous, too, perished in the river. This coincidence immediately gave rise to much speculation and has continued to do so ever since. Our sources suggest that Hadrian referred to Antinous' death as an accident in his autobiography; many have subsequently thought that he did so because he had something to hide.[23] Rumours appear to have circulated that Hadrian either forced or convinced Antinous to commit suicide in order to prolong his own life, influenced by unusual esoteric beliefs and perhaps prompted by his astrologers. Yet most of these testimonies are late and their malicious intent is obvious. Modern commentators have instead highlighted the fact that Antinous had now reached manhood and that, according to traditional Greek norms, he had become too old to continue a sexual relationship with Hadrian. Of course his sudden death may simply have been a tragic accident.

The events that followed inspired the Antinous myth and are in fact the main reason to suggest that a deep emotional bond existed between him and the emperor. For Hadrian mourned Antinous in a manner completely unexpected by his Roman contemporaries. More importantly, he commemorated him in a fashion entirely unusual for someone of Antinous' lowly status. Bypassing the traditional Roman process for the official deification of a deceased person – one of the last, carefully guarded privileges of the senate – Hadrian now encouraged the locals to venerate Antinous as the incarnation of Osiris. Egyptians in his entourage may have suggested this to him on their own initiative, for in Egypt it was a long-held belief that those who drowned in the river underwent the same transformation as the god and were reborn. The proximity of Antinous' death to the Osiris festival made this link even more apposite.

A few days later, on 30 October, Hadrian founded a new city close to the spot where Antinous had died. Located on the opposite bank to the existing town of Hermopolis, he named the new settlement Antinoopolis – 'Antinous-City'. This seems a very grand, deeply emotional gesture. It was steeped in classical precedent, where new cities grew around the tombs of their founding heroes. And yet, there are some indications that the emperor had intended to found a new city for Greek settlers in Egypt from the outset. This would have been part of his general policy of strengthening the Greek element in the eastern provinces; it may have seemed particularly acute in the wake of the various internal and external threats facing the eastern empire. Economic considerations probably played a part, too, as a new port on the right bank of the Nile was highly

**Fig. 156** Statue of Antinous in the guise of the Egyptian god Osiris (see also detail next page). Like Osiris, Antinous was believed to have been reborn from the waters of the Nile. The statue follows ancient Egyptian models, subtly classicizing and eroticizing them. It can now be attributed to the Antinoeion at Hadrian's villa.

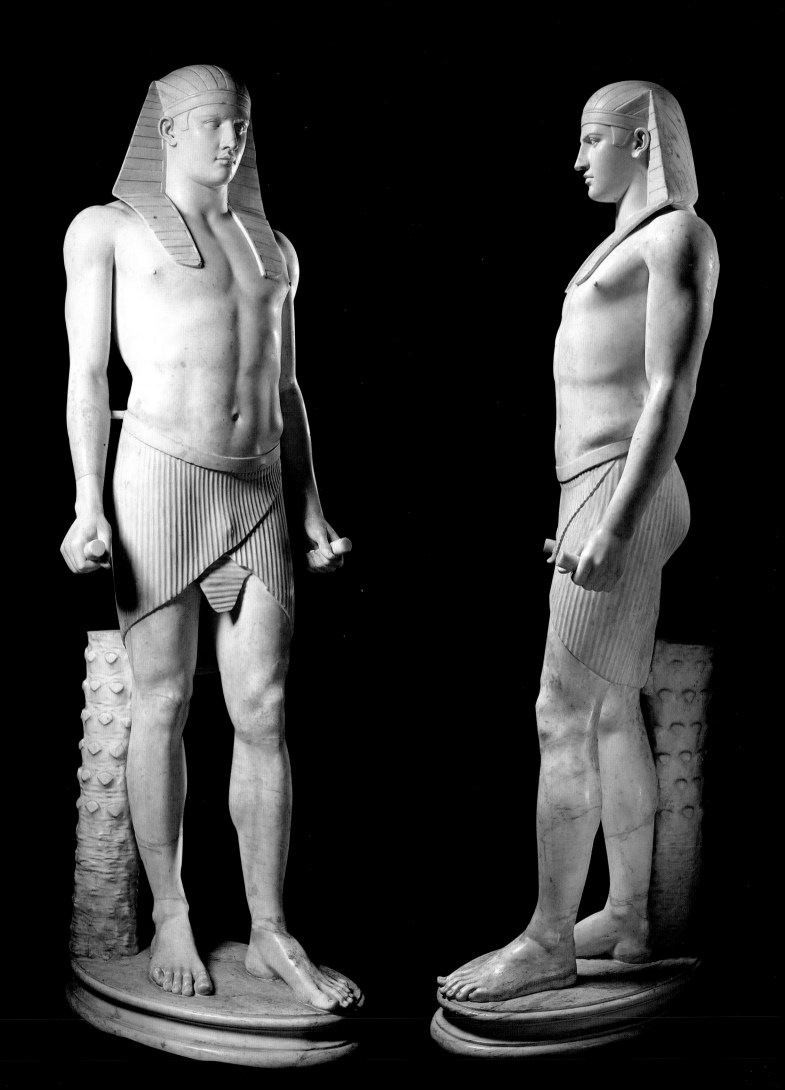

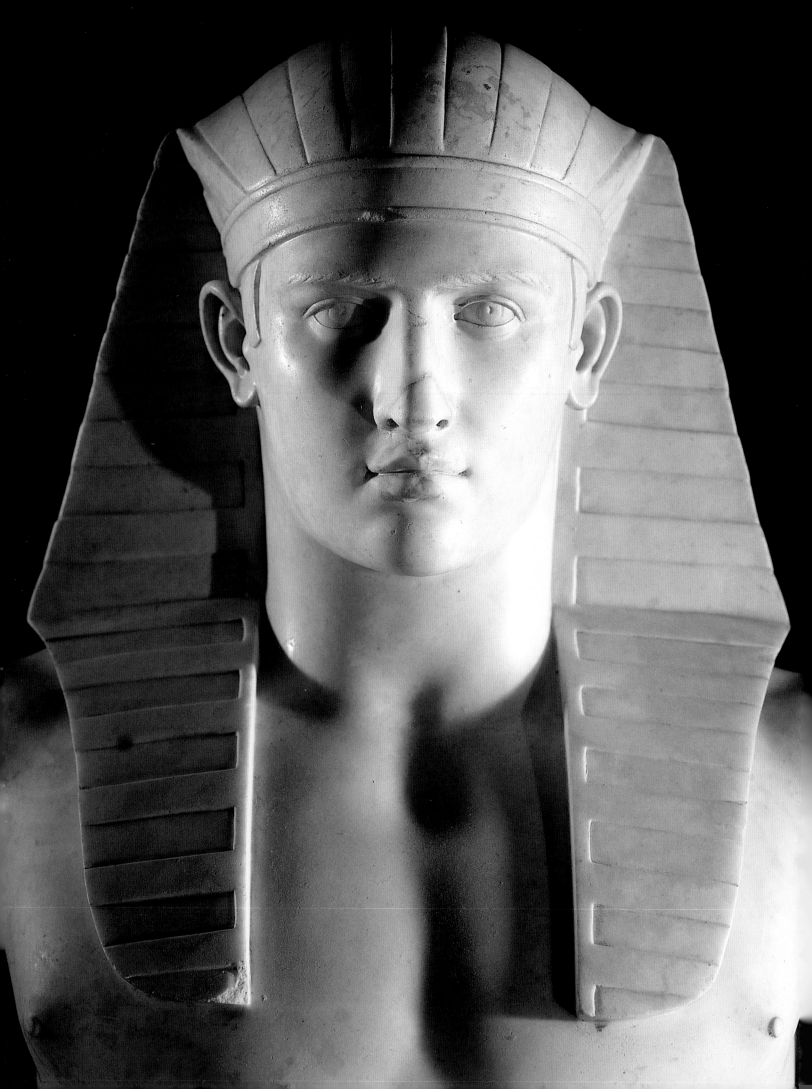

**Fig. 158** The Pincio obelisk, a monument in Egyptian style describing in hieroglyphic script the cult for Antinous. New research suggests that it may have come from the Antinoeion at Hadrian's villa.

desirable to complement the old entrepôt of Koptos much further south. If this were true, then the foundation of Antinoopolis appears less as a romantic act of devotion and more as a highly opportunistic measure of improvisation. Antinous, dead only a few days, was well on the way to becoming a cultural icon around which the Greeks could rally.

The new city sprang up around the temple, or temple-tomb, of Antinous. Otherwise, it was closely modelled on Naucratis, the oldest Greek settlement in Egypt. Its first citizens, initially a mix of descendants from Greek families and army veterans, were tempted to move there by tax breaks and various other privileges. Following the model of classical Athens, they were divided into ten tribes of five demes, or parishes, each, mostly named after members of Hadrian's family (Nervanios, Traianios, Aelieus, Hadrianeios, Paulinios, Matidios, Sabinios, Sebasteios, Oseirantinoeios and Athenaieus). A major festival, the Antinoeia, was instigated in Antinous' memory.

An obelisk inscribed with Egyptian hieroglyphs, now standing on the Pincio hill in the centre of Rome, specifies the honours for Antinous in the new city. It was long thought that this obelisk was brought to Rome from Antinopolis

LEFT
**Fig. 157** Head of statue of Antinous as Osiris (see previous page).

**Fig. 159** Sketch drawing of the grand entrance to Hadrian's villa for official visitors. At the end is the Great Vestibulum and in a very prominent position on the right, the newly discovered Antinoeion.

at some time in later antiquity, but new discoveries in Hadrian's villa may suggest otherwise. The hieroglyphic text describes Antinous' temple, of which nothing now survives, in detail: it was built of good white stone, surrounded by statues of the gods and by numerous columns.[24]

Many details of the city's infrastructure and the Antinous cult were undoubtedly worked out only after the imperial party had returned to Alexandria, where the court remained for several months. It was here that courtiers and intellectuals now gathered and delivered speeches and poems to console Hadrian. Pankrates' lion hunt poem gives us a flavour of these offerings. No

**Fig. 160** Computer model of the Antinoeion at Hadrian's villa. The palm trees evoked the landscape along the Nile in which Antinous perished. At the centre is the obelisk now in Rome.

**Figs 161–4** Architectural fragments (column, capital and wall fragment with hieroglyphic inscription) from the temple-like shrines in the Antinoeion. Sculptures copying Egyptian models, like the small head in dark stone with pharaonic headgear, as well as genuine ancient Egyptian works formed the decoration of the monument. The wall fragment has been assigned to the interior of one of the shrines. It shows the base of a throne, which may have supported a seated god receiving Antinous-Osiris.

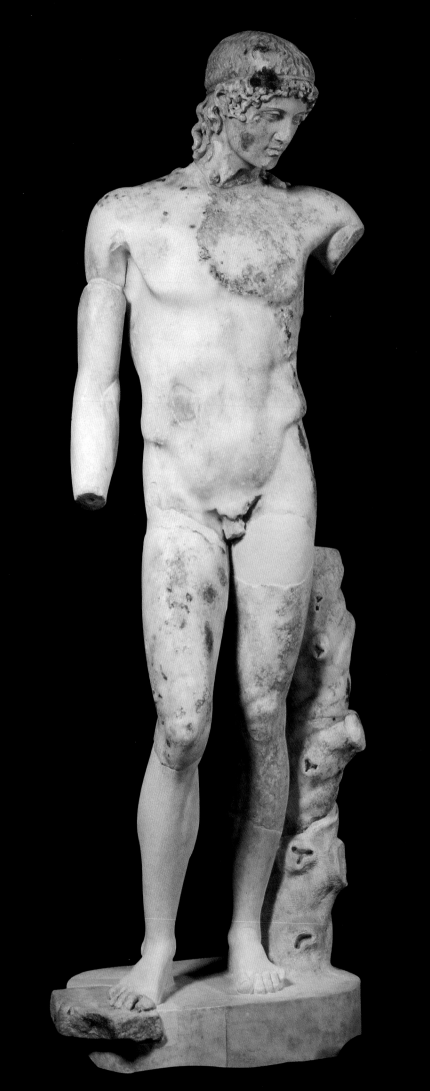

doubt there was also a sense of competition between the various performers; much of Antinous' later iconography must have been developed at that time. This spontaneous reaction to the emperor's obvious emotional distress is the clearest indication of the intensity of Hadrian's relationship with Antinous.

## Creating the image

Hadrian clearly felt a strong need to surround himself with Antinous' images and thereby perpetuate his presence. His suffering and intense sense of bereavement are nowhere more obvious than at the great villa at Tivoli. At least ten marble images of Antinous were found there, dedicated, at the latest, after Hadrian's return to the villa in AD 134, and other evidence indicates that one of the existing sets of rooms was converted into a small chapel-like shrine.[25]

Only recently, however, in the year 2000, have Italian archaeologists made a key discovery at the site. South of the so-called Cento Camerelle, along one of the main access routes to the villa (see map, pp. 138–9), they found the remains of a substantial structure consisting of two small facing temple buildings in front of a large semi-circular exedra (fig. 160). Fragments of Egyptian-style sculpture, as well as of ancient Egyptian originals, and remnants of the outer walls of the temples with hieroglyphic inscriptions, leave little doubt that this was a sanctuary, perhaps even a monumental tomb or cenotaph for Antinous himself.[26]

Even though it seems that the exedra may not have been finished, undoubtedly due to Hadrian's own death in AD 138, the location of the monument along one of the main access roads to the palace, near the grand entrance *vestibulum*, could not have been more prominent. Here, elite visitors from all corners of the empire would have encountered images of Antinous that must have left a lasting impression on them. In accordance with the Egyptian-style carvings on the Antinous obelisk, they appear to have shown him in his posthumous incarnation as Antinous-Osiris. With these new discoveries it now seems a distinct possibility that the obelisk on the Pincio in Rome (fig. 158) may in fact have come from this structure in the villa, and not from the city of Antinoopolis in Egypt. Of particular significance in this new context is the following inscription on the obelisk: 'The god who is there, he rests in this place, which belongs to the Lord of Prosperity, [the ruler] of Rome', which would fit the setting in the villa perfectly. Furthermore, detailed research in archives documenting excavations at the villa in the eighteenth century and before has revealed that this is where most of the surviving statues of Antinous-Osiris once stood.[27]

Yet how were these images of Antinous created in the first place? At some point, presumably immediately after Antinous' death, a gifted court artist must have been commissioned to create an official portrait type of the young Bithynian.[28] This artist, who like nearly all of the sculptors of this period remains

**Fig. 165** The Tiber Apollo, a Roman copy after the type of classical statue that served as a model for the newly created image of Antinous.

OVERLEAF
**Fig. 166** Head from an over-lifesized statue of Antinous in the guise of the Greek god Dionysus.

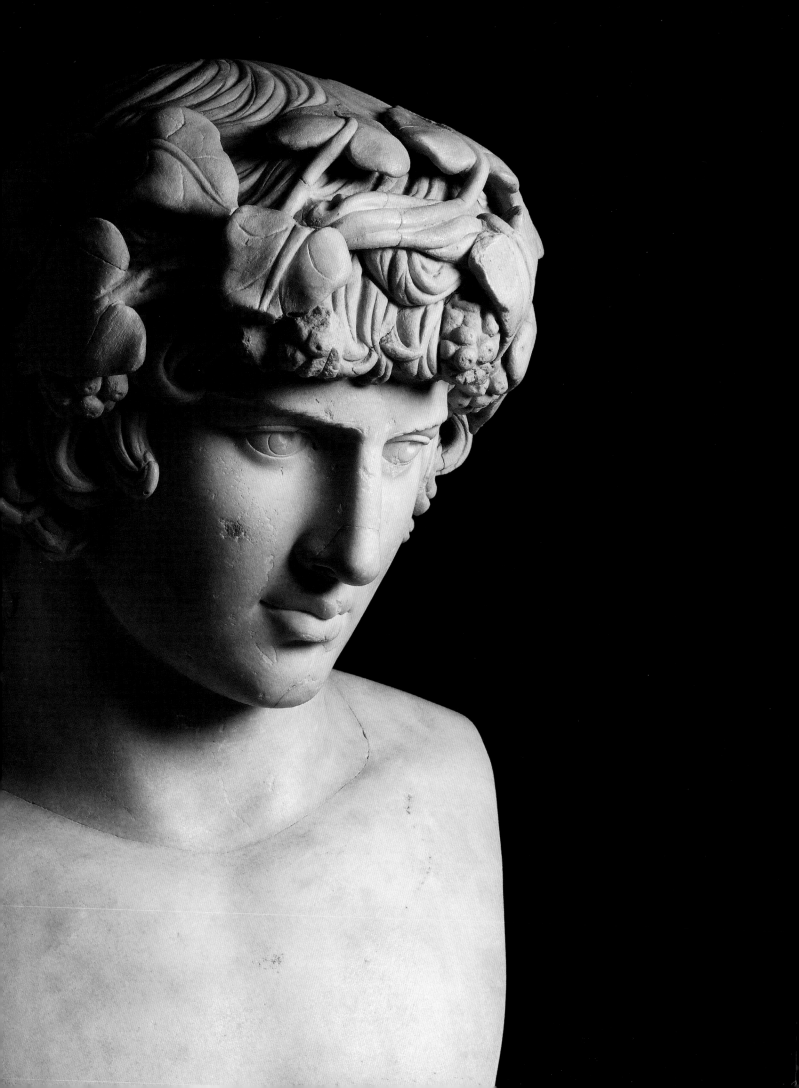

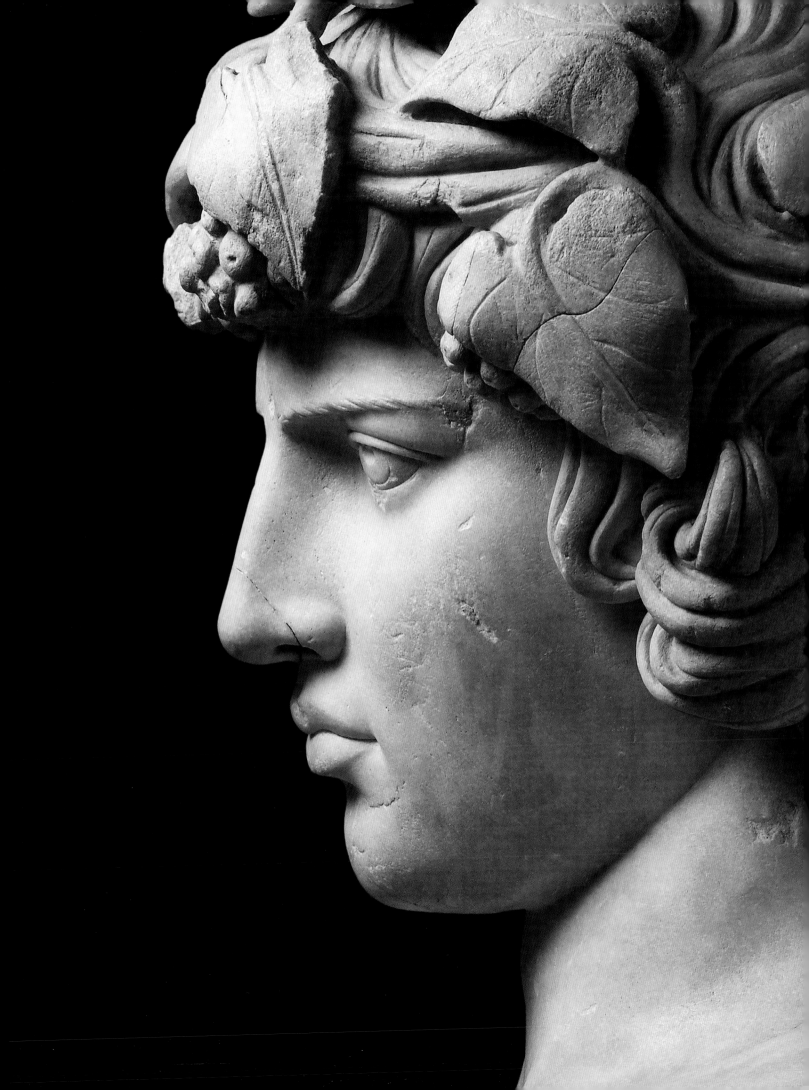

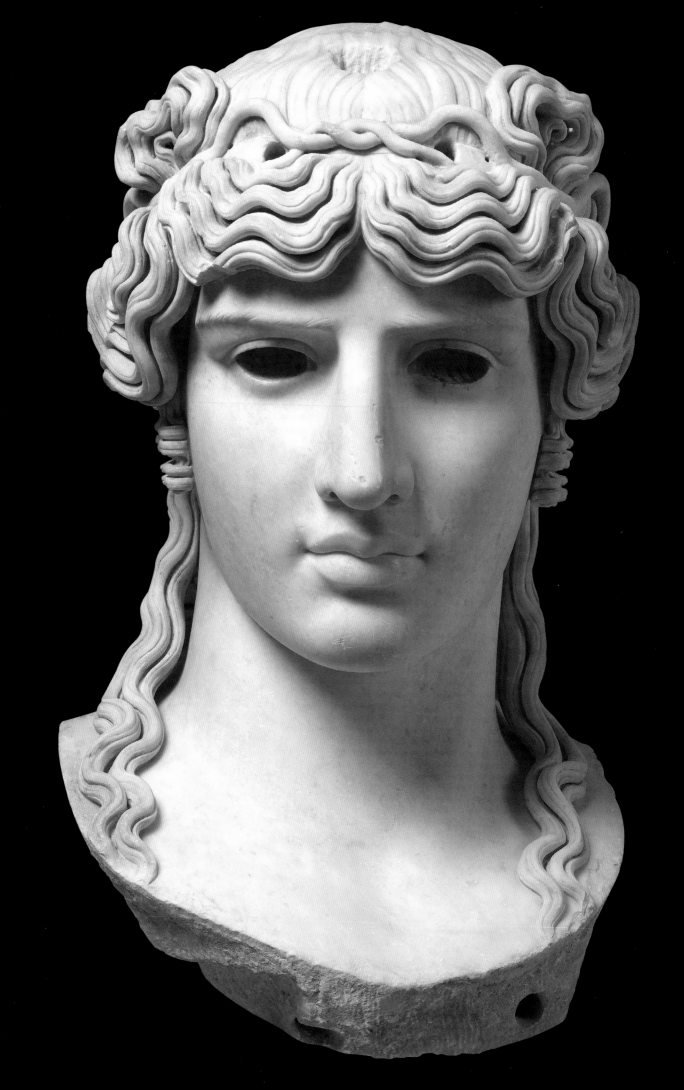

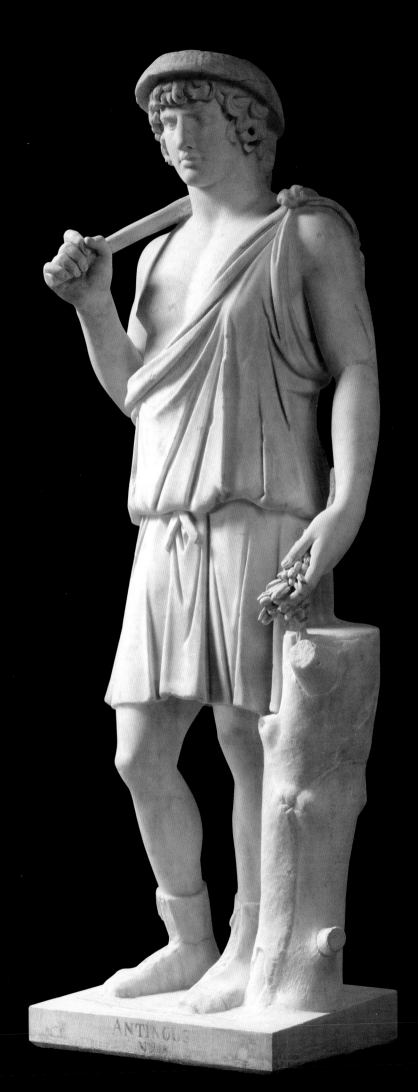

**Fig. 167** The Mondragone Head, a magnificent colossal head of Antinous from a villa near Frascati. Originally, it would have been part of a statue with a wooden torso and marble extremities, a technique normally used for cult images. The eyes were inlaid in a different material, such as coloured marble or glass paste, adding a life-like gaze. The eyelashes were probably made of metal. A series of holes drilled into the hair would have held additional metal leaves and small fruits to complement the wreath carved in marble. The large central hole held a metal crown, probably of the Egyptian type. This would have marked Antinous as the god Dionysus-Osiris.

**Fig. 168** Antinous as Aristaios, a god associated with the hunt, agriculture and animal husbandry. He is dressed in a simple, short garment and wears a Greek-style hat, a hoe in his right hand. Coins issued by the city of Bithynion-Claudiopolis in Asia Minor represent Antinous in the same manner.

anonymous to us, created a masterpiece, fitting for one of the last pagan gods of antiquity and emblematic of what has been termed the Hadrianic Renaissance, with its great increase in sculptural output. For this purpose he took the body type of a famous fifth-century-BC statue of a classical god (fig. 165) and combined it in a more contemporary style with an individual-looking portrait head with long hair and a sensuous face. This Ur-Antinous was probably equipped with the attributes of the god Dionysus, the closest equivalent in the Greek pantheon to the Egyptian Osiris. The intense, beautiful face of this Antinous-Dionysus provides a beguiling contrast with the powerful, masculine build of the body. A number of full-length copies, among them a statue in Delphi, and a few very large busts give an idea of what this first statuary type of Antinous looked like.

Depending on their intended setting, many different types of Antinous statues were created in the following years. Antinous was likened to an array of different gods, from Osiris himself to minor deities like Sylvanus and Autumnus. Busts and small statues were made for domestic settings, colossal statues for religious shrines. There were also reliefs and more intimate objects, such as gems, bearing his portrait.

About one hundred marble images of Antinous are currently known to archaeologists. They turn his portrait type into one of the most powerful legacies from classical antiquity, in numbers only surpassed by the images of the Emperors Augustus and Hadrian himself. Archaeologists can divide the various portraits into a number of distinct types and trace the way they were disseminated. Importantly, the pattern that thus emerges is very clearly the same as for imperial portraits, and it seems that the same workshops were involved.

## The Antinous cult

According to the historian Dio, images of Antinous could be found 'in the entire world'.[29] Yet how and why did Antinous' posthumous fame spread so widely and rapidly? On closer analysis, it quickly becomes apparent that the processes involved provide an insight into the nature of Roman rule itself.[30]

It seems that, apart from the initial establishment of the cult at Antinoopolis and a similar arrangement at Mantineia, the Greek mother city of Antinous' birthplace Mantineum, Hadrian issued no orders. Rather, he set an example, a precedent that others could follow of their own accord. For centuries, Rome had understood how to co-opt the local elites into her rule, to make them identify with Rome's cause because it was to their own advantage. The same principle applied now. In general terms, the Antinous phenomenon ought to be closely linked to the nature of Hadrian's perceived philhellenism. But how much of this was selfless admiration for a superior culture and how much clever cultural realpolitik designed to get the key ethnic group of the eastern empire on side?

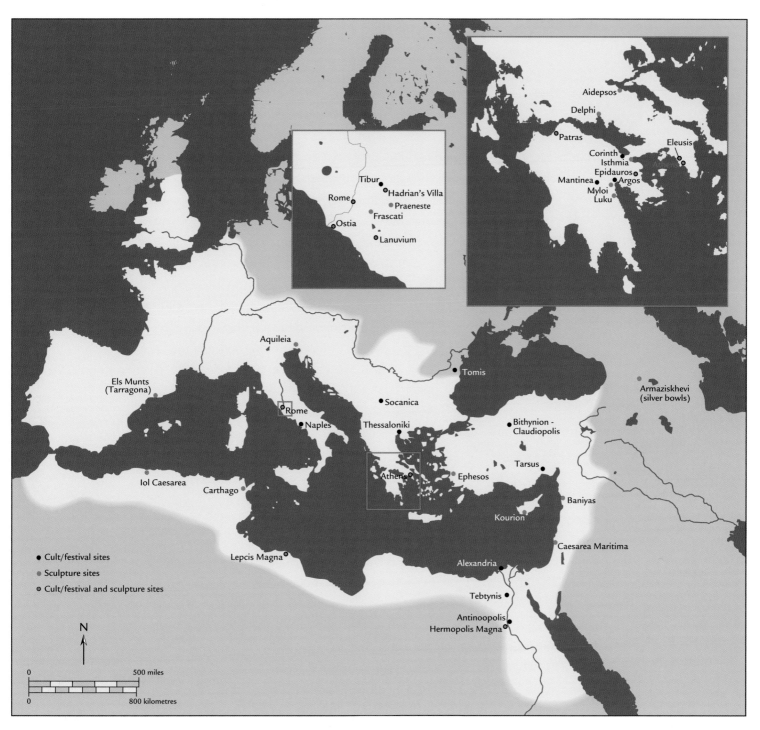

**Fig. 169** Findspots of Antinous sculptures and attested cult sites. In addition, many cities in the Greek east issued coins with Antinous' image.

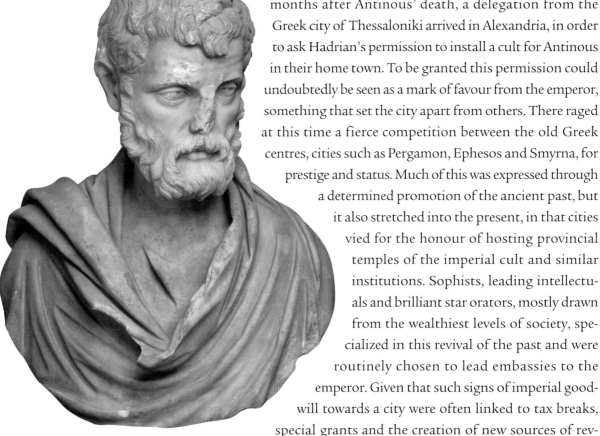

Already in late AD 130 or early AD 131, only a few months after Antinous' death, a delegation from the Greek city of Thessaloniki arrived in Alexandria, in order to ask Hadrian's permission to install a cult for Antinous in their home town. To be granted this permission could undoubtedly be seen as a mark of favour from the emperor, something that set the city apart from others. There raged at this time a fierce competition between the old Greek centres, cities such as Pergamon, Ephesos and Smyrna, for prestige and status. Much of this was expressed through a determined promotion of the ancient past, but it also stretched into the present, in that cities vied for the honour of hosting provincial temples of the imperial cult and similar institutions. Sophists, leading intellectuals and brilliant star orators, mostly drawn from the wealthiest levels of society, specialized in this revival of the past and were routinely chosen to lead embassies to the emperor. Given that such signs of imperial goodwill towards a city were often linked to tax breaks, special grants and the creation of new sources of revenue, this certainly had eminently practical consequences. Clearly, the establishment of shrines and festivals for Antinous now fell into exactly the same category.

To the west of Alexandria, in Roman north Africa, the citizens of Lepcis Magna similarly seem to have been in a hurry to show their reverence to the emperor, perhaps because they expected Hadrian to visit their city. Thus, they quickly set up images of his recently deceased beloved. To achieve this rapidly, and economically, it seems that they replaced the face of a statue of the god Apollo Lykeios in their recently finished bath building with one of Antinous-Dionysus.

It appears to have been the senatorial elite in particular that took the lead in spreading the cult. Much of the detail of this process is still unknown, but some very recent archaeological discoveries allow fascinating insights. In a country villa of the fabulously wealthy

**Fig. 170** Herodes Atticus (*c.* AD 103–78) had close personal links with Hadrian. As a fifteen-year-old, he was sent to convey the congratulations of the Athenians on Hadrian's accession, but broke down with nerves before the emperor. Later, Herodes pursued a political career in Athens and Rome. After Hadrian's death, he was one of the tutors of the young crown princes Marcus Aurelius and Lucius Verus. As a young boy, he had himself learnt Latin in the house of Marcus' grandfather in Rome.

**Fig. 171** Bust of Hadrian, discovered in the villa of Herodes Atticus at Luku in 1995. Here, the usual image of the mythical Gorgon Medusa decorating the emperor's breastplate has been replaced by a portrait of Antinous. So far without parallel, the sculpture intimately links Hadrian and his deceased lover. Upper-class Greeks like Herodes were instrumental in spreading the Antinous cult.

Athenian sophist Herodes Atticus at Luku in the eastern Peloponnese, a colossal seated statue of Antinous was recently excavated.[31] It seems that it was housed in a purpose-built shrine, a sort of private sanctuary. The image may have been originally set up by Atticus, Herodes' father. Atticus, who died in AD 138, the same year as Hadrian, had been one of the first senators from Greece and high priest of the emperor in Athens. Later, he even became a Roman consul. This naturally brought him into very close contact with Hadrian, and Atticus may have been one of his hosts when the emperor visited Athens.

**Fig. 172** Colossal seated statue of Antinous, also from Luku. He is shown tying a fillet around his head like a victorious athlete.

**Fig. 173** Antinous as Iakchos, a minor deity associated with the religious cult at Eleusis near Athens. Coin issued by the city of Adramyttion in Asia Minor.

He therefore may also have been involved with the introduction of the Antinous cult in the city. At Athens, too, this certainly involved the creation of a new festival, the Antinoeia, which was still celebrated early in the third century.

Not yet identified is the owner of a further important Roman villa at Myloi on the Peloponnese, not too distant from Luku. Here, a large marble statue of Antinous was recently found, as well as the inscribed base of a bronze statue of the young Bithynian.[32] In Spain a portrait statue of Antinous was found in the villa of Caius Valerius Avitus, the local governor, at El Munts near Tarragona.[33]

The display of images of Antinous in the private sphere by these leading individuals was paralleled by their actions in public. At Smyrna Antonius Polemo, the leading sophist of the era, sponsored the issue by the local mint of coins bearing the image of Antinous.[34] At Mantinea the wealthy Spartan Caius Iulius Eurycles Herculanus Lucius Vibullius Pius, a close contemporary and distant relative of Atticus, left funds in his will to erect a splendid stoa with exedras in the city's main agora. It was to be dedicated to the city and to its god, Antinous. Like Atticus, Eurycles was a Roman senator and high priest of the emperor in his home town.[35]

In parallel to this elite promotion of Antinous that was almost certainly influenced by political ends and may have become just one more way of expressing loyalty to the emperor, there developed a genuine and increasingly popular religious cult with a mass following. Its adherents hoped for salvation and eternal life. Lamps, bronze vessels and other objects of daily life demonstrate how Antinous was received by the wider populace and entered everyday iconography.

## Political transformation

An extraordinary find was made in the 1960s in what is now the Republic of Georgia. In Hadrian's time this area, located between the Black and Caspian Seas and north of the Roman province of Armenia, was known as Iberia. It was a typical buffer-state, a vast region that did not really justify the enormous expense of being turned into a full Roman province but that could not be allowed to fall under the control of Rome's powerful eastern adversary, the Parthian empire. Iberia guarded the mountain passes over the mighty Caucasus and with them trade routes and potential invasion points for the peoples of the vast Asian steppes to the north. Realizing that any direct intervention brought with it the imminent

risk of a military confrontation with the rival power, both Rome and Parthia tried to lure Iberia into their camp through diplomatic means. On several occasions Roman texts refer to Hadrian's dealings and not always trouble-free relationship with the Iberian King Pharasmanes II, whom he tried to woo with precious gifts. In the end, after long negotiations and possibly not until the reign of Hadrian's successor Antoninus Pius, Pharasmanes came to Rome on a spectacular state visit.[36]

**Fig. 174** Signet ring of Aspaurukis.

Near the ancient Iberian capital at Armaziskhevi archaeologists discovered a large necropolis with luxurious burials of members of the local higher aristocracy. One of the tombs was particularly rich in grave goods, mostly of gold and silver, and seems to have belonged to a regional governor, a man called Aspaurukis. He can be identified by his seal ring (fig. 174), a carnelian with the portrait of a bearded man and an inscription in Greeks letters giving his name and title: 'Aspaurukis Pitiaxes'. In his grave, together with the signet ring and a ceremonial belt and dagger, a large Roman silver bowl came to light, decorated with a bust of Antinous (fig. 177).[37] Like two other silver bowls found in a tomb nearby (figs 175 & 176), it was certainly made in the West. So how did it get to Georgia? The best interpretation is that they formed part of an official, diplomatic gift. Not only does the Armaziskhevi silver therefore allow us a rare glimpse into how the image of Antinous permeated the luxury arts, but also what we see here is the transformation of the Antinous phenomenon from a private obsession of the emperor into a cultural tool of Roman power politics.

It was this practical use, together with the genuine popularity of the cult, that ensured that the veneration of Antinous did not end with the Hadrian's own death in AD 138. Whether this was intended at the outset or had developed over time, Antinous became an ideal focus that allowed particularly the Greek population of the empire to celebrate its own identity while at the same time expressing loyalty to Rome and thus strengthen the cohesion of the empire.

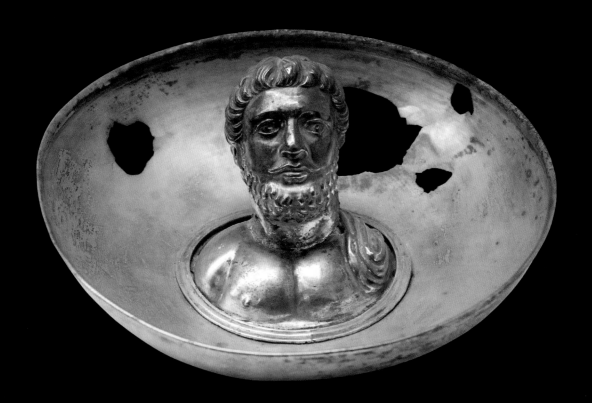

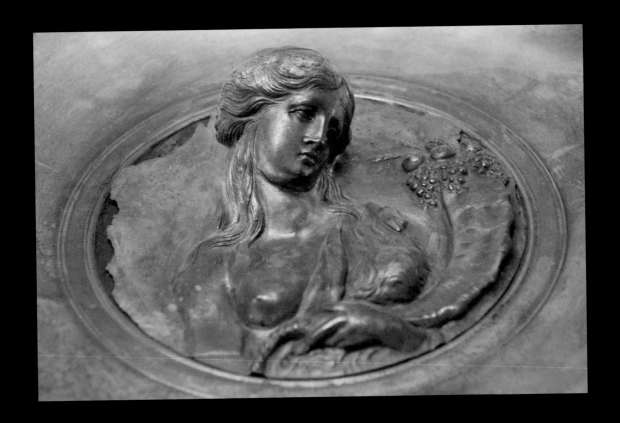

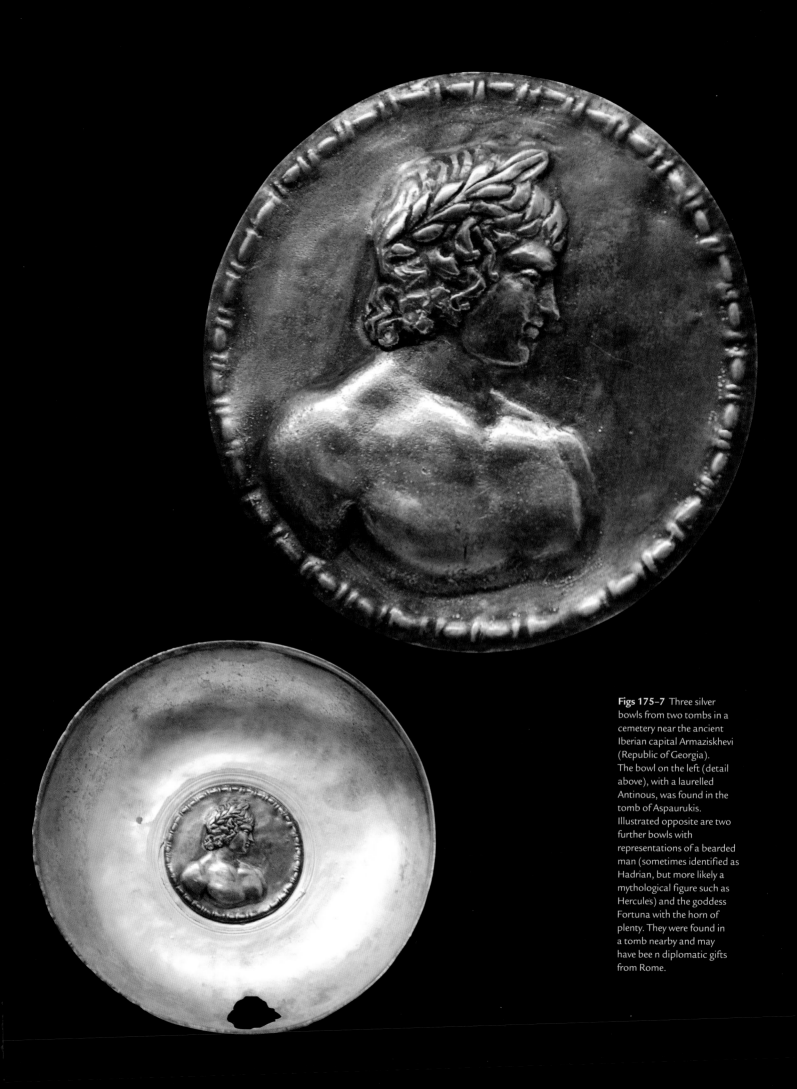

**Figs 175–7** Three silver bowls from two tombs in a cemetery near the ancient Iberian capital Armaziskhevi (Republic of Georgia). The bowl on the left (detail above), with a laurelled Antinous, was found in the tomb of Aspaurukis. Illustrated opposite are two further bowls with representations of a bearded man (sometimes identified as Hadrian, but more likely a mythological figure such as Hercules) and the goddess Fortuna with the horn of plenty. They were found in a tomb nearby and may have bee n diplomatic gifts from Rome.

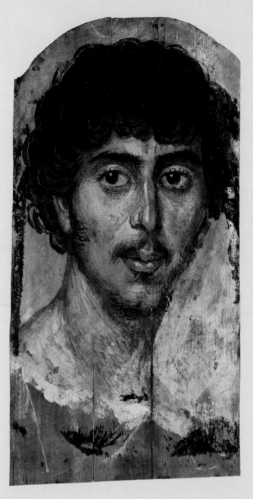

## Mummy portraits

A fascinating group of objects produced as part of the Egyptian funerary cult provides a titillating glimpse of the first generations of settlers in Antinoopolis and their compatriots in other parts of the country. They are portrait paintings on wood or canvas that were wrapped up with the embalmed bodies of the deceased.[38] In their striking immediacy, they seem to bring us face to face with the people who lived when Hadrian and his party visited Egypt and can stand in for the thousands of people all over the empire he must have met.[39] The portrayed belonged to the local elites and more privileged sections of society in Roman Egypt. Women regularly appear with a fine array of jewellery, all recognizable types worn in real life, while the dress details of some men suggest that they belonged to the military or administrative class.[40] Their hairstyles nearly without exception show fashion coiffures common in all parts of the empire, often following trends set at the imperial court at Rome, sometimes with certain modifications found throughout the eastern provinces.[41]

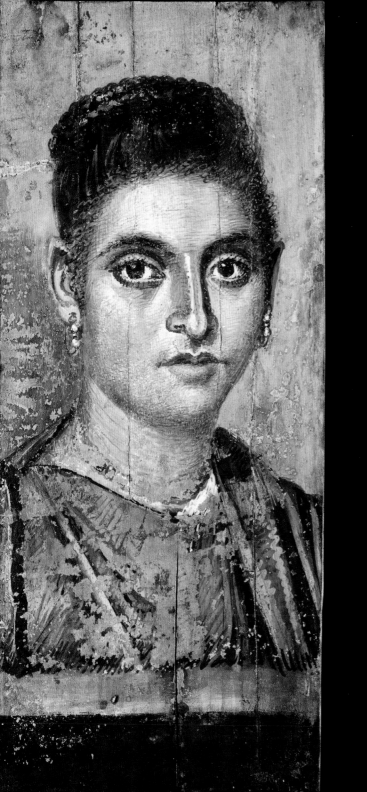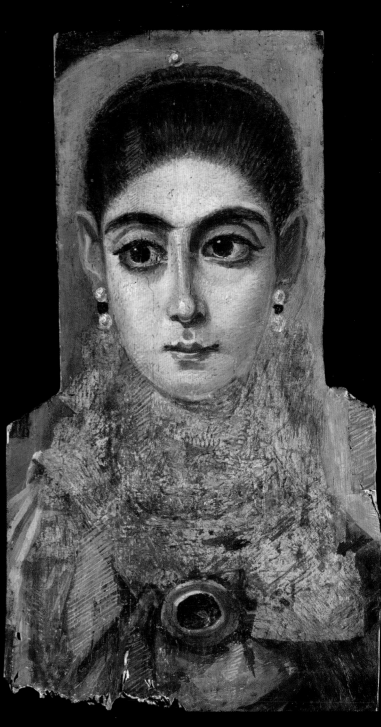

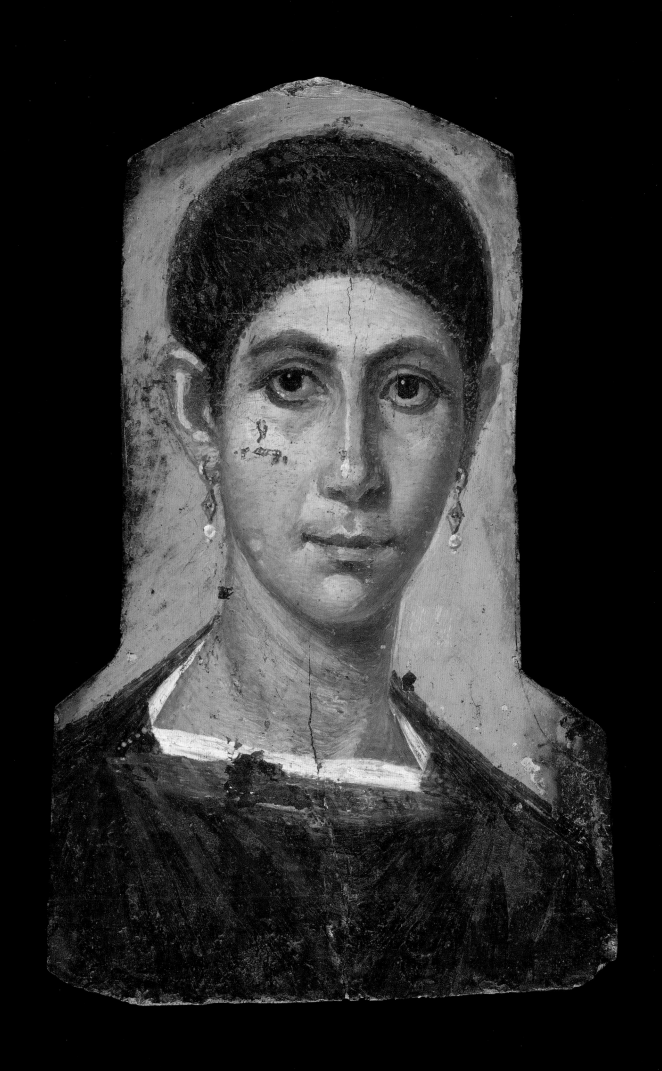

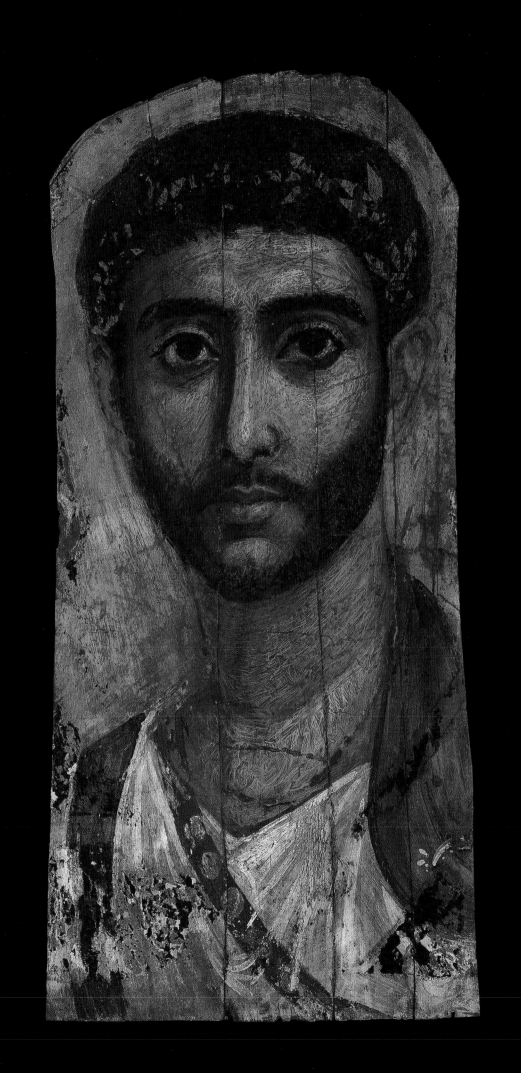

# VI Sabina

'*Yesterday Memnon was silent as he received the wife, in order that the fair Sabina would return here, for the exquisite beauty of our queen pleases you.*'

JULIA BALBILLA (CARVED ON THE LEG
OF THE COLOSSUS OF MEMNON)

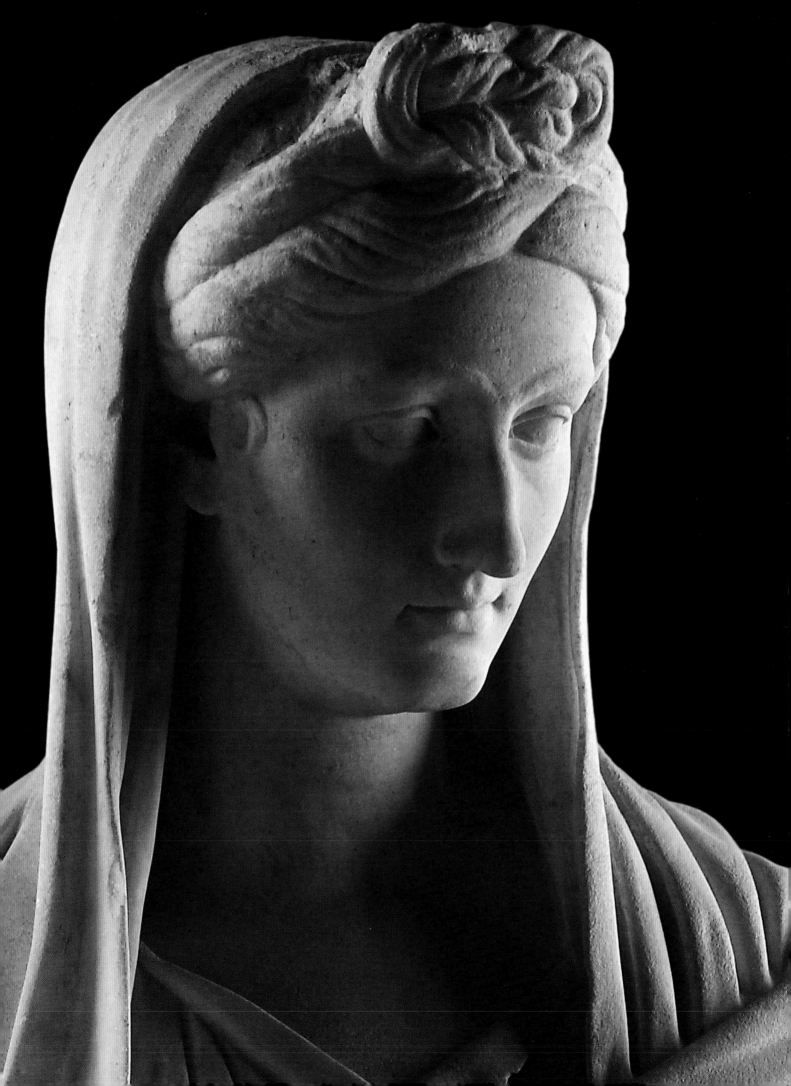

IN the accounts of Hadrian's life, his wife and empress, Vibia Sabina, remains mostly in the shadows.[1] Little detail about Sabina can be gleaned from the ancient literary sources, and what there is hints at a very strained relationship between Hadrian and her. Whether these remarks constitute late echoes of genuine court gossip or are outright inventions is impossible to tell; their hostility towards Hadrian is obvious.

Sabina was born in about AD 86, the daughter of Trajan's beloved niece Matidia and her husband, the senator L. Vibius Sabinus.[2] Her mother had already been married before, to the senator Lucius Mindius. From this union stemmed another daughter, Sabina's older half-sister, Mindia Matidia, or Matidia the Younger (figs 188 & 189).[3] The lives of all the women in the family were transformed when Trajan became emperor in AD 98, despite his wife Plotina's modest – and very popular – pledge when first setting foot in to the imperial palace: 'I enter this building the same woman as I hope to leave it.'[4]

While Sabina's sister seems never to have been married, the marriage between Sabina and Hadrian was arranged in about AD 100, not long after Trajan had acceded to the throne. Sabina was probably about fourteen, the typical age of Roman brides. The union would become politically very advantageous for Hadrian, but it also conformed to the usual patterns within the elite, where marriage alliances between relatives were seen as a way to strengthen family ties and keep family property together. Not long after, in 102, Sabina's father died, and it may be that Sabina and her mother then lived for a while at Trajan's court while Hadrian was away, although she is likely to have joined him later in the east, just as Matidia and Plotina accompanied Trajan into Syria.

Following Trajan's death and Hadrian's succession in AD 117, Sabina became empress. There is no indication that she was involved in politics, and in this she very much conformed to the pattern set by the other women in her family. This was in sharp contrast to the imperial women of the earlier Julio-Claudian period. Livia in particular, the wife of Augustus, had been an equal partner with considerable powers, even if her status was exceptional by any standards. This difference has been explained somewhat awkwardly by the diminished role of imperial spouses under the adoptive emperors, when they had no role to play as mothers of imperial princes.[5] A better explanation might lie in their traditional, provincial background and the very different roles expected from women in this social class as opposed to the daughters of the old patrician aristocracy. While Trajan's wife Plotina is

LEFT
**Fig. 184** Portrait of Sabina in the most widely used type. Crowned by a circlet, this is a much simplified version of her earlier hairstyle (cf. fig. 36).

RIGHT AND PREVIOUS PAGE
**Fig. 185** Over-lifesized portrait statue, probably posthumous.

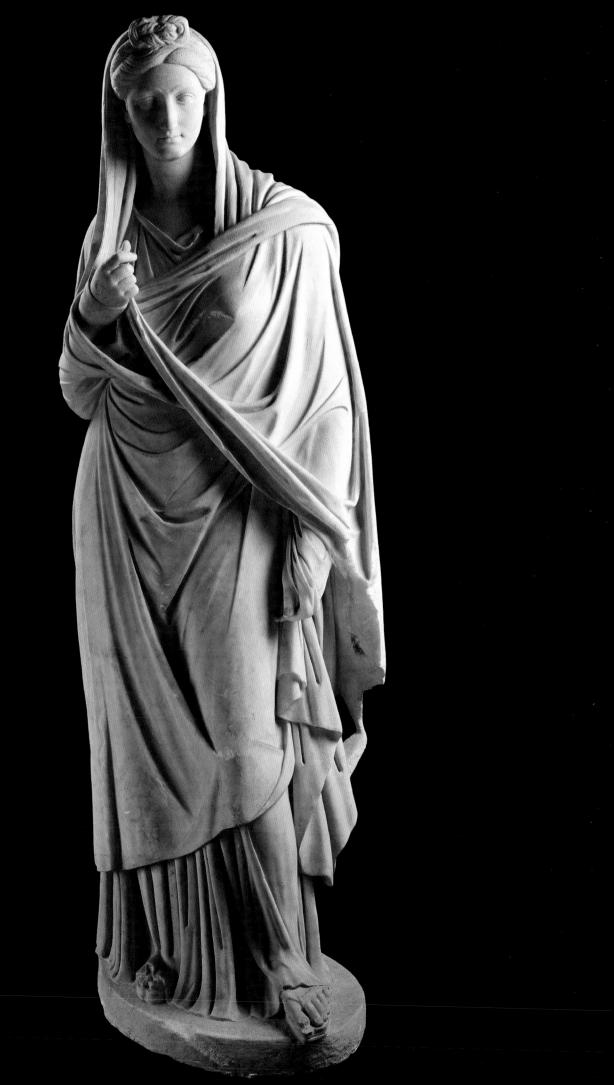

**Fig. 186** Detail of the Sabina statue on the previous page. Traces of red pigment are visible on the folds of the garment below the right hand. Most marble statues were originally painted in colour to appear more life-like.

credited by some sources with being the driving force behind the marriage arrangements for Hadrian and Sabina and later for Hadrian's adoption, even this influence on her husband's decisions does not compare to the much more active public role played by earlier empresses. Nothing like Plotina's influence on Trajan is anywhere ascribed to Sabina in connection with Hadrian, although he did enjoy a close personal relationship with both his mother-in-law Matidia, who may not have been much older than he was, and with Plotina herself.

Hardly anything is known about Sabina's life in the following years. Many scholars assume that Sabina accompanied Hadrian on his extended journeys, although her presence is only explicitly attested for the voyage to the Orient in AD 130. However, in the context of Hadrian's first journey and his stay in Britain in AD 122, the *Historia Augusta* does refer to Sabina. It states that Hadrian '*removed from office Septicius Clarus, the prefect of the guard, and Suetonius Tranquillus, the imperial secretary, and many others besides, because without his consent they had been conducting themselves toward his wife, Sabina, in a more informal fashion than the etiquette of the court demanded. And, as he was himself wont to say, he would have sent away his wife too, on the ground of ill-temper and irritability, had he been merely a private citizen.*'[6] As the guard

**Fig. 187** Cast of a graffito on the colossus of Memnon in Egypt commemorating Sabina's visit. The Greek text states: 'Sabina Augusta, wife of the Imperator Caesar Hadrian, during the first hour heard Memnon twice.'

prefect and the secretary normally accompanied the emperor, this has been taken as evidence that Sabina travelled with the imperial party, although the text does not explicitly say that the misconduct occurred at this time.[7] Without corroborative evidence, the passage is hard to interpret. Marital infidelity and political intrigue have both been adduced.[8] While nothing is certain, the epithets used to characterize Sabina, *aspera* and *morosa*, 'harsh' and 'irritable', have stuck. If Hadrian was not well inclined towards his wife, then some late sources claim the feeling was mutual. According to the *Epitome de Caesaribus*, Sabina 'used to boast openly that she had taken steps to make sure she did not become pregnant by him – offspring of his would harm the human race.'[9] While these passages make entertaining reading, it is hard to assess their veracity. Her marriage to Hadrian, if ever consummated, certainly remained childless. However, the descriptions of Hadrian's behaviour towards Sabina were clearly designed to contrast with his reported treatment of Antinous, and this dichotomy, and Sabina's reaction to that relationship, have very much intrigued all modern commentators.

Whatever the truth may have been, the Roman public's perception of the first couple is likely to have been very different. In the official court ritual and the public representation of the imperial family Hadrian treated Sabina in the same respectful manner with which Trajan had treated his female relatives before him. He granted her the prestigious title of *Augusta*, possibly as early as AD 119, after the death of her mother Matidia.[10] In his funerary address for Matidia Hadrian referred to his wife as *Sabina mea*, 'my Sabina'.[11] Sabina was regularly honoured on coins (see figs 190 & 191), whose legends stressed her matronly virtues (e.g. *pietas* and *pudicitia*, 'piety' and 'modesty') and the marital harmony between her and Hadrian (*concordia augusta*) in the customary manner. Cities around the empire erected statues in her honour, usually in conjunction with those for Hadrian and sometimes in the guise of goddesses such as Juno, Venus and Ceres.[12] Also in line with her

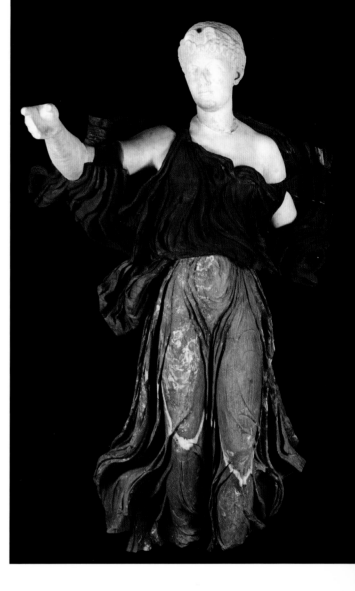

**Fig. 189** Statue of Sabina's sister, Mindia Matidia, from the theatre of Suessa Aurunca in southern Italy, which she had renovated. Different-coloured stones are used to great effect.

**Fig. 188** Marble portrait head of Mindia Matidia, probably from the villa of the Vibii Vari, next to Hadrian's villa at Tivoli.

**Figs 190 & 191** Coin portraits of Sabina help to identify her marble images. The individual portrait types (differentiated mostly by variations in the coiffure) carried political messages or marked important events.

husband, she had numerous portrait types, which were regularly updated, probably to reflect anniversaries and political events.[13] They allow a glimpse of changing fashions and hairstyles, and of course set the standard emulated by women all over the empire.

A small number of epigraphic sources provide a little more detail on Sabina's circumstances and activities.[14] She owned a mansion in Rome, not far from those of her female relatives, and numerous of her freedmen are attested in various parts of the empire, giving an indication of her substantial household. Sabina also owned brickyards outside Rome, perhaps in part inherited from her mother, which provided her with an independent income. At Velleia in Italy, where she seems to have owned land, she made a substantial contribution of 100,000 sesterces to the local alimentary scheme while still at a very young age. In Rome she made a dedication to the *matronae*, probably erected in the Forum of Trajan. All this seems very modest in scale and does not help much to gain a better understanding of her interests and character, but it is quite possible that new finds might one day help to fill in the picture.[15]

Much more is known in this respect about Sabina's older half-sister, Mindia Matidia, almost entirely through epigraphic evidence.[16] Apparently never married, she possessed considerable wealth, partly derived from vast land holdings in Africa, Asia Minor and also southern Italy, as well as brickyards around Rome, which enabled her to act as an active patron in her own right. In the Italian town of Suessa Aurunca in Campania for example, she provided funds for a library and the renovation of the theatre, for which she was honoured by the local community with, among other things, a magnificent portrait statue (fig. 189).[17] The discovery of this statue, together with further inscriptions, has also allowed the provisional identification of her portrait type.[18] Some of Mindia Matidia's properties are attested in Rome, Tusculana and Ostia; also known is a charitable foundation that she established in the Italian city of Vicetia together with her mother.[19] Unfortunately, there are no sources discussing her relationship with her sister.

More information concerning Sabina comes from Egypt. Among Sabina's circle of friends or ladies-in-waiting was Julia Balbilla, a descendant of the ancient royal house of Commagene, a wealthy, formerly independent kingdom on the upper Euphrates. Balbilla was a member of the imperial party that toured Egypt in AD 130. On 19, 20 and 21 November they visited one of the great sights of Upper Egypt, the colossal statue of Memnon. In fact the northern twin of a pair of huge seated images of an ancient Egyptian pharaoh, the Memnon had been damaged by an earthquake long before and from then on, in the early mornings, emitted a strange, oracular sound that beguiled the onlookers, who tended to commemorate their visit by scratching graffiti in the statue. In this manner Julia Balbilla now recorded the imperial party's presence in four lengthy poems

on the ancient colossus (see fig. 187). A highly educated woman, she used the ancient Greek Aeolic dialect associated with the famous poetess Sappho.[20] In epic language she referred to Hadrian, 'loved by all the gods' and his 'lovely queen Sabina'. No mention was made of Antinous, who had perished only a few weeks before.[21] Julia Balbilla would have been only one of Sabina's ladies-in-waiting; the empress's household and entourage gave her considerable emotional independence, whatever her relationship with Hadrian may have been.

Sabina died at some time in AD 136 or early 137. The *Epitome* claims that Hadrian drove her into suicide,[22] while the *Historia Augusta* states that 'when his wife Sabina died, the rumour arose that the Emperor had given her poison',[23] but there is nothing at all to substantiate these claims. Instead, Hadrian had her consecrated and honoured publicly, undoubtedly in an elaborate ceremony (see next chapter). It seems that a last, posthumous portrait type was created in her memory, to which a beautiful statue discovered in or near Hadrian's villa at Tivoli belongs (fig. 185).[24]

Her sister Mindia Matidia outlived both Sabina and Hadrian and may not have passed away until the very beginning of the reign of Marcus Aurelius, thus witnessing the continuation of the dynasty through Hadrian's adopted successors. A letter by the orator and politician Cornelius Fronto to Marcus refers to the very substantial inheritance she left in her will.[25]

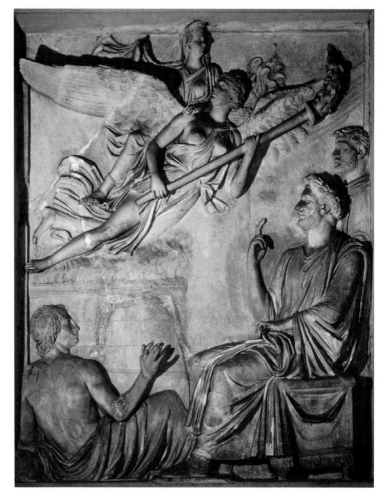

**Fig. 193** Sabina's apotheosis on a much-restored relief from an official monument, perhaps her consecration altar. She is borne aloft from the funerary pyre while Hadrian looks on.

**Fig. 192** Aureus minted to commemorate Sabina's official deification. Her portrait is on the obverse, while on the reverse she is borne to the heavens on a mighty eagle.

# VII Towards Eternity

*'He lived for
sixty-two years,
five months,
seventeen days.
He reigned for
twenty years,
eleven months.'*

*HA HADRIAN 25.11*

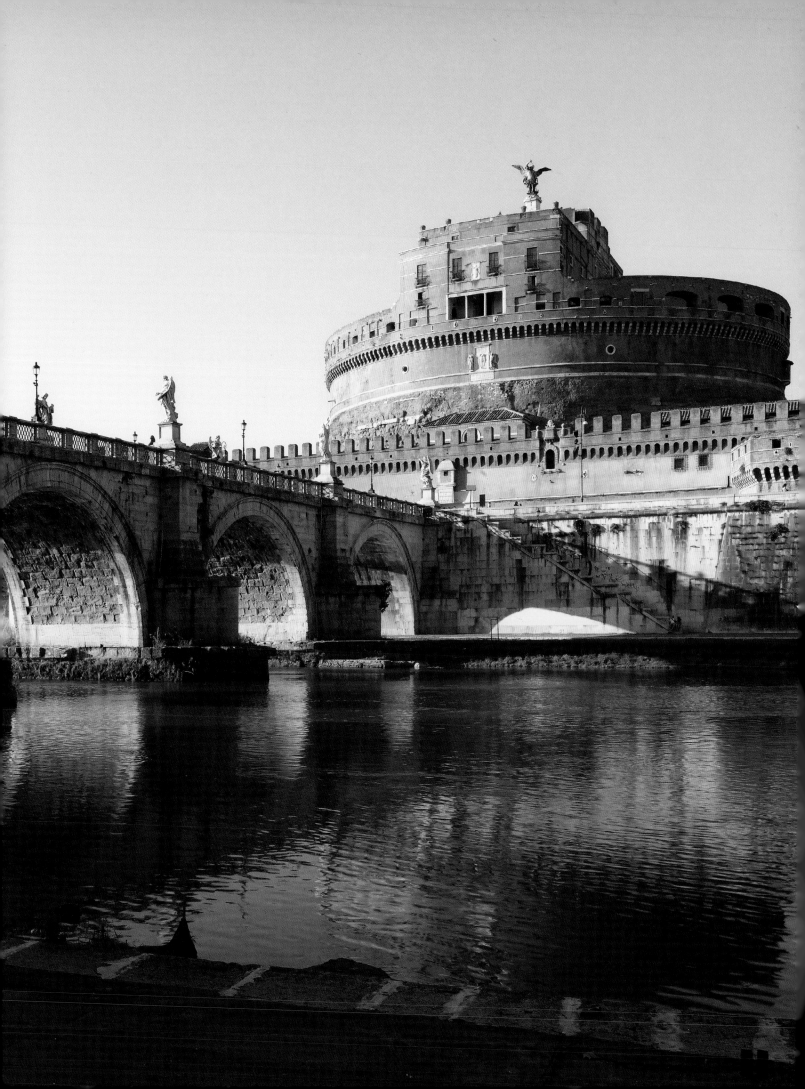

**V**ERY early in his reign, Hadrian turned his attention to his own monumental tomb. This was not primarily out of concern with the afterlife but for eminent political reasons. The mausoleum, a structure still little understood despite its physical prominence in the modern city, had a dual function.[1] It formed the culmination of a massive building programme that transformed both the urban fabric and the spiritual landscape of Rome, designed to manifest the legitimacy of Hadrian's rule and firmly establish the permanent presence of the new Spanish elite.

It also looked forward in time: here was the new ruler, already in his late forties yet still without a natural heir, preparing a massive tomb for yet unborn generations of his new dynasty. Finally, at a time when Hadrian travelled the provinces and devoted much of his attention to the Greek east, it reassured the Roman public about his intentions towards the capital. In this sense Hadrian's tomb closely paralleled the symbolic significance of the monument by which it was undoubtedly inspired and against which it must be measured: the Mausoleum of Augustus, Rome's first emperor and Hadrian's great role model.[2]

While scholars in the past have concentrated mostly on reconstructing the original physical structure of Hadrian's mausoleum, the key to understanding the monument lies more in analysing its place within this network of commemorative sites and buildings and the spectacular political theatre associated with them in grand public ceremonies during Hadrian's lifetime.[3] Unfinished at Hadrian's death, the monument could then serve a similar function for his eventual heir.

Hadrian's accession to the throne had been controversial. It was only natural that in a system that favoured adoption over the succession of close blood relatives there should be many in the senatorial aristocracy who considered themselves equally worthy, if not worthier of the imperial purple. The execution of the four senators at the beginning of Hadrian's reign (see p. 56) cast a further, permanent shadow over his relations with the senate. One way of establishing a working relationship with this august body and at the same time obliging it to acknowledge publicly the legitimacy of Hadrian's rule was the consecration of his predecessor and adoptive father Trajan, and further members of the family soon after.

PREVIOUS PAGE
**Fig. 194** Hadrian's mausoleum was located on the right bank of the Tiber, opposite the Campus Martius. In late antiquity and the Middle Ages it served as a fortified bridgehead, then as the papal fortress Castel Sant'Angelo. The ancient core of the mausoleum's central drum is visible above the crenellations of the Renaissance outer wall. The modern bridge incorporates elements of the Pons Aelius, which linked the mausoleum to the city.

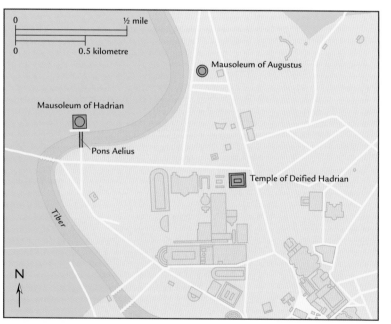

LEFT
**Fig. 195** The northern Campus Martius gradually turned into an 'apotheosis landscape', filled with often ornately decorated consecration altars and shrines dedicated to deceased members of the imperial family. Many have yet to be firmly located. Hadrian's tomb was inspired by the Mausoleum of Augustus, situated a little further to the east.

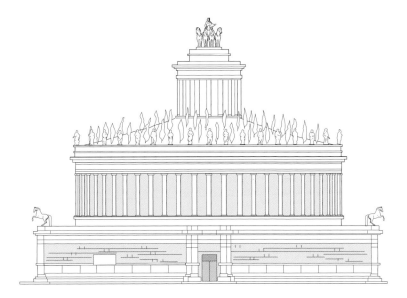

The process of consecration, that is, the deification of a deceased ruler and his adoption into the official state pantheon, was a highly complex procedure.[4] Crucially, it was by no means an automatic process but one of the few occasions where the senate held real power. It also provided a moment of spectacular pageantry in the centre of Rome, unforgettable for the tens, if not hundreds of thousands who witnessed it as spectators or active participants. Yet it has left hardly any traces in the archaeological record, so that its great significance as a tool of propagandistic manipulation has often been underestimated.

Hadrian certainly knew how to make best use of the ritual for his own needs. His predecessor Trajan himself had shown the way. He had induced the senate to deify not only his predecessor and adoptive father Cocceius Nerva but also his natural father Ulpius Traianus, although in the latter case little is known about the precise circumstances.[5] The elder Traianus had thus become the first member of the new Spanish elite in the Roman state pantheon. Trajan then also asked the senate to deify his sister Marciana after her death in AD 112.

We know from a number of literary sources what a drawn-out, complex and highly public ritual involving the entire populace the consecration ceremony was. Even if these testimonies only refer to a small number of ceremonies, one much earlier and two considerably later than the time of Hadrian, they enable us to reconstruct a typical sequence of events.[6]

The real body of the person to be deified was normally swiftly removed for a relatively private burial soon after the death. Yet for the consecration ceremony, which could take place after a considerable time interval,[7] an artificial body, probably a wax effigy, was laid out in state and its slow 'death' was publicly re-enacted over a period of several days.[8] Once the artificial body had been officially pronounced dead, it was transferred to the forum, where the new ruler gave a lengthy funerary oration in front of the assembled populace and dignitaries of various ranks. The effigy was then carried to the Campus Martius in a long procession involving musicians, priests, senators, knights, magistrates, representatives of the

**Fig. 196** Reconstruction sketch of Hadrian's tomb. The restoration of the mausoleum's superstructure is largely hypothetical, based on a few scattered fragments and literary descriptions from late antiquity. The burial chamber was inside a massive drum that rose above a square base.

**Figs 197 & 198** These magnificent peacocks were made of gilded bronze. They are thought to have stood on a fence that surrounded the outside of the mausoleum. For the Romans peacocks were linked to the goddess Juno, wife of their supreme god Jupiter. In analogy, they were associated with the empress. The peacocks were appropriated by the popes, which ensured their survival. In the Middle Ages they decorated a fountain outside the old Basilica of St Peter's.

various guilds and detachments of the army. Its destination was the *ustrinum*, or cremation site. There, the effigy would be put on the *rogus*, a spectacular, multi-storey funerary pyre. These pyres were richly decorated with garlands of flowers and precious ornaments, even statuary, and served as receptacles for official gifts deposited by delegates from all parts of the empire. Senators, knights and the army units then circled the pyre in a solemn procession. Finally, the pyre and all its contents were set alight, and as the effigy was consumed by the flames an eagle was released from a hidden cage on its top, soaring to the heavens and thus symbolizing the apotheosis of the deceased before the eyes of the assembled citizenry. The remains of the pyre, an ephemeral structure of magnificent richness and beauty that after the event was sometimes commemorated on coins, were then removed and a permanent structure, a consecration altar surrounded by ornate fences or balustrades, erected in or near its spot. The new *divus* or *diva*, the deified deceased, received a permanent cult with designated priests that kept his or her memory alive, often in a new temple or shrine. For minor members of the imperial family the procedure may have been adapted, following the same basic arrangement but more modest in scale. This, then, was the time-honoured ritual for imperial consecrations that had evolved since the days of the great Augustus.

After his official entry into Rome on 9 July 118, almost a year after his accession to the throne following Trajan's death in the east, Hadrian now ceremonially carried through the consecration of his adoptive father, which he had dutifully requested from the senate while still in the east.[9] With Trajan's reputation as *optimus princeps*, 'best of princes', intact, his appeal had been promptly granted. In this way Hadrian not only established himself as a loyal and devoted child but also

automatically gained the prestigious title of *divi filius*, or 'son of the deified', from then on part of his official nomenclature. The senate thus, despite any lingering misgivings, inevitably recognized and legitimized Hadrian's succession almost a year after the initial transfer of power. A fascinating papyrus fragment from Egypt seems to refer to a local re-enactment of Trajan's apotheosis, with various actors in the roles of Trajan, Hadrian and the god Apollo.[10] This underlines the importance of the consecration for the public legitimization of any succession and may have occurred elsewhere in the empire. Back in Rome Hadrian promptly began construction of a lavish temple in honour of his predecessor at the northern end of Trajan's monumental forum, one of the first and most important elements of his extensive building programme in the city and perhaps only a part of a wider complex dedicated to the memory of his adoptive parents.[11]

When Hadrian's mother-in-law Matidia died shortly after, in AD 119, she, too, was deified and honoured with a temple in the Campus Martius, close to the Pantheon (see p. 125). Plotina, Trajan's widow, was granted the same honour after her death in AD 123 and the Temple of the Deified Trajan was rededicated jointly to Trajan and her.[12] Once more, the consecration ceremonies must have provided a grand stage for the celebration of the new ruling family and its members, including games and gifts for the populace.[13] The text of Hadrian's funerary address for Matidia is preserved.[14] The events were also commemorated on coins.[15] Over a relatively short space of time, five Spaniards had thus joined the ranks of the deified Julio-Claudians and Flavians. The new dynasty had become firmly established, the new *divi* equalling in numbers several generations of their predecessors, each with their own cults and commemorative buildings dedicated to them.

As a formal end to this process Hadrian could now turn to his own resting place. Nerva, Trajan's predecessor, had been interred in the Mausoleum of Augustus, which was then closed for further burials.[16] This closure was perhaps necessitated more by political and dynastic ambitions than a lack of physical space. Similarly, the Emperor Domitian had already transferred the ashes of the members of the Flavian dynasty, his father Vespasian and his brother Titus, from the Mausoleum of Augustus, where they had been first interred, to a new monument on the Caelian Hill. Nerva, the elderly Roman aristocrat chosen by his fellow senators to succeed the tyrannical Domitian after the latter's assassination in AD 96, had only ruled for two years. Towards the end, he unexpectedly adopted the successful general Trajan in an ingenious ploy designed to ensure his own political

survival. The deposition of his remains in the Mausoleum of Augustus may have seemed an honourable, yet quite noncommittal solution.

By contrast Trajan, and later his wife Plotina, now received the extraordinary honour of being granted a tomb within the sacred limits of the city itself: their urns were placed in the base of Trajan's column, situated between Trajan's forum and their new temple.[17] Whether he intended this himself is disputed; we certainly do not know if he had already made alternative arrangements. Equally, the final resting places of the other deified family members, the elder Traianus and Marciana as well as Matidia are unknown.

Clearly, it was time to create an impressive mausoleum of their own for the new dynasty, just as the Flavians had done before them. Perhaps Hadrian even intended to transfer the remains of his relatives to the new tomb when it was finished.

For the new family mausoleum Hadrian chose a site outside the Campus Martius, on the opposite bank of the Tiber in a somewhat remote area of the *Ager Vaticanus* known as the Gardens of Domitia. By disregarding the Campus he forfeited the most prestigious area outside the *pomerium*, the sacred border of the city, but then the Flavians had already done so before him. No ancient source preserves the reasoning for this choice of location, leading modern scholars to find explanations of their own, most of them negative. Some stress that a tomb outside the *pomerium* lay outside the formal jurisdiction of the senate, giving Hadrian free hand to proceed as he wanted.[18] Even a parallel with ancient Egypt has been suggested, where the cities of the dead lay on the opposite bank of the Nile from those of the living.[19] Yet in simple urbanistic terms this location afforded the new monument a similar relative isolation and absolute dominance over its immediate surroundings as the Mausoleum of Augustus had enjoyed when it was first built, while its enormous size assured that it could easily be seen from the city. At any rate, a monumental bridge, the Pons Aelius, planned in conjunction with the mausoleum, provided convenient physical access to the new tomb, as well as an architecturally impressive approach, situated as it was on the main axis of the building. In logistical terms the location on the river bank, opposite one of the main ancient river ports, could only be advantageous. A quay was built between the mausoleum site and the bridge, together with an embankment road, facilitating construction as well as the later development of the area.

**Fig. 199** This truly colossal torso draped in a toga is thought to have been part of the mausoleum's sculptural decoration. It belonged to a statue that was some 5 metres tall.

Over many years, the mausoleum must have formed a gigantic building site. The work was to prove yet another triumph of Roman engineering, if only for sheer scale. The solid construction of the monument, with its brick and concrete core, ensured its survival through the millennia. The site had to be carefully prepared in order to take the weight of its immense superstructure. Large foundations were dug to accommodate a solid platform of rough concrete some two metres thick on which the building could rise.

The exact date for the beginning of the building work is unknown. Most scholars assume that work started around AD 130, when Hadrian had returned from his first lengthy journey around the empire. Yet most of the brick-stamps found, although their direct association with the building is not absolutely certain, date to AD 123. The bulk of these bricks were supplied by yards owned by Domitia Lucilla, an extremely wealthy noblewoman with close ties to the Spanish elite.[20] It is unlikely that much time elapsed between the firing of the bricks and their eventual use on the building site, and taking into account the political and propagandistic importance of the monument, the earlier date suggested by the brick stamps seems more preferable. In this scenario Hadrian, whose physical presence was perhaps not even necessary, would have decided to build the structure while still in Rome or shortly after the start of his extended journey. Work would have proceeded in parallel with the construction of new Temple of Venus and Roma, another massive structure begun shortly before.

The mausoleum rose some 50 metres high. It was surrounded by a fence of metal grilles between travertine pillars, about 115 metres long on each side. Large peacocks made of gilded bronze, of which two have miraculously survived, surmounted the pillars. A symbol of eternal life, peacocks were associated with

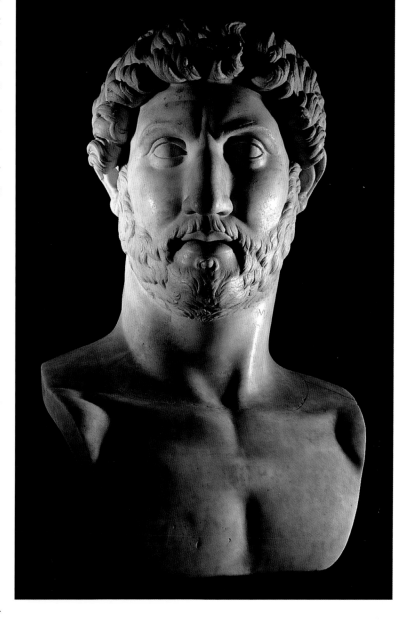

Fig. 200 This large-scale marble portrait of Hadrian is believed to have come from the interior of the mausoleum. It may have belonged to a colossal statue of Hadrian that stood in the central niche of the tomb's entrance vestibule.

the apotheosis of the empress; perhaps bronze eagles, referring to the apotheosis of the emperor, existed too.[21] Some 15 metres behind the fence rose a massive square base on a low socle, more than 80 metres long on each side and between 10 and 15 metres high, crowned by a carved frieze of boucrania and garlands with pilaster capitals at the corners. The outer walls of this enormous base were made of travertine, faced on the outside with Luni marble. In the structure's core rose a cylinder, from which sixty-seven interconnected barrel-vaulted chambers with walls made of brick-faced concrete radiated outwards, creating a large platform capable of supporting great weight.

The central drum, made of concrete and faced on the outside with tufa and travertine blocks, had a diameter of 74 metres up to the height of the square base. Above, the diameter was reduced to 68 metres. The total height of the drum was some 31 metres above ground level, 21 metres above the top of the square base. From the entrance, a corridor led to a large vestibule. A niche in the central axis is believed to have held a large statue of Hadrian, the head of which is now in the Vatican Museum (fig. 200). To the left was a second, rectangular niche. The walls and floor of the corridor and vestibule originally had revetments of precious marble. Opposite, on the right, a long spiral ramp rose gently in an anti-clockwise direction to a higher level. Some 6 metres high and 3 metres wide, this ramp had

a simple black and white mosaic floor. The walls were faced with marble and the barrel-vaulted ceiling was decorated with relief decoration in painted stucco. Turning in a full circle, the ramp opened onto a second corridor that led to the burial chamber, a large square room more than 10 metres high and 8 metres square, situated some 12 metres above the vestibule. Rectangular recesses in its north, east and west sides must have held the urns containing the cremated remains of the imperial family.

A similar-sized room was located above the burial chamber in the top of the drum. This was surmounted by a tower that contained a domed circular chamber reached via an external staircase. The tower was crowned by a monumental sculptural group, presumably showing Hadrian in a quadriga, or chariot, rising to the heavens.[22]

The external appearance of the mausoleum's superstructure is quite unknown, and the very substantial changes and rebuilding work carried out during the monument's later history make it impossible to reach any certain conclusion. By analogy with the Mausoleum of Augustus it has been proposed that earth may have been used to create a tumulus above the square base or at least above the drum. A purely architectural solution, with four distinct tiers, has also been put forward, but the coins cited as evidence do in fact show ornate funerary pyres, not permanent monuments. The basic structure of the building, however, like the Augustus mausoleum, can be understood as a monumentalization and elaboration of aristocratic Roman tombs of the late Republic, without recourse to more exotic models.[23]

More unusually, from the few scattered remains it seems that the mausoleum was richly decorated with sculpture, some of it fittingly on a truly colossal scale. It is not always easy to reconcile these remnants with the sparse descriptions of the mausoleum given by ancient and medieval authors. Procopius, in the sixth century AD, relates that there were marble statues of men and horses on top of the mausoleum and that many of them were hurled down on the besieging Goths in AD 537.[24] The twelfth-century *Mirabilia Urbis Romae* mentions gilded bronze horses at the four corners of the monument and, together with the bronze peacocks of the surrounding fence, a bronze bull.[25] All this suggests a very rich decoration.

Today it is the sheer scale of the remaining fragments more than their quality that is most impressive. The reconstruction of the original iconographic programme behind the sculptures is unfortunately not longer possible.[26] Some fragments of colossal horses matching Procopius' descrip-

**Fig. 205** This portrait bust of Antinous supported a tall statue, most likely of a god or Hadrian himself. It is thought to come from the mausoleum or its immediate surroundings.

tion, albeit made of marble, not bronze, have been identified.[27] There is also a torso of a togate figure that, when complete, must have stood nearly 4 metres tall (fig. 199).[28] Of particular interest is a colossal head identified as a portrait of Antinous (fig. 205).[29] It was carved in the form of a portrait herm and originally supported an even larger statue, perhaps of Hadrian himself, echoing on a much grander scale their intimate connection on the Luku bust (fig. 171).[30] In total, these remains suggest a monument more similar in the richness of its sculptural decor to the Mausoleum of Halicarnassos, one of the wonders of the ancient world, than the tomb of Augustus with its sombre, tree-lined earthen mound.[31]

The Pons Aelius was completed by AD 134, as is clear from Hadrian's monumental dedicatory inscription that decorated the bridge.[32] It seems that large bronze medallions depicting the bridge were struck to commemorate the event.[33] Building work on the giant structure of the mausoleum by contrast was still in progress.

## Adopting a successor

In the last few years of his reign, with construction of the mausoleum still ongoing, Hadrian's health deteriorated considerably. Lacking a son of his own, he now urgently needed to formalize the succession.

A natural transfer of power to a close relation and therefore a continuation of the direct family line would have been possible and may have been expected by many, not least the relatives in question. Still alive in these years was Hadrian's ancient brother-in-law, Lucius Iulius Servianus (fig. 210), himself rated a potential successor of Trajan many years before; more importantly, there was a young man named Pedanius Fuscus, grandson of Servianus and his wife, Hadrian's

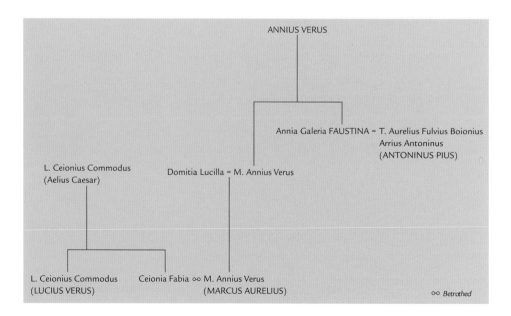

**Fig. 206** Simplified family tree showing Hadrian and his successors.

sister Domitia Paulina, and Hadrian's own great-nephew. Domitia Paulina had died shortly before Antinous and Hadrian's lack of grief over her passing, especially when compared with his intense sorrow over the loss of the young Greek, had been noted.[34] His intense rivalry with the older Servianus, especially acute when Trajan was still alive, seems eventually to have abated, for finally, in AD 134, the eighty-four-year-old Servianus was honoured with a third consulship. Young Pedanius Fuscus, after the early death of his parents, was Hadrian's closest living male relative.[35]

Yet for reasons unknown, Hadrian now decided to pass over Servianus and Pedanius Fuscus. In AD 136, his health in decline, he suddenly announced his intention to adopt one of the two consuls of that year, Lucius Ceionius Commodus.[36] Again, there were misgivings in the senate and malicious rumours were spread as to the reasons behind Hadrian's choice.[37] Curiously, Ceionius Commodus was the stepson and son-in-law of Avidius Nigrinus, one of the four consulars killed in AD 118. Was this a belated gesture of atonement? Yet Lucius Aelius Caesar, as he was to be called after his adoption, was in ill health himself, already marked by tuberculosis to an extent that made it impossible for him to deliver a speech of thanks for the adoption in the senate. However, he had a healthy son and several daughters, one of whom was betrothed to the young Marcus Annius Verus. Marcus was the grandson of a close associate of Trajan and Hadrian, and his father had hailed from Ucubi in Baetica. Clearly, the Spaniards formed a close-knit network, even the second and third generation in Rome. It has been postulated that Aelius Caesar was only meant to ease the transition until Marcus had come of age and gained sufficient experience; later events seem to confirm this.[38] Hadrian showed his favour to Marcus, whom he called *Verissimus*, the 'truest' or 'sincerest', by allowing him to hold important offices. Not only did young Marcus show intellectual promise, but the Annii seem also to have been related to Hadrian's family.[39] Marcus' mother Domitia Lucilla, widowed early, had a lucrative stake in the Hadrianic building boom (see fig. 104 and p. 109).

Aelius Caesar was soon dispatched to the important border province of Pannonia, but his deteriorating illness forced him to return to Rome after only a short presence. He died on 1 January AD 138. It seems that just before, in late 137, the frustrated erstwhile heir, Pedanius Fuscus, had attempted some sort of coup; details are unclear, but it appears that he was executed and his grandfather Servianus forced to commit suicide.[40]

**Fig. 207** In June AD 136 Hadrian adopted the thirty-three-year-old Roman aristocrat Lucius Ceionius Commodus as his son and successor. To mark his new status, Ceionius Commodus took the name Lucius Aelius Caesar. Coins with his image were issued, and cities throughout the empire erected statues in his honour. This statue comes from Cumae in southern Italy. Aelius died on 1 January 138, leaving a son and two daughters.

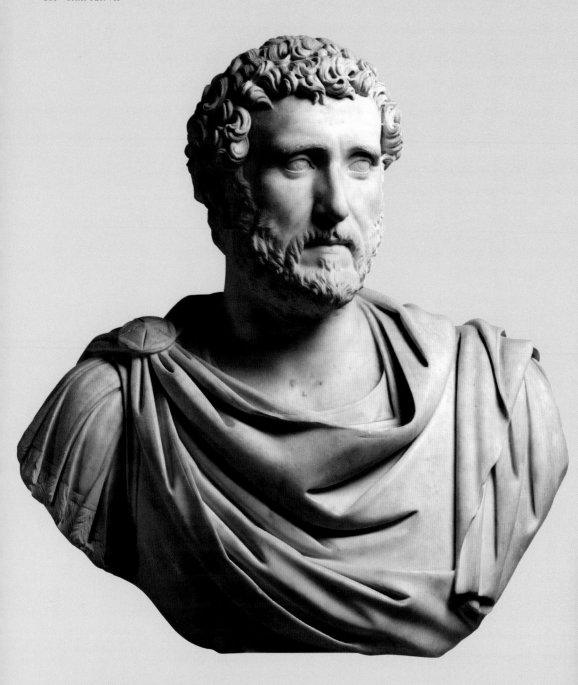

**Fig. 208** Antoninus Pius was born into a wealthy Roman family with origins in Nîmes (France). His wife Faustina was the daughter of Hadrian's close associate Annius Verus from Ucubi in Spain. Antoninus was a member of Hadrian's inner circle and frequently attended the imperial council. Following the death of Aelius Caesar, Hadrian adopted Antoninus on 25 February 138.

**Fig. 209** This papyrus fragment from the Fayum region of Egypt preserves a few lines of text that have been plausibly interpreted as the only extant excerpt of Hadrian's lost autobiography. Written shortly before Hadrian's death, this autobiography appears to have taken the form of a series of letters to Antoninus Pius. On the papyrus the text was first written by the hand of a teacher, and afterwards the beginning was copied by a pupil. (Translation opposite, below)

## The politics of succession

Lucius Julius Servianus was married to Hadrian's sister Domitia Paulina. He had been one of Trajan's most trusted and experienced generals and a possible contender for the throne after Trajan's death. A touching letter by Pliny (opposite, above) is preserved in which he congratulates Servianus on the marriage of his daughter and wishes for the birth of a grandson. This grandson, Pedanius Fuscus, long considered Hadian's heir presumptive, appears to have attempted a coup when he was excluded from the succession. Hadrian ordered Fuscus to be executed in AD 137 and forced Servianus to commit suicide. Hadrian's eventual successor was Antoninus Pius, who was adopted following the death of his first choice, Aelius Caesar.

*To Julius Servianus*

*I am glad to hear that your daughter is to marry Fuscus Salinator, and must congratulate you on your choice. He belongs to one of our noble families and his father and mother are both highly respected; while he himself is scholarly, well read, and something of an orator, and he combines a childlike frankness and youthful charm with mature judgement. Nor am I blinded by affection – I love him as dearly as his merits and regard for me deserve, but I have kept my critical powers: in fact they are sharpened by my love for him. I can assure you (knowing him as I do) that he will be a son-in-law who will prove better than your fondest hopes could wish. It only remains for him to give you grandchildren like himself as soon as possible. It will be a happy day for me when I can take his children, who are also your grandchildren, from your arms as if it were my right and they were my own.*

(Pliny the Younger, Letters VI, 26)

*The Emperor Caesar Hadrian Augustus to his most esteemed Antoninus, greeting. Above all I want you to know that I am being released from my life neither before my time, nor unreasonably, nor piteously, nor unexpectedly, nor with faculties impaired, even though I shall almost seem, as I have found, to do injury to you who are by my side whenever I am in need of attendance, consoling and encouraging me to rest. From such considerations I am impelled to write to you as follows, not, by Zeus, as one who subtly devises a tedious account contrary to the truth, but rather making a simple and most accurate record of the facts themselves ... and he who was my father by birth fell ill and passed away as a private citizen at the age of forty, so that I have lived half as long again as my father, and have reached nearly the same age as my mother.*

(Hadrian to Antoninus, part of Hadrian's autobiography?)

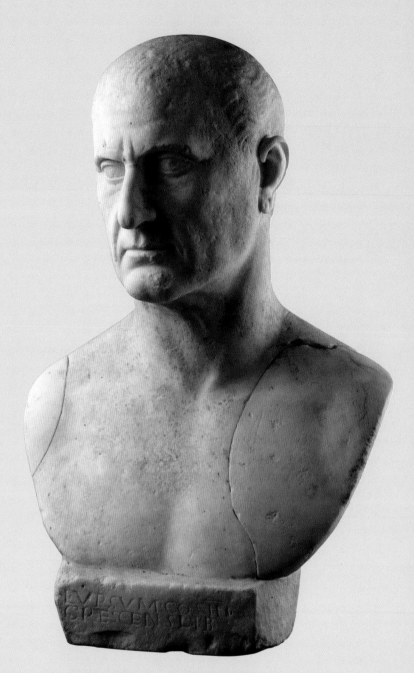

**Fig. 210** Portrait bust of Hadrian's brother-in-law Lucius Julius Servianus. According to the inscription, the bust was dedicated by one of his freedmen, Crescens, when Servianus was consul for the third time in AD 134. The portrait type, however, shows Servianus much younger and clearly had not been updated.

**Fig. 211** Marcus Annius Verus was a grandson of Hadrian's Spanish friend Annius Verus and nephew by marriage of Antoninus. The emperor fondly called him *Verissimus* (the 'truest'). In AD 136 Marcus was betrothed to one of the daughters of Aelius Caesar, probably as part of Hadrian's succession arrangements. After Aelius' death, Hadrian ordered Antoninus to adopt Marcus together with Aelius' son Lucius. It seems likely that this remarkable bust shows Marcus at the time of the adoption, when he was not yet seventeen.

At about the same time, Hadrian's wife Sabina also passed away. Even though their relationship had been impossibly strained for many years, Hadrian asked the senate to have her deified, which was duly granted. A beautiful, if much restored, relief in the Capitoline Museum (fig. 193) shows her apotheosis, which was also commemorated on coins (fig. 102). It may originally have formed part of the decoration of her untraced consecration altar.[41]

Following Aelius' death, Hadrian, by now gravely ill himself, had to act quickly to find an alternative solution. On 25 February 138 he adopted T. Aurelius Fulvius Boionius Arrius Antoninus (fig. 208). Antoninus' family originally stemmed from the city of Nemausus in southern Gaul, just as Plotina. A wealthy patrician, he had for a while belonged to Hadrian's inner circle of advisers. On this occasion, too, there were malcontents in the senate, most probably men who felt they had a better claim to power; they were removed from their positions.[42] On the day of his adoption Antoninus himself had to adopt Lucius Ceionius Commodus, the young surviving son of Aelius Caesar, who was henceforth to be known as Lucius Aelius Aurelius Commodus, and Marcus Annius Verus, his own nephew by marriage, who took the name Marcus Aelius Aurelius Verus. In effect, Hadrian had thus secured the succession for two generations. More than a century before, Augustus had attempted a similar solution when he adopted his stepson Tiberius on the condition that Tiberius in turn adopted the princes Drusus and Germanicus, whom the emperor much preferred. Antoninus' and later Marcus' successful reigns would prove the wisdom of Hadrian's decision. While Hadrian's choices may have been unpopular with some elements of the senate, his arrangement provided the clarity that had so obviously been lacking before Trajan's demise.

Hadrian died at Baiae on 10 July 138, having suffered several haemorrhages and grown tired of life. A fragmentary letter to Antoninus, probably part of his epistolary autobiography (fig. 209), and a poem preserved

**Fig. 212** Lucius Ceionius Commodus was the infant son of Aelius Caesar, Hadrian's first chosen successor. Only seven years old when Aelius died, he was adopted by Antoninus on Hadrian's request and betrothed to Antoninus' daughter. It is possible that this beautiful bust, which comes from the tomb of a wealthy aristocratic family in Rome, was produced in the same workshop as the bust of Marcus Aurelius (fig. 211). Both busts use portrait types that were probably created to celebrate the adoption.

in the *Historia Augusta* (below) provide a touching insight into his psyche in his final moments. He was provisionally buried in the grounds of the former villa of the famous republican orator and politician Cicero at nearby Puteoli, *invisus omnibus*, 'hated by all' or perhaps more simply 'unseen by all', according to the *Historia Augusta*.[43] Antoninus, who had rushed to the dying Hadrian's side, succeeded swiftly to the throne, less than four months after his official adoption. Yet in the following months he struggled to get the senate to pass a decree for Hadrian's deification. In the end he had to resort to blackmail, saying that if the senate did not deem Hadrian worthy to be deified this would also cast in doubt Antoninus' own adoption, a very clear indication of the importance of the deification of the deceased ruler for the legitimization of his heir.[44] With no alternative to Antoninus, the senate's hands were tied; Hadrian was granted divine honours and Antoninus received the title Pius in recognition of his filial devotion to his adoptive father.

The mausoleum's main structure, in the meantime, must have neared completion. In AD 139 Antoninus dedicated it to his adoptive parents, Hadrian and Sabina, whose remains, together with those of Aelius Caesar, were deposited in the burial chamber.[45]

Historians, both ancient and modern, normally finish their account of Hadrian's life with his quiet death on the Bay of Naples. Yet the real end in the public consciousness of the Roman people surely came now in a spectacular consecration ceremony, where Antoninus recounted his great deeds on the forum and Romans and foreigners paid homage as Hadrian turned into a god before their eyes, the symbolic progenitor of a powerful new dynasty.[46] Gold coins commemorated the event, showing Hadrian being carried to the heavens by a mighty eagle.[47] Following tradition, Antoninus built a splendid temple to his deified adoptive father in the Campus Martius and instigated a cult with dedicated priests, as well as a five-yearly festival, to keep alive his memory.[48]

Figs 214 & 215 The reverses of two coins commemorating the deification of Antoninus show important elements of the consecration ritual: the ornate, multi-storey funerary pyre (top) and the consecration altar (above) later erected in its place. The splendour of the pyre, complete with ranks of statues and a crowning quadriga, is astonishing. In the past some scholars mistook the pyre for a representation of the mausoleum.

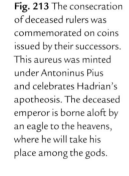
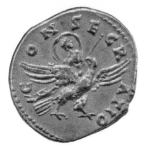

Fig. 213 The consecration of deceased rulers was commemorated on coins issued by their successors. This aureus was minted under Antoninus Pius and celebrates Hadrian's apotheosis. The deceased emperor is borne aloft by an eagle to the heavens, where he will take his place among the gods.

*Animula vagula blandula,*
*hospes comesque corporis,*
*quo nunc abibis? in loca*
*pallidula rigida nubila –*
*nec ut soles dabis iocos.*

'Little soul, little wanderer, little charmer,
body's guest and companion,
to what places will you set out for now?
To darkling, cold and gloomy ones –
and you won't make your usual jokes.'[49]

# LIST OF ROMAN EMPERORS

Dates and dynasties of Roman emperors mentioned in the text.

**Julio-Claudian dynasty**
Augustus (27 BC–AD 14)
Tiberius (14–37)
Caligula (37–41)
Claudius (41–54)
Nero (54–68)

Galba (8 June 68 to 15 January 69)
Otho (15 January to 16 April 69)
Vitellius (17 April to 20 December 69)

**Flavian dynasty**
Vespasian (69–79)
Titus (79–81)
Domitian (81–96)

Nerva (96–98)
Trajan (98–117)
Hadrian (117–138)

**Antonine dynasty**
Antoninus Pius (138–161)
Marcus Aurelius (161–180) and Lucius Verus (161–169)
Commodus (180–192)

# GLOSSARY

### Aedicula
Framed niche giving the appearance of depth.

### Aedile
Annual public office in the city of Rome, part of the *cursus honorum*. These elected officials were responsible for the maintenance of public buildings and the regulation of festivals; they also supervised markets and the supply of grain and water.

### Agrippa / Marcus Vipsanius Agrippa (c. 63–12 BC)
Roman statesman and general. Agrippa was a close friend and son-in-law of Octavian, the future emperor Caesar Augustus. He built the original Pantheon and other important buildings in Rome.

### Apollodorus of Damascus (died c. AD 130)
Greek military engineer and architect who built Trajan's bridge over the Danube and Forum in Rome, as well as many other important structures.

### Apsidial niche
Recessed space within a building that has a half-dome concha and a semi-circular (or similarly shaped) exterior wall.

### Archon
The highest office-holder in the Greek city of Athens.

### Arrian / Flavius Arrianus (c. AD 86–after 146)
Greek historian, public servant, military commander and philosopher of the Roman period. His works preserve the philosopher of Epictetus and include the Ananbasis of Alexander, considered as one of the best sources on the campaigns of Alexander the Great.

### Atrium
Central hall of a Roman house of the traditional type.

### Auxiliary troops / auxilia
Auxiliary troops (non-citizen cavalry units or specialized fighters) who were to aid and relieve the legions. Upon discharge, they were granted Roman citizenship.

### Cella

The inner part of a Roman temple in which the image of the deity was kept.

### Censor

Roman official whose task was to supervise state revenues and public morals.

### Coffer

In architecture, a sunken panel in the shape of a square, rectangle or octagon in a ceiling or vault.

### Cohort / cohors

A tactical unit within a legion, 500 or in some cases 100 strong.

### Consul

One of the two magistrates who held supreme civil and military power at Rome during the Republic. Consuls were elected annually by the *Comitia Centuriata* ('the Centuriate assembly'). Later, the office took on a more ceremonial nature, but many emperors sought to hold the consulship themselves.

### Consul ordinarius (cos ord)

The title given to each of the two consuls whose term started off a year and after whom the year was named.

### Consul suffectus (cos suff)

In Hadrian's time, a consul who served in the later part of the year (the office carried less prestige than that of *consul ordinarius*).

### Corinthian capital

Ornate capital decorated with leaves and small volutes.

### Cryptoportico

Semi-subterranean gallery whose vaulting supports portico structures above ground and which is lit from openings at the top of its arches.

### Cuirass

A piece of body armour, covering the torso from the neck to the girdle.

### Cursus honorum

Literally 'succession of offices'; the prescribed series of public offices that Roman senators sought to hold during their career. The basic pattern was: military tribune, quaestor, aedile, praetor, consul, censor. A minimum age applied.

### Dio Cocceianus, later called Chrystomos (c. AD 40–after 112)

Greek orator and popular philosopher, who began a career as a rhetorician in Rome but soon devoted himself to the study of Stoic-Cynic philosophy.

### Entablature

The superstructure that is supported by columns consisting of architrave (lintel or beam carried from the top of one column to the top of another), frieze (above the architrave) and cornice, including gutter at the top.

### Eques / equites

'Knights'. Roman citizens with a minimum property of 400,000 sesterces. Originally, they had served as cavalrymen. Under the empire, they were the second most powerful social group after the senators and could hold important offices.

### Fronto / Marcus Cornelius Fronto (c. AD 100–170)

Roman grammarian, rhetorician and advocate, who became the foremost orator of his day. After passing through the *cursus honorum*, he was appointed tutor in Latin to the future Emperors Marcus Aurelius and Lucius Verus.

### Governor

The official in charge of an entire province. In Rome, governors were endorsed by the emperor and appointed by the Senate.

**Graeculus**

Literally 'Little Greek'. Nickname given to Hadrian in reference to his interest in Greek literature and arts.

**Imperium**

From the verb *imperare* ('to command'), supreme authority in Rome's affairs vested in certain office-holders.

**Legion**

The standard large Roman military formation, comprising around 5000 heavy infantry.

**Martial / Marcus Valerius Martialis (c. AD 40–104)**

Latin poet from Hispania. Martial is best known for his twelve books of *Epigrams* published in Rome between AD 86 and 103, during the reigns of the emperors Domitian, Nerva and Trajan. In his epigrams he satirized city life and the scandalous activities of his acquaintances.

**Military Tribune / tribunus militum**

High-ranking officers in the Roman military. This office was the first official step of the *cursus honorum*.

**Ornamenta triumphalia**

Military awards equivalent to a triumph.

**Palladion / palladium**

An ancient sacred image of Pallas (Athena), said to have been sent down from heaven by Zeus to Dardanus, the founder of Troy or to his ascendant Iulus. It was believed that the protection of the city depended on its safe custody. Taken by the Trojan hero Aeneas to Italy.

**Pankrates of Athens (c. AD 140)**

Cynic philosopher.

**Patera**

A shallow circular cup or dish mostly employed at sacrifices or feasts.

**Patrician**

Member of the more privileged group of Roman citizens (in contrast to the *plebs*, or plebeian group). Patrician status could normally be gained only by birth (although the emperor could bestow it as a special privilege).

**Pausanias (fl.c. AD 160)**

Greek traveller and geographer of the second century AD, who knew Palestine, Egypt, Italy and Rome, but especially Greece. Pausanias lived in the times of Hadrian, Antonius Pius and Marcus Aurelius and is famous for his *Description of Greece*, which is a crucial link between classical literature and modern archaeology.

**Peristyle**

A continuous colonnade surrounding either a building or a space; thus an external peristyle is the colonnade that surrounds a Greek temple and an internal peristyle is the colonnade enclosing the space inside a courtyard, as in many Hellenistic and later Roman houses.

**Plebeian / the plebs**

Member of the less privileged group of Roman citizens (in contrast to patricians).

**Pliny the Younger / Gaius Plinus Caecilius Secundus (AD 61/63–113)**

Roman lawyer, writer and natural philosopher. Pliny was brought by his uncle and adoptive father Pliny the Elder and published nine books of literary letters between 100 and 109.

**Podium**

Platform on which Roman temples were built, accessible by steps only from the front.

**Praefect**

Military or public official. The duties included low- to high-ranking position with the Roman police or the Roman military.

**Praetor**
Annual public office with *imperium*, an important step in the *cursus honorum*. Praetors were charged with maintaining public order and justice.

**Praetorian Guard**
The emperor's bodyguard, instituted by Augustus.

**Princeps**
Literally 'first citizen'. A title borne by the emperors from Augustus to Diocletian.

**Propylon**
Gateway with a porch on either side.

**Quaestor**
Annual public office without *imperium*, the first step in the *cursus honorum*. The duties of the Roman quaestors were mainly financial or judicial.

**Senate / Senatus**
The highest Roman collegiate magistracy. During the empire, members needed to own property worth 1 million sesterces. They were elected from the sons of former senators or appointed by the emperor.

**Statius / Publius Papinius Statius (c. AD 45–96)**
Roman poet, born in Naples, Italy. Statius wrote two epic poems, the *Achilleis* and the *Thebais*, and is famous for his *Silvae* devoted among other topics to flattery of the emperor and his favourites.

**Suetonius / Gaius Suetonius Tranquillus (c. AD 69/75–after 130)**
Prominent Roman historian and biographer. Suetonius is mainly remembered as the author of *De Vita Caesarum*, twelve biographies from Julius Caesar to Domitian, best known in English as *The Twelve Caesars*. Probably written in Hadrian's time, this is his only extant work except for brief lives and other fragments.

**Tablinum**
Central room at the far end of the atrium of a traditional Roman house.

**Tribunes / Tribuni**
Roman officials who, under the Republic, had the right – in the People's name – to veto the decisions even of the highest authorities of the State. Later, the office reverted to the emperor.

**Victor / Aurelius Victor (c. AD 327–390)**
Historian and politician of the Roman empire, who wrote a *History of Rome from Augustus to Julian*, published c. 361. The Emperor Julian honoured him and appointed Aurelius prefect of Pannonia Secunda.

**Vitruvius / Marcus Vitruvius Pollio (c. 80/70–15 BC)**
Roman writer, architect and engineer. Vitruvius is famous for his treatise on architecture dedicated to the Emperor Augustus, *De architectura,* known today as *The Ten Books on Architecture*, which is the only surviving major book on architecture from classical antiquity.

# LIST OF EXHIBITS

Details correct at the time of going to press. 'Cat. fig.' at the end of an entry denotes objects illustrated in this catalogue.

**1. Manuscript of *Mémoires d'Hadrien***
(includes Carnet de notes)
1949–1951
Paper
28 x 21.6 cm
Houghton Library, Harvard, USA; inv. no. bMS
Fr372.2 (231)

**2. Sheet with coin legends**
(from Notebook containing notes and
parts of copied literary texts in Greek, Latin
and English)
Undated
Leather/paper
18.5 x 13 cm
Houghton Library, Harvard, USA; inv. no. bMS
Fr372.2 (265)

**3. Notebook with notes for *Mémoires
d'Hadrien***
1952
Paper
18.4 x 10.8 cm
Houghton Library, Harvard, USA; inv. no. bMS
Fr372.2 (266)

**4. Colossal marble head of Hadrian from
Sagalassos (Turkey)**
*c.* AD 117–138
Marble
Height 70 cm
Burdur Museum, Turkey
Selected literature: Waelkens (2007), pp. 3–4;
Waelkens (2008)
Cat. fig. 8

**5. Leg from above statue**
*c.* AD 117–138
Marble
Height 150 cm
Burdur Museum, Turkey
Selected literature: Waelkens (2007), pp. 3–4;
Waelkens (2008)
Cat. fig. 9

**6. Foot with sandal from above statue**
*c.* AD 117–138
Marble
Height 80 cm
Burdur Museum, Turkey
Selected literature: Waelkens (2007), pp. 3–4;

Waelkens (2008)
Cat. fig. 10

**7. Panel showing the Buddha and his
disciples**
1st–2nd century AD
Schist
Height 50.1 cm
The British Museum; OA 1980,0225.1
Selected literature: Zwalf (1985), p. 15; Zwalf
(1996), p. 128; Blurton (1997), p. 253

**8. Ceramic Liubo players**
1st–2nd century AD
Ceramic
Height 25.9 cm
The British Museum; OA 1933,1114.1d
Selected literature: Vainker (1991)

**9. *Historia Augusta* manuscript**
9th century
Parchment
28.6 x 23.5 cm
Staatsbibliothek Bamberg; inv. no. Msc. Class.
54 (alt E III 19)
Selected literature: Bamberg (2004), no. 32,
pp. 231–3
Cat. fig. 12

**10. Portrait bust of Hadrian from Italica**
AD 117–138
Marble
Height 81 cm
Museo Arqueológico de Sevilla, Seville, Spain;
inv. no. 151
Selected literature: Garcia y Bellido (1949), no.
22, pp. 33–4, pl. 21; Garcia y Bellido (1951), no.
17, pp. 19–20, 3 illus.; Wegner (1956), pp.
14–15, 34, 57, 70–71, 113–14, pls 11b, 19a;
Fernández-Chicarro & Fernández Gómez
(1980), p. 106, n. 21; Wegner (1984),
p. 139; Evers (1994), pp. 182–3; León (1995),
no 22; León (2001), no. 93
Cat. fig. 28

**11. Cast of tomb inscription of Hadrian's
wet nurse**
After AD 138
Plaster cast height 55 cm, length 75 cm
Original in Schloss Glienicke, Potsdam,
Germany

Selected literature: CIL XIV, 3721
Cat. fig. 19 (original inscription)

**12. Portrait bust of Hadrian**
AD 117–138
Marble
Height 79 cm
The British Museum; GR 1805,0703.94
Selected literature: Smith (1904), no. 1897;
Wegner (1956), pp. 15, 69, 101; Fittschen &
Zanker (1983), pp. 50–51; Wegner (1984),
p. 123; Evers (1994), no. 60
Cat. fig. 35

**13. Portrait bust of Trajan**
*c.* AD 108–117
Marble
Height 75 cm
The British Museum; GR 1805,0703.93
Selected bibliography: Smith (1904), no. 1893;
Gross (1940), pp. 85–6
Cat. fig. 17

**14. Portrait bust of Plotina**
*c.* AD 108–117
Marble
Height 61.5 cm
Musée d'art et d'histoire du Genève, Geneva,
Switzerland; inv. no. 19479
Selected literature: Calza (1964), no. 94;
Fittschen & Zanker (1983), vol. III, pp. 8–9;
Chamay & Maier (1989), no. 16; Valeri (2001),
pp. 303–7
Cat. fig. 32

**15. Portrait bust of Marciana**
*c.* AD 108–117
Marble
Height 58 cm
Museo di Ostia, Ostia, Italy; inv. no. 20, 2
Selected literature: Calza (1964), no. 92
Cat. fig. 33

**16. Portrait bust of Matidia**
*c.* AD 117–138
Marble
Height 45 cm
Musei Capitolini, Rome, Italy; inv. no. 889
Selected literature: Fittschen & Zanker (1983),
vol. III, no. 8
Cat. fig. 34

**17. Portrait bust of Sabina**
*c.* AD 117–138
Marble
Height 22.5 cm
Ny Carlsberg Glyptotek, Copenhagen,
Denmark; inv. no. 774
Selected literature: Wegner (1956), p. 126;
Calza (1964), no. 125; Carandini (1969), no. 17;
Poulsen (1974), no. 44; Johansen (1995), no.
43; J. S. Østergaard in Adembri & Nicolai
(2007), p. 158
Cat. fig. 36

**18. Amphora handle**
Late 1st–early 2nd century AD
Terracotta
Height 15 cm
The British Museum; PE 1856,0701.39
Selected literature: CIL VII, 90 (1757);
Callender (1965), no. 1370; Carreras & Funari
(1998), no. 14.a.1
Cat. fig. 24

**19. Amphora Dressel 20**
*c.* AD 138–161
Terracotta
Height 80 cm
The Museum of Antiquities of the University
and Society of Antiquaries of Newcastle upon
Tyne, Newcastle upon Tyne, UK; inv. no.
1904.11
Cat. fig. 27

**20. Amphora Dressel 20**
*c.* AD 138–161
Terracotta
Height 75 cm
Mercati di Traiano – Museo dei Fori Imperiali,
Rome, Italy; inv. no. MT7

**21. Amphora Dressel 20**
*c.* AD 138–161
Terracotta
Height 73 cm
Mercati di Traiano – Museo dei Fori, Imperiali,
Rome, Italy; inv. no. MT 10

**22. Amphora Dressel 20**
*c.* AD 138–161
Terracotta
Height 69 cm
Mercati di Traiano – Museo dei Fori Imperiali,
Rome, Italy; inv. no. MT 21

**23. Amphora Dressel 20**
*c.* AD 138–161
Terracotta
Height 70 cm
Mercati di Traiano – Museo dei Fori Imperiali,
Rome, Italy; inv. no. MT 50

**24. Amphora Dressel 20**
*c.* AD 138–161
Terracotta
Height 77 cm
Mercati di Traiano – Museo dei Fori Imperiali,
Rome; Italy inv. no. MT 69

**25. Dressel 20 amphora fragment with**
*titulus pictus*
*c.* AD 117–138
Terracotta
Height 18.1 cm
The British Museum; GR 1965,0506.1

**26. Portrait bust of 'young' Hadrian**
*c.* AD 117–138
Marble
Height 82 cm
Museo del Prado, Madrid, Spain; inv. no. 176-E
Selected literature: Hübner (1862), 130; Barrón
(1908), 138, no. 176; Blanco (1957), 146, no.
176-E; Schröder (1993), cat. no. 54; Schröder
(1995), pp. 292–7; Bergmann (1997), pp.
137–53
Cat. fig. 40

**27. Portrait bust of 'young' Hadrian from**
**Hadrian's villa**
After AD 128
Marble
Height 34 cm
Villa Adriana, Tivoli, Italy; inv. no.
Antiquarium 2260
Selected literature: Bracker (1968), pp. 81–3;
Raeder (1983), pp. 89–92; Evers (1994), pp.
274–7; Coraggio (2000), pp. 240–41, n. 50;
Reggiani (2004), pp. 94–5; Adembri & Nicolai
(2007), p. 172
Cat. fig. 44

**28. Coin with portrait of young Hadrian**
*c.* AD 117–138
Gold
The British Museum; CM THO.1433
Selected literature: RE p. 303.528
Cat. fig. 43

**29. Coin with portrait of young Hadrian**
*c.* AD 117–138
Gold
The British Museum; CM 1850,0601.4
Selected literature: RE p. 318.603
Cat. fig. 41

**30. Cameo with portrait of Trajan and Plotina**
*c.* AD 117–138
Sardonyx
Height 5 cm
The British Museum; GR 1824,0301.97
Selected literature: Gems no. 3610
Cat. fig. 45

**31. Statue of Hadrian in a toga**
*c.* AD 117–138
Marble
Height 225 cm
Musei Capitolini, Rome, Italy; Atrio 5, inv. no. 54
Selected literature: Wegner (1956), pp. 30–31, 66,
106–7, pl. 16b; Wegner (1984), p. 131; Fittschen
& Zanker (1983), no. 51; Goette (1990), cat. Bb
56; Evers (1994), pp. 158–9
Cat. fig. 38

**32. Marble head from a statue of Augustus**
*c.* AD 117–138
Marble
Height 71 cm
The British Museum; GR 1812,0615.1
Selected literature: Smith (1904), no. 1877;
Boschung (1993), no. 120
Cat. fig. 37

**33. Cast of relief showing burning of tax**
**records**
*c.* AD 117–138
Plaster cast
Height 84 cm, width 168 cm
Original in Chatsworth House, Derbyshire;
inv. no. A 59
Selected literature: Boschung et al. (1997),
no. 76
Cat. fig. 39 (original relief)

**34. Statue of Hadrian in Greek mantle**
**from Cyrene**
*c.* AD 117–138
Marble
Height 240 cm
The British Museum; GR 1861,1127.23
Selected literature: Smith (1904), no. 1381;
Rosenbaum (1960), no. 34 pp. 51–22; Wegner
(1956), pp. 9, 36, 57, 66, 71, 100–101;

Fittschen & Zanker (1983), pp. 44–55; Wegner (1984), p. 122; Evers (1994), pp. 125–6; Adams (2003), pp. 43–7
Cat. fig. 53

### 35. Cast of statue of Hadrian in cuirass
1930s
Plaster
Height 262 cm
Museo della Civiltà Romana, Rome, Italy; inv. no. 395
Selected literature: *Catalogo del Museo della Civiltà Romana* 1982
Selected literature on the original statue: Vermeule (1980), no. 62; Fittschen & Zanker (1983), p. 44, Zanker (1983), p. 17; Wegner (1984), p. 117; Evers (1994), p. 119; Gergel (2004), pp. 377–9
Cat. fig. 49

### 36. Torso of cuirassed statue from Cyrene
*c*. AD 117–138
Marble
Height 150 cm
The British Museum; GR 1861,1127.35
Selected literature: Smith (1904), no. 1466; Gergel (2004), pp. 398–9
Cat. fig. 52

### 37. Statue of Hadrian as Mars
*c*. AD 117–138
Marble
Height 211.5 cm
Musei Capitolini, Rome, Italy; Salone 13, inv. no. 634
Selected literature: Wegner (1956), pp. 31, 67, 107, 71, 100–101; Fittschen & Zanker (1983), no. 48 pp. 48–9; Wegner (1984), p. 131; Evers (1994), pp. 159–60
Cat. fig. 54

### 38. Bronze head of Hadrian from the River Thames, London
*c*. AD 117–138
Bronze
Height 43 cm
The British Museum; PE 1848,1103.1
Selected literature: Wegner (1956), pp. 28, 57, 64, 101; Wegner (1984), p. 123; Potter (1997) p. 54; Evers (1994), no. 55; Lahusen & Formigli (2001), no. 114
Cat. fig. 64 and frontispiece

### 39. Rudge Cup
Text:
.A.MAISABALLAVAVXELODVMCAMBOGLA NSBANNA '*Maia* [Bowness-on-Solway] *Aballava* [Burgh-by-Sands] *Uxelodunum* [Stanwix] *Camboglannae* [Castlesteads] *Banna* [Birdoswald]'
2nd century AD
Bronze/enamel
Diameter 9 cm
Alnwick Castle, Northumberland, UK
Selected literature: RIB II, 2415.52; Breeze (2006), pp. 34–5
Cat. fig. 68

### 40. Staffordshire Moorlands Pan
Text: MAISCOGABATTAVXELODVNVM CAMMOGLANNA RIGORE VALI AELI DRACONIS '*Maia* [Bowness-on-Solway] *Cogabatta* [Drumburgh] *Uxelodunum* [Stanwix] *Cammoglanna* [Castlesteads] [...]'
2nd century AD
Bronze/enamel
Height 4.7 cm
The British Museum; PE 2005,1204.1
Selected literature: Pitts & Worrell (2003), pp. 22–7; Tomlin (2004), pp. 344–5
Cat. fig. 67

### 41. Amiens Patera
Text:
MAISABALLAVAVXELODVNVMCAMBOGS BANNA '*Maia* [Bowness-on-Solway] *Aballava* [Burgh-by-Sands] *Uxelodunum* [Stanwix] *Camboglannae* [Castlesteads] *Banna* [Birdoswald], *Aesica* [Great Chesters]'
Early 3rd century AD
Bronze/enamel
Diameter 10 cm
Musée de Picardie, Amiens, France; M. P. 3984
Selected literature: Heurgon (1951), pp. 22–4; Braemer 1963, no. 526; Mahéo (1990), pp. 266–9, no. 151
Cat. fig. 69

### 42. Vindolanda Tablet
Late 1st/early 2nd century AD
Wood
Length 9.3 cm
The British Museum; PE 1986,1001.34
Selected literature: *Tab. Vindol.* II 164; Bowman (1998), no. 3

### 43. Vindolanda Tablet
Late 1st/early 2nd century AD
Wood
Length 7.7 cm
The British Museum; PE 1989,0602.73
Selected literature: *Tab. Vindol.* II 344; Bowman (1998), no. 43

### 44. *Pilum murale*
2nd century AD
Wood
Length 124.7 cm
The Museum of Antiquities of the University and Society of Antiquaries of Newcastle upon Tyne, Newcastle upon Tyne, UK; inv. no. 1956.305
Cat. fig. 65

### 45. Iron axe head from Housesteads
2nd century AD
Iron
Length 18.5 cm
The Museum of Antiquities of the University and Society of Antiquaries of Newcastle upon Tyne, Newcastle upon Tyne, UK; inv. no. 1956.151.51
Selected literature: Manning (1976), no. 55
Cat. fig. 59

### 46. Iron axe hammer from Housesteads
2nd century AD
Iron
Length 23.5 cm
The Museum of Antiquities of the University and Society of Antiquaries of Newcastle upon Tyne, Newcastle upon Tyne, UK; inv. no. 1956.151.48
Selected literature: Manning (1976), no. 54
Cat. fig. 59

### 47. Mason pick from Housesteads
2nd century AD
Iron
Length 15.6 cm
The Museum of Antiquities of the University and Society of Antiquaries of Newcastle upon Tyne, Newcastle upon Tyne, UK; inv. no. 1956.151.53
Selected literature: Manning (1976), no. 64
Cat. fig. 59

**48. Stonemason's pick from Housesteads**
2nd century AD
Iron
Lenth 22.8 cm
The Museum of Antiquities of the University
and Society of Antiquaries of Newcastle upon
Tyne, Newcastle upon Tyne, UK; inv. no.
1956.151.58
Selected literature: Manning (1976), no. 65
Cat. fig. 59

**49. Iron rock wedge from Brunton Bank**
2nd century AD
Iron
Length 26 cm
The Museum of Antiquities of the University
and Society of Antiquaries of Newcastle upon
Tyne, Newcastle upon Tyne, UK; inv. no.
1957.5
Selected literature: Manning (1976), no. 62
Cat. fig. 59

**50. Iron chisel from Housesteads**
2nd century AD
Iron
Length 16.2 cm
The Museum of Antiquities of the University
and Society of Antiquaries of Newcastle upon
Tyne, Newcastle upon Tyne, UK; inv. no.
1956.151.83
Selected literature: Manning (1976), no. 68
Cat. fig. 59

**51. Iron turf cutter from Housesteads**
2nd century AD
Iron
Length 34 cm
The Museum of Antiquities of the University
and Society of Antiquaries of Newcastle upon
Tyne, Newcastle upon Tyne, UK; inv. no.
1956.151.46
Selected literature: Manning (1976), no. 80
Cat. fig. 59

**52. Mason's trowel from Housesteads**
2nd century AD
Iron
Length 14 cm
The Museum of Antiquities of the University
and Society of Antiquaries of Newcastle upon
Tyne, Newcastle upon Tyne, UK; inv. no.
1956.151.59
Selected literature: Manning (1976), no. 71
Cat. fig. 59

**53. Plumb bob from Housesteads**
2nd century AD
Iron
Length 5.5 cm
The Museum of Antiquities of the University
and Society of Antiquaries of Newcastle upon
Tyne, Newcastle upon Tyne, UK; inv. no.
1956.151.14
Selected literature: Manning (1976)
Cat. fig. 59

**54. Centurial stone (Caecilius Proculus)**
c. AD 117–138
Sandstone
Length 34 cm
The Museum of Antiquities of the University
and Society of Antiquaries of Newcastle upon
Tyne, Newcastle upon Tyne, UK; inv. no.
1938.01
Selected literature: CIL VII, 625; RIB 1570
Cat. fig. 66

**55. Centurial stone (Sentius Priscus)**
c. AD 117–138
Sandstone
Length 34.5 cm
The Museum of Antiquities of the University
and Society of Antiquaries of Newcastle upon
Tyne, Newcastle upon Tyne, UK; inv. no.
1864.5.2
Selected literature: CIL VII, 490; RIB 1311
Cat. fig. 66

**56. Centurial stone (Valerius Flavus)**
c. AD 117–138
Sandstone
Length 25 cm
The Museum of Antiquities of the University
and Society of Antiquaries of Newcastle upon
Tyne, Newcastle upon Tyne, UK; inv. no.
1936.1
Selected literature: RIB 1363
Cat. fig. 66

**57. Centurial stone (Valerius Verus)**
c. AD 117–138
Sandstone
Length 32 cm
The Museum of Antiquities of the University
and Society of Antiquaries of Newcastle upon
Tyne, Newcastle upon Tyne, UK; inv. no.
1969.13
Selected literature: Wright (1961), p. 194 no.
11f
Cat. fig. 66

**58. Centurial stone (Eighth cohort)**
c. AD 117–138
Sandstone
Length 32 cm
The Museum of Antiquities of the University
and Society of Antiquaries of Newcastle upon
Tyne, Newcastle upon Tyne, UK; inv. no.
1864.5.13
Selected literature: CIL VII, 947; RIB 2052
Cat. fig. 66

**59. Centurial stone (Second cohort of
Thracians)**
c. AD 117–138
Sandstone
Length 37.5 cm
The Museum of Antiquities of the University
and Society of Antiquaries of Newcastle upon
Tyne, Newcastle upon Tyne, UK; inv. no.
1971.20
Selected literature: CIL VII, 363; RIB 803
Cat. fig. 66

**60. Inscription from Milecastle 38**
c. AD 117–138
Marble
Height 101 cm
The Museum of Antiquities of the University
and Society of Antiquaries of Newcastle upon
Tyne, Newcastle upon Tyne, UK; inv. no.
1887.21.1
Selected literature: CIL VII, 660; RIB 1638;
Smith (1974), no. 11
Cat. fig. 66

**61. Coin from River Tyne**
c. AD 117–138
Bronze
Diameter 3.2 cm
The Museum of Antiquities of the University
and Society of Antiquaries of Newcastle upon
Tyne, Newcastle upon Tyne, UK; inv. no.
1925.1.60.h
Selected literature: RIC 706; Smith (1974),
no. 74
Cat. fig. 5

**62. Coin with representation of Britannia**
AD 119
Bronze
Diameter 2.5 cm
Mr Ivan Jones
Selected literature: Portable Antiquities
Scheme website IOW-072A43

**63. Ribchester Helmet**
Late 1st–early 2nd century AD
Bronze
Height 27.6 cm
The British Museum; PE 1814,0705.1
Selected literature: Edwards (1992), Jackson &
Craddock (1995), pp. 78–81, fig. 48
Cat. fig. 61

**64. Torso and head of cuirassed statue of
Hadrian from Beth Shean**
c. AD 117–138
Bronze
Height 83 cm
The Israel Museum, Jerusalem, Israel; inv. nos
IDAM 75-763 (head) and 75-764 (cuirass)
Selected literature: Förster (1980), pp. 107–110;
Vermeule (1978), pp. 85–123; Wegner (1984),
p. 118; Avida (1984), pp. 90–91; Förster (1986),
pp. 139–60; Gergel (1991), pp. 231–51; Evers
(1994), 119–20
Cat. fig. 73 and p. 63

**65. Tile with stamp L(egio) X Fre(tensis)
and caliga footprint**
AD 130–135
Terracotta
Length 29 cm
The Israel Museum, Jerusalem, Israel; inv. no.
IAA 94-2406
Selected literature: Barag (1967), pp. 244–67;
Arrubas & Goldfus (1995), pp. 96–107
Cat. fig. 81

**66. Military diploma issued to Gaius
mentioning 'Syria Palestina'**
22 November AD 139
Bronze
Height 13.9 cm
Musée du Louvre, Paris, France; inv. no. Br 4088
Selected literature: CIL XVI, 87; Russell (1995),
pp. 79–80
Cat. fig. 84

**67–70. Fragments of inscription of victory
arch from Tel Shalem**
AD 130s
Marble
Height 126 cm
The Israel Museum, Jerusalem, Israel; inv. no.
IAA 77-524
Selected literature: Förster (1986), pp. 139–57;
Eck (1999), pp. 87–9; Eck & Förster (1999),
pp. 294–313; Bowersock (2003), pp. 171–80
Cat. fig. 83

**71. Key from Cave of Letters**
Before AD 135
Bronze and wood
Height 20 cm
The Israel Museum, Jerusalem, Israel; inv. no.
96-306
Selected literature: Yadin (1963), p. 94, pl. 26;
no. 55-65.1, fig. 37 top
Cat. fig. 86

**72. Key from Cave of Letters**
Before AD 135
Bronze and wood
Height 3.5 cm
The Israel Museum, Jerusalem, Israel; inv. no.
96-904
Selected literature: Yadin (1963), p. 94, pl. 26;
no. 47-61.3.6, fig. 33 top
Cat. fig. 86

**73. Key from Cave of Letters**
Before AD 135
Bronze and wood
Height 11 cm
The Israel Museum, Jerusalem, Israel; inv. no.
61-1361
Selected literature: Yadin (1963), p. 94, pl. 26;
no. 53-61.1.9, fig. 36 top
Cat. fig. 86

**74. Sandal from Cave of Letters**
Before AD 135
Leather
Length 22.5 cm
The Israel Museum, Jerusalem, Israel; inv. no.
61-1312
Selected literature: Yadin (1963), p. 167, pl. 57;
no. 27-61.1.8
Cat. fig. 87

**75. Basket from Cave of Letters**
Before AD 135
Date palm fibre
Width 42 cm
The Israel Museum, Jerusalem, Israel; inv. no.
96-9108
Selected literature: Yadin (1963), p. 143, pl. 43
bottom no. 2-2.109
Cat. fig. 92

**76. Knife from Cave of Letters**
Before AD 135
Bronze and wood
Length 40.5 cm
The Israel Museum, Jerusalem, Israel; inv. no.
96-295
Selected literature: Yadin (1963), p. 84, pl. 24;
no. 23-7.2, fig. 30

**77. Knife from Cave of Letters**
Before AD 135
Bronze and wood
Length 33 cm
The Israel Museum, Jerusalem, Israel; inv. no.
96-292
Selected literature: Yadin (1963), p. 95, pl. 24;
no. 26-62.2, fig. 31
See Cat. fig. 92

**78. Plate from Cave of Letters**
Before AD 135
Wood
Diameter 14.5 cm
The Israel Museum, Jerusalem, Israel; inv. no.
96-9111
Selected literature: Yadin (1963), p. 128, pl. 39;
fig. 50
Cat. fig. 92

**79. Bowl from Cave of Letters**
Before AD 135
Wood
Diameter 13 cm
The Israel Museum, Jerusalem, Israel inv. no.
IAA61-1359
Selected literature: Yadin (1963), p. 128, pl. 39;
fig. 50

**80. Patera from Cave of Letters**
Before AD 135
Bronze
Diameter 22.6 cm
The Israel Museum, Jerusalem, Israel inv. no.
96-290
Selected literature: Yadin (1963), p. 58, pl. 17;
fig.16
Cat. fig. 90

**81. Bowl from Cave of Letters**
Before AD 135
Bronze
Diameter 40 cm
The  Israel Museum, Jerusalem, Israel; inv. no.
96-286
Selected literature: Yadin (1963), p. 46, pl.13;
fig. 10
Cat. fig. 93

**82. Incense shovel from Cave of Letters**
Before AD 135
Bronze
Height 13.3 cm
The Israel Museum, Jerusalem, Israel; inv. no.
96-291
Selected literature: Yadin (1963), p. 48, pl. 15;
figs 11, 12
Cat. fig. 94

**83. Jug from Cave of Letters**
Before AD 135
Bronze
Height 20.5 cm
The Israel Museum, Jerusalem, Israel; inv. no.
96-900
Selected literature: Yadin (1963), p. 64, pl. 20
top no. 9; figs 17 top, no. 9
Cat. fig. 92

**84. Jug from Cave of Letters**
Before AD 135
Bronze
Height 17.7 cm
The Israel Museum, Jerusalem, Israel; inv. no.
61-1305
Selected literature: Yadin (1963), p. 64, pl. 19
top; fig. 17

**85. Jug from Cave of Letters**
Before AD 135
Bronze
Height 12.8 cm
The Israel Museum, Jerusalem, Israel; inv. no.
61-1357
Selected literature: Yadin (1963), p. 64, pl. 21
top; fig. 18 bottom
Cat. fig. 92

**86. Large bowl from Cave of Letters**
Before AD 135
Glass
Diameter 33.8 cm
The Israel Museum, Jerusalem, Israel; inv. no.
IAA96-901
Selected literature: Yadin (1963), p. 106, pl. 29;
fig. 40
Cat. fig. 91

**87. Pyxis from Cave of Letters**
Before AD 135
Wood
Height 5.7 cm
The Israel Museum, Jerusalem, Israel; inv. no.
61-1363

Selected literature: Yadin (1963), p. 124, pl. 36
no. 3-7.42; fig. 51
Cat. fig. 89

**88. Box from Cave of Letters**
Before AD 135
Wood/pigmented parchment
Height 7.3 cm
The Israel Museum, Jerusalem, Israel;
inv. no. 61-1364
Selected literature: Yadin (1963), pl. 37, fig. 47
Cat. fig. 89

**89. Mirror from Cave of Letters**
Before AD 135
Tinned copper/lead handle/wood
Height 20 cm
The Israel Museum, Jerusalem, Israel; inv. no.
61-1365
Selected literature: Yadin (1963), p. 125, pl. 38,
fig. 49
Cat. fig. 88

**90. Document with text by Jewish rebels**
AD 133–135
Papyrus
21.5 x 9.5 cm
Israel Museum, Jerusalem, Israel; P. Yadin 56

**91. Coin with Hadrian's portrait overstruck
by rebels**
(1/4 shekel reusing Roman denarius)
c. AD 133–135
Silver
The British Museum; CM 1888,0512.36
Selected literature: BMC p. 297.61
Cat. fig. 74

**92. Weight of Bar Kokhba with Hebrew
inscription**
Before AD 135
Lead
Height 9.4 cm
The Israel Museum, Jerusalem, Israel; inv. no.
IAA 87-1541
Cat. fig. 77

**93. Shekel showing Temple of Jerusalem**
c. AD 133–135
Silver
The British Museum; CM 1908,0110.776
Selected literature: BMC p. 294.44
Cat. fig. 76

**94. Model of Pantheon**
Modern
Wood and resin
Height 64.5 cm
Museo Tàttile Statale Omèro, Ancona, Italy
Cat. fig. 107

**95. Pilaster capital from the interior of
the Pantheon**
c. AD 117–138
Marble
Height 48 cm
The British Museum; GR 1805,0703.276
Selected literature: Smith (1904), no. 2590
Cat. fig. 114 and p. 99

**96. Pilaster capital from the interior of
the Pantheon**
c. AD 117–138
Marble
Height 48 cm
The British Museum; GR 1805,0703.277
Selected literature: Smith (1904), no. 2592

**97. Pilaster capital from the interior of
the Pantheon**
c. AD 117–138
Marble
Height 48 cm
The British Museum; GR 1805,0703.275
Selected literature: Smith (1904), no. 2593

**98. Pilaster capital from the interior of
the Pantheon**
c. AD 117–138
Marble
Height 48 cm
The British Museum; GR 1805,0703.437
Selected literature: Smith (1904), no. 2594

**99. Portrait head of Marcus Agrippa**
25–10 BC
Marble
Height 62 cm
The British Museum; GR 1873,0820.730
Selected literature: Smith (1904), no. 1881;
Romeo (1998), 184 no. R16, figs 143–4;
Walker & Higgs 2001, p. 264 no. 313
Cat. fig. 105

**100. Brick with stamp**
EX P(raediis) AR(riae) FADILLAE IVLI(us)
LVPIO
AD 123–127
Terracotta

Height 14 cm
Villa Adriana, Tivoli, Italy; inv. no. 390
Selected literature: CIL XV.1, 78; Bloch (1948),
p. 147 no. 78
Cat. fig. 104

### 101. Brick with stamp

-]OP(us) D(oliare)
DORYPHOR(i)DOMITI(iae)P(ubli)F(iliae)LU
CILL(ae)[- - -]/ [- - - ]PAET(ino) ET
APRO(niano)[CO(n)S(ulibus)]
AD 123
Terracotta
Height 14 cm
Museo Nazionale di Castel Sant'Angelo, Rome,
Italy; inv. no. CSA 203/II (Sch. no. 870)
Selected literature: CIL XV.1, 1033; Bloch
(1948), nos 19–21, p. 254; Mercalli (1998),
no. 36
Cat. fig. 104

### 102. Brick with stamp

EX PR(aediis) DOM(itiae)
LUCIL(lae)O(pus)D(oliare)MUNATI(-?-)
AD 123
Terracotta
Height 50 cm
Museo Nazionale di Castel Sant'Angelo, Rome,
Italy CSA 203/II
Selected literature: CIL XV.1, 125; Bloch
(1948), nos 9–12, p. 254; Mercalli (1998), no. 34
Cat. fig. 104

### 103. Brick with stamp

OP(us)D(oliare) EX PR(aedis) C IULI
STEPHANI/APRO(niano) ET CATUL[-]
CO(n)S(ulibus)
AD 130
Terracotta
Height 50 cm
Museo Nazionale di Castel Sant'Angelo, Rome,
Italy CSA 203/II
Selected literature: CIL XV.1, 1212a; Bloch
(1948), no. 7, p. 254; Mercalli (1998), no. 38
Cat. fig. 104

### 104. Frieze block with marine thiasos from Hadrian's villa

AD 117–138
Marble
Length 178 cm
Villa Adriana, Tivoli, Italy; inv. no. 3127
Selected literature: Gusman (1904), pp. 237–51
Cat. fig. 103

### 105. Ionian capital from the 'Garden – stadium', Hadrian's villa

AD 117–118
'*Bigio morato*' marble
Width 81 cm
Villa Adriana, Tivoli, Italy
Selected literature: Hoffmann (1980), pp. 48–9;
*Hadrien* (1999), pp. 190–2; *Adriano* (2000), no. 22
Cat. fig. 100

### 106. Corinthian capital from the 'Heliocaminus Baths', Hadrian's villa

AD 117–118
White marble
Height 42 cm
Villa Adriana, Tivoli, Italy
Selected literature: *Hadrien* (1999), p. 190;
*Adriano* (2000), no. 21
Cat. fig. 101

### 107. Ionian capital from the 'Garden – stadium', Hadrian's villa

AD 117–118
White marble
Width 109 cm
Villa Adriana, Tivoli, Italy
Selected literature: Hoffmann (1980),
pp. 49–50; *Hadrien* (1999), p. 192; *Adriano*
(2000), no. 23
Cat. fig. 99

### 108. *Opus Sectile* fragment from 'Building of the Three Exedrae', Hadrian's villa

AD 117–118
Marble
Height 60 cm
Villa Adriana, Tivoli, Italy
Selected literature: Guidobaldi (1994),
pp. 131–2; *Hadrien* (1999), p. 205; *Adriano*
(2000), no. 26
Cat. fig. 135

### 109. Nine stucco fragments from Hadrian's villa

AD 117–118
Villa Adriana, Tivoli, Italy
Selected literature: Gusman (1904), pp. 215–18
Cat. fig. 137

### 110. Six fresco fragments from Hadrian's villa

AD 117–18
Villa Adriana, Tivoli, Italy
Selected literature: Gusman (1904), pp. 215–18
Cat. fig. 136

### 111. Model of Hadrian's villa

1930s
Wood/alabaster/plaster
Height 43 cm
Museo della Civiltà Romana, Rome, Italy;
inv. no. 2122
Selected literature: *Civiltà Romana* (1982),
pp. 428–30; Liberati, A. M. in *Adriano* (1998),
pp. 177–9
Cat. figs 123, 129, 134

### 112. Water pipe (*fistula*) from Hadrian's villa

AD 117–118
Lead
Length 236 cm
Villa Adriana, Tivoli, Italy; inv. no. 2147
Cat. fig. 140

### 113. Fragment of wall decoration from 'Building of the Three Exedrae', Hadrian's villa

AD 117–118
Marble
Height 27 cm
Villa Adriana, Tivoli, Italy
Cat. fig. 139

### 114. Head from a statue of a goat from Hadrian's villa

AD 117–118
Marble
Height 24.1 cm
The British Museum; GR 1805,0703.469
Selected literature: Smith (1904), no. 2129
Cat. fig. 143

### 115. Rectangular pillar from the 'Scenic Canal (Canopus)', Hadrian's villa

AD 117–118
Marble
Height 176 cm
Villa Adriana, Tivoli, Italy; inv. no. Antiquarium
423540
Selected literature: Vighi (1958), fig. a p. 62;
Raeder (1983), p. 301; Mathea-Förtsch (1999),
p. 184 cat. no. 245; *Adriano* (2000), p. 204

### 116. Rectangular pillar from the 'Scenic Canal (Canopus)', Hadrian's villa

AD 117–118
Marble
Height 176 cm
Villa Adriana, Tivoli Italy; inv. no. 1063
Selected literature: Vighi (1958), fig. a p. 62;
Mathea-Förtsch (1999), p. 184 cat. no. 247;

*Adriano* (2000), p. 204
Cat. fig. 141 (p. 156)

### 117. Triangular pillar from the 'Scenic Canal (Canopus)', Hadrian's villa
AD 117–118
Marble
Height 151 cm
Villa Adriana, Tivoli, Italy
Selected literature: Mathea-Förtsch (1999),
p. 184 cat. no. 246
Cat. fig. 141 (p. 157)

### 118. Triangular pillar from the 'Scenic Canal (Canopus)'
AD 117–118 AD
Marble
Height 151 cm
Villa Adriana, Tivoli, Italy
Selected literature: Gusman (1904),
pp. 237–251; Adembri (2000), pp. 81–92
Cat. fig. 141 (p. 157)

### 119. Triangular pillar from the 'Scenic Canal (Canopus)', Hadrian's villa
AD 117–118
Marble
Height 151 cm
Villa Adriana, Tivoli, Italy
Selected literature: Gusman (1904),
pp. 237–51; Adembri (2000), pp. 81–92
Cat. fig. 141 (p. 157)

### 120. Satyr from Hadrian's villa
AD 117–118
Marble
Height 174 cm
Musei Capitolini, Rome, Italy; inv. no. 657
Selected literature: Stuart Jones (1912), no. 1,
p. 309, pl. LXXVII; Raeder (1983), p. 65, I, 48;
Barberini (1993), pp. 23–5; Mattei, M. in
*Adriano* (1998), pp. 221–3
Cat. fig. 149

### 121. Bearded head of a companion of Ulysses from Hadrian's villa
AD 117–118
Marble
Height 74 cm
The British Museum; GR 1805,0703.86
Selected literature: Smith (1904), no. 1860;
Säflund (1972); Raeder (1983), p. 40
Cat. fig. 147

### 122. Head from a colossal statue of Hercules from Hadrian's villa
AD 117–118
Marble
Height 98 cm
The British Museum; GR 1805,0703.75
Selected literature: Smith (1904), no. 1734;
Raeder (1983), p. 39
Cat. fig. 146

### 123. Head of Dionysus from Hadrian's villa
AD 117–118
Marble
Height 65 cm
The British Museum; GR 1805,0703.62
Selected literature: Smith (1904), no. 1612;
Raeder (1983), p. 149
Cat. fig. 145

### 124. Relief of boy with horse from Hadrian's villa
AD 117–118
Marble
Height 76 cm
The British Museum; GR 1805,0703.121
Selected literature: Smith (1904), no. 2206
Cat. fig. 142

### 125. Sphinx from the 'Palaestra', Hadrian's villa
AD 117–118
Marble
Height 80 cm
Villa Adriana, Tivoli, Italy; inv. no. 32
(excavation number)
Selected literature: Mari (2006), pp. 47–53
(with previous bibliography)
Cat. fig. 148

### 126. Portrait bust of Hadrian from Hadrian's villa
AD 117–118
Marble
Height 84 cm
The British Museum; GR 1805,0703.95
Selected literature: Smith (1904), no. 1896,
pp. 157–8; Wegner (1956), pp. 27, 57, 69, 101;
Raeder (1983), pp. 40–41; Fittschen & Zanker
(1983), pp. 46–8; Wegner (1984), p. 122; Evers
(1994), no. 59
Cat. fig. 134

### 127. Warren Cup
AD 50–70
Silver
Height 11 cm
The British Museum; GR 1999,0426.1
Selected literature: Polloni (1999), pp. 21–52;
Williams (2006)
Cat. fig. 151

### 128. Bust of Hadrian in cloak (*paludamentum*)
AD 117–118
Marble
Height 73 cm
Ny Carlsberg Glyptotek, Copenhagen,
Denmark; inv. no. 777
Selected literature: Wegner (1956), pp. 25–6,
70, 99; Poulsen (1974), no. 42, p. 70; Johansen
(1995), no. 41; Evers (1994), no. 30
Cat. fig. 154

### 129. Papyrus fragment with poem of Pankrates
2nd century AD
Papyrus
Height 24.3 cm
Bodleian Library, Oxford; Ms Gr. Class d. 113 P
Selected literature: *POxy* VIII, 1085
Cat. fig. 155

### 130. Statue of Antinous-Osiris
After AD 130
Marble
Height 241 cm
Musei Vaticani (Museo Gregoriano Egizio),
Vatican, Italy; inv. no. 22795
Selected literature: Botti & Romanelli (1951),
no. 143; Clairmont (1966), p. 16; Malaise
(1972), p. 108, no. 18; Raeder (1983), p. 114,
no. I, 136; Meyer (1991), p. 121 cat. no. IV, 3
Cat. figs 156, 157

### 131. Egyptian head from the 'Antinoeion', Hadrian's villa
After AD 130
Marble
Height 21.5 cm
Villa Adriana, Tivoli, Italy; inv. no. 56
(excavation number)
Selected literature: Mari (2003–4),
pp. 263–314; Mari & Sgalambro (2007),
pp. 83–104
Cat. fig. 161

**132. Wall fragment with hieroglyphic inscription from the 'Antinoeion', Hadrian's villa**
After AD 130
Marble
Height 62 cm
Villa Adriana, Tivoli, Italy; inv. no. 183 (excavation number)
Selected literature: Mari (2002–3), pp. 145–85; Mari & Sgalambro (2007), pp. 83–104
Cat. fig. 164

**133. Capital of spiral fluting column from the 'Antinoeion', Hadrian's villa**
After AD 130
Marble
Height 19 cm
Villa Adriana, Tivoli, Italy; inv. no. 31 (excavation number)
Selected literature: Mari (2002–3), pp. 145–85; Mari & Sgalambro (2007), pp. 83–104
Cat. fig. 162

**134. Colossal portrait head of Antinous ('Mondragone Head')**
After AD 130
Marble
Height 95 cm
Musée du Louvre, Paris, France; inv. no. MA 1205
Selected literature: Clairmont (1966), no. 58; Meyer (1991), p. 114 cat. no. III, 3; Kersauson 1996, no. 63
Cat. figs 150, 167

**135. Statue of Antinous-Aristaios**
After AD 130
Marble
Height 191 cm
Musée du Louvre, Paris, France; inv. no. MA 578
Selected literature: Clairmont (1966), no. 23; Meyer (1991), pp. 63–4 cat. no. I, 43; Kersauson (1996), no. 65
Cat. fig. 168

**136. Head from statue of Antinous-Dionysus**
After AD 130
Marble
Height 81 cm
The British Museum; GR 1805,0703.97
Selected literature: Smith (1904), no. 1899; Clairmont (1966), no. 37; Meyer (1991), pp. 52–3 cat. no. I, 31
Cat. fig. 165

**137. Head of Herodes Atticus**
AD 177–188
Marble
Height 35.5 cm
The British Museum; GR 1990, L01.1
Selected literature: Walker (1989), pp. 324–6; Walker (1991), p. 268; Bol (1998), p. 121 no. 1

**138. Silver bowl with Antinous tondo**
c. AD 117–138
Silver
Diameter 20.54 cm
Georgian National Museum, Tbilisi, Georgia
Selected literature: Apakidze (1958), p. 275; Strong (1966), p. 175; Machabeli (1972), pp. 291–3; Braund (1994), p. 236f.
Cat. fig. 177 (p. 193)

**139. Silver bowl with Fortuna tondo**
c. AD 117–138
Silver
Diameter 24.38 cm
Georgian National Museum, Tbilisi, Georgia
Selected literature: Apakidze (1958), p. 276; Strong (1966), p. 175; Machabeli (1972), pp. 291–3; Braund (1994), p. 236f.
Cat. fig. 176 (detail)

**140. Silver bowl with bearded man tondo**
c. AD 117–138
Silver
Diameter 22.9 cm
Georgian National Museum, Tbilisi, Georgia
Selected literature: Apakidze (1958), p. 276; Strong (1966), p. 175; Machabeli (1972), pp. 291–3; Braund (1994), p. 236f.
Cat. fig. 175

**141. Gold signet ring of Aspaurukis**
c. AD 117–138
Gold/gemstone
Height 3.23 cm
Georgian National Museum,Tbilisi, Georgia
Selected literature: Apakidze (1958), p. 276
Cat. fig. 174

**142. Mummy portrait of a woman**
c. AD 117–138
Encaustic on panel
Height 35.3 cm
The Arthur M. Sackler Museum, Harvard University, USA; inv. no. 1923.60
Selected literature: Parlasca (1969), no. 121

with bibliography)
Cat. fig. 182

**143. Mummy portrait of a young man**
AD 130–180
Encaustic on panel
Height 39 cm
Berlin Staatliche Museen (Antikesammlung), Berlin, Germany; inv. no. 31161/8
Selected literature: Parlasca (1977), no. 328 (with bibliography); Doxiadis (1995), p. 82; Borg (1996), pp. 75, 159 and 192; Borg (1998), p. 36; Parlasca & Seeman (1999), no. 72; Schädler, U. in Walker (2000), no. 39
Cat. fig. 179

**144. Mummy portrait of a woman**
AD 120–130
Encaustic on panel
Height 42 cm
Musée du Louvre, Paris, France; inv. no. MND 2047 (P 217)
Selected literature: Parlasca (1969), no. 139 (with bibliography); Aubert & Cortopassi 1998, no. 80; Parlasca & Seeman (1999), no. 181; Aubert, M.-F. in Walker (2000), no. 49
Cat. fig. 181

**145. Mummy portrait of a woman**
AD 140–150
Encaustic on panel
Height 40 cm
Berlin Staatliche Museen (Bodemuseum), Berlin, Germany; inv. no. 22606
Selected literature: Parlasca (1969), no. 129 (with previous bibliography)
Cat. fig. 180

**146. Mummy portrait of a woman**
c. AD 117–138
Encaustic on panel
36.2 x 18.5 cm
The Manchester Museum, Manchester, UK; inv. no. 5379
Selected literature: Petrie (1911), p. 11; Parlasca (1969), no. 132; Borg (1996), pp. 41, 86, 161 and 164
Cat. fig. 178

**147. Mummy portrait of a young man**
AD 110–140
Encaustic on panel
41.5 x 19 cm
Berlin Staatliche Museen (Antikesammlung) Berlin, Germany inv. 31161/2
Selected literature: Parlasca (1977), no. 334 (with

bibliography); Doxiadis (1995), p. 22; Borg (1996), p. 75; Parlasca & Seeman (1999), pp. 39, 72; Schädler, U. in Walker (2000), no. 31

### 148. Statue of Sabina from Hadrian's villa
AD 117–138
Marble
Height 204 cm
Villa Adriana,Tivoli, Italy
Selected literature: Vermeule (1981), no. 270; Vermeule (1988), no. 48; Adembri & Nicolai (2007), pp. 111–16; Adembri (2007), p. 332 no. 67
Cat. figs 185, 186 and p.198

### 149. Portrait head of Matidia Minor
AD 117–138
Marble
Height 30 cm
Villa Adriana, Tivoli, Italy
Selected literature: Adembri & Nicolai (2007), pp. 122–5 (with previous bibliography)
Cat. fig. 188

### 150. Portrait of Sabina
AD 117–138
Marble
Height 57 cm
Musei Capitolini, Rome, Italy inv. 338
Selected literature: Stuart Jones (1912), no. 94, Wegner (1956), 90.128; Carandini (1969), no. 57; Fittschen & Zanker (1983), no. 10
Cat. fig. 184

### 151. Portrait statue of Aelius Caesar
AD 138
Marble
Height 192 cm
Musée du Louvre, Paris, France; inv. no. Ma 1167
Selected literature: Kersauson (1996), no. 60 (with previous bibliography); Fittschen (1999)
Cat. fig. 207

### 152. Portrait bust of young Lucius Verus
c. AD 138
Marble
Height 34 cm
Ny Carlsberg Glyptotek, Copenhagen, Denmark; inv. no. 787
Selected literature: Calza (1964), p. 96; Poulsen (1974), no. 87; Johansen (1995), no. 87; Fittschen (1999), p. 32  no. C1
Cat. fig. 212

### 153. Portrait bust of young Marcus Aurelius
c. AD 138
Marble
Height 76 cm
Musei Capitolini, Rome Italy; inv. no. 279
Selected literature: Stuart Jones (1912), no. 28; Calza (1964), nos 150 and 1951; Fittschen & Zanker (1983), no. 61; Fittschen (1999), p. 14 no. A11
Cat. fig. 211

### 154. Portrait bust of Antoninus Pius
c. AD 140
Marble
Height 86 cm
Musei Capitolini, Rome, Italy; inv. no. 446
Selected literature: Stuart Jones (1912), no. 35; Fittschen & Zanker (1983), no. 59
Cat. fig. 208

### 155. Portrait bust of L. Julius Ursus Servianus
AD 117–138
Marble
Height 55.5 cm
Stratfield Saye House, Hampshire, UK
Selected literature: Giuliano (1957), no. 53; Dow & Vermeule (1965), pp. 288–9
Cat. figs 29, 210

### 156. Fragment of Hadrian's autobiography
AD 117–138
Papyrus
Height 22 cm
Haskell Oriental Institute, University of Chicago, USA
Selected literature: Grenfell (1900), no. 19 = PFayum 19
Cat. fig. 209

### 157. Model of Hadrian's mausoleum
1930s
Wood and plaster
Height 64 cm
Museo della Civilta Romana, Rome, Italy; inv. no. 1571
Selected literature: Civiltà Romana (1982)

### 158. Cornice from Hadrian's mausoleum
AD 117–138
Marble
Height 21 cm
Museo Nazionale di Castel Sant'Angelo, Rome, Italy; inv. no. CSA IV/160

Selected literature: Mercalli (1998), no. 17
Cat. fig. 204

### 159. Capital from Hadrian's mausoleum
AD 117–138
Marble
Height 58 cm
Museo Nazionale di Castel Sant'Angelo, Rome, Italy; inv. no.  CSA IV/173
Selected literature: Mercalli (1998), no. 41
Cat. fig. 202

### 160. Capital from Hadrian's mausoleum
AD 117–138
Marble
Height 49 cm
Musei Vaticani (Museo Gregoriano Profano), Vatican, Italy; inv. no. 9627
Selected literature: Fiore (2005)
Cat. fig. 203

### 161. Frieze block from Hadrian's mausoleum
AD 117–138
Marble
Height: 82 cm
Museo Nazionale di Castel Sant'Angelo, Rome, Italy; inv. no. CSA IV/138
Selected literature: Adriano (1998), no. 9
Cat. fig. 201

### 162. Peacock from Hadrian's mausoleum
AD 117–138
Bronze
Height 115 cm
Musei Vaticani, Vatican, Italy; inv. no. 5117
Selected literature: Manodori (1998), pp. 147–59
Cat. fig. 197

### 163. Peacock from Hadrian's mausoleum
AD 117–138
Bronze
Height 115 cm
Musei Vaticani, Vatican, Italy; inv. no. 5120
Selected literature: Manodori (1998), pp. 147–59
Cat. fig. 197

### 164. Portrait head from Hadrian's mausoleum
AD 117–138
Bronze
Height 63 cm
Musei Vaticani, Vatican, Italy; Sala Rotunda 543, inv. no. 253
Selected literature: Lippold (1936), no. 543; Wegner (1956), pp. 28, 50, 63, 65, 72, 11; Wegner (1984), p. 134; Evers (1994), no. 119
Cat. fig. 200

# NOTES

## Introduction

1    Cf., for example, Begley & De Puma (1991); Schmidt-Colinet (2005).

2    While Hadrian's military reforms have received regular attention, his economic and legal measures require further study.

3    He had already spent more than half of his life outside Italy before he came to the throne. On Hadrian's journeys and their relationship with those of other emperors see Halfmann (1986).

4    Cf. Millar (1992).

5    A very useful discussion of these issues, albeit with a predominant focus on German scholarship, can be found in Mortensen (2004).

6    These include the security installations around Gaza and the West Bank, the border fence between the USA and Mexico, and the planned fence between India and Bangladesh. One wall has come down in our own time – in Berlin.

7    The Emperor Domitian had already been closely engaged with Greece, while Hadrian's predecessor Trajan actively promoted members of the Greek elite. His pragmatic, rather than intellectual, attitude towards the Greeks is revealed by Philostratus (*Vitae Sophistorum* 1.2); when Trajan rode through Rome with the Greek writer Dio of Prusa by his side on the triumphal chariot, he remarked to the Greek: 'I have no idea what you are talking about, but I love you as myself.' Yet if the emperor cared little about Greek intellectual subtleties, he did promote energetic Greeks to high ranks in the army, awarding them signal honours for their merits. The year AD 105 was thus inaugurated by two military leaders of Greek descent holding the consulship, A. Julius Quadratus and C. Julius Quadratus Bassus, both from the city of Pergamon. Frederic II of Prussia (1712–86), flute-player, amateur poet and friend of Voltaire, provides an example of a historic leader deeply absorbed in another country's culture (in his case France's – he spoke better French than German), who still single-mindedly pursued his own political agenda.

8    Cf. Waelkens (2007); Waelkens (2008).

9    It was this strengthening of a revitalized Greek east that allowed Constantine the Great to transfer the capital of the Roman Empire from Rome to Byzantium in AD 324; when the Byzantines used the term *Rhomaioi* to describe themselves this also denoted their Christian identity, as opposed to the term 'Hellenes', which was associated with paganism.

10   Cf. Bollansée (1994).

11   The preserved sections of the *Historia Augusta* appear as the work of six different, otherwise unknown authors named Aelius Spartianus, Iulius Capitolinus, Vulcacius Gallicanus, Aelius Lampridius, Trebellius Pollio and Flavius Volpiscus. The life of Hadrian was written under the name of 'Aelius Spartianus'. The original title of the work is unknown; in the modern period it was therefore referred to as *Scriptores historiae Augustae* (*SHA* – 'Writers of Imperial History'). The beginning may be lost; the extant text covers the reigns from Hadrian (AD 117–38) to Carinus (AD 283–4/5), but a large section on the mid-third century is not preserved. Several of the earlier biographies contain dedications to emperors that would suggest they were composed in the years between AD 293 to 330. Yet, based on the ground-breaking research by the scholar H. Dessau in 1889, it is now thought that the biographies are in fact the work of a single anonymous author and were composed towards the end of the fourth or beginning of the fifth century AD. Hence, the more neutral name *Historia Augusta* (*HA*) is now more commonly used (although some scholars, particularly in Italy, still prefer to cite the section relating to Hadrian under 'Aelius Spartianus').

12   On Cassius Dio see Millar (1966).

13   For example, three letters by Hadrian concerning the organization of certain festivals were recently discovered at Alexandreia Troas; cf. Petzl & Schwertheim (2006).

14   Yourcenar was initially interested mainly in Antinous and had intended a work soley on him. Her own sexuality (she came to live with her American partner Grace Flick) may have played a part in this.

15   Cf. Rovira (2008).

16   '*Mais enfin, on allait beaucoup à Londres, à la National Gallery, au British Museum. Là, j'ai vue Hadrien pour la première fois, le viril et presque brutal Hadrien de bronze vers la quarantième année, repêché dans la Tamise au XIX siècle, et puis les statues du Parthénon*' (M. Yourcenar, *Les yeux ouverts. Entretiens avec Matthieu Galey* [Paris 1980], 31–2). Yourcenar's family had moved from Brussels to France and then temporarily to England to escape the ravages of the First World War.

17   '*Pour l'iconographie d'Hadrien, je me suis surtout servie d'un autre portrait du British Museum, la tête de bronze du "capitaine encore jeune" retrouvé dans la Tamise vers 1900, et d'une tête du Musée d'Alexandrie, admirable d'acuité psychologique, qui représente, et jusqu'aux "pattes d'oie", un home d'une cinquanaine d'années, à l'expression tendue, meditative, et fatigue*' (letter to Jean Ballard, 7 October 1951, published in M. Yourcenar, *D'Hadrien à Zénon. Correspondance 1951–1956* [Paris 2004], 79).

18   Cf. Lanciano (2005). For Yourcenar's own comments on the transformation of the villa see Yourcenar (1954), 287–8.

19   Syme (1986).

## I  A New Elite

1    *HA* Hadrian 1.4.

2    Cf. Remesal Rodríguez (1998), 197.

3    The remainder was made up of African oil amphorae (15–17%) and containers for Southern Spanish *garum*, wine from Gaul and Italy and various oriental goods (*c*.3.5% in total).

4    Normally the stamps give a full personal name, the so-called *tria*

*nomina*, consisting of name (*praenomen*), family name (*nomen gentile*) and surname (*cognomen*). However, these can be abbreviated to initials, making firm identifications with individuals known through other sources very difficult.

5 Aguilera Martín (2007).

6 Strabo 3.2.3.

7 Cf. Chic García (1985) and Caballos Rufino (1990), 44–5; followed by Birley (1997), 24. While this identification remains theoretically possible, more recent finds suggest the possibility of a different solution; cf. Chic García (2001), 270–71 (who thereby revised his original proposal): a more complete new stamp with the letters 'P.ANHBS', with a ligature 'AN', could indicate that the 'A' should be Annius, for example, rather than Aelius. See also, Pons Pujol (2002). For other potential sources of Hadrian's family's wealth see Caballos Rufino (2004), 37–55.

8 Cf. Remesal Rodríguez (1997), 50 (?). Naturally, these estimates can only be approximate. However, as olive oil still plays such an important part in Mediterranean countries, it is to some extent possible to extrapolate typical figures from more recent data.

9 C. Antius A. Julius Quadratus from Pergamon, suffect consul from 1 May until the end of August, a friend of Trajan's, has been suggested; cf. Birley (1997), 30, with references.

10 Cf. Birley (1997), 37.

11 See Petrakis (1980).

12 Hojte (2005), 129, however, argues that the small number of pre-accession bases shows that Hadrian was not publicly built up as heir apparent.

## II *War and Peace*

1 Cf. Mortensen (2004), 119–49.

2 Aeneid I.275–9.

3 See below, p. 67, notes 11, 14.

4 Cf. Mortensen (2004), 1–22.

5 The following description of events is closely based on Birley (1997), 66–76.

6 Cassius Dio 68.29.1 on Trajan's statement and 68.29.4 on the renewed fighting.

7 Cf. Smallwood (1966), no. 23.

8 Cassius Dio 68.32.1–3. Some details of Dio's account of the atrocities committed by the Jewish rebels seem hard to believe: 'They would eat the flesh of their victims, make belts for themselves of their entrails, anoint themselves with their blood and wear their skins for clothing; many they sawed in two, from the head downwards; others they gave to wild beasts, and still others they forced to fight as gladiators.'

9 For these events, cf. Birley (1997), 77–92.

10 Cassius Dio 68.13.6.

11 The *Historia Augusta* calls his measures unpopular and claims that Hadrian incurred further criticism by attributing his measures to secret instructions by the late Trajan (*HA* Hadrian 9.2). A distant echo of the rumours spread by Hadrian's critics may be the fourth-century writer Eutropius' absurd assertion that Hadrian's actions were due to his envy of Trajan's successes (Eutropius 8.6.2). Cornelius Fronto, still a young man when Hadrian came to power, later expressed a carefully veiled criticism of his actions in a letter to Marcus Aurelius (after all, Hadrian's adopted 'grandson'), saying that, due to his love of peace, Hadrian refrained even from justified actions, thereby displaying a lack of vanity only comparable to the ancient Roman King Numa; cf. Fronto, *Principia Historiae* 11 (p. 209 van den Hout).

12 On Hadrian's eastern diplomacy, see Syme (1981).

13 Cf. Birley (1997), 86.

14 No doubt Hadrian stressed them himself in his autobiography many decades later. The *Historia Augusta* comments quite neutrally that 'on taking possession of the imperial power Hadrian at once resumed the policy of the early emperors, and devoted his attention to maintaining peace throughout the world.' (*HA* Hadrian 5.2).

15 Cf. Bergmann (1997).

16 Emblematic for this interpretive approach is the chapter 'Hadrian's beard' in Zanker (1995); see also Walker (1991).

17 BM Cat Sc. 1381; Evers (1994).

18 Zanker (1995), 218, however, in line with his general interpretation of Hadrian's image felt that 'Cyrene was surely not the only city that paid homage to him in this style'.

19 Above, note 19.

20 This confirmed the doubts some scholars had voiced on iconographic grounds, cf. e.g. Adams (2003), 43–7. Adams' proposed restoration of the statue with a different head from Cyrene is not possible as they do not join. A full publication of the recent examination is in preparation.

21 Evers (1994) with references; Gergel (2004).

22 Cf. Stemmer (1978), 160–61; for the interpretation of the political significance see Gergel (2004), who proposes more detailed readings for the variations of the type.

23 Research in recent years has focused on the Greeks' rediscovery and manipulation of their ancient past during the so-called Second Sophistic, both as a way to gain favours from the ruling power based on past eminence and, at the other extreme, a means of ignoring Rome's existence altogether; cf. e.g. Swain (1996) with ample bibliography. Much more needs to be done to examine the convergence of Greek and Roman interests and the active part taken by some members of the Greek elites in shaping policies, especially those who joined the Roman military and administration in leading positions, and especially those in the eastern theatre.

24 Fittschen & Zanker (1987); Evers (1994).

25 See also Bergmann (1997); for a similar interpretation of the beard to the one proposed here see Schmidt-Colinet (2005A) and Vout (2006), who does not, however, question the Cyrene statue. If any similarities with classical models are looked for, then the portrait of the famous fifth-century-BC Athenian statesman Perikles comes to mind, but surely this would have been mostly lost on a normal Roman audience.

26 *HA* Hadrian 11.2: 'Ergo conversis regio more militibus Britanniam petiit, in qua multa correxit murumque per octaginta milia passuum primus duxit, qui barbaros Romanosque divideret.'

27 In recent years scholars have much advanced our understanding of Hadrian's Wall and other borders of the empire, see, for example, Breeze *et al.* (2005).

28 See, for example, Breeze & Dobson (2000); Collingwood Bruce (2006) with further references.

29 Agricola's actions are described in detail in the biography written by his son-in-law, the Roman historian Cornelius Tacitus.

30 The northernmost key military base, a 20-hectare legionary fort at Inchtuthil, had been established in AD 83 but was abandoned before its final completion in AD 87. *Perdomita Britannia et statim omissa* – 'Britain was subjugated and immediately let slip' – Tacitus commented.

31 *HA* Hadrian 5.2.

32 It is likely that he inspected the border installations along the German Limes. Whether he actually ordered the erection of a new, continuous wooden palisade, as Birley (1997), 116, suggests, is a matter of dispute. Considerable changes had already taken place under Trajan, and dendrochronological analyses indicate that the palisade section of the Limes might be Antonine rather than Hadrianic.

33 Work to upgrade the governor's residence in the provincial capital Londinium has been linked to Hadrian's visit, as has a round temple in the spa-town of Aquae Sulis (modern Bath), which resembles examples in Italy. It has also been proposed that the draining of the Fenns was prompted by Hadrian; for these and further examples cf. the summary in Fraser (2006), ch. 4, with bibliography. Given Hadrian's short stay, his involvement in such projects must have been limited.

34 In AD 123 Hadrian had to interrupt his tour of the western provinces and rush east, where new conflict with the Parthians loomed. A strong show of military force coupled with diplomacy averted the threat. The *Historia Augusta* laconically states 'The war with the Parthians had not at that time advanced beyond the preparatory stage, and Hadrian checked it by a personal conference.' (*HA* Hadrian 12.8).

35 Dio Cassius 69.9.4.

36 Both Dio Cassius (69.9.1–6) and the *Historia Augusta* (Hadrian 10.1–11.1) stress in considerable detail Hadrian's close involvement in practical military matters, his familiarity with the troops and the way he led by example.

37 On this see now M.P. Speidel, *Emperor Hadrian's Speeches to the African Army: A New Text* (Mainz 2006). The translation of the selected quotes is that of A. Birley in Birley (1997), 210–11.

38 Cf. Birley (1997), 205.

39 Cornelius Fronto – star orator, consul and tutor of imperial princes – embodies this new African ascendancy.

40 See Birley (1997), 268–78, with references.

41 On this topic see, for example, Y. Zerubavel, 'Bar Kokhba's Image in Modern Israeli Culture', in Schäfer (2003), 279–98.

42 For convenience, see the essays and bibliography in Schäfer (2003); cf. also Bowersock (1985).

43 Fronto for example wrote of a 'great number of Roman soldiers killed under Hadrian by the Britons and by the Jews', but practically nothing is known about the events in Britain he

referred to (Fronto, *De Bello Parthico* 2, p. 221 van den Hout).

44 The full account of the rebellion is Dio Cassius 69.9.12.1–14.3.

45 Cf. the contributions by Bowersock and Cotton in Schäfer (2003).

46 Autograph letters by Bar Kokhba found in the Judaean desert reveal his real name as Shimon bar Kosba. While his supporters used Bar Kokhba, 'Son of the Star', his detractors preferred Bar Koziba, 'Son of the Lie'; cf. Birley (1997) 270-71. The letters also give an impression of his character and gruff style of leadership.

47 Cf. M. Goodman, 'Trajan and the Origins of the Bar Kokhba War', in Schäfer (2003), 23–30. For the relationship between Rome and the Jews and the long run-up to the Second Jewish revolt, see now also Goodman (2007).

48 Dio is explicit in naming Hadrian's plans for Aelia Capitolina as a trigger for the rebellion, although some scholars think that the decision to build the new colony dates to immediately afterwards; cf. the discussion in Schäfer (2003).

49 As Roman citizenship was a condition for service in the legions, but not in the navy, this transfer may have necessitated the hasty grant of citizenship to the navy units involved – a further sign of the emergency faced by the Roman command; cf. Eck (1999), 79–80.

50 Cf. Eck (1999), 81.

51 Cf. Eck (1999), 82-7, who convincingly argues that the *ornamenta* awarded to all three must refer to the Jewish rebellion.

52 Cf. Eck (1999), 86-7.

53 The interpretation of the arch's significance depends in part on the restoration of the incomplete inscription and is hotly disputed; cf. the contributions by Bowersock (who believes it was built to commemorate Hadrian's earlier visit to the province) and Eck in Schäfer (2003). However, the remote location in which the fragments were found, considerably to the south of the next major city of Skythopolis, seems to make its link to military events more plausible.

54 For the statue see Foerster (1986), Lahusen & Formigli (2002) and the important article by Gergel (1991). It seems possible that some of the bronze fragments belonged to different statues and were deposited there in later antiquity for future reuse. The bronze cuirass is highly unusual in its iconography, and it seems doubtful that cuirass and head belong together. New survey work at Tel Shalem is currently in progress and promises a much needed, better understanding of the site and its context.

55 Cf. Eck (1999), 88-9.

56 For the Cave of Letters see Yadin (1971) and Yadin (1963–2002).

57 For the papyri see Yadin (1963–2002); a good introduction is Cotton (1999). The personal archive of a woman named Babatha provides particularly important insights into the organization of daily life and dealings with the ruling power; cf. the important studies by Cotton.

## III *Architecture and Identity*

1 The bibliography on this topic is vast and ever expanding. Very useful summaries in English with full references can be found in Boatwright (1987) and Boatwright (2000); for the western provinces see also Fraser (2006). On Hadrian and architecture in

general see for example Gros (2002).

2 On the programmatic intent of Hadrian's building projects in Rome see also Kienast (1980).

3 For Trajan's building activity in Rome and Italy see Packer (1997), Hesberg (2002), Nünnerich-Asmus (2002B) with further references. Cf. also Claridge (2007).

4 See for example MacDonald & Pinto (1995) and MacDonald (2002).

5 An inscription from ancient Smyrna, for example, records that Hadrian donated ninety-eight column shafts for a specific building; seventy-two were made of Phrygian and twenty of Numidian marble, a further six of porphyry (ISmyrna II.1 no. 697). On Hadrian's benefactions at Smyrna see also Boatwright (2000), 157–62.

6 See for example Lancaster (2005).

7 There is no shortage of other examples of rulers throughout history who were closely involved in planning processes, without being architects in any sense. Frederic II of Prussia, for example, sketched plans for his palace at Sanssouci; Adolf Hitler's brutalist visions of Germanic grandeur were turned into built reality by his favourite architect, Albert Speer.

8 Cassius Dio 69.4.1–5.

9 See for example Ridley (1989).

10 This was first proposed by Brown (1964), 57–8.

11 To what extent free, unskilled labour was used in Roman building projects is a much discussed question, but most scholars now seem to agree with the view put forward by Brunt (1980).

12 Vitruvius, *De Architectura* 1.2.2.

13 Cf. A.M. Reggiani in *Adriano: Archittetura e Progetto* (Milan 2000), 209, cat. no. 24. MacDonald & Pinto (1995), 11, fig. 5, by contrast refer to the miniature stadium as a fountain. Still useful on ancient architectural models in general is Benndorf (1902).

14 *Epit. de Caes.* 14.5: '*Namque ad specimen legionum militarium fabros, perpendiculatores, architectos geusque cunctum exstruendorum moenium seu decorandum in cohorts centuriaverat.*'

15 This and the following is closely based on Freyberger (1990).

16 According to Freyberger, Workshop B supplied Ostia and Villa Hadriana. Stylistic differences between the Corinthian capitals of the latter site suggest the presence there of at least three different workshops, whose output differed in manufacture and quality, cf. Freyberger (1990), 73. It seems that the workshops generally were commissioned according to the importance of the building or the prominence of the decorative elements they produced within a given building.

17 They can be identified by their carving styles, which have parallels in buildings of their regions of origin.

18 Freyberger (1990), 39.

19 Freyberger (1990), 67.

20 This is a highly specialized and constantly evolving field of study; for further references see for example Steinby (1978)

21 Cf. Anderson (1997), 157–8.

22 See Lamprecht (1996); Lancaster (2005) with further references.

23 Oros. Hist. VII 12.5: '*Pantheum Romae fulmine concrematum*' (note referring to the year AD 110).

24 The bronze letters of the inscription visible today are a modern restoration.

25 *HA* Hadrian 19.10: '*Romae instauravit Pantheum, Saepta, Basilicam Neptuni, sacras aedes plurimas, Forum Augusti, Lavacrum Agrippae; eaque omnia propriis auctorum nominibus consecravit*' (At Rome he restored the Pantheon, the Voting Enclosure, the Basilica of Neptune, very many temples, the Forum of Augustus, the Baths of Agrippa, and dedicated all of them in the names of their original builders).

26 Cf. Wilson Jones (2000), 180.

27 Virgili & Battistelli (1999), *passim*.

28 The new excavations could not exactly separate the Agrippa structures from the Domitianic ones, cf. Virgili & Battistelli (1999). However, a monumental staircase facing north was found below the existing one and earlier probings had discovered two further floor layers below the floor of the rotunda, in short all signs of continuity in the building's basic layout.

29 Cf. Virgili & Battistelli (1999), 142–5.

30 Dio Cassius 53.27.3.

31 Cf. Wilson Jones (2000), 182–4.

32 This did not, of course, prevent the removal of materials and changes to the building's fabric.

33 The exact dimensions of this square are disputed. It may have extended north as far as the modern Church of the Maddalena.

34 Cf. Virgili & Battistelli (1999).

35 The original ceiling arrangement was captured in Renaissance drawings. The bronze ceiling decoration was removed by Pope Urban VIII in the 1620s in order, it is said, to cast cannons for Castel Sant Angelo. From this episode stemmed the cynical Roman popular saying, *quid non fecerunt barbari, fecerunt Barbarini* – 'what the barbarians did not do, the Barberini [i.e. the family of Urban] did'.

36 Cf. Wilson Jones (2000), 184 with references.

37 Cf. Wilson Jones (2000), 183.

38 Other Roman examples for this free approach to façade design exist.

39 For the uppermost sections the concrete mixture included an increasing proportion of light and airy volcanic matter, so-called *lapilli*, imported from the Vesuvius region of southern Italy, so that the weight could be kept to a minimum.

40 Cf. Lancaster (2005), 43–5.

41 While the lower course of the transitional block's brickwork is bonded with the wall of the rotunda, it simply abuts the rotunda's wall further up.

42 Davies *et al.* (1987); Wilson Jones (2000), ch. 10.

43 Taylor (2003), 129–31, argues that the decision to use shorter column shafts was not prompted by problems with the quarrying or transport, but with a lack of space for tilting them into position on the Pantheon's platform once the intermediate block had been built. This seems less convincing.

44 P. Giss. 69. In the letter, a local official urgently requests a consignment of barley for the draught animals he has assembled to transport the column from the quarry to the river; cf. Peña (1989). At the same time, the lessee of the quarries at Mons

Claudianus and Mons Porphyrites, an imperial slave named Epaphroditus Sigerianus, appears to have accumulated enough wealth during this boom period to finance a sanctuary of the god Serapis in each place; cf. Klein (1988), 34–5 and 102.

45 See Haselberger (1994).

46 Cf. Wilson Jones (2000), 209.

47 See for example Heilmeyer (1975) and most recently Hetland (2007). Most, however, prefer a Hadrianic date for the entire structure, cf. eg. Wilson Jones (2000), MacDonald (2002).

48 This holds true even if the first courses of brickwork were laid before Hadrian came to power. If the plans for the Pantheon thus demonstrate the pinnacle of design achievement in the second decade of the second century AD, the novel structures at Hadrian's villa demonstrate the rapid evolution of ideas and technological advance following immediately after.

49 Cf. Boatwright (1987), 58–62.

50 Dio Cassius 69.7.1.

51 Cf. Boatwright (1987), 119–33; Stamper (2005), 206–12.

52 *HA* Hadrian 19.12.

53 *HA* Hadrian 19.13.

54 Cf. above, p. 102. Therefore, either Dio's account is simply wrong, or Apollodorus' suggestions were taken up; in the latter case, it is hard to imagine that he suffered any harm for having put them forward.

55 Cassatella & Pensabene (1990); see also Stamper (2005), 210–12.

56 There are strong similarities between the carved ornaments of the Temple of Venus and Roma and the Traianeum at Pergamon, so that the involvement of a Pergamene workshop has been suggested, cf. Strong (1953), 127–9. A local workshop seems to have been involved to a lesser extent.

57 For an overview cf. Boatwright (2000), Fraser (2006).

58 Fronto, Loeb 2, 206–7.

59 On the Panhellenion league see Spawforth & Walker (1985).

60 Cf. Willers (1990). Still useful is Graindor (1934).

61 Pliny, *Nat. Hist.* 36.45, cf. Willers (1990), 33–4.

62 Cf. Philostratus, *Vitae Soph.* 1.25.3.

63 On the organization of the Panhellenion see Spawforth & Walker (1985); Spawforth & Walker (1986).

64 On Hadrian's activities in Cyrene and the Cyrenaica see Boatwright (2000), 173–84 and Walker (2002) with further references. For the Jewish revolt see above, p. 65.

65 See Boatwright (2000), 174, with references.

66 See Spawforth & Walker (1986) with references.

67 On Italica, see for example Caballos & Leon (1997) and Boatwright (2000), 162–7, with further references.

## IV *Hadrian's Villa*

1 Literature on the villa is vast. Apart from the short recent guide by Adembri (2000), the best comprehensive account in English is MacDonald & Pinto (1995). A detailed recent study in Italian is Salza (2001). Together, these works provide exhaustive bibliographies. Ongoing small, targeted excavations and recent discoveries made in connection with a modest upgrade of the modern infrastructure on the site, as well as a number of international research projects on various aspects of the villa, have brought spectacular new insights and greatly enhanced our understanding.

2 MacDonald & Pinto (1995). In terms of its function and use, the villa appears like a mixture between the splendid extravagance of Versailles combined with the purposeful informality of a large English country house.

3 The most dramatic example is the restoration and exploration of the *vestibulum*, which unexpectedly led to the discovery of completely unknown structures, cf. Mari (2002).

4 Three aqueducts were built to supply the villa, cf. Mari (2002), 200, n. 5.

5 Mari (2002).

6 Some have speculated that it may have come into Hadrian's possession through Sabina, but this is little more than conjecture. On the local setting of the villa see Mari (2002).

7 Cf. Syme (1982–3).

8 A law introduced by Trajan stipulated that Roman senators had to invest one third of their property in Italy, so that even senators from the provinces acquired substantial landholdings, particularly in the vicinity of Rome.

9 Cf. most recently Mari (2007). Mari mentions an unpublished inscription dedicated by unidentifiable *'possessores Vibii'* (that is, owners belonging to the family of the Vibii) in a Tiburtine villa 10 km from the Villa Adriana; cf. Mari (2007), p. 63.

10 Mari & Sgalambro (2007).

11 Other villas of Trajan were located at Telamon and Portus Ostiae.

12 Cf. Mari (2002), 197–8.

13 Vita Apollonii VIII, 20: 'the palace at Antium, which was that one of his Italian palaces in which this Emperor took most pleasure'. The context of this passage is interesting, for Philostratus suggests that Hadrian kept important books and letters by Greek philosophers at the Antium villa.

14 Provided the identification of the so-called Terme Taurine near Civitavecchia with Trajan's villa is correct, cf. MacDonald & Pinto (1995), 194. Later, both Marcus Aurelius and Lucius Verus are known to have frequented the Centum Cellae villa.

15 Cf. also Becker (1925), 101ff. Traces of a villa near Praeneste are usually attributed to Hadrian, but this is solely because a spectacular acrolithic statue of Antinous was found there in the eighteenth century. More recent finds, such as at Luku, now demonstrate that members of the senatorial aristocracy could also have had such images in their houses. The ownership of the Praeneste villa therefore remains unresolved.

16 Cf. Boatwright (1987), 150–55.

17 Cf. Boatwright (1987), 155–60.

18 CIL XIV 3911. Gascou & Janon (2000); Danziger & Purcell (2005), 187; Mari (2002), 190–91, fig. 22. The quote is part of a dedicatory inscription set up in a Roman sanctuary at Aque Albuli, not far from the villa. It celebrates the successful cure of an injured horse named Samis through the sanctuary's sulphurous springs. The tone of the inscription, very reminiscent of Hadrian's epigram for his favourite charger Borysthenes, has led several scholars to assume his authorship

for this text, too, which then would preserve a description of the villa in Hadrian's own words. However, the letter forms seem to suggest a later date, perhaps early in the third century AD.

19 Adembri (2000), 36.

20 Cf. Adembri (2000), 24. MacDonald & Pinto (1995), 36–7.

21 MacDonald & Pinto (1995), 28.

22 MacDonald & Pinto (1995), 56.

23 MacDonald & Pinto (1995), 132.

24 The main study on the Republican villa remains Lugli (1927). See also Rakob (1973).

25 Cf. Rakob (1973), 122 with note 28. The intriguing question of whether Hadrian owned the estate already before he came to power and began some of these alterations before AD 117 cannot be answered on present evidence.

26 Adembri (2000), 36.

27 Raeder (1983), 344, n. 321 with references.

28 MacDonald & Pinto (1995), 185.

29 For possible suggestions see Salza (2001), 393–6.

30 The modern visitor experience reflects this separation, for public access to the Cento Camerelle and most of the underground network is sadly not permitted. A future reorganization of visitor routes could eventually reflect the social and physical separation of the ancient villa population through the provision of distinctive tours and thereby greatly enhance the understanding of the site.

31 MacDonald & Pinto (1995), 56.

32 This renders obsolete the older hypothesis that the large baths served men and the smaller baths women.

33 Cf. De Franceschini (1991), 619–30. A very useful English summary by the author is available on the internet (www.villa-adriani.net).

34 Cf. Jansen (2007).

35 *HA* Hadrian 26.5.

36 Cicero asked Atticus to send him sculptures and architectural elements for his villa from Athens (*Cicero ad Att* I 2.2; 4.2; 5.2; 6.3; 8.2; 9.3; 10.5). Cf. Raeder (1983), 287–9; MacDonald & Pinto (1995), 145–7.

37 The following remarks are based very closely on the analysis in MacDonald & Pinto (1995).

38 Cf. Lancaster (2005).

39 Cf. MacDonald & Pinto (1995), esp. chs 3–4 ('Familiar Architecture', 'Unfamiliar Architecture').

40 It is fascinating to see how Renaissance architects, whose theoretical knowledge was first and foremost based on a thorough study of the Vitruvian text, were clearly overwhelmed by what they measured and recorded of the villa's buildings and almost subconsciously made subtle changes to their plans, so that the buildings looked more like those described by Vitruvius.

41 The architecture of Trajan's forum, for example, has been likened to a gigantic military camp; cf. Zanker (1970).

42 Cf. MacDonald & Pinto (1995), 181–2; for the toilets, see Jansen (2007).

43 Cf. MacDonald & Pinto (1995), 177.

44 Cf. A. Plassart, *Fouilles de Delphes* III.4 (Paris 1970), no. 302.

45 *HA* Hadrian 8.6.

46 *HA* Hadrian 9.7; 17.4; 22.4–5; 26.4. Cf. also Cassius Dio 69.7.3.

47 The basic study remains Raeder (1983).

48 Raeder (1983), 248–50.

49 Raeder (1983), 292.

50 Raeder (1983), 212.

51 Raeder (1983), 233.

52 Raeder (1983), 237.

53 Raeder (1983), 206–13.

## V  Antinous

1 Still the most comprehensive account of Antinous' life, as well as Christian and modern attitudes towards his and Hadrian's relationship, is Lambert (1984). For the history of scholarship and the prevailing negative responses, see especially ch. 1, 'Scandal of the Centuries'. The conscious or subconscious censorship concerning Roman homosexuality that prevailed for so long is even echoed in many of the standard translations of the relevant classical texts, where explicit terms are frequently replaced by more general ones. Lambert's study is excellent in dealing with the general background and the literary sources, but much less sound in the interpretation of some of the archaeological evidence.

2 For the sculptured portraits of Antinous and representations in other media see the thorough catalogue in Meyer (1991), now also Vout (2007).

3 Williams (1999) provides an excellent discussion of Roman homosexuality in its social context. Cf. also Lambert (1984), ch. 6 ('Pederasty in the Imperial Age').

4 See, for example, the discussion in Williams (1999), ch. 5 ('Sexual Roles and Identities').

5 For the *lex Scantinia* see Williams (1999), 119–24.

6 *HA* Hadrian 11.7.

7 Cf. Lambert (1984), 76f., with examples of the attempts by various nineteenth-century scholars to explain away the clear evidence for homosexual practices provided by the ancient sources and portray Hadrian instead as a heterosexual.

8 Suetonius, Vita Caesarum *Nero* 29.

9 Martial, Epigrams 9.11–13, 16, 17, 36. Statius, Silvae 3.4. Cf. Williams (1999), 34.56–9.

10 Cf. Cassius Dio 68.6.4.

11 *HA* Hadrian 4.5 casually refers to Trajan's *delicati*, giving the impression that the presence of such pleasure-boys was a normal occurrence within the imperial household. Cf. Williams (1999), 34.

12 *HA* Hadrian 1.7.

13 *HA* Hadrian 4.5.

14 *HA* Hadrian 14.9. Apuleius, *Apologia* 1.11.

15 Cf. Williams (1999), *passim*. The same difficulties apply to the interpretation of objects; for the Warren Cup, for example, see Williams (2006), with the review by Clarke (2006), which demonstrates the lack of consensus in decoding these images.

16 See, for example, Lambert (1984), 78–81.

17 Lambert (1984), ch. 2 ('Antinous, the Young Greek, c. 110–23') is an attempt to reconstruct Antinous' background and biography.

Lambert's near certainty that Hadrian and Antinous met in 123 is misplaced.

18  *HA* Hadrian 2.1.

19  For the symbolic importance of the hunt and its practical details see, for example, Aymard (1951) and Tuck (2005). The Borysthenes inscription (CIL XII 1122): 'Borysthenes the Alan, Caesar's hunting-horse, used to fly over plains and marshes and hills and thickets, at Pannonian boars – nor did any boar, with tusks foaming white, dare to harm him as he followed, or spray the tip of his tail with spittle from its maul (as tends to happen), but in unimpaired youth, with limbs unscarred, after meeting his day of fate, he lies in this field.' Another inscription was found near Thespiae, in central Greece (IG VII 1828). Here Hadrian commemorated the dedication of a bear skin to Eros.

20  For the tondo reliefs see, for example, Meyer (1991), 218–21, with previous literature. Conforto (2001) has recently proposed that the arch of Constantine in fact simply modified an existing arch of Hadrian, keeping most of the lower structure.

21  POxy. VIII 1085.

22  The Egyptian background is conveniently set out in Lambert (1984), ch. 10 ('Death in the Nile, October 130').

23  Cf. Cassius Dio 69.11.2.

24  On the obelisk see Meyer (1994). For the suggestion that it may have stood in the newly discovered Antinoeion at Hadrian's villa, cf. Mari (2007).

25  For the provenances of the Antinous portraits see Meyer (1991). Renaissance accounts mention the discovery of a fine sculpture of Antinous, now lost, in a room close to the private residence that shows clear signs of structural alterations, cf. Raeder (1983), 125 II.1; 247–8.

26  For the most recent account in English of the new discoveries associated with the Antinoeion, see Mari (2007); cf. also Adembri (2006). The excavations are ongoing.

27  Mari (2007).

28  See Meyer (1991), 17–23.

29  Cassius Dio 69.11.4.

30  Meyer (1991), 183–211, discusses the cult in detail.

31  For the finds from Luku see Spyropoulos (2006). On Herodes Atticus cf. also Tobin (1997) and most recently Galli (2002). Dr Spyropoulos, who currently prepares a full publication of the finds from Luku, has very generously granted permission to reproduce here, pp. 188–9, images from his 2006 book, which provides a preliminary discussion.

32  For Myloi see Meyer (1991), 27–8 (cat. I 4); Barakari-Gleni (2006).

33  Cf. Meyer (1991), 80–81 (cat. I 59).

34  Meyer (1991), 202–3.

35  Dedicatory inscription: IG V2, 281. Cf. Meyer (1991), 200, with further literature.

36  Cf. Braund (1991).

37  Cf. Kossack (1974), 26–7, with references for earlier Russian publications. The tomb of Aspaurukis (no. 1) was conspicuous through its opulence. Apart from the skeleton, it contained numerous grave goods, mostly made of gold or silver. Among the other finds were a belt richly decorated with gems, the sheath of a ceremonial dagger and a diadem, a pair of silver oinochoae, and fragments of a funerary couch encased in silver. Six Roman aurei (four of them dating to the reign of Hadrian, the other two earlier) and a denarius were also found. Tomb no. 6 also contained grave goods. Apart from the two silver bowls, there were two silver oinochoae and a silver patera as well as fragments of a funerary couch encased in silver. Also found were numerous Roman coins, ranging in date from the reigns of Augustus to Commodus.

38  For mummy portraits see Parlasca (1969–2003); Borg (1996); Walker & Bierbrier (1997). These paintings came into use in Egypt during the Roman imperial period and partly replaced more traditional, idealized masks. They were found throughout Egypt but were concentrated in a few cemeteries in the Nile valley, such as Achmim and Antinoopolis, and particularly in the Fayum, so that they are sometimes also known as 'Fayum portraits'.

39  The portraits were painted in sometimes very elaborate encaustic techniques, using layers of coloured, heated wax that produced vivid chromatic tones, but cheaper versions in tempera on white backgrounds and even watercolour are also known. A particular appeal lies in their seemingly striking realism. In the rare cases, however, where portraits by one particular artist or at least from one workshop can be compared, a degree of stylization and the application of recurring formulae can be observed.

40  The portrayed tend to be clad in the standard Greek-style *pallium* and *palla*, not the distinctly Roman toga.

41  The chronology of the portraits is mostly based on a detailed comparison between the hairstyles represented on them and on more closely dated sculptures. This obviously can only provide an approximate framework, as some people may have retained old-fashioned coiffures for a long period.

## VI *Sabina*

1  On Sabina, see most recently Adembri & Nicolai (2007) with bibliography. The name Vibia is not explicitly attested for Sabina, but derived from the inscriptions of two of her freedmen (who would have adopted her names upon their manumission). Similarly the name and career of her father, who may have been consul in AD 97, is not beyond doubt; cf. Eck (1978b), 909; Rapsaet-Charlier (1987), no. 802.

2  Most information on Sabina's early life and immediate family is derived from a painstaking examination of epigraphic sources, cf. Eck (1978b). Cassius Dio (69.1.1) and the *Historia Augusta* (Hadrian 2.10) wrongly call her Trajan's niece; in fact, she was Trajan's great-niece. Sabina's date of birth is a conjecture, based on the information that her marriage with Hadrian took place shortly before he became quaestor in AD 101, when she can be assumed to have been fourteen or fifteen if she married at the normal age.

3  As with Sabina, almost all of the prosopographical detail about the younger Matidia, including the name of her father, and her own name 'Mindia' is deduced from inscriptions and in part

conjectural; cf. Eck (1978a); Rapsaet-Charlier (1987), no. 533. The elder Matidia's marriage to L. Mindius seems to have ended relatively soon, either through divorce or her husband's death. Divorce was commonplace, especially among the aristocracy. The often very substantial age difference between husbands and wives meant that many women were widowed early and then remarried.

4 Cassius Dio 68.5.5. On the role of Trajan's female relatives see Temporini (1978).

5 Cf. e.g. Boatwright (1991).

6 *HA* Hadrian 11.3.

7 Cf. Birley (1997), 125. He assumes that Sabina had accompanied Hadrian to Britain.

8 Birley (1997), 125.

9 *Epit. de Caes.* 14.8.

10 Cf. Eck (1978b). There is some controversy concerning the exact date, as some later sources link the award of the *Augusta* title to Hadrian's assumption of the title *Pater Patriae* in AD 128, but other evidence makes the earlier date more likely.

11 Eck (1978b), 911 with references.

12 Cf. Carandini (1969); Adembri & Nicolai (2007).

13 Adembri & Nicolai (2007); see also the entries for Sabina in Fittschen & Zanker (1983).

14 See the list in Boatwright (1991), 523.

15 Plotina for example was interested in Epicurean philosophy and personally obtained favours for the Epicurean school at Athens from Hadrian, as the inscribed text of one of her letters attests; cf. Birley (1997), 109 with references.

16 For Mindia Matidia see Eck (1978a), Boatwright (1991), esp. 522, and Reggiani (2004) with further references.

17 Cf. C. Valeri and F. Zevi in Reggiani (2004), 128–33.

18 The portrait type is currently known in six replicas: New York, Metropolitan Museum inv. 21.160.6; Paris, Louvre inv. MA 4882; Sessa Aurunca, Castello Ducale inv. 297045; Sessa Aurunca, Castello Ducale inv. 297048; Villa Adriana no. inv.; Warsaw, National Museum inv. 198721. A previous suggestion had been that it represented Domitia Paulina, Hadrian's sister, cf. Fittschen (1996), 46.

19 Most of the information on her properties is derived from inscriptions relating to her freedmen, who administered them.

20 Inevitably, some scholars have drawn from this Sapphic language and the affectionate terms Balbilla used to describe Sabina some rather far-reaching conclusions, even speculating about a lesbian relationship between the two; cf. Birley (1997), 251. There is little to substantiate this view. For the inscriptions on the colossus see Bernand (1960); English translations of Balbilla's poems can be found in Lefkowitz & Fant (1992).

21 The continuation of the journey, as if nothing had happened, perhaps puts into perspective later reports about Hadrian's extreme distress over the death of his 'beloved'.

22 *Epit. de Caes.* 14.9.

23 *HA* Hadrian 23.9.

24 See B. Adembri in Adembri & Nicolai (2007), 75–85; 111–15.

25 Eck (1978a) with references.

## VII *Towards Eternity*

1 Boatwright (1987), 161–81, provides a good summary in English on the mausoleum and bridge, complete with bibliography. A very useful more recent discussion in Italian of the monument (including illustrations of architectural and sculptural fragments) and its wider historical context can be found in Mercalli (1998 [for a shorter, English version see Giustozzi 2003]), while Davies (2000) sets the mausoleum into the framework of other imperial tombs. Reconstructions, especially of the superstructure of the tomb vary greatly; a major new survey of the monument, led by the German Archaeological Institute in Rome, is in progress.

2 On the ideological context of the Mausoleum of Augustus see Zanker (1988); on the physical reconstruction of the monument Hesberg & Panciera (1994). Nothing had harmed Augustus' erstwhile rival Marc Antony's reputation more than the stipulation in his will to be buried not in Rome, but Alexandria, next to his lover Cleopatra.

3 See the discussion below. The fact that so many monuments, which belong in this context, from consecration altars to entire temples, still lie buried and unidentified under the streets of modern Rome, has played a role in this. The locations for example of the Temple of Divus Traianus Pater, of the burial places and consecration altars of Diva Marciana and Matidia, as well as the *ustrina* of Sabina and Hadrian himself, are all unknown, although they must have been prominent landmarks of the ancient city. The dynastic purpose of the mausoleum is discussed by Kienast (1980).

4 For the consecration ritual see Price (1987), Davies (2000) and most recently the important study by Zanker (2004), which contains a useful bibliography.

5 See above, n. 3. Coins commemorating the consecration of Traianus Pater are known; cf. Schulten (1979), 71–2; BMC 500–508.

6 Cassius Dio 56.34–6 and Suetonius, *Divus Augustus*, 100, describe the consecration of Augustus (AD 14); Cassius Dio 75.4–5 discusses the consecration of Pertinax (AD 193) and Herodian 4.2 the consecration of Septimius Severus (AD 211).

7 For example, the precise date of the death of Trajan's father is unknown, but it must have occurred some time before Trajan came to power and was in a position to have him consecrated.

8 The following summary is mostly based on the account in Zanker (2004); certainly individual ceremonies may have differed to some degree from this ideal version.

9 Celebrations included a posthumous triumph for Trajan (again making use of a wax effigy) for victories over the Parthians; cf. *HA* Hadrian 6.3.

10 P. Gies. 3; cf. Alexander (1938), 143–4.

11 It is now clear that this temple was not part of the original master plan of Trajan's forum, even if archaeological maps of the 1930s suggest so. For the current state of research and a far-reaching new proposal, including Trajan's tomb and other Hadrianic structures north of the forum, see Claridge (2007).

12 For the dedicatory inscription, see CIL VI 966 = Smallwood

(1966), no. 141a; cf. also Boatwright (1987), 74–5 (a different view in Claridge [2007], 92–3). According to the *Historia Augusta*, this was the only building in Rome Hadrian officially dedicated in his own name; cf. *HA* Hadrian 19.9. Cassius Dio 69.10.3.1 mentions a temple Hadrian dedicated to Plotina, which could refer to a separate monument.

13 For example, the Arval Brethren, an important college of priests, marked Matidia's consecration on 23 December 119 with 2 pounds of perfume and 50 pounds of incense; cf. Smallwood (1966), 23 no 7. The Historia Augusta records 'special honours to [Hadrian's] mother-in-law, with gladiatorial games and other ceremonies' (*HA* Hadrian 9.9) and elsewhere states 'after other enormous delights, he presented the people with spices in honour of his mother-in-law' (*HA* Hadrian 19.5). These references may relate to the consecration ceremony or later commemorative events; the cult for the deified members of the imperial family, catered for by dedicated priests, provided regular opportunities for such celebrations.

14 The text is known through an inscription from Tibur (modern Tivoli), where Matidia may have died and – at least initially – been buried; cf. CIL XIV 3579; Smallwood (1966) no. 114. It is unclear whether the speech was delivered at the funeral or during the consecration.

15 See Schulten (1979), 77–8 (Plotina, always together with Trajan), 78–9 (Matidia).

16 With the single exception of Julia Domna in AD 217.

17 Claridge (2007) argues instead for a separate tomb just to the north of the column.

18 Davies (2000), 179.

19 Davies (2000), 179.

20 She was the mother of Marcus Aurelius, see the stemma p. 126.

21 For the iconographic significance of peacocks, see Schulten (1979), 25; for eagles, ibid. 22–5.

22 This is described by John of Antioch (John Malalas), cf. Pierce (1925), 78, n. 4.

23 Cf. Hesberg & Panciera (1994).

24 Procopius, *De Bello Gothico* 1.22.

25 Cf. Pierce (1925), 76–7.

26 As the area around the mausoleum was full of sculptures, the attribution of some of the fragments to the monument is by no means certain.

27 Cf. Tomei (1998), 109.

28 Tomei (1998), 136 no. 31.

29 Tomei (1998), 116 no. 2; see also Meyer (1991), 70 cat. I 49, pl. 57.

30 See above, chapter five and fig. p.189. The entire group would have measured some 5 metres in height. If the colossal figure did not represent Hadrian, then it probably showed a god like Apollo.

31 For the Mausoleum at Halikarnassos see most recently Jenkins (2006), 203–35 with bibliography.

32 CIL VII.973 = Smallwood (1966) no. 379.

33 Four such medallions are known; cf. Boatwright (1987), 178–9, fig. 39, with brief discussion and bibliography.

34 Cassius Dio 69.11.2; cf. Birley (1997), 255, 257.

35 Some scholars believe that Hadrian initially groomed Pedanius Fuscus as his future heir; to judge from the offices the young man held, known from a number of inscriptions on the bases of statues set up in his honour, he did enjoy Hadrian's favour. Cf. Champlin (1976).

36 Cf. Birley (1997), 289 with references.

37 The *Historia Augusta* claims that L. Ceionius Commodus' 'sole recommendation was his beauty' (*HA* Hadrian 23.10), and again that 'he was endeared to Hadrian, as the malicious say, rather by his beauty than by his character' (*HA* Aelius 5.1). Some modern scholars have been misled by this to draw rather absurd conclusions, postulating an erotic relationship between Hadrian and Aelius or alternatively claiming that Aelius was Hadrian's illegitimate son; see the summary in Birley (1997), 289–90 with note 24.

38 See Birley (1987), 47, and Birley (1997), 295–6 with references. Opinions on this, do, however, vary. After all, Aelius had a son of his own to whom he may have intended to pass the crown; cf. Barnes (1967).

39 Cf. Birley (1987), ch. 2 with stemma c. It has even been proposed that Marcus' grandmother was a half-sister of Sabina, turning him into Hadrian's great-nephew by marriage; ibid. 29 with references.

40 Cf. Birley (1997), 291–2 with references.

41 Cf. Boatwright (1997), 226–9, fig. 54, with references; for the relief itself, see La Rocca (1986).

42 Cf. Birley (1997), 295–6.

43 HA Hadrian 25.5.

44 Cassius Dio 70.1–3.

45 CIL VI.984 = Smallwood (1966) no. 124. In the inscription Sabina is referred to as 'Diva', while Hadrian himself still lacks the 'Divus' title, hinting perhaps at the difficult negotiations with the senate. The transfer of Hadrian's remains from Puteoli to Rome therefore seems to have preceded his official consecration.

46 Over the following years, all the members of Antoninus' family would be buried in the mausoleum, the monument even acquired the name 'Antonianum'. Later the family of Septimius Severus was also interred there.

47 BMC 32–4; cf. also Schulten (1979), 81.

48 On the Temple of Divus Hadrianus see most recently Novelli (2005). Hadrian's *ustrinum* still needs to be located; on previous proposals see Boatwright (1987), 218–30, whose scepticism as to its existence is unconvincing.

49 HA Hadrian 25.9; translation after Birley (1997), 301.

# BIBLIOGRAPHY

## Abbreviations

*AA = Archäologischer Anzeiger*

*ABull = Art Bulletin*

*AK = Antike Kunst*

*AJA = American Journal of Archaeology*

*AJPh = American Journal of Philology (=AJPh)*

*ANcSoc = Ancient Society*

ANRW = H. Temporini (ed.), *Aufstieg und Niedergang der römischen Welt* (Berlin 1972).

*AntJ = Antiquaries Journal*

*AntPl = Antike Plastik*

*BABesch = Bulletin Antieke Beschaving*

*BJ = Bonner Jahrbücher des Rheinischen Landesmuseums in Bonn und des Vereins von Altertumsfreunden im Rheinlande*

*BullCom = Bullettino della Commissione Archeologica Comunale di Roma*

CIL XIV = H. Dessau (ed.), *Corpus inscriptionum latinarum. Inscriptiones Latii veteris latinae* (Berlin 1887–1933).

CIL XV = H. Dressel (ed.), *Corpus inscriptionum latinarum. Inscriptiones urbis Romae latinae: Instrumentum domesticum* (Berlin 1891).

CIL VI = Smallwood (1966)

CIL VII = E. Hübner (ed.) *Corpus inscriptionum latinarum. Inscriptiones Britanniae latinae* (Berlin 1873).

CIL XVI = H. Nesselhauf (ed.), *Corpus inscriptionum latinarum. Diplomata militaria: ex constitutionibus imperatorum de civitate et conubio militum veteranorumque expressa* (Berlin 1873).

Gems = Walters (1926)

*Hadrien* 1999 = Charles Gaffiot (1999)

*HSPH = Harvard Studies in Classical Philology*

*IMN = Israel Museum News*

*JDAI = Jahrbuch des Deutschen Archäologischen Instituts*

*JÖAI = Jahreshefte des Österreichischen Archäologischen Instituts*

*JRA = Journal of Roman Archaeology*

*JRS = Journal of Roman Studies*

*PBRS = Papers of the British School at Rome*

*RAN = Revue archéologique de Narbonnaise*

RE = A. F. Pauly and G. Wissowa (eds), *Real-Encyclopädie der classischen Altertumswissenschaft* (Stuttgart 1893).

RE 4 = Mattingly (1968)

RIB I, II = Collingwood & Wright (1995)

*RM = Mitteilungen des Deutschen Archäologischen Instituts, Römische*

*Tab. Vindol.* II = Bowman (1994)

*ZPE = Zeitschrift für Papyrologie und Epigraphik*

**Adams (2003)**

N. Adams, 'Greek and Roman Sculpture from Cyrene: recent joins and proposed associations, including a "new" portrait statue, and some recent epigraphic discoveries', *Libyan Studies* 34 (2003), 43–64.

**Adembri (2000)**

B. Adembri, *Hadrian's Villa* (Milan 2000).

**Adembri (2006)**

B. Adembri (ed. in collaboration with Z. Mari), *Suggestioni egizie a Villa Adriana* (Milan 2006).

**Adembri (2007)**

B. Adembri in *Nostoi. Capolavori ritrovati. Roma, Palazzo del Quirinale Galleria di Alessandro VI, 21 dicembre–2 marzo 2007* (Rome 2007), no. 67, 232.

**Adembri & Nicolai (2007)**

B. Adembri and R.M. Nicolai (eds), *Vibia Sabina: Da Augusta a Diva* (Milan 2007).

***Adriano* 2000**

*Adriano. Archittetura e progetto* (Milan 2000).

**Aguilera Martín (2007)**

A. Aguilera Martín, 'Evolución de los titoli picti delas de las ánforas Dressel 20 entre mediados del siglo I y mediados del siglo II' in *Acta XII Congressus Internationalis Epigraphiae Graecae et Latinae, Barcelona 3–8 Septembris 2002* (Barcelona 2007), 15–22.

**Alexander (1938)**

P.J. Alexander, 'Letters and Speeches of the Emperor Hadrian', *HSPh* 49 (1938), 141–77.

**Anderson (1997)**

J.C. Anderson, *Roman Architecture and Society* (Baltimore 1995).

**Apakidze (1958)**

A.M. Apakidze, *Archaeological excavations at Armazis-Khevi near Mzkheta in 1937–1946* (Tbilisi 1958).

**Arrubas & Goldfus (1995)**

B. Arrubas and H. Goldfus, 'The kilnworks of the Tenth legion Fretensis', in J.H. Humphrey (ed.), *The Roman and Byzantine Near East: Some Recent Archeological Research*, *JRA*, Supplementay Series Number 14 (Ann Arbor 1995), 96–107

**Aubert & Cortopassi (1998)**

M.-F. Aubert and R. Cortopassi, *Portraits de l'Égypte Romaine* (Paris 1998).

**Avida (1984)**

A. Avida in *Highlights of Archaeology. The Israel Museum* (Jerusalem 1984), 90–91.

**Aymard (1951)**

J. Aymard, *Les Chasses Romaines des origins à la fin du siècle des Antonins* (Paris 1951).

**Bamberg (2004)**

*Katalog der illuminierten Handschriften der Staatsbibliothek Bamberg.* Vol. 1 (Wiesbaden 2004).

**Barag (1967)**

D. Barag, 'Brick stamp-impressions of the legio X Fretensis', *BJ* 167 (1967), 244–67.

**Barakari-Gleni (2006)**

K. Barakari-Gleni, 'Nea topographica stoicheia apo tis teleutaies sostikes anaskephes stin periochi tis Lernas', in *A'Archaiologiki Synodos Notias kai Dytikis Ellados [Patras 9–12 June 1996]* (Athens 2006, 289–98 (esp. 293–98).

**Barberini (1993)**

M.G. Barberini, 'Dei lavori ad un fauno di rosso anticoed altre strutture del Museo Capitolino' (1736-1746), *Bollettino dei Musei Comunali di Roma*, VII (Rome 1993), 23–5.

**Barnes (1967)**

T.D. Barnes, 'Hadrian and Lucius Verus', *JRS* 57 (1967), 65–79.

**Barrón (1908)**

E. Barrón, *Catálogo de la escultura, Museo Nacional del Prado* (1908).

**Becker (1925)**

P. Becker, *Der römische Villenbesitz in Italien zur Kaiserzeit* (Bonn 1925).

**Begley & De Puma (1991)**

V. Begley and R.D. De Puma (eds), *Rome and India: The Ancient Sea Trade* (Madison 1991).

**Benndorf (1902)**

O. Benndorf, 'Antike Baumodelle', *JÖAI* 5 (1902), 175–95.

**Bergmann (1997)**

M. Bergmann, 'Zu den Porträts des Trajan und Hadrian', in A. Caballos and P. Leon (eds), *ITALICA MMCC: Actas de las Jornadas del 2.200 Aniversario de la Fundación de Itálica [Sevilla, 8–11 noviembre 1994]* (Seville 1997), 137–53.

**Bernand (1960)**

A. and E. Bernand, *Les inscriptions grecques et latines du Colosse de Memnon* (Paris 1960).

**Birley (1987)**

A.R. Birley, *Marcus Aurelius: A Biography* (rev. edn, London 1987).

**Birley (1997)**

A.R. Birley, *Hadrian: The Restless Emperor* (London/New York 1997).

**Blanco (1957)**

A. Blanco, *Catálogo de la escultura, Museo Nacional del Prado* (1957), 146, no. 176-E.

**Bloch (1938, 1939)**

H. Bloch, *I bolli laterizi e la storia edilizia romana: contributi all'archeologia e alla storia romana* (Rome 1938, 1939).

**Bloch (1948)**

H. Bloch, *Supplement to volume XV, 1, of the Corpus inscriptionum latinarum, including complete indices to the Roman brick-stamps* (Cambridge Mass. 1948).

**Blurton (1997)**

T.R. Blurton, *The Enduring Image: Treasures from the British Museum* (London 1997).

**Boatwright (1987)**

M.T. Boatwright, *Hadrian and the City of Rome* (Princeton 1987).

**Boatwright (1991)**

M. T. Boatwright, 'The imperial women of the Early Second Century AD', *AJPh* 112 (1991), 513–40.

**Boatwright (2000)**

M.T. Boatwright, *Hadrian and the Cities of the Roman Empire* (Princeton 2000).

**Bol (1998)**

R. Bol, 'Die Porträts des Herodes Atticus und seiner Tochter Athenais', *Antike Kunst* 41 (1998), 119–29.

**Bollansée (1994)**

J. Bollansée, 'P. Fay. 19, Hadrian's Memoirs, and imperial epistolary autobiography', *AncSoc* 25 (1994), 279–302.

**Borg (1996)**
B. Borg, *Mumienporträts und verwandte Monumente. Chronologie und kulturelle Kontext* (Mainz 1996).

**Borg (1998)**
B. Borg, *'Der zierlichste Anblick der Welt ...'. Ägyptische Porträtmumien* (Mainz 1998).

**Boschung (1993)**
D. Boschung, *Die Bildnisse des Augustus*, Das römische Herrscherbild, I.Abteilung; Bd.2 (Berlin 1993).

**Boschung (1997)**
D. Boschung, H. Von Hesberg and A. Linfert, *Die antiken Skulpturen in Chatsworth*, Monumenta Artis Romanae XXVI (Mainz 1997).

**Botti (1951)**
G. Botti and P. Romanelli, *Le sculture del Museo Gregoriano Egizio* (Roma 1951).

**Bowersock (1985)**
G.W. Bowersock, 'Palestine: Ancient History and Modern Politics', *Journal of Palestine Studies* 14, no. 4 (Summer 1985), 49–57.

**Bowersock (2003)**
Bowersock, G. W., 'The Tel Shalem Arch and P. Nahal Hever/Seiyal 8', in Schäfer 2003, 171–80.

**Bowman (1994)**
A.K. Bowman and A.K. Thomas, *The Vindolanda writing-tablets. Tabulae Vindolandenses II* [= *Tab. Vindol.* II] (London 1994).

**Bowman (1998, 2003)**
Bowman, A. K., *Life and letters on the Roman Frontier: Vindolanda and its People* (London 1998, 2nd edn 2003).

**Braemer (1963)**
F. Braemer, *L'Art dans l'Occident romain* (Paris 1963).

**Bracker (1968)**
J. Bracker, 'Ein Trauerbildnis Hadrians aus Köln', *AntPl*, VIII (1968), 75–84.

**Braund (1991)**
D. Braund, 'Hadrian and Pharasmanes', *Klio* 73 (1991), 208–19.

**Braund (1994)**
D. Braund, *Georgia in antiquity. A history of Colchis and Transcaucasian Iberia 550 BC-AD 562* (Oxford 1994).

**Breeze (2006)**
D.J. Breeze, *J. Collingwood Bruce's Handbook to the Roman Wall* (Newcastle 2006).

**Breeze & Dobson (2000)**
D.J. Breeze and B. Dobson, *Hadrian's Wall* (4th edn, London 2000).

**Breeze et al. (2005)**
D.J. Breeze, S. Jilek and A. Thiel, *Frontiers of the Roman Empire = Grenzen des Römischen Reiches = Frontières de l'Empire Romain* (Edinburgh 2005).

**Brown (1964)**
F.E. Brown, 'Hadrianic Architecture', in L. Freeman Sadler (ed.), *Essays in Memory of Karl Lehmann* (New York 1964), 55–8.

**Brunt (1980)**
P.A. Brunt, 'Free Labour and Public Works at Rome', *JRS* 70 (1980), 81–100.

**Caballos Rufino (1990)**
A. Caballos Rufino, *Los senadores hispanorromanos y la romanización de Hispania: siglos I al III p. C.: prosopografía* (Ecija 1990).

**Caballos Rufino (2004)**
A. Caballos Rufino, 'Raíces hispanas de la familia imperial de Trajano a Adriano', in J.M. Cortés

Copete and E. Muñiz Grijalva (eds), *Adriano Avgvsto* (Seville 2004), 37–55.

**Caballos & Leon (1997)**
A. Caballos and P. Leon (eds), *Italica MMCC* (Seville 1997).

**Callender (1965)**
M.H. Callender, *Roman amphorae, with index of stamps* (London and New York 1965).

**Calza (1964)**
R. Calza, *I ritratti. 1, Ritratti greci e romani fino al 160 circo D.C.* (Ostia V), (Rome 1964).

**Carandini (1969)**
A. Carandini, *Vibia Sabina. Funzione politica, iconografia e il problema del classicismo adrianeo* (Florence 1969).

**Carreras Monfort (1998)**
C. Carreras Monfort and P.P.A. Funari, *Britannia y el Mediterráneo: estudios sobre el abastecimiento de aceite bético y africano en Britannia* (Barcelona 1998).

**Cassatella & Pensabene (1990)**
A. Cassatella and S. Pensabene, 'Restituzione dell'impianto Adrianeo del Tempio di Venere e Roma', Archeologia Laziale 10 (1990), 54.

**Chamay (1989)**
J. Chamay and J.-L. Maier, *Art Romain. Sculptures en pierre du Musée de Genève* (Mainz 1989), no. 16.

**Champlin (1976)**
E. Champlin, 'Hadrian's Heir', *ZPE* 21 (1976), 79–89.

**Charles-Gaffiot (1999)**
J. Charles-Gaffiot and H. Lavagne (eds.), *Hadrien. Trésors d'une villa impériale* [= *Hadrien* 1999] (Milan 1999).

**Chic García (1985)**
G. Chic García, *Epigrafía anfórica de la Bética* (Seville 1985–8).

**Chic García (2001)**
G. Chic García, *Datos para un studio socioeconómico de la Bética. Marcas de alfar sobre ánforas olearias* (Ecija 2001).

**Civiltà Romana (1982)**
*Catalogo del Museo della Civiltà Romana* (Rome 1982).

**Clairmont (1966)**
C.W. Clairmont, *Die Bildnisse des Antinous* (Rome 1966).

**Claridge (2007)**
A. Claridge, 'Hadrian's lost Temple of Trajan', *JRA* 20 (2007), 54–94.

**Clarke (2006)**
J.R. Clarke, 'The Warren cup: Greek or Roman lovemaking?', *JRA* 11 (2006), 509–10.

**Collingwood & Wright (1995)**
R.G. Collingwood and R.P. Wright, *The Roman inscriptions of Britain. 1, Inscriptions on stone; Epigraphic indexes* [= RIB] (Stroud 1995).

**Collingwood & Wright (1995)**
R.G. Collingwood and R.P. Wright, *The Roman inscriptions of Britain. Vol.2, Instrumentum domesticum (personal belongings and the like)* [= RIB II] (Stroud 1995).

**Collingwood Bruce (2006)**
J. Collingwood Bruce, *Handbook to the Roman Wall*, 14th edn, ed. David J. Breeze (Newcastle 2006).

**Conforto (2001)**
M.L. Conforto *et al.*, *Adriano e Constantino. Le due fasi dell' arco nella valle del Colosseo* (Milan 2001).

**Coraggio (2000)**
F. Coraggio, 'Adriano giovane', in *Adriano.*

*Architettura e progetto. Catalogo della mostra (Tivoli, Villa Adriana, 13 aprile 2000–7 gennaio 2001)*, (Milan 2000), 240–41, n. 50.

**Cotton (1999)**
H.M. Cotton, 'Die Papyrusdokumente aus der judäischen Wüste und ihr Beitrag zur Geschichte', *Zeitschrift des Deutschen Palästina-Vereins* 115 (1999), 228–47.

**Danziger & Purcell (2005)**
D. Danziger and N. Purcell, *Hadrian's Empire: When Rome Ruled the World* (London 2005).

**Davies (2000)**
P.J.E. Davies, *Death and the Emperor: Roman Imperial Funerary Monuments from Augustus to Marcus Aurelius* (Cambridge 2000).

**Davies et al. (1987)**
P. Davies, D. Hemsoll and M. Wilson Jones, 'The Pantheon: triumph of Rome or triumph of compromise?', *Art History* 10.2 (1987), 135–53.

**De Franceschini (1991)**
M. de Franceschini, *Villa Adriana: Mosaici, pavimenti, edifici* (Rome 1991).

**Dow & Vermeule (1965)**
S. Dow and C.C. Vermeule, 'The statue of the Damaskenos', *Hesperia* 34 (1965), 273–97.

**Doxiadis (1995)**
E. Doxiadis, *The Mysterious Fayum Portraits. Faces from Ancient Egypt* (London 1995).

**Eck (1978a)**
W. Eck, s.v. 'Matidia, no. 2', *RE Suppl.* 15 (1978), 131–3.

**Eck (1978b)**
W. Eck, s.v. 'Vibia (?) Sabina, no. 72b', *RE Suppl.* 15 (1978), 909–14.

**Eck (1999)**
W. Eck, 'The Bar Kokhba Revolt: The Roman Point of View', *JRS* 89 (1999), 76–89.

**Eck & Förster (1999)**
W. Eck and G. Förster, 'A triumphal Arch for Hadrian near Tel Shalem in the Beth Shean Valley', *JRA* 12 (1999), 294–313.

**Edwards (1992)**
B.J.N. Edwards, *The Ribchester Hoard* (Preston 1992).

**Evers (1994)**
C. Evers, *Les portraits d'Hadrien. Typologie et ateliers*, Académique royale de Belgique (Brussels 1994).

**Fernández-Chicarro & Fernández Gómez (1980)**
F. Fernández-Chicarro and F. Fernández Gómez, *Catálogo del Museo Arqueológico de Sevilla* (II), (Madrid 1980) 106, n. 21.

**Fiore (2005)**
F.P. Fiore, *La Roma di Leon Battista Alberti: umanisti, architetti e artisti alla scoperta del'antico nella città del Quattrocento* (Milan 2005).

**Fiore & Mari (2003)**
M.G. Fiore and Z. Mari, *Villa di Traiano ad Arcinazzo Romano: Il recupero di un gran monumento* (Rome 2003).

**Fittschen (1996)**
K. Fittschen, 'Courtly Portraits of Women in the Era of the Adoptive Emperors (98–180) and their Reception in Roman Society', in Kleiner-Matheson (1996), 42–52.

**Fittschen (1999)**
Fittschen, K., *Prinzenbildnisse antoninischer Zeit* (Mainz 1999).

**Fittschen & Zanker (1983)**
K. Fittschen and P. Zanker, *Katalog der römischen Porträts in den Capitolinischen Musee und den anderen kommunalen Sammlung der Stadt Rom* (Mainz 1983).

**Foerster (1986)**
G. Foerster, 'A Cuirassed Bronze Statue of Hadrian', *Atiquot*, Engl. Series 17 (1986), 139–60.

**Förster (1980)**
G. Förster 'A Cuirassed Statue of Hadrian' *IMN* 16 (1980), 107–110.

**Fraser (2006)**
T.E. Fraser, *Hadrian as a Builder and Benefactor in the Western Provinces* (London 2006).

**Freyberger (1990)**
K.S. Freyberger, *Stadtrömische Kapitelle aus der Zeit von Domitian bis Alexander Severus: zur Arbeitsweise und Organisation stadtrömischer Werkstätten der Kaiserzeit* (Mainz 1990).

**Galli (2002)**
M. Galli, *Die Lebenswelt eines Sophisten: Untersuchungen zu den Bauten und Stiftungen des Herodes Atticus* (Mainz 2002).

**Garcia y Bellido (1949)**
A. Garcia y Bellido, *Esculturas romanas* (Madrid 1949), no. 22, pl. 21, 33–4.

**Garcia y Bellido (1951)**
A. Garcia y Bellido, *Museo Arqueológico de Sevilla. Catálogo de los retratos romano* (Madrid 1951), no. 17, 3 ill, 19–20.

**Gascou & Janon (2000)**
J. Gascou and M. Janon, 'Les chevaux d'Hadrien', *RAN* 33 (2000), 61–8.

**Gergel (1991)**
R.A. Gergel, 'The Tel Shalem Hadrian Reconsidered', *AJA* 95 (1991), 231–51.

**Gergel (2004)**
R.A. Gergel, 'Agora S 166 and Related Works: The Iconography, Typology and Interpretation of the Eastern Hadrianic Breastplate Type', in *Essays in Honour of Sara A. Immerwahr* [= *Hesperia Supplements*, vol. 33] (2004), 371–409.

**Giuliano (1957)**
A. Giuliano, *Catalogo dei ritratti romani del Museo profano lateranense* (Città del Vaticano 1957).

**Giustozzi (2003)**
N. Giustozzi (ed.), *Castel Sant'Angelo* (Milan 2003).

**Goette (1990)**
H.R. Goette, *Studien zu römischen Togadarstellungen* (Mainz 1990).

**Goodman (2007)**
M. Goodman, *Rome and Jerusalem: The Clash of Ancient Civilisations* (London 2007).

**Graham (2006)**
S. Graham, *Ex Figlinis: The Network Dynamics of the Tiber Valley Brick Industry in the Hinterland of Rome* [=BAR International Series 1468] (London 2006).

**Graindor (1934)**
P. Granidor, *Athènes sous Hadrien* (Cairo 1934).

**Grenfell (1900)**
B.P. Grenfell, *Fayûm towns and their papyri* (London 1900).

**Gros (2002)**
P. Gros, 'Hadrien Architecte: Bilan des recherches', in M. Mosser and H. Lavagne (eds), *Hadrien: Empereur et architecte. La Villa d'Hadrien: Tradition et modernité d'un paysage culturel'* (Paris 2002), 32–53.

**Gross (1940)**
W.H. Gross, *Bildnisse Traians*, Das Römische Herrscherbild II. Abt; Bd. 2 (Berlin 1940).

**Guidobaldi (1994)**
F. Guidobaldi, '*Sectilia pavimenta* di Villa Adriana', in *Mosaici antichi in Italia* (Rome 1994), 131–2, pls XXXV and LXI.

**Gusman (1904)**
P. Gusman, *La villa impériale de Tibur (Villa Hadriana)* (Paris 1904).

**Haley (2003)**
E.W. Haley, *Baetica Felix: People and Prosperity in Southern Spain from Caesar to Septimius Severus* (Austin 2003).

**Halfmann (1986)**
H. Halfmann, *Itinera Principum: Geschichte und Typologie der Kaiserreisen im Römischen Reich* (Stuttgart 1986).

**Haselberger (1994)**
L. Haselberger, 'Ein Giebelriss der Vorhalle des Pantheon: Die Werkrisse vor dem Augustusmausoleum', *RM* 101 (1994), 279–308.

**Heilmeyer (1975)**
W.-D. Heilmeyer, 'Apollodorus von Damascus, der Architekt des Pantheon', *JDAI* 90 (1975), 317–47.

**Helen (1975)**
T. Helen, *Organization of Roman brick production in the first and second centuries AD: an interpretation of Roman brick-stamps* (Helsinki 1975).

**Hesberg (2002)**
H. von Hesberg, 'Die Bautätigkeit Trajans in Italien', in *Nunnerich-Asmus* (2002 A), 85–96.

**Hesberg & Panciera (1994)**
H. von Hesberg and S. Panciera, *Das Mausoleum des Augustus: der Bau und seine Inschriften* (Munich 1994).

**Hetland (2007)**
L.M. Hetland, 'Dating the Pantheon', *JRA* 20 (2007), 95–112.

**Heurgon (1951)**
J. Heurgon, 'The Amiens Patera', *JRS*, vol. 41, parts 1 and 2 (1951), 22–4.

**Hill 1914**
G.F. Hill, *Catalogue of the Greek coins of Palestine (Galilee, Samaria, and Judaea)* (London 1914).

**Hoffmann (1980)**
A. Hoffmann, *Das Gartenstadium in der villa Hadriana* (Mainz 1980).

**Hübner (1862)**
E. Hübner, *Die antiken Bildwerke in Madrid* (Berlin 1862).

**Jackson & Craddock (1975)**
R.P.J. Jackson and P.T. Craddock, 'The Ribchester Hoard', in B. Raftery *et al.* (eds), *Sites and sights of the Iron Age* (Oxford 1995), 75–102.

**Jansen (2007)**
G. Jansen, 'Toilets with a view: The luxurious toilets of the Emperor Hadrian at his villa near Tivoli', *BAbesch* 82 (2007), 165–81.

**Jenkins (2006)**
I. Jenkins, *Greek Architecture and its Sculpture in the British Museum* (London 2006).

**Johansen 1995**
F. Johansen, F., *Catalogue Roman Portraits NY Carlsberg Glyptotek* (Copenhagen 1995).

**Keay (1998)**
S. Keay (ed.), *The Archaeology of Early Roman Baetica* [= *JRA Supplementary Series Number 29*] (Portsmouth 1998).

**Kersauson (1996)**
K. de Kersauson, *Catalogue des portraits romains. Tome II, De l'année de la guerre civile (68-69 après J.-C.) à la fin de l'Empire. Musée du Louvre* (Paris 1996).

**Kienast (1980)**
D. Kienast, 'Zur Baupolitik Hadrians in Rom', *Chiron* 10 (1980), 391–412.

**Klein (1988)**
M. Klein, *Untersuchungen zu den kaiserlichen Steinbrüchen an Mons Porphyrites und Mons Claudianus in der östlichen Wüste Ägyptens* (Bonn 1988).

**Kleiner & Matheson (1996)**
D.E. Kleiner and S.B. Matheson (eds), *I Claudia: Women in Ancient Rome* (New Haven 1996).

**Kossack (1974)**
G. Kossack, 'Prunkgräber: Bemerkungen zu Eigenschaften und Aussagewert', in G. Kossack and G. Ulbert (eds), *Studien zur Vor- und Frühgeschichtlichen Archäologie: Festschrift für Joachim Werner zum 65. Geburtstag* (Munich 1974), 3–33.

**Lahusen & Formigli (2002)**
G. Lahusen and E. Formigli, *Römische Bildnisse aus Bronze* (Mainz 2002).

**Lambert (1984)**
R. Lambert, *Beloved and God: The Story of Hadrian and Antinous* (London 1984).

**Lamprecht (1996)**
H.O. Lamprecht, *Opus Caementicium. Bautechnik der Römer* (5th edn, Dusseldorf 1996).

**Lancaster (2005)**
L. Lancaster, *Concrete Vaulted Construction in Imperial Rome: Innovations in Context* (Cambridge 2005).

**Lanciano (2005)**
N. Lanciano, *Hadrian's Villa between Heaven and Earth: A Tour with Marguerite Yourcenar* (Rome 2005).

**La Rocca (1986)**
E. La Rocca, *Rilievi storici Caitolini: Il restauro dei pannelli di Adriano e di Marco Aurelio nel Palazzo dei Conservatori* (Rome 1986).

**Lefkowitz & Fant (1992)**
M.R. Lefkowitz and M.B. Fant (eds), *Women's Life in Greece and Rome: A Source Book in Translation* (2nd edn, Baltimore 1992).

**León (1995)**
P. León, *Esculturas de Itálica* (Sevilla 1995).

**León (2001)**
P. León, *Retratos romanos de la Bética* (Sevilla 2001).

**Lippold (1936)**
G. Lippold, *Die Sculpturen des Vaticanischen Museums.* iii, I (Berlin 1936).

**Lugli (1927)**
G. Lugli, 'Studi topografici intorno alle antiche ville suburbane VI Villa Adriana', *Bull. Com.* 55 (1927), 139–204.

**MacDonald (1982)**
W. MacDonald, *The Architecture of the Roman Empire I: An Introductory Study* (New Haven 1982).

**MacDonald (2002)**
W. MacDonald, *The Pantheon: Design, Meaning, and Progeny. With a New Foreword by John Pinto* (Cambridge, Mass. 2002).

**MacDonald & Pinto (1995)**
W. MacDonald and J. Pinto, *Hadrian's Villa and its Legacy* (New Haven 1995).

**Machabeli (1972)**
K. Machabeli, 'Les coupes d'argent d'Armaziskhevi', *Bedi Kartlisa* 29 (1972), 291-3.

**Mahéo (1990)**
N. Mahéo (ed.), *Les collections archéologiques du musée de Picardie* (Amiens 1990).

**Malaise (1972)**
M. Malaise, *Inventaire préliminare des documents égyptiens découverts en Italie* (Leiden 1972).

**Manodori (1998)**
A. Manodori, 'Memorie sparse del Mausoleo di Adriano', in *Adriano e il suo mausoleo. Studi, indagini e interpretazioni. Castel Sant'Angelo 30 maggio 1998* (Milan 1998), 147-59.

**Mari (2002)**
Z. Mari, 'Tivoli in eta adranea', in Reggiani (2002), 181-202.

**Mari (2003)**
Z. Mari, 'L'Antinoeion di Villa Adriana: risultati della prima campagna di scavo', in *Rendiconti della Pontificia Accademia Romana di Archeologia (Serie III)*, vol. LXXV (2002-2003), 145-85.

**Mari (2004)**
Z. Mari, 'L'Antinoeion di Villa Adriana: risultati della seconda campagna di scavo', in *Rendiconti della Pontificia Accademia Romana di Archeologia (Serie III)*, vol. LXXV (2003-2004), 263-314.

**Mari (2006)**
Z. Mari, 'Il complesso monumentale della palestra a Villa Adriana', in Adembri (2006), 47-53.

**Mari (2007)**
Z. Mari, 'Vibia Sabina e Villa Adriana', in Adembri & Nicolai (2007), 51-65.

**Mari & Sgalambro (2007)**
Z. Mari and S. Sgalambro, 'The Antinoeion of Hadrian's Villa: Interpretation and Architectural Reconstruction', *AJA* 111 (2007), 83-104.

**Mathea-Förtsch (1999)**
M. Mathea-Förtsch, *Römische Rankenpfeiler und –Pilaster* (Mainz 1999), 184 cat. N. 247.

**Mattingly (1968)**
H. Mattingly, *Coins of the Roman Empire in the British Museum; v. 4. Antoninus Pius to Commodus* [= RE4] (London 1968).

**Mercalli (1998)**
M. Mercalli (ed.), *Adriano e il suo Mausoleo* [= Adriano 1998] (Rome 1998).

**Meyer (1991)**
H. Meyer, *Antinoos: Die archäologischen Denkmäler unter Einbeziehung des numismatischen und epigraphischen Materials sowie der literarischen Nachrichten. Ein Beitrag zur Kunst- und Kulturgeschichte der hadrianisch-frühantoninischen Zeit* (Munich 1991).

**Meyer (1994)**
H. Meyer (ed.), *Der Obelisk des Antinoos. Eine kommentierte Edition* (Munich 1994).

**Millar (1966)**
F. Millar, *A Study of Cassius Dio* (Oxford 1966).

**Millar (1992)**
F. Millar, *The Emperor in the Roman World* (2nd edn, London 1992).

**Mortensen (2004)**
S. Mortensen, *Hadrian: Eine Deutungsgeschichte* (Bonn 2004).

**Novelli (2005)**
R. Novelli, *Hadrianeum* (Rome 2005).

**Nünnerich-Asmus (2002A)**
A. Nünnerich-Asmus (ed.), *Trajan. Ein Kaiser der Superlative am Beginn einer Umbruchzeit?* (Mainz 2002).

**Nünnerich-Asmus (2002B)**
A. Nünnerich-Asmus, 'Er baute für das Volk?! Die stadtrömischen Bauten des Trajan', in Nünnerich-Asmus (2002A).

**Packer (1997)**
J. Packer, *The Forum of Trajan in Rome: a study of the monuments, 3 vols* (Berkeley 1997).

**Parlasca (1969–2003)**
K. Parlasca, *Repertorio d'arte dell'Egitto greco-romano. Serie B, I. Ritratti di mummie. I–IV* (Rome 1969-2003).

**Parlasca (1969)**
K. Parlasca, *Ritratti di mummie. Repertorio d'Arte dell'Egitto Greco-romano, serie B – Volume I* (Rome 1969).

**Parlasca (1977)**
K. Parlasca, *Ritratti di mummie. Repertorio d'Arte dell'Egitto Greco-romano, serie B – Volume II* (Rome 1977).

**Parlasca & Seeman**
K. Parlasca and H. Seeman (eds.), *Augenblicke. Mumienporträts und ägyptische Grabkunst aus römischer Zeit* (Frankfurt 1999).

**Peña (1989)**
J.T. Peña, 'P. Giss.69: evidence for the supplying of stone transport operations in Roman Egypt and the production of fifty-foot monolithic column shafts', *JRA* 2 (1989), 126-32.

**Petrakis (1980)**
N.L. Petrakis, 'Diagonal Earlobe Creases, Type A Behavior and the Death of Emperor Hadrian', *Western Journal of Medicine* 132.1 (Jan 1980), 87-91.

**Petrie (1911)**
W.M.F. Petrie, *Roman portraits and Memphis (IV)* (London 1911).

**Petzl & Schwertheim (2006)**
G. Petzl and E. Schwertheim, *Hadrian und die dionysischen Künstler. Drei in Alexandria Troas neugefundene Briefe des Kaisers an die Künstler-Vereinigung*, Asia Minor Studien 58 (Bonn 2006).

**Pierce (1925)**
S.R. Pierce, 'The Mausoleum of Hadrian and the Pons Aelius', *JRS* 15 (1925), 75-103.

**Pitts 2003**
M. Pitts & S. Worrell, 'Dish fit for the gods', *British Archaeology* (2003), 22-7.

**Polloni (1999)**
J. Polloni, 'The Warren Cup: homoerotic love and symposial rhetoric in silver', in *ABull* (March 1999), 21-52.

**Pons Pujol & Berni Millet (2002)**
L. Pons Pujol and P. Berni Millet, 'La figlina Virginensis y la Mauretania Tingitana', in *L'Africa romana XIV, Sassari 2000* (Rome 2002), 1541-70.

**Poulsen (1974)**
V. Poulsen, *Les portraits romains. Volume II, De Vespasien à la Basse-Antiquité* (Copenhagen 1974).

**Potter (1997)**
T.W. Potter, *Roman Britain* (London 1997).

**Price (1987)**
S. Price, 'From Noble Funerals to Divine Cult. The Consecration of Roman Emperors', in: D. Cannadine and S. Price, *Rituals of Royalty: Power and Ceremonial in Traditional Societies* (Cambridge 1987), 56-105.

**Raeder (1983)**
J. Raeder, *Die statuarische Ausstattung der Villa Hadriana bei Tivoli* (Frankfurt 1983).

**Rakob (1973)**
F. Rakob, 'Der Bauplan einer kaiserlichen Villa', in W. Hartmann (ed.), *Festschrift Klaus Lankheit zum 20. Mai 1973* (Cologne 1973), 113-25.

**Rapsaet-Charlier (1987)**
M.T. Rapsaet-Charlier, *Prosopographie des femmes de l'ordre senatorial (Ier–IIe siecles)* (Louvain 1987).

**Reggiani (2002)**
A.M. Reggiani (ed.), *Villa Adriana: paesagio antico e ambiente moderno. Elementi di novità e ricerche in corso. Atti del convegno, Roma, Palazzo Massimo alle Terme, 23–24 giugno 2000* (Milan 2002).

**Reggiani (2004)**
A.M. Reggiani (ed.), *Adriano: Le Memorie al Femminile* (Milan 2004).

**Remesal Rodríguez (1983)**
J. Remesal Rodríguez, 'Ölproduktion und Ölhandel in der Baetica: ein Beispiel fur die Verbindung archäologischer und historischer Forschung', *Münstersche Beiträge zur Antiken Handelsgeschichte* 2.2 (1983), 91-111.

**Remesal Rodríguez (1997)**
J. Remesal Rodríguez, *Heeresversorgung und die wirtschaftlichen Beziehungen zwischen der Baetica und Germanien* (Stutttgart 1997).

**Remesal Rodríguez (1998)**
J. Remesal Rodríguez, 'Baetican olive oil and the Roman economy', in Keay (1998), 183-99.

**Ricard (1923)**
R. Ricard, *Marbres antiques du Musée du Prado* (Bordeaux 1923), 94, no. 145.

**Ridley (1989)**
A.T. Ridley, 'The Fate of an Architect: Apollodorus of Damascus', *Athenaeum* 77 (1989), 551-65.

**Romeo (1998)**
I. Romeo, *Ingenuus Leo. L'Immagine di Agrippa* (Rome 1998).

**Rosenbaum (1960)**
E. Rosenbaum, *Cyrenaican Portrait Sculpture* (London 1960), 51-2, no. 34.

**Rovira (2008)**
R. Rovira Guardiola, 'Museums and literature: Marguerite Youcernar's *Mémoirs d'Hadrien*', in *La Antigüedad clásica en las artes escénicas y visuales* (forthcoming, La Rioja 2008).

**Russell (1995)**
J. Russell, 'A Roman military diploma from Rough Cilicia', *BJ* 195 (1995), pp. 67-133.

**Säflund (1972)**
G. Säflund, *The Polyphemus and Scylla group* (Stockholm 1972).

**Salza (2001)**
E. Salza Prina Ricotti, *Villa Adriana: il sogno di un imperatore* (Rome 2001).

**Setälä (1977)**
P. Setälä, *Private Domini in Roman brick stamps of the empire: a historical and prosopographical study of landowners in the district of Rome* (Helsinki 1977).

**Schäfer (2003)**
P. Schäfer, *The Bar Kokhba War Reconsidered* [= *Texts and Studies in Ancient Judaism 100*] (Tübingen 2003).

**Schmidt-Colinet (2005A)**
A. Schmidt-Colinet, 'Des Kaisers Bart: Überlegungen zur Propagandageschichte im Bildnis des römischen Kaisers Hadrian', in R. Gries and W. Schmale (eds), *Kultur der Propaganda* (Bochum 2005), 95–117.

**Schmidt-Colinet (2005B)**
A. Schmidt-Colinet (ed.), *Palmyra. Kulturbegegnungen im Grenzbereich* (3rd edn, Mainz 2005).

**Schröder (1993)**
S. Schröder, *Katalog der antiken Skulpturen des Museo del Prado in Madrid* (Mainz 1993), cat. no. 54.

**Schröder (1995)**
S. Schröder, 'Hadrian als neuer Romulus? Zum letzten Porträt Kaiser Hadrians', *MM,* 36 (1995), 292–7.

**Schulten (1979)**
P.N. Schulten, *Die Typologie der römischen Konsekrationsprägungen* (Frankfurt 1979).

**Smallwood (1966)**
E.M. Smallwood, *Documents Illustrating the Principates of Nerva, Trajan and Hadrian* (Cambridge 1966).

**Smith (1904)**
A.H. Smith, *A catalogue of sculpture in the Department of Greek and Roman Antiquities* (London 1904).

**Smith (1974)**
D.J. Smith, *Museum of Antiquities Newcastle upon Tyne. An illustrated introduction* (Newcastle 1974).

**Spawforth & Walker (1985)**
A. Spawforth and S. Walker, 'The World of the Panhellenion I. Athens and Eleusis', *JRS* 75 (1985), 78–104.

**Spawforth & Walker (1986)**
A. Spawforth and S. Walker, 'The World of the Panhellenion II. Three Dorian Cities', *JRS* 76 (1986), 88–105.

**Speller (2002)**
E. Speller, *Following Hadrian: A second-century-journey through the Roman Empire* (London 2002).

**Stamper (2005)**
J.W. Stamper, *The Architecture of Roman Temples: The Republic to the Middle Empire* (Cambridge 2005).

**Steinby (1978)**
M. Steinby, 'Ziegelstempel von Roun und Umgebung', *RE*, Suppl. 15 (1978), 1489–1531.

**Steinby (1993)**
M. Steinby, 'L'organizzazione produttiva dei laterizi: un modello interpretativo per l'instrumentum in genere?', in W.V. Harris (ed.), *The Inscribed Economy: Production and distribution in the Roman Empire in the light of instrumentum domesticum* (Ann Arbor 1993), 139–143.

**Stemmer (1978)**
K. Stemmer, *Untersuchungen zur Typologie, Chronologie und Ikonographie der Panzerstatuen* [= Deutsches Archäologisches Institut: *Archäologische Forschungen*, vol. 4] (Berlin 1974).

**Strong (1953)**
D.E. Strong, 'Late Hadrianic Architectural Ornament in Rome', *PBRS* 21 (1953), 118–151.

**Strong (1966)**
D.E. Strong, *Greek and Roman Gold and Silver Plate* (London 1966).

**Stuart Jones (1912)**
H.I. Stuart Jones, *The Sculptures of the Museo Capitolino* (Rome 1912).

**Swain (1996)**
S. Swain, *Hellenism and Empire. Language, classicism and power in the Greek world AD 50-250* (Oxford 1996).

**Syme (1981)**
R. Syme, 'Hadrian and the Vassal Princes', *Athenaeum* 59 (1981), 273–83.

**Syme (1982–3)**
R. Syme, 'Spaniards at Tivoli', *AncSoc* 13–14 (1982-3), 241–63 [= A.R. Birley (ed.), R. Syme, *Roman Papers* vol. IV (Oxford 1988), 94].

**Syme (1986)**
R. Syme, *Fictional History Old and New: Hadrian*. A James Bryce Memorial Lecture, 10 May 1984 (Sommerville College, Oxford, 1986) [= A. R. Birley (ed.), R. Syme, *Roman Papers* vol. VI (Oxford 1991), 157–81].

**Taylor (2003)**
R. Taylor, *Roman Builders: A Study in Architectural Process* (Cambridge 2003).

**Temporini (1978)**
H. Temporini, *Die Frauen am Hofe Trajans* (Berlin 1978).

**Tobin (1997)**
J. Tobin, *Herodes Attikos and the City of Athens: Patronage and Conflict under the Antonines* (Amsterdam 1997).

**Tomei (1998)**
M. A. Tomei, 'Il Mausoleo di Adriano: la decorazione sculturea', in Mercalli (1998), 101–47.

**Tomlin (2004)**
R.S.O. Tomlin, 'Inscriptions', *Britannia* (2004), 344–5

**Tuck (2005)**
S.L. Tuck, 'The Origins of Roman Imperial Hunting Imagery: Domitian and the Redefinition of *Virtus* under the Principate', *Greece & Rome* 52.2 (2005) 221–45.

**Vainker (1991)**
S.J. Vainker, S. J. *Chinese pottery and porcelain* (London 1991).

**Valeri (2001)**
C. Valeri, 'Le portrait de Plotine à Genève et la décoration statuaire des Thermes de la Porta Marina' in Descoeudres, J.-P. (ed.), *Ostia. Port et porte de la Rome antique* (Geneva 2001), 303–7.

**Vermeule (1978)**
C.C. Vermeule, 'Cuirassed Statues – 1978 Supplement', *Berytus* 26 (1978), 85–123.

**Vermeule (1980)**
C.C. Vermeule, *Hellenistic and Roman cuirassed statues* (Boston 1980).

**Vermeule (1981)**
C.C. Vermeule, *Greek and Roman Sculpture in America* (Berkeley 1981).

**Vermeule (1988)**
C.C. Vermeule, *Sculpture in Stone and Bronze in the Museum of Fine Arts, Boston. Additions to the Collections of Greek, Etruscan and Roman Art, 1971–1988* (Boston 1988).

**Vighi (1958)**
R. Vighi, 'Villa Adriana e il suo Canopo', *Rivista Pirelli*, VIII, 6 (1958), 11.

**Virgili & Battistelli (1999)**
P. Virgili and P. Battistelli, 'Indagini in piazza Rotonda e sulla fronte del Pantheon', *BullCom* 100 (1999), 137–54.

**Visconti (1874)**
*BullCom*, 2 (1874), 126 ss., tav. 10, 1.2.

**Vout (2006)**
C. Vout, 'What's in a beard? Rethinking Hadrian's Hellenism', in S. Goldhill and R. Osborne (eds), *Rethinking Revolutions through Ancient Greece* (Cambridge 2006), 96–123.

**Vout (2007)**
C. Vout, *Power and Eroticism in Imperial Rome* (Cambridge 2007).

**Waelkens (2007)**
M. Waelkens, 'Colossal Statue of Hadrian Found at Sagalassos, Turkey', *Minerva* 18.6 (November/December 2007), 3–4.

**Waelkens (2008)**
M. Waelkens, Article on Sagalassos Hadrian, forthcoming, *British Museum Magazine*, Issue 61 (Autumn 2008).

**Walker (1989)**
S. Walker, 'A marble head of Herodes Atticus from Winchester City Museum', *Antiquaries Journal* 69 (1989), 324–6.

**Walker (1991)**
S. Walker, 'Bearded Men', *Journal of the History of Collections* 3 (1991), 265–77.

**Walker (2000)**
S. Walker (ed.), *Ancient Faces. Mummy Portraits from Roman Egypt* (London 2000).

**Walker (2002)**
S. Walker, 'Hadrian and the Renewal of Cyrene', *Libyan Studies* 33 (2002), 45–56.

**Walker & Bierbrier (1997)**
S. Walker and M. Bierbrier with P. Roberts and J. Taylor, *Ancient Faces: Mummy Portraits from Roman Egypt* [*A Catalogue of Roman Portraits in the British Museum*, 4] (London 1997).

**Walker & Higgs (2001)**
S. Walker and P. Higgs (eds), *Cleopatra of Egypt* (London, 2001).

**Walters (1926)**
H.B. Walters, H. B., *Catalogue of the engraved gems and cameos, Greek, Etruscan and Roman, in the British Museum*, London 1926

**Wegner (1956)**
M. Wegner, *Hadrian, Plotina, Marciana, Matidia, Sabina. Das Römische Herrscherbild* ; II. Abt., Bd. 3 (Berlin 1956).

**Wegner (1984)**
M. Wegner, 'Verzeichnis der Bildnisse von Hadrian', *Boreas* 7 (1984), 105–45.

**Willers (1990)**
D. Willers, *Hadriens Panhellenisches Programm: Archäologische Beiträge zur Neugestaltung Athens durch Hadrian* (Basel 1990).

**Williams (1999)**
C.A. Williams, *Roman Homosexuality: Ideologies of Masculinity in Classical Antiquity* (New York 1999).

**Williams (2006)**
D. Williams, *The Warren Cup* (London 2006).

**Wilson Jones (2000)**
M. Wilson Jones, *Principles of Roman Architecture* (New

Haven 2000).

**Wright (1961)**
R.P. Wright, 'Roman Britain in 1960: I. Sites Explored: II. Inscriptions', *JRS*. 51, Parts 1 and 2 (1961), 157–98.

**Yadin (1963–2002)**
Y. Yadin, *The Finds from the Bar Kokhba Period in the Cave of Letters*, 4 vols in 3 (Jerusalem 1963–2002).

**Yadin (1971)**
Y. Yadin, *Bar-Kokhba: The Rediscovery of the Legendary Hero of the Last Jewish Revolt against Imperial Rome* (London 1971).

**Yadin (1989)**
Y. Yadin, *The Documents from the Bar Kokhba period in the Cave of Letters* (Jerusalem, Israel Exploration Society; Hebrew University of Jerusalem 1989).

**Yourcenar (1954)**
M. Yourcenar, *Memoirs of Hadrian* (trans. London and New York 1954).

**Zahrnt (1989)**
M. Zahrnt, 'Antinoopolis in Ägypten', *ANRW* 2.10.1 (Berlin 1989), 669–706.

**Zanker (1988)**
P. Zanker, *The Power of Images in the Age of Augustus* (Ann Arbor 1988).

**Zanker (1970)**
P. Zanker, 'Das Trajansforum im Rom', *Archäologischer Anzeiger*, (1970), 499–544.

**Zanker (1995)**
P. Zanker, *The Mask of Socrates: The Image of the Intellectual in Antiquity* (Berkeley, Calif. 1995).

**Zanker (2004)**
P. Zanker, *Die Apotheose der römischen Kaiser: Ritual und städtische Bühne* (Munich 2004).

**Zwalf (1985)**
W. Zwalf (ed.), *Buddhism: art and faith* (London 1985).

**Zwalf (1996)**
W. Zwalf, *Catalogue of the Gandhara Sculpture in the British Museum* (London 1996)

# ILLUSTRATION ACKNOWLEDGEMENTS

**Half-title page**: The Trustees of the British Museum (John Williams and Saul Peckham)

**Frontispiece:** The Trustees of the British Museum (John Williams and Saul Peckham)

**p. 4** The Trustees of the British Museum (CM, RE3, 325.670)

**p. 5** The Trustees of the British Museum (CM 1888,0512.2)

**p. 6** The Trustees of the British Museum (John Williams and Saul Peckham)

**pp. 14–15** The Trustees of the British Museum (Paul Goodhead)

**Fig. 1** The Trustees of the British Museum (John Williams and Saul Peckham)

**Fig. 2** Roger Clegg

**Fig. 3** Lee Frost / Robert Harding

**Fig. 4** The Trustees of the British Museum (Paul Goodhead)

**Fig. 5** The Museum of Antiquities of the University and Society of Antiquaries of Newcastle upon Tyne

**Fig. 6** The Dayton Art Institute, Gift of Mr and Mrs Elton F. MacDonald, 1957.141

**Figs 7–11** Sagalassos Archaeological Project

**Fig. 12** Staatsbibliothek Bamberg Msc.Class.54, fol. 3r

**Fig. 13** Houghton Library, Harvard University

**Fig. 14** *Marguerite Yourcenar* Mt. Desert Island, Maine 16 September 1983 © Mariana Cook 1983

**Fig. 15** Archive Petite Plaisance

**Fig. 16** The Trustees of the British Museum

**Fig. 17** The Trustees of the British Museum (John Williams and Saul Peckham)

**Fig. 18** The Trustees of the British Museum (David Hoxley, after Birley 1997)

**Fig. 19** Stiftung Preußische Schlösser und Gärten Berlin-Brandenburg

**Fig. 20** Michael Brusselle / Robert Harding

**Fig. 21** The Trustees of the British Museum (BMC Hadrian 843)

**Fig. 22** The Trustees of the British Museum (Paul Goodhead)

**Fig. 23** CEIPAC

**Fig. 24** The Trustees of the British Museum

**Fig. 25** The Trustees of the British Museum (Paul Goodhead)

**Fig. 26** Antonio Aguilera / Piero Berni

**Fig. 27** The Museum of Antiquities of the University and Society of Antiquaries of Newcastle upon Tyne

**Fig. 28** Consejería de Cultura de la Junta de Andalucia (Guillermo Mendo Murillo)

**Fig. 29** Stratfield Saye Preservation Trust (John Williams and Saul Peckham)

**Fig. 30** Alinari Archives – Florence

**Fig. 31** Sites&Photos

**Fig. 32** Musée d'art et d'histoire, Ville de Genève, inv. no. 19479 (Bettina Jacot-Descombes)

**Fig. 33** Soprintendenza per I Beni Archeologici di Ostia (Giulio Sanguinetti)

**Fig. 34** Musei Capitolini (John Williams and Saul Peckham)

**Fig. 35** The Trustees of the British Museum (John Williams and Saul Peckham)

**Fig. 36** NY Carlsberg Glyptotek, Copenhagen

**Fig. 37** The Trustees of the British Museum (John Williams and Saul Peckham)

**Fig. 38** Musei Capitolini (John Williams and Saul Peckham)

**Fig. 39** Devonshire Collection, Chatsworth. Reproduced by permission of Chatsworth Settlement Trustees.

**Fig. 40** Museo Nacional del Prado, Madrid

**Fig. 41** The Trustees of the British Museum

**Fig. 42** The Trustees of the British Museum (John Williams and Saul Peckham)

**Fig. 43** The Trustees of the British Museum

**Fig. 44** Soprintendenza per i Beni Archeologici del Lazio - Villa Adriana (John Williams and Saul Peckham)

**Fig. 45** The Trustees of the British Museum

**Fig. 46** Collection The Israel Antiquities Authority, Jerusalem. Photograph ©The Israel Museum, Jerusalem (John Williams and Saul Peckham).

**Fig. 47** The Trustees of the British Museum (BMC Hadrian 1106)

**Fig. 48** The Trustees of the British Musem (Paul Goodhead)

**Fig. 49** Museo della Civiltà Romana (John Williams and Saul Peckham)

**Fig. 50** The Trustees of the British Museum (BM Trajan 613)

**Fig. 51** The Trustees of the British Museum (BM Trajan 1035)

**Fig. 52** The Trustees of the British Museum (John Williams and Saul Peckham)

**Fig. 53** The Trustees of the British Museum

**Fig. 54** Musei Capitolini (John Williams and Saul Peckham)

**Fig. 55** The Trustees of the British Museum (Paul Goodhead)

**Fig. 56** Roger Clegg

**Figs 57–8** Museo della Civiltà Romana (John Williams and Saul Peckham)

**Fig. 59** The Museum of Antiquities of the University and Society of Antiquaries of Newcastle upon Tyne

**Fig. 60** Georg Gerster / Panos Pictures

**Fig. 61** The Trustees of the British Museum

**Fig. 62** The Trustees of the British Museum (Paul Goodhead)

**Fig. 63** G. Cope Collection (photo. The Trustees of the British Museum)

**Fig. 64** The Trustees of the British Museum (John Williams and Saul Peckham)

**Fig. 65** The Museum of Antiquities of the University and Society of Antiquaries of Newcastle upon Tyne

**Fig. 66** The Museum of Antiquities of the University and Society of Antiquaries of Newcastle upon Tyne

**Fig. 67** The Trustees of the British Museum

**Fig. 68** Collection of the Duke of Northumberland

**Fig. 69** Musée de Picardie, deposit of the State; inv. no. M.P.D. 3984 (Hugo Maertens)

**Fig. 70** The Trustees of the British Museum (BMC

# INDEX

Page numbers in *italics* denote illustrations. Where appropriate, Roman names appear under each name component (*praenomen*, *cognomen* and/or *nomen*) for ease of access.